ART IN THE MAKING

REMBRANDT

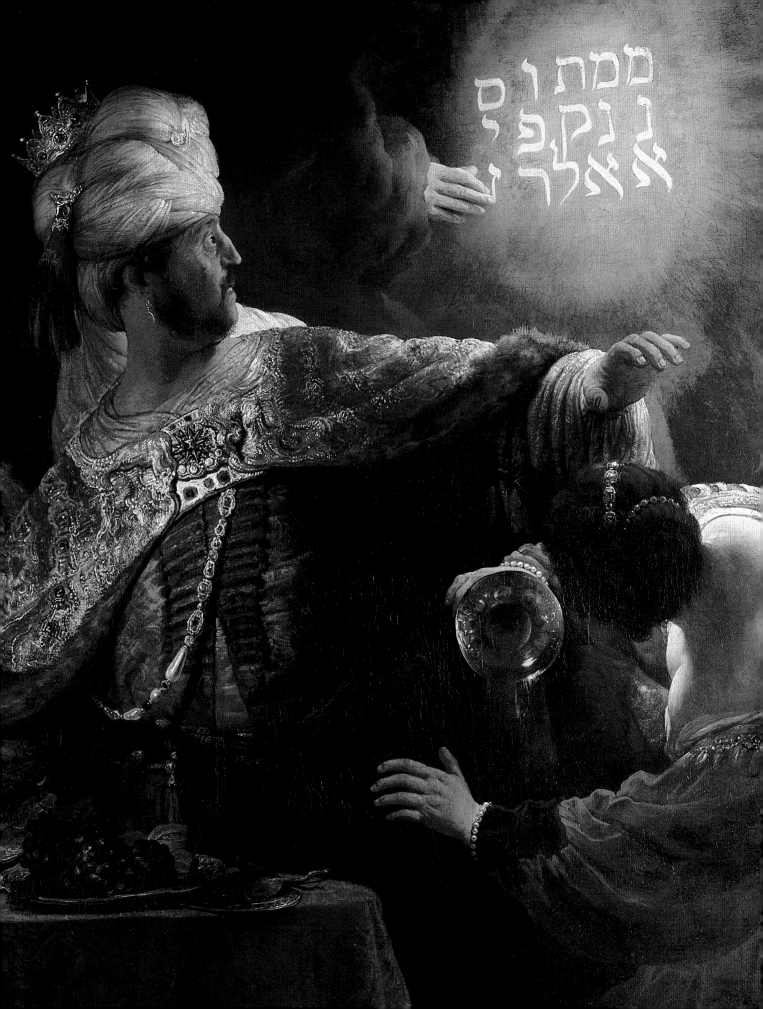

ESSAYS

Studio practice and the training of artists

The training of painters in the northern Netherlands in the seventeenth century was essentially practical, based on a long studio apprenticeship, much as it always had been. Here, as in other parts of northern Europe, the trade of the painter, like that of other craftsmen, was controlled more or less rigorously by the appropriate town guild. In Amsterdam, Leiden and many other Dutch cities the painters had their own guild, the Guild of Saint Luke. In order to practise his trade the painter had to belong to the guild, to register his pupils and to fulfil any other obligations laid down in the guild regulations. On its side, the guild protected the interests of its members; it controlled the number of pupils a master might have – generally four to six; very frequently it exerted a degree of quality control on the work the painter produced. It could also control the number of masters who could work in the town, thereby restricting competition: if a painter moved to another town, as Rembrandt did, from Leiden to Amsterdam early in his career, he was obliged to register with the local guild.[1]

Over the years, the painters' guilds, like those of other crafts, had to respond to the ebb and flow of religious and sociological changes. The influx of foreign craftsmen from Antwerp and other parts of the southern Netherlands in the last decades of the sixteenth century had important consequences for northern Netherlandish cities, which benefited considerably from the skills that were imported:[2] not for nothing is the seventeenth century known as the Golden Age of the Netherlands, and painters flourished in this period of overall prosperity. During these years also, painters in the Netherlands, as in other parts of Europe and following the example of painters in Italy, came to feel that their particular intellectual skills should be accorded some recognition and that they merited a higher social standing. This was not in conflict with the guild framework; changes in the guild structures and their methods of operation took place gradually from within, in ways that differed from place to place. Already in 1480, for example, the Antwerp Guild of Saint

Fig. 1 Samuel van Hoogstraten, *Studio Scene: Rembrandt with his Pupils*, about 1642–8.
Brush and brown ink, 18 x 31.7 cm.
Klassik Stiftung Weimar, inv. KK 5503

Luke joined with the so-called Chamber of Rhetoric, the Violieren, thus linking themselves with a group of high social position in the city.[3] In Rembrandt's home town of Leiden, the painter Philips Angel gave a lecture to members of the painters' guild on 18 October 1641, the feast day of Saint Luke, in which he aimed to define the intellectual status of the painter and the means by which the painter's work could be appreciated by connoisseurs.[4] However, even allowing for this change in the intellectual climate in northern Europe generally, it is quite rare to find an example of a seventeenth-century Dutch – or, indeed, Flemish – painter, however successful, whose career ran its course outside the influence of the guild structure.

Studio training, drawing schools and instruction manuals

The pupils probably received little theoretical teaching in the studio. Apart from the preparation of the materials and supports to be used, they probably began by drawing – copying drawings and perhaps published engravings; by drawing from casts and other objects in the studio, such as drapery; and by drawing from the life. As well as paper and ink, it is very probable that the pupils used specially prepared erasable papers or boards, *tafeletten*, prepared with a priming of ground bone or some other white material in an aqueous medium; this could be drawn on using a metal stylus (lead, a lead-tin alloy or silver) and the drawing could be erased: the surface could even be regrounded if necessary.[5]

The pupil would thus learn how to compose a design for a composition suitable for the subject matter. The inventory of Rembrandt's property made when he was declared insolvent in 1656 excludes the studio itself and its contents, but reveals that he had a wide range of plaster casts, shells, corals, textiles, pieces of armour and other curios; this is confirmed by his own drawings of shells and other items. He also owned books of engravings after the works of other artists, including Raphael and Titian, trial proofs by Rubens and Jordaens, paintings by contemporaries such as Jan Lievens, many drawings and so on.[6] This sort of material would form a useful teaching aid. The only book listed in the inventory that would be of practical use is ' 't proportie boeck van Albert Durer'.[7] Albrecht Dürer's works on geometry, perspective and human proportions were among several such books available in the Netherlands in the seventeenth century and still influential.

The study of drawing was seen as an essential part of education in general, and not just for the study of painting. A number of drawing books from which young artists might be helped to learn to draw were published during the seventeenth century: in these the pictorial, rather than the theoretical, content is dominant. One of the most important was Crispijn van de Passe the Younger's *Van t'light der Teken en Schilder Konst* ... (Amsterdam 1643), which illustrates the correct proportions of the human body, includes figure studies and representations of animals and birds and also covers other aspects of the painter's training.[8] De Passe gives instructions for the setting up of classes for the study of life drawing. Drawing classes or 'Academies' complemented studio training, following Italian models, but in the seventeenth century were

rather less concerned with the status of the artist than their Italian counterparts and were generally organised informally. One of the earliest was that set up by Karel van Mander and his friends in Haarlem in 1583; another was associated with the Utrecht artist Gerrit van Honthorst, who had also been to Italy. In 1631 a group of Haarlem painters drafted a new charter for their Guild of Saint Luke in which joint sessions in drawing were to be encouraged.[9] Some life drawing seems to have been carried out in Rembrandt's studio and so this too could have the term 'Academy' applied to it (Fig. 1).[10] A well-known image of an academy at work is that of Michiel Sweerts, who around 1656 set up an academy for life drawing in Brussels; its aim, however, was not to educate painters, but to teach design to young people intending to work as designers of carpets or tapestries, luxury industries for which Brussels was renowned.[11] His painting (Fig. 2) shows young pupils sketching a male model standing on a raised platform while the teacher in his white cap shows a visitor around.

Contemporary literature describing the practice of painting was rarely intended as a tool for the apprentice painter; it was more for the enlightenment of the amateur or connoisseur, or to enhance the status of the painter. Three books on watercolour painting fall into the former category: Gerard ter Brugge's *Verlichtery Kunst-Boeck* (Amsterdam 1616), Willem Goeree's *Verligterie-Kunde* (Amsterdam 1670, a revision of ter Brugge) and Willem Beurs's *De groote Waerelt in t'kleen geschildert* (Amsterdam 1692). These are relatively straightforward manuals of instruction, listing suitable materials and describing their use. Beurs contains some colour theory in the tradition of Giovanni Paolo Lomazzo's *Trattato dell'arte de la pittura* (Milan 1584) and other works, but this is not unusual. Another example is Cornelis Pietersz. Biens's *De Teecken-Const* (Amsterdam 1636).[12] Drawing heavily on Karel van Mander's *Het Schilder-Boeck* (Haarlem 1604) and ter Brugge's *Verlichtery Kunst-Boeck*, it also contains practical information, which must have been gained from artist friends, and a description of making a lay figure apparently unique in seventeenth-century Netherlandish literature. A lay figure was a useful studio prop (Fig. 3): two, one wooden, the other covered with linen, appear in the 1671 inventory made of the possessions of Lodewijck, the son, and Anna du Pierre, the widow of the Amsterdam portraitist Bartholomeus van der Helst, who died in 1670.[13]

In the Netherlands pupils normally began their training at between twelve and sixteen years of age – Rembrandt was about fourteen – and the period of apprenticeship stipulated by the guilds was a minimum of two to three years, although this varied from place to place and contract to contract: some were for as long as seven years.[14] A contract was drawn up between the painter who was to give tuition and the apprentice, or his parents or guardians, and a fee was arranged: Rembrandt appears to have charged the high amount of 100 guilders annually, without a reduction towards the end of the contract.[15] For this, the pupil usually received his board and lodging from the master as well as tuition, and learnt the mechanics of painting. For his part, the student was not allowed to leave before the contract had expired and

Fig. 2 Michiel Sweerts, *The Academy*, about 1655–60. Oil on canvas, 76.5 × 109.5 cm. Haarlem, Frans Hals Museum, inv. os I-317

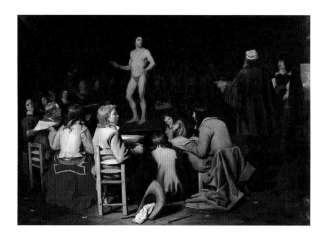

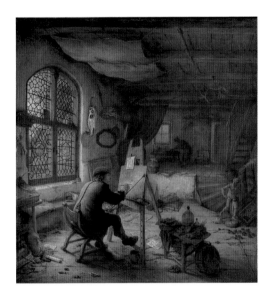

Fig. 3 Adriaen van Ostade,
The Painter in his Studio, 1663.
Oil on panel, 38 × 33.5 cm.
Staatliche Kunstsammlungen
Dresden, Gemäldegalerie Alte
Meister, inv. Gal. Nr. 1397

he was expected to be industrious, loyal and to work on his master's behalf. Clearly, as the student's training progressed, he became more useful in the everyday work of the studio and contributed to the income earned; often, then, the fees that were paid for him decreased accordingly. If the master provided the tools and materials for work carried out by the pupil, as was usually the case, the master kept the profits.[16]

Often the young apprentice chose to complete his training with a second master, to gain more experience and also to learn his manner of painting; by studying with a successful master with a flourishing studio the apprentice increased his own chances of success in his future career. By this time, the apprentice was able to take a useful part in the work of the studio and his status changed to that of an assistant or journeyman. Thus, after his three years or so as a pupil of the history painter Jacob van Swanenburgh in Leiden, in 1624 Rembrandt went to study with Pieter Lastman, also a history painter, in Amsterdam for about six months, before returning to Leiden to practise painting as an independent master.[17]

Rembrandt's studio organisation

Presumably Rembrandt's first studio was in his parents' house in Leiden – in general there was no separation between home and place of work at that time – and when he in his turn took on his first pupils in 1628, Gerrit Dou in February and Isaac Jouderville in November, they lodged with him. As his reputation grew, however, Rembrandt decided to leave his native city and seek his fortune in Amsterdam. From 1631 he appears to have been receiving portrait commissions through the art dealer Hendrick Uylenburgh, who rented a building in the Sint-Anthonisbreestraat, a street in which many artists, including Rembrandt's second master, Pieter Lastman, lived. Here Rembrandt lodged and had studio space. In 1634 he bought citizenship, he joined the Amsterdam Guild of Saint Luke and he married Uylenburgh's niece Saskia (see also Cat. 3).[18] The question of the identities and number of Rembrandt's pupils from this time onwards is extremely vexed and has generated much discussion. The names of perhaps 20 pupils and painters known to have worked in his studio have been recorded by early biographers, but not all these names have painted works associated with them. The records of the guild in Amsterdam, with which Rembrandt would have registered his pupils, have largely been lost. In a well-known passage, Joachim von Sandrart, who worked principally as a portrait painter in Amsterdam from about 1637 to about 1645 and who would thus have been well aware of Rembrandt's practice and prestige at that time, recorded how Rembrandt had 'countless distinguished children for instruction and learning, of whom every single one paid him 100 guilders annually', and whose works he sold.[19] Selling the works produced in the studio by trained assistants was, as we have seen, not

exceptional, but the number of students or assistants passing through Rembrandt's studio at this time in his career, when he was at his most successful, may have been quite large.

Assistants or journeymen were not registered with the guild in the same way as pupils. It is clear from the records of students that are known, that many were assistants rather than pupils, having completed their apprenticeship elsewhere, and it is probable that this represents the actual situation fairly accurately: most came after their initial training period – as Rembrandt went to Lastman – because of his high reputation. The more successful an artist's business was, the more young painters would wish to finish their training with him. Samuel van Hoogstraten, for example, probably received much of his basic training in Rembrandt's studio and could accurately be described as a pupil because he came to Rembrandt at the age of about thirteen in 1640, after the death of his father, with whom he began his training in Dordrecht, and stayed until about 1648. Rembrandt's Leiden pupil Isaac Jouderville, however, followed him to Amsterdam and worked as an assistant. Govert Flinck from Leeuwarden, who joined him in about 1633, while he was still using studio space in Hendrick Uylenburgh's premises, was also a journeyman or assistant, rather than a pupil. Ferdinand Bol, similarly, had already trained, probably in Utrecht, and practised painting in his native Dordrecht before arriving in Rembrandt's studio in about 1636.[20]

Not surprisingly, Rembrandt's own early works show the influence of his period with Pieter Lastman, before his own style developed. Similarly, it is only to be expected that painters who trained with him at some point in their careers show his influence in the design and some aspect of the technique of their early works – this, after all, was why they came – but generally they moved away stylistically as their careers developed. This can lead to problems in separating the work of the master of the studio from that of the apprentices or assistants who were trained in his methods. In the case of Rembrandt's studio, as well as the students whose names are known, there also appear to be works to which no name can be attached and it has been argued that this has led to the postulated existence of an unrealistically large number of possible studio members.[21]

In large, busy studios of the sixteenth century and earlier, popular designs were often reproduced repeatedly, perhaps with some slight variation; as a result, several versions are known of many designs. This pattern was continued in the seventeenth century: the Antwerp studio of Peter Paul Rubens, who was Lastman's contemporary, is an obvious example. There are, indeed, some points of comparison between the practice in Rembrandt's studio, as far as we know it, and in that of Rubens,[22] and the studios of both seem to be somewhat different from those of their contemporaries. Probably, however, if we knew more about Lastman's studio and those of countless other seventeenth-century Dutch and Flemish painters, we would be able to observe the similarities and to see very much more clearly that the differences are those of degree. In Rubens's studio a painting would be produced according to his design; he may or may not have painted some part of it, but if it was a satisfactory product of the studio, it bore his signature, like a trade mark. Rembrandt, too,

seems to have signed paintings produced in his studio that appear to be largely the work of others and, in the sense that the signature was the 'trade mark', this was acceptable. It has been suggested that his assistants appear sometimes to have had a slightly freer hand in the production of copies after his designs than might be expected in traditional studio practice, or in Rubens's studio, for example, thereby producing rather more individual works.[23] It seems as likely, however, that variations between versions of a design from Rembrandt's studio would derive from an alteration that Rembrandt made at some stage in the life of that particular design. Interestingly, the concept of a painting from Rembrandt's hand, as opposed to a studio version being somehow different, was already beginning to enter public consciousness in the seventeenth century.[24]

Sources for Rembrandt's studio practice

Much can be deduced about the appearance, content and routine of the seventeenth-century painter's studio from written accounts and from contemporary inventories, made, for example, after an artist's death. There are also many seventeenth-century depictions of artists at work and representations of the studio, which, although sometimes allegorical or somewhat idealised, give a very good impression of how the painter went about his task and the appearance of the easel, the palette, the canvases, panels, brushes and other everyday tools. They also show the relative constancy of the appearance of much of this equipment: the appearance of the easel, the brushes, the table with its vessels for paint and oil shown in the studio scene painted by Aert de Gelder in 1685, *The Artist Himself painting an Old Lady* (see Fig. 7) hardly differs from a sixteenth-century depiction (see p. 49, Fig. 21).[25] It is interesting that in the *Self Portrait* of 1665 (Fig. 4), Rembrandt showed himself holding brushes, mahlstick and a rectangular palette, while de Gelder's palette is the newer, oval format.

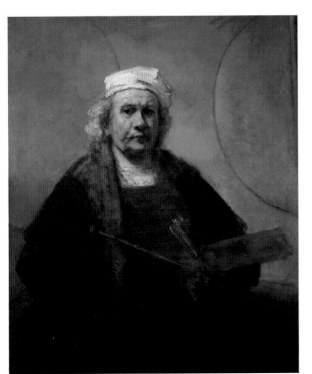

Fig. 4 *Self Portrait*, 1665.
Oil on canvas, 114 × 94 cm.
London, Kenwood House, Iveagh Bequest, English Heritage, inv. IBK 957

Written accounts rarely document studio practice directly, although it is possible to gain an idea of how a painter went about his work. It is rather easier to find snippets of information on Rembrandt's methods and to piece these together with whatever more general descriptions are available. On rare occasions, artists contemporary with Rembrandt and certain others with a good knowledge of current painting practice committed their thoughts to paper. Some observations on painting technique, attributed to Sir Anthony Van Dyck and dating from the 1640s, were preserved in the commonplace book of Dr Thomas Marshall and provide material for comparison with the observed technique of Rembrandt during this period.[26] A more important source is the so-called de Mayerne

manuscript, 'Pictoria, sculptoria, tinctoria et quae subalternarum artium spectantia . . .' (British Library, MS Sloane 2052), which was compiled by the physician Theodore Turquet de Mayerne (1573–1655) between the years 1620 and 1646, during his period of residence at the English court. Here he was able to meet and obtain practical information from many distinguished painters visiting from the Low Countries, including Rubens and Van Dyck. Much of the information he compiled on materials, including those used for grounds and their methods of application, is as valid for the Netherlands as it was for London.[27]

Of the Dutch authors, Karel van Mander included a long introductory essay on the practice of painting in *Het Schilder-Boeck* (Haarlem 1604, 1618), which throws some light on the tradition within which Rembrandt himself would have trained, if not on his later practice. Following the example of the Italian writers, many later authors contributed to the growing interest in the work of classical Greek and Roman artists and, indeed, a more classical style of painting: many of the criticisms of Rembrandt's work from his early biographers and from writers on painting, some of whom, like Hoogstraten and Gerard de Lairesse, had actually trained with him, stem from this.

The best known of the painting treatises, Willem Goeree's *Inleyding tot de Praktyk der algemeene Schilderkonst* (Amsterdam 1670), Hoogstraten's *Inleyding tot de hooge Schoole der Schilderkonst* (Rotterdam 1678) and Lairesse's *Het groot Schilderboek* (Amsterdam 1707), date from late in the century and their treatment reflects the current academic approach to painting, with a heavy emphasis on theory and many references to the painters of classical Greece and Rome. Hoogstraten's book contains little on studio practice, which is disappointing from a former pupil of Rembrandt, although he does list the available pigments. More specifically, he comments on Rembrandt's use of colour, particularly in his flesh tints, and his handling of light and shade.[28] The most practical of these books is that by Lairesse, who in his first six chapters describes quite systematically the procedure of constructing a painting, from sketching the composition on the prepared support, applying an underpaint or dead-colouring (*doodverf*) of appropriate colour, then applying the final layers of colour, highlights and reworkings required.[29]

The studio

According to the few contemporary descriptions of the ideal studio, the most important points to consider were the size of the room and the lighting. Joachim von Sandrart gave exact specifications for a 'proper room, especially for painting pictures life-size, also for history painting and the like'. He suggested the room should be about 30 feet (9 m) square; the window, in the highest part of the room, should be about 5 or 6 feet (1.5 to 1.8 m) in width, and it should have an upper and a lower part, both of which could be covered independently. Earlier painters, he thought, had worked in spaces that were too small, so that they could not step back and inspect their work, and with too much light and sunshine:

'Many of our forefathers . . . have erred in that too small chambers, everywhere filled with light and sunshine, served them for their work: whereby lacking the space and the necessary distance to walk far enough back and forth from their model or panel, to inspect their work from a distance . . . as well as the strength of the light so that all colours become diminished and confused to them. They would, if they had been in a proper studio, have given their excellent works far more life, force and veracity.'[30]

Many studios had two windows, one to illuminate the painting, the other for the subject, and both would have systems of blinds or shutters to control the light (Figs 3 and 5). Von Sandrart wrote that ideally the windows should be north-facing:

if one must take the light from mid-day, from a lack of better accommodation, one can provide the window with blinds made of oiled paper: thus the sun causes no false variability in the light. In general, the height of the light should be such that every illuminated body gives a shadow of as great a length on the ground as its own size. When one wishes to represent a History by night, one makes a large fire blazing with light, the brilliance of which shines far from it . . . one sees from the inconstant appearance of the objects how, from the colour of the fire they naturally appear now nearer, now redder . . .

The author of an English manuscript, 'The Art of Painting in Oyle by the Life' (British Library, MS Harley 6376) suggested that the distance of the artist from the model should be about four to six yards – that is, 12 to 18 feet or 3.6 to 5.4 m – and that it was often more flattering to the sitter to reduce the amount of shadow.[31]

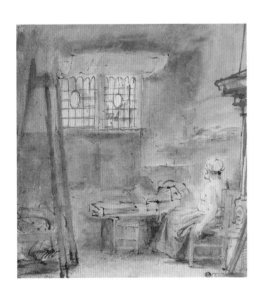

Fig. 5 *The Artist's Studio with a Model*, about 1654.
Pen and brown wash,
20.5 x 19.1 cm.
Oxford, Ashmolean Museum,
inv. PI 192

Rembrandt's first studio space in Amsterdam was in Hendrick Uylenburgh's premises in the Sint-Anthonisbreestraat, which had previously been occupied by the portrait painter Cornelis van der Voort. The studio was thus already set up for the painting of formal portraits when Uylenburgh took it over, and he decided to continue with this business, to which Rembrandt contributed. The *Portrait of Philips Lucasz.* of 1635 (Cat. 5) was probably painted there. After their marriage Rembrandt and Saskia moved into their own house, on the Nieuwe Doelenstraat in 1635. Thereafter Rembrandt lived, and had his studio in, first, the Suyckerbackerij (sugar refinery) buildings on the Binnen-Amstel (41 Zwanenburgerstraat) from 1637 and second, from 1639, the house in Sint-Anthonisbreestraat (now 4–6 Jodenbreestraat) which is known today as the Rembrandthuis. This is the house and studio that, although now much altered, one immediately associates with the painter and where he lived until 1658 (Fig. 5). When he was declared insolvent in 1658 Rembrandt rented a smaller house on the Rozengracht (now no. 184) in the new artists' quarter of the Jordaan; he remained there until his death in 1669.[32] 'Rembrandt's studio'

is, therefore, not one, but six spaces, in six different buildings over his working life in Leiden and Amsterdam. The studio set-up that Hoogstraten knew, and was probably at the back of his mind when he wrote his own treatise on painting, was that in the Rembrandthuis. The somewhat envious comments made by von Sandrart and those by Arnold Houbraken, who derived much information from Hoogstraten, can be linked with this studio. However, the studio known by Rembrandt's last documented pupil Aert de Gelder, who joined him some time after 1659, perhaps in 1661, would have been in the Rozengracht house.

Sint-Anthonisbreestraat runs at a slight angle to an east–west direction, so the studio in the Rembrandthuis certainly could have had partial north light. More interestingly, Houbraken records that in a warehouse that Rembrandt rented on the Bloemgracht in Amsterdam, his pupils 'in order to be able to paint from life without disturbing each other, made small cubicles, each one for himself, by setting up partitions of paper or oilcloth'. This can also be related to the Rembrandthuis as when it was sold in 1658 Rembrandt was asked to remove partitions in the attic installed for his pupils.[33]

The small picture of the *Artist in his Studio* painted in about 1628 (Fig. 6) shows a young painter – perhaps even Rembrandt himself at work in Leiden – stepping back to consider his work. Unusually, the light source is somewhere high up and to our left (behind the painter and slightly to his right), although he is clearly right-handed (a right-handed painter would normally work with the window at his left, so that his arm did not cast a shadow on his work). He is shown standing, pausing in the act of painting: perhaps standing back to take stock of his work; perhaps seeing the composition in his mind's eye before laying a brush on the canvas. Most painters of the period – Gerrit Dou and Aert de Gelder, for example – showed themselves seated at the easel (see Fig. 7); Rembrandt may have worked standing up, but this would have been unusual. The easel shown is of a standard type, a simple hinged trestle with movable pegs to support the work at the right height. The panel on the easel is a large one and is strengthened at the top and bottom edges by grooved wooden battens.

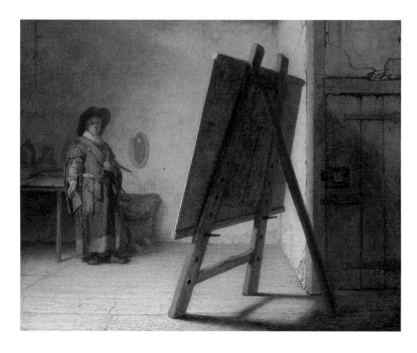

Fig. 6 *The Artist in his Studio*, about 1628.
Oil on panel, 24.8 × 31.7 cm.
Boston, Museum of Fine Arts. Zoe Oliver Sherman
Collection given in memory of Lillie Oliver Poor, inv. 38.1838

The practice of painting

Panels and canvases

Most of Rembrandt's early paintings are on wood panel supports (there are a very few on copper and paper). Panels were bought ready made from specialist craftsmen, who were members of the joiners' and cabinetmakers' guild and protected their monopoly in panel-making by a restrictive charter. Until the early seventeenth century Dutch panels were generally made of oak imported from the Gdansk region; Amsterdam was a centre for the Baltic trade in timber in the sixteenth and earlier seventeenth centuries.[34] This trade was disrupted by conflicts, particularly the wars between Poland and Sweden in 1626–9 and 1650–5, with the result that panel-makers were obliged to use a different range of woods: oak from elsewhere in Europe, walnut, beech and tropical hardwoods such as mahogany have all been identified in panels from Rembrandt's studio.[35] As in the southern Netherlands, panels were made in a range of standard sizes, often denoted by cost ('guilder-size' and so on). Rembrandt appears to have been content to restrict himself to standard panel sizes, probably from necessity, since frames were produced to the same dimensions.[36] A variety of differently sized panels appears in the inventories of artists' property, for example that of Tryntge Pieters, the widow of the Rotterdam painter Crijn Hendricksz. Volmarijn, taken in 1648.[37] Close similarities between some of Rembrandt's panels revealed by dendrochronological examination also suggest that he purchased them in batches from particular panel-makers. Larger panels were made by butt-jointing two or three planks together. The back edges were often bevelled in order to fit the finished painting into its frame, and this can be a useful indication of the original size and shape of a panel if it has later been cut down (see, for example, the *Portrait of Philips Lucasz.*).

Canvases, like panels, could be obtained in a range of standard sizes. Linen canvases were made on looms with a range of sizes which were usually multiples of an 'ell', a standard fabric width which in the Netherlands was equal to about 69 cm. Canvas was also imported from Antwerp and here too it was made to various widths: 'six quarters' of an ell and so forth.[38] The ell of Brabant, widely used for trading, measured about 69.6 cm, so was very similar; the 'six quarter' measurement mentioned would be about 104 cm. Allowing for tacking margins and seam overlaps, many of the canvas pieces which make up Rembrandt's paintings, singly or sewn together, correspond to these measurements. In fact it would generally be extremely difficult to say that a particular canvas was from linen woven in any particular region. The problem is compounded by the fact that most seventeenth-century canvas paintings have been lined, so the fibre characteristics cannot be ascertained; the weave, however, can be examined by means of X-rays and many examples are discussed in the catalogue section below. So many of Rembrandt's canvases have been studied that it has been possible to assign them to groups where the canvases are so similar in thread count and in weaving characteristics that it has been proposed that they are from the same bolt of linen.

In those cases where the pictures concerned date from the same year or are related by commission this is certainly plausible.[39]

The ground or preparation layers (see pp. 27–9) might be applied by the panel-maker or by a specialist primer. The application of the ground may have been a specialist trade in the Netherlands, as it was in Antwerp, for example,[40] although the possibility that it was sometimes applied in the painter's studio cannot be excluded. It is possible that the panel-maker or primer was responsible for the first layer of preparation and subsequent layers were the painter's responsibility, but there is no firm evidence yet available which clarifies this point. It is certainly the case, however, that Rembrandt could be dissatisfied with the way a panel was prepared: for *The Woman taken in Adultery* (Cat. 10) he clearly scraped down the ground in the centre of the panel before painting, presumably because it was too rough.

Canvases too could be bought ready prepared, but were also routinely stretched and prepared in the studio. Canvas primings could be applied as a single or as several layers and are quite variable in their constitution; there is growing evidence, however, that they can be related to the particular centre where an artist was working (see pp. 27–9). There were specialists in making and applying grounds, and the 1673 inventory of a Rotterdam shop selling artists' materials refers to ready-primed canvases.[41] There is evidence, however, that at least some canvas grounds were applied in Rembrandt's studio – as was the case for the *Portrait of Jacob Trip* (Cat. 17), for example (discussed on pp. 168–9). It is possible that in some cases, the person commissioning the painting may have provided the support: there is some evidence for Rembrandt charging the cost of the canvas and frame to the patron on occasion; this was certainly not uncommon in other cities.[42]

For the application of ground layers the canvas would be stretched in a temporary frame, probably with cords. This would produce cusping, that is, scalloping of the regular weave pattern along each stretched edge, the point of each cusp corresponding to the point of tension. When the ground was applied and allowed to dry, these cusps would become locked into the fabric: they can usually be seen now in X-rays (see Glossary) and can, like the bevelling on wood panels, be a valuable indicator of whether a painting has been altered or cut down. Rembrandt occasionally cut up stretched, primed canvases and reused them (for example in *The Lamentation over the Dead Christ*, Cat. 7); in such cases incomplete cusping is an original feature and must be recognised as such. Canvas was sometimes stretched in lengths between long battens for the application of the ground and then cut into smaller sections for individual paintings.[43] In this situation, one might only see cusping on two sides of the canvas; an example of this seems to be *A Bearded Man in a Cap* (Cat. 15).

Canvas pictures were also often painted in a temporary stretching frame. Many contemporary paintings of artists' studios show painters at work on canvases laced inside a larger

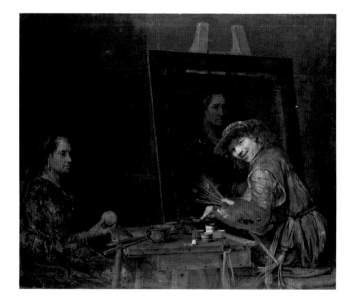

Fig. 7 Aert de Gelder, *The Artist Himself painting an Old Lady*, 1685. Oil on canvas, 142 x 169 cm. Frankfurt-am-Main, Städelsches Kunstinstitut, inv. 1883

wooden framework. A particularly interesting example is de Gelder's *The Artist Himself painting an Old Lady* (Fig. 7), which shows the laughing painter, in the guise of Zeuxis – the fifth-century BC Greek painter who was said to have died laughing at his comical portrait of an old woman – surrounded by the paraphernalia of a seventeenth-century studio. The Rembrandt connection is significant here, because this composition was probably based on an original by Rembrandt of which only part, the fragmentary *Self Portrait as Zeuxis* in the Wallraf-Richartz-Museum, Cologne, survives.[44]

In de Gelder's picture the canvas is indeed shown stretched with cords inside its temporary frame. Behind the easel is another canvas, perhaps finished, which is on a strainer, tacked conventionally around the edges. Presumably, when complete, a painting would be cut from its stretching frame and mounted on a strainer in the modern fashion; but other painters also depicted themselves actually at work on canvases tacked to strainers in this way. The modern expanding stretcher with wedges or keys was not yet in use.

The painter at work

More can be learned from de Gelder's picture. The light comes from the painter's left in the accustomed way and knotted cords just visible behind the easel may well be connected to blinds or shutters controlling the light. On the table there are several clues to the painter's working methods. From a nail hang dividers with which proportions were checked on both subject and picture. At the near side is a lump of chalk for sketching a rough design on to the prepared canvas. There is no evidence that Rembrandt himself used chalk for the initial sketch – he seems usually to have roughed in his design with a brush and brown paint – but certainly it was common practice for many painters of the period, especially when working on dark grounds.

Paints, oils and other materials are shown in various earthenware pots on the table, together with discarded brushes of miniver, badger or hog hairs tied inside quill ferrules. In his left hand the painter holds a curved wooden palette, brushes and a mahlstick which would be braced against the edge of the picture or frame to support the painting hand and prevent it from touching the wet paint. The palette is loaded with oil colours, ranging from white at the top to black at the bottom. Painters usually had a standard working order for colours and any assistants or apprentices in the studio would be trained to load the master's palette in the preferred way. Between white and black on Aert de Gelder's palette is a range of yellow, red and brown earth colours, but, significantly, no blue. It has been argued very persuasively that this limitation was deliberate: because pigments had their own drying characteristics and the painter organised his work in sections, generally working from back to front,[45] it was most convenient and least wasteful of materials to prepare a palette only of those colours necessary for the area to be painted. Not surprisingly, a painter might have several palettes: Bartholomeus van der Helst had 28, according to the inventory relating to

his property.[46] The colours on de Gelder's palette are those suitable for painting flesh tones; this is the palette generally illustrated in painting as the painting of the human body was deemed the worthiest part of the painter's work.[47]

Pigments and other artists' materials were still bought from certain apothecaries (*apotheeks*) or grocers (*kruideniers*) as in other parts of northern Europe; however, Dutch towns had benefited from the influx of sophisticated specialist traders from Antwerp and specialist colour merchants, supplying a variety of materials, began to appear. One of the earliest general suppliers of such materials was the painter and dealer Leendert Hendricksz. Volmarijn who, in 1643, established a shop in Leiden for 'prepared and unprepared colours, panels, canvas, brushes and painting utensils of every kind'.[48] Very shortly afterwards, other shops appeared, including those of Daniel Rulandts in Amsterdam, Cornelis van Bolenbeek in Dordrecht and other members of the Volmarijn dynasty (who came originally from Antwerp) in Rotterdam.[49]

To grind the pigments to powder, mechanical colour mills could be used by colour merchants or painters: Gillis van Coninxloo, for example, is recorded as having had one in about 1600 and Vincent van der Vinne had one about a century later.[50] Probably, however, the pigment was usually bought ready ground. The paint itself was generally still prepared in the studio by grinding pigment and oil together on a stone slab; this is sometimes illustrated in seventeenth-century pictures of artists' studios (Fig. 8) and it is interesting that the person shown at work is usually not, as one might expect, a young apprentice, but a mature figure: this would be part of the studio training, no doubt, but under supervision. The different properties of the pigments, the varying amounts of grinding each needed and the different amounts of oil required to give a paint of satisfactory consistency in each case all suggest that this was not a task for inexperienced students.[51] Although pigments and containers for oil are also occasionally mentioned in inventories of artists' property, usually, as in Rembrandt's case, they are not itemised. Two rare examples are the inventories of the property of the flower painter Jacob Marrell made in 1649, following the death of his wife, and that of the possessions of the painter Cornelisz. Cornelisz. van Haarlem made in 1639. Here are listed many of the things we can recognise from Aert de Gelder's picture and other contemporary illustrations of the painter at work, including primed and dead-coloured panels and canvases; easels (Cornelis van Haarlem had seven); grinding stones (Marrell's stone was made of porphyry; one of Cornelis van Haarlem's was round); mullers; and boxes, bags, parcels or packets of pigments: different grades of ultramarine, the dearest pigment; smalt; green or blue ash or ashes (*asse* or *asch* – verditer); red lakes (*lack*); yellow lake (*scheijtgeel, schijtgeel*) and lead-tin yellow (*mastichot*).[52] All these are discussed below (see pp. 30–47). From records such as these, from the literature and from the paintings themselves, a picture of the studio and its life can be built up.

Jo Kirby

Fig. 8 Adriaen van Ostade, *The Painter's Studio*, about 1640. Oil on panel, 37 × 36 cm. Amsterdam, Rijksmuseum, inv. SK-A-298

Rembrandt's materials and technique

The ground layer: function and type

Before the creation of any easel painting the panel or canvas must be prepared by the application of a 'ground' or preparatory surface on which the layers of paint can be laid. In the seventeenth century this could be done either in the studio, as appears to have been the case with the portrait pair of *Jacob Trip* and *Margaretha de Geer* (Cats 17 and 18), or the artist could buy the wood panels or canvases with the ground already prepared.

Karin Groen of the Instituut Collectie Nederland (ICN), working on behalf of the Rembrandt Research Project, has recently published the fullest survey of the constitution of the ground layers on a large number of Rembrandt's paintings spanning the whole of the painter's career.[1] As a result, this aspect of his technique is uniquely well researched. However, it is difficult to know whether there are grounds of paintings by Rembrandt unique to him, or whether they are types frequently found on other pictures from the Low Countries in the seventeenth century. If canvases and panels were invariably supplied with a commercially prepared priming, the same ground type must occur frequently – not just in works by Rembrandt, but in any representative group of pictures of the period. Unfortunately, the techniques of relatively few seventeenth-century Dutch artists have been studied comprehensively, and interpretation is complicated further because ground types that are both similar and markedly different in constitution to Rembrandt's have been found for the work of a few other artists painting on canvas.

In the seventeenth century it was usual for painters to work over a coloured ground or priming, generally a light or dark tone of grey or brown or sometimes a rather warmer reddish-brown colour. This meant that the ground could stand for the mid-tones of the painting, either uncovered, as in parts of many of Rembrandt's late paintings, or modified by the application of paint. The use of coloured grounds originated in sixteenth-century painting, both in northern Europe and in Italy, but only became standard practice in the seventeenth century.[2] For an underlayer properly to be called a ground it must cover the entire area of the support, whether or not it plays a visual part in the final composition. Ideally the ground layer or layers are finished to be fairly smooth, possibly by scraping or rubbing, but in one particular type found on Rembrandt's canvas paintings the texture is far

from smooth, and would have had a noticeable 'tooth' (Fig. 9). The advantage of this kind of surface may lie in the ease with which thickly laid impasto can be pulled up from a coarse painting surface. Generally, however, the ground layers for the canvas pictures fully fill the canvas weave, and present a flat surface of appropriate absorbency for the application of the layers of oil paint that make up the picture. There are few clear results of medium analysis of the ground layers, but it seems probable that for grounds on canvas the binder is a drying oil.

The ground for Rembrandt's paintings on oak panel is quite distinct from that used on the canvas paintings, and is thoroughly consistent in all the cases examined at the National Gallery and elsewhere. Each of the panel paintings bears a fairly thin layer of natural chalk (calcium carbonate) bound in animal-skin glue, which tends just to fill the grain of the wood. The mixture is usually creamy white. The minute fossil coccoliths detected by the scanning electron microscope in the lower ground layer of the *Portrait of Aechje Claesdr* (Cat. 3) and in the *Portrait of Philips Lucasz.* (Cat. 5; Fig. 10) prove that the chalk is of natural origin.

Fig. 9 SEM micrograph of the top surface of a fragment of 'quartz' ground from *The Adoration of the Shepherds* (Cat.11), showing its coarse texture. Magnification 771×

There is a long tradition of the use of chalk grounds for panel paintings in Northern Europe, reaching as far back as the van Eycks and even before. Unlike that of most panels of the fifteenth and sixteenth centuries, the chalk ground of Rembrandt's panel paintings is then covered with a very thin priming or *primuersel*, generally of a warm yellowish brown, made up of a mixture of lead white, chalk and a little umber, probably bound in oil. This *primuersel* coats the entire chalk underlayer and absorbs X-rays sufficiently strongly to show the grain of the wood panel beneath, which is usually only partially filled by the lower layer of chalk. Manganese has been detected by analysis in several examples of this brownish *primuersel*, indicating that the tinting earth pigment is a true umber, rather than merely a brown-coloured ochre. Apart from imparting colour, the umber content would have assisted rapid drying of the *primuersel* by catalysing the process. All the works on oak panel examined here, including the early *Judas returning the 30 Pieces of Silver* (Cat. 1), have this type of standard panel ground.

Rembrandt's canvas paintings are more variable in their ground structure, although there are two basic types. One consists of so-called 'double grounds', in which the first layer applied directly to the canvas is ochreous, usually of red, reddish-orange, yellow or yellow-brown earth pigments. There follows an overlayer of grey, light brown or dull greyish yellow, containing lead white as a main component and coloured pigments, often with black, to tint this second priming. The lower layer commonly contains a high proportion of calcium carbonate or silica, or a mixture of both. Examples of this type of double-layered ground are to be found in *Saskia van Uylenburgh as Flora*, *Belshazzar's Feast* and the *Self Portrait at the Age of 34* (Cats 6, 8 and 9). There are variations in the essential form. For example *An Elderly Man as Saint Paul* (Cat. 16) has a brown umber-containing lower ground layer, with on top a second greyish-brown priming of coarse lead white, splintery particles of charcoal

black and some umber. The constitution of the lower orange-coloured grounds on the canvas paintings varies too, particularly in the purity of the earth pigment used (see Table 1, pp. 224–5). Studio works on canvas have also been found to have similar double grounds: *An Old Man in an Armchair* (Cat. 25) is a case in point.

It is probable that quantities of fairly cheap earth pigments were used for the first layer on the canvas, merely to fill the interstices of the weave, while the second layer, containing lead white, was the surface chosen, both in colour and texture, for the painting to be executed on top. As with the grounds on panel, it is the upper layer of ground on the canvas paintings containing lead white, which readily absorbs X-rays, that is mainly responsible for the canvas weave registering on the radiograph. Double grounds such as this are by no means unique to Rembrandt. An earlier Dutch painting in the National Gallery's Collection with a comparable ground structure is Hendrick ter Brugghen's *Jacob reproaching Laban for giving him Leah in Place of Rachel* (NG 4164) dated 1627; while elsewhere double grounds were regularly being employed by Rubens and Van Dyck for their works on canvas.

The second category of canvas priming for Rembrandt's canvas paintings is quite different, and begins to appear in his pictures during the 1640s. It is of a single layer of coarsely sieved quartz (silica sand), tinted with a little brown ochre and containing a low proportion of lead white, the mixture bound together in a drying oil. The principal component is the quartz, and its coarse texture is evident at the painting surface (see Fig. 9). The motivation for the use of this slightly improbable combination for canvas grounds may again lie in the cheapness and wide availability of the materials. The lead white content in these dark-coloured grounds, although quite low, is still sufficient to show the canvas weave to some degree on X-rays of the paintings that bear them. Rembrandt employed this kind of 'quartz' ground on the

Fig. 10 SEM micrograph of fossil coccoliths that make up the chalk in the lower ground layer of the *Portrait of Philips Lucasz.* (Cat. 5). Magnification 8500X

exceptionally large *Company of Frans Banning Cocq and Willem van Ruytenburch ('The Nightwatch')* in the Rijksmuseum, Amsterdam, while examples in the National Gallery include *The Adoration of the Shepherds*, the *Portrait of Hendrickje Stoffels*, the *Portrait of Frederik Rihel on Horseback* and the *Self Portrait at the Age of 63* (Cats 11, 13, 20 and 21). Here again, whether the 'quartz' type would have been applied in the studio or was one of a range of standard commercial products, perhaps the least expensive, is unknown, but the probability is that it is a studio preparation and perhaps unique to Rembrandt's practice and to those in his circle.[3] Significantly, the main part of the canvas of *A Young Man and Girl playing Cards* (Cat. 24), attributed to Rembrandt's studio, carries a 'quartz' ground. So far no example of its use has been found for a picture that has no connection with Rembrandt.

Two of the paintings on canvas, *A Franciscan Friar* and the *Portrait of Margaretha de Geer (bust length)* (Cats 14 and 19), carry grounds which fit neither main category (see Table 1), but are modifications of the other two practices. These anomalies are discussed in the relevant catalogue entries.

Ashok Roy

The paint layers

Writing in 1693, in one of the four surviving treatises of this period, Marshall Smith observed, 'Rembrant had a Bold free way, Colours lay'd with a great Body, and many times in old Men's Heads extraordinary deep Shaddows, very difficult to Copy, the *Colours* being layd on Rough and in full touches, though sometimes neatly Finish'd.'[1] This succinct description certainly captures the characteristic surface appearance of Rembrandt's paintings – the use of texture and expressive brushwork, the juxtaposition of impasto and smooth paint, the precise calculation of colour – but it does not attempt to describe the way in which the paint layers were built up or what the preliminary stages were.

Gerard de Lairesse, who knew Rembrandt and had his portrait painted by him, was more analytical in his *Het groot Schilderboek* of 1707. He identified three main stages in the painting process: the 'dead-colouring', the 'second colouring' or 'working-up', and the 'retouching' or 'finishing'.[2] Since he was reflecting on the practices of the second half of the seventeenth century, it is worth bearing these three stages in mind when examining the methodical build-up of Rembrandt's paintings.

In arriving at a final effect Rembrandt had certain variables to exploit. The first and most profound was the ground colour. As we have seen (pp. 27–9), this could vary from white or beige on the panels to shades of grey, grey-brown and dark brown on the canvases. When painting on a pale ground Rembrandt seldom used its tone directly as a passage of colour, he exploited it simply to provide a general luminosity, shining through the superimposed paint layers and appearing between brushstrokes or where adjacent blocks of paint do not quite meet. However, he did use the underlying ground tone directly to suggest detail and liveliness in the background architecture of *The Woman taken in Adultery* (Cat. 10).

By contrast, coloured ground layers on canvas were frequently left exposed and used directly for design elements such as background colours and areas of shadow in faces and hands: a particular place to check is around the eyes in many of the later portrait heads, where projecting highlights are painted but receding shadows are often left as exposed dark ground colour. Rembrandt did not always adopt this method: in the meticulously finished *Self Portrait at the Age of 34* (Cat. 9), for example, the ground is entirely covered and all shadows in the face are constructed in the upper paint layers only.

Rembrandt's working method on both panel and canvas seems usually to have begun with a lay-in of brown paint, defining the main forms, principal shadows and so on. This could

vary in detail and complexity, sometimes having distinct drawing lines within it, but often consisting simply of broad washes of brown tone. There may have been some rudimentary drawing preceding this to fix the position of the design – perhaps in chalk on dark-ground canvases, although this has never been observed – but the lay-in was usually the first painting stage and formed the basis for the colour that was to follow.

The lay-in may correspond to the first paint layer identified by Lairesse, the *doodverf* or dead-colouring, but the term has been variously interpreted. It is often referred to in documents and treatises – indeed, as Miedema pointed out, it was even prescribed by guild regulations in the previous century as an essential test of quality – but it remains a slightly elusive concept.[3] Its relevance to the study of Rembrandt's methods would seem largely academic were it not for the fact that occasional layers of underpaint in his pictures seem to correspond neither to the preliminary lay-in nor to the fully realised colour layers.

The reddish-brown layer beneath the shift in *A Woman bathing in a Stream* (Cat. 12) could be reasonably described as either a lay-in or sketchy dead-colouring, and perhaps a distinction is superfluous; but the dark underpaints in *Belshazzar's Feast* (Cat. 8) certainly represent something more substantial than an initial sketch and could well correspond to a complete dead-colouring or Lairesse's secondary working-up stage.

Two paintings that have the appearance of unfinished works are helpful in clarifying these variations. *The Concord of the State* (Fig. 11) – presumably 'finished' to Rembrandt's satisfaction since it is signed – is a more or less monochrome composition that may correspond to a fully worked-up dead-colouring on panel. All the forms are sketched out in brown paint, allowing the luminosity of the pale chalk ground to show through. No upper colour layers are present, except a thin green-blue for the sky and some areas of creamy lead white in the centre and towards the right. The amount of detail is considerable, and may be more elaborated than in other cases, but it is likely that Rembrandt's multi-figured panel paintings were laid out in a manner similar to this. This particular work may have been the design for a print (see also *Ecce Homo*, Cat. 4) – but one that was never executed.

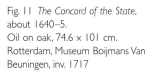

Fig. 11 *The Concord of the State*, about 1640–5.
Oil on oak, 74.6 × 101 cm.
Rotterdam, Museum Boijmans Van Beuningen, inv. 1717

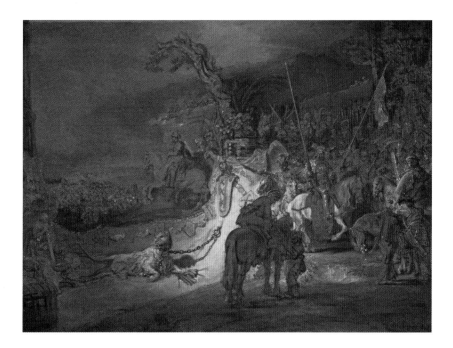

The other work, the apparently unfinished *Man in Oriental Costume*, of about 1635, in the National Gallery of Art, Washington (Fig. 12), has a costume which is painted rather loosely in curiously drab, flat tones. Here, almost certainly, is a painting left either at the deadcoloured stage or at the beginning of the second colouring, lacking its final colour layers. The head and elaborate turban, unlike the costume, are fully finished, but quite possibly not by Rembrandt himself.

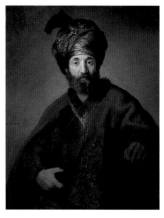

Fig. 12 Rembrandt and his workshop (probably Govert Flinck), *Man in Oriental Costume*, about 1635. Oil on canvas, 98.5 × 74.5 cm. Washington, DC, National Gallery of Art, inv. 1940.1.13

It is now clear that 'dead colour' is a somewhat flexible term and has been applied by some writers to an entirely monochrome stage beneath the colour layers, but by others to dull preliminary colouring that was to be heightened and made more colourful in the next stage of painting. Sandrart seemed to imply the latter, because he was specific in describing distinct stages: first (he said) the artist should lay on the sketch, including 'all its appurtenances', then 'examine it well and with dead colours (which one calls under-painting) correct the errors still to be found and finally, when it is thoroughly dry, with diligence paint over and complete it'.[4] In the case of Rembrandt it is certainly worth bearing in mind the possibility of such a layer, as we have seen, but it is a mistake to assume that his paintings must conform to a standard or theoretical pattern of construction. Rembrandt was, above all, a spontaneous and innovative painter and was certainly not constrained by a set academic method: his paintings should be approached empirically and described in a terminology that seems appropriate in each case.

When he came to the principal layers, Rembrandt's approach was direct and straight-forward, and can usually be interpreted quite simply from a close comparison of the picture surface and the X-ray. In more complex compositions he would generally – but not always – paint from back to front, filling in the background around a 'reserve' left for foreground figures.[5] These reserves can be seen as dark shapes in the X-rays of, for example, *The Woman taken in Adultery* (see Fig. 125, p. 129) and *The Adoration of the Shepherds* (see Fig. 135, p. 135). They are fractionally smaller in outline so that, when the figure itself was painted, it overlapped and appeared to be in front of the background.

By varying the thickness, texture, transparency and colour juxtaposition of the paint layers, a whole range of effects could be achieved. One that all painters have to master if they are to suggest form convincingly is the cool half-tone between light and shadow: form will appear solid and deceptive only if this is observed correctly. Essentially, the depiction in paint of three-dimensional objects (faces, hands and so on) requires alternating use of warm and cool colours: reflections into shadows are cool, the shadows themselves are warm, half-tones are cool, lights warm and highest lights cool again. If this sequence is not observed, the illusion of depth and roundness will not be successful. It is instructive to note how Rembrandt almost always adhered to this convention and that where he failed to the result is flat and unconvincing: *Belshazzar's Feast* is a good example of this, and there is every reason to believe that a deliberately theatrical effect was being sought here.

The actual painting of the cool half-tone could be done in two basic ways. Either it could

be painted directly between light and shadow as a band of colour containing cool, blue-toned pigments; or it could be achieved – and Rubens's later paintings are perhaps the most outstanding example of the method – by exploiting the 'turbid medium effect'. A light colour painted thinly over a warm dark tone will appear cooler than if painted over a lighter tone. Thus, by underpainting the shadows and half-tone areas with a dark colour and then overlapping it with the warm translucent colour of the general lights, the cool half-tones are produced automatically. Both techniques may be observed in the paintings described here: the use of turbid medium effects can be seen, for example, in *A Woman bathing in a Stream* (Fig. 13) and the use of direct surface colour in the *Self Portrait at the Age of 34*.

Rembrandt's use of texture and impasto is highly characteristic. He used paint to suggest substance and form in an extraordinarily direct, sometimes deliberately illusionistic way: the shift in *A Woman bathing in a Stream*, the waistband of *Saskia van Uylenburgh as Flora* (Cat. 6) and the glittering coat of the *Portrait of Frederik Rihel on Horseback* (Cat. 20) are all notable examples. Some texture tricks could become slightly mechanical, such as the use of the brush-handle to scratch hairs and shadows in wet paint, and were much imitated by pasticheurs of Rembrandt's style (for example, the *Seated Man in a Lofty Room*, Cat. 22). But Rembrandt himself, perhaps more than any other painter, challenged that ambiguity of paint as image and image as paint that underlies the whole technique of painting. He instilled in his pupils too a proper sense of the material possibilities of paint: Samuel van Hoogstraten might have been reporting directly his master's teaching when he wrote:

> It is above all desirable that you should accustom yourself to a lively mode of handling so as to smartly express the different planes or surfaces; giving the drawing due emphasis and the colouring, when it admits of it, a playful freedom, without ever proceeding to polishing or blending; . . . it is better to aim at softness with a well-nourished brush . . . for, paint as thickly as you please, smoothness will, by subsequent operations, creep in of itself.'[6]

The visual dialogue between rough and smooth paint was a conscious aesthetic choice in seventeenth-century Holland. Rembrandt began his career as one of the Leiden 'fine' painters

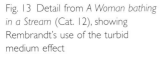

Fig. 13 Detail from *A Woman bathing in a Stream* (Cat. 12), showing Rembrandt's use of the turbid medium effect

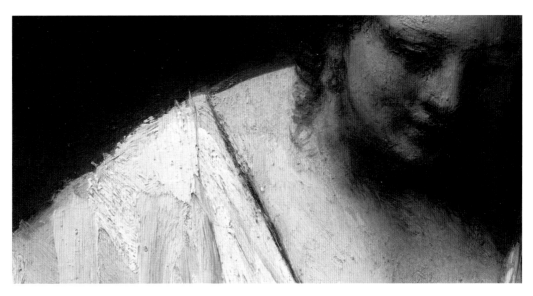

and ended it as a celebrated exponent of the so-called 'rough manner', seen as a direct stylistic inheritance from the later works of Titian. The highly visible brushstrokes in Rembrandt's paintings – and how best to view them – were commented on at the time, as well as later: in a letter of 27 January 1639 to Constantijn Huygens, the international diplomat, secretary to the Stadholder and patron of the young Rembrandt, the artist himself suggested that a painting should be hung so that 'it can be viewed from a distance.'[7] Houbraken, writing in 1718, said that Rembrandt would pull visitors to his workshop away from inspecting paintings too closely, claiming that the smell of paint would bother them.[8]

Rembrandt's use of bold, dynamic brushwork was not confined to the great showpiece pictures like the *Portrait of Jan Six* (Amsterdam, Six Collection) or spontaneously vivid works like the *Woman bathing in a Stream*. He also routinely contrasted rougher passages with areas of smooth finely worked paint to emphasise light and shade in his subjects, even in his earlier paintings. The flesh paints of the *Portrait of Aechje Claesdr* (Cat. 3) brilliantly juxtapose the protruding light-coloured impasto of the nose and forehead with the thin, smoothly painted cheek receding first into shadow and then into the pale light reflected from the ruff (Fig. 14).

Rembrandt's whole manner of working out his compositions directly on the panel or canvas – rather than in preliminary drawings – inevitably led (as it had with Titian in the previous century) to revisions or *pentimenti* as the idea for each work developed. Frequently in Rembrandt's paintings, X-rays reveal significant changes, from the early *Judas returning the 30 Pieces of Silver* (Cat. 1), with its bafflingly complicated multiple *pentimenti*, right up to the final 1669 self portrait (Cat. 21). In the latter, the change is small in size, but striking in its meaning. In the X-ray Rembrandt seems originally to have painted himself holding a paint brush in his open hand: but then, in order to focus attention on his own face, he closed the hand and eliminated the brush, the symbol of the painter's art.

David Bomford

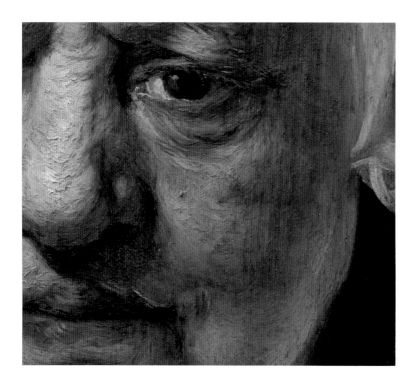

Fig. 14 Detail from *Portrait of Aechje Claesdr* (Cat. 3)

Rembrandt's palette

Technical study of the paintings by Rembrandt in the National Gallery has provided us with a mass of detailed information about the painting methods he used throughout his career. Central to these investigations has been the recording of the artist's painting materials and the way in which he used them to recreate colour and form, light and shadow. The range of pigments Rembrandt employed involves no arcane knowledge, no secret formulae, but instead falls firmly within the mainstream of painting practice in Holland in the seventeenth century. His palette is entirely made up of pigments that were commercially widely available,[1] and by that time well understood in their qualities and drawbacks. Seventeenth-century Holland was something of a centre for the manufacture of artists' pigments on an industrial scale, and the technologies required had evolved far enough to have removed the uncertainties in the preparation of standard products. Fairly large-scale chemical processes for the production of high-quality lead white, manufactured vermilion, smalt and lead-tin yellow, all of which are found frequently in Rembrandt's paintings, had reached an advanced degree of empirical refinement and these pigments were available in both home and foreign markets. Imported pigments from Italy and elsewhere made up local deficiencies in both naturally occurring mineral and earth pigments, and in some of the raw materials for the preparation of certain manufactured colours.[2]

Some commentators have been inclined to stress the restricted nature of Rembrandt's palette, suggesting that this was the deliberate consequence of the artist's particular approach to painting. It is true that the total number of pigments he regularly used is not large, especially if the natural earth colours which contribute substantially to the palette are treated as a single group; but the way in which they were used, combined with the complexities of pigment mixture and elaborate paint layer structure gave Rembrandt access to an extremely impressive range of effects, particularly in translucency and texture, but also in the variety of colours employed.[3] His painting method is highly sophisticated in its use of materials, and the resulting works succeed not only visually, but also in the soundly based painting procedures he adopts. It is Rembrandt's choice of mainly stable materials used in compatible combinations, and his thorough understanding of the ways in which those chosen materials behave singly and in combination that account for the good condition of so many of the pictures included in this catalogue. Rembrandt combined the introduction of unusual and innovative techniques in paint sequence with ways of painting that are thoroughly

traditional. No single pattern emerges, and although ways of painting recur they are rarely part of a rigidly controlled technical framework.

Rembrandt's paintings are certainly dominated by the most limited selection of pigments – the manufactured colours lead white and bone black, as well as a generous selection of natural earth pigments, such as the ochres, siennas and umbers; other pigments are regularly used, but these are his staples. Yet this description of Rembrandt's palette, however accurate, does not do justice to the subtlety of his painting method, in which colour and transparency are achieved by continuously varying combinations of relatively few pigments, and further modified by building up the layers of paint, one over another, until the desired effect has been reached. Opacity and built-up texture are usually interrelated, with much of the thickest impasto formed from the most solid and opaque of pigments, frequently lead white and sometimes lead-tin yellow. But there are also passages of very thickly laid translucent dark-coloured paint, and for these Rembrandt used novel methods that involved unusual combinations of pigments chosen for their bulk and transparency as well as for their colour.

Lead white and chalk

Among the manufactured pigments, lead white is of the greatest importance in Rembrandt's work. Used on its own, it forms the thick white paint of collars and cuffs and other highlighted details of costume (Fig. 15). In mixture with other tinting pigments, it is the essential component of the lighter flesh paints. The presence of lead white in large quantities in the opaque parts of Rembrandt's paintings ensures that radiography can successfully reveal something of the structure of the pictures, since the pigment absorbs X-rays strongly. Where it is used in high impasto it does not produce excessive cracking as the paint film dries because, in common with all lead-containing pigments, lead white enhances the drying of oil paint, forming a particularly tough and flexible film.

Lead white has been used as an artists' pigment since classical times. In the first decades of the seventeenth century it was made on a large scale in the Zaan area, in Amsterdam and in Rotterdam. The method used, which came to be known as the 'Dutch process' (or the stack process), was based on the ancient means of manufacture. This involved exposing strips or buckles of metallic lead to the chemical action of vinegar vapours in closed but not sealed

Fig. 15 Detail from *Portrait of Aechje Claesdr* (Cat. 3) showing the presence of lead white in the headdress

containers, in an atmosphere rich in carbon dioxide generated by decomposing manure or tanbark.[4] The pigment forms as a pure white corrosion crust on the lead and is collected by scraping the metal.[5] Chemically the product that forms is a basic lead carbonate, $2PbCO_3.Pb(OH)_2$, which often contains a proportion of neutral lead carbonate, $PbCO_3$. In samples of lead white from paintings by Rembrandt, varying quantities of the neutral carbonate have been detected by analysis, from very little to up to roughly one-third of the total weight. In seventeenth-century pictures Dutch lead white is often seen under the microscope to contain large aggregate particles of very pure, rather pearlescent white pigment in association with more fine-grained material;[6] the samples from the Gallery's Rembrandts are no exception. A number of cross-sections (see Fig. 104, p. 115; Fig. 171, p. 162; and Fig. 193, p. 177) show these coarse particles of lead white, particularly those from the upper ground layers of the paintings with double grounds.

The manufacturing process produces a certain proportion of neutral lead carbonate naturally, but samples of white also frequently contain deliberately added chalk, $CaCO_3$, and analysis and contemporary literature suggest that at least two grades of lead white were offered as artists' pigments. Pure basic lead carbonate, known as *schulpwit* or *schelpwit* (seemingly a reference to the shape of the rolls – *schulpen* – or cakes of unground pigment that are formed in the manufacturing process),[7] was the finest-quality pigment, equivalent to modern flake white. A cheaper mixture of lead white extended with chalk, very common in the Dutch industry, may be the product known as *lootwit*,[8] and this served for the less demanding applications, for example in grounds, and was used also for underpaint layers. This addition of chalk to lead white reduces the opacity of the pigment when used in oil.

Each of the works in the catalogue section makes use of lead white in some section at least, but it can be seen to best advantage as a pure white pigment of great opacity, used in high impasto, in the painting of the lace collar in the *Portrait of Philips Lucasz.* (Cat. 5), the turban in *Belshazzar's Feast* (Cat. 8), and also the woman's shift in *A Woman bathing in a Stream* (Cat. 12). The white ruffs in the portraits of women, including the two of *Margaretha de Geer* (Cats 18 and 19), are painted principally in pure lead white.

Rembrandt used chalk in its own right as a pigment and extender, where bulk without density is required in the paint. When mixed in oil medium, chalk is virtually transparent, making it suitable as a modifying agent for glazing paints that also contain translucent coloured pigments. The effect is to add body and translucency to glaze-like paints without inducing a great change in colour. The dark-coloured glazes to the background of *Saskia van Uylenburgh as Flora* (Cat. 6) contain chalk mixed with other pigments, particularly earths, to achieve a rich translucent effect.

Lead-tin yellow

The second traditional manufactured lead pigment of prominence in Rembrandt's work is a binary oxide, that is, a chemically combined oxide of lead and tin, known today as lead-tin yellow. The early history of lead-and-tin-based yellows has not been established fully, but they began to appear in European painting around 1300, disappearing entirely from artists' palettes around the beginning of the eighteenth century. Lead-tin yellow was made in two distinct varieties at various times and in several centres. Both types were used for oil painting in Venice during the sixteenth century, but in Northern Europe only one variety, which has the chemical composition Pb_2SnO_4, appears to have been made regularly from the early decades of the fifteenth century.[9] There is documentary evidence that this specific form of the yellow pigment, now known as lead-tin yellow type I, was a Northern European product (the Milanese painter Giovanni Paolo Lomazzo described it as 'il giallolino di fornace di Fiandra') and was, of course, used locally as well as being exported to Italy.[10] All the examples that have been identified in Rembrandt's work correspond to this particular constitution. Lead-tin yellows of both types probably owe their origins to the combined use of lead and tin for ceramic glazes and to their use as opacifiers for glass, which perhaps accounts for the production of both forms of the pigment in sixteenth-century Venice.

The type of lead-tin yellow used by Rembrandt would have been made by roasting to a high temperature a starting material such as lead white, red lead (lead tetroxide, known as minium) or even metallic lead with tin dioxide.[11] The conditions of preparation, particularly the temperature of the furnace, and the presence of impurities in the starting materials determine the precise shade of yellow in the final product, which ranges in colour from a light primrose to a deep golden yellow. Descriptions in the contemporary literature, which term this artificial yellow *massicot* (or *masticot* and other spellings), imply that several kinds of the pigment were available, although these are always found to be chemically identical. That the painting treatises refer to artists' pigments described as *massicots* (in the plural) suggests varying shades of the same material.[12] Curiously, the modern name 'massicot' is reserved for a yellow or orange-yellow simple monoxide of lead and not a compound of lead and tin, although early recipes for the preparation of the opaque yellow artists' pigment confirm the equivalence of the name *massicot* with the modern designation lead-tin yellow.

Like lead white, lead-tin yellow is dense and opaque, and dries well in the oil medium. It has recently been discovered that lead-tin yellow interacts chemically with drying oil media in paint films to form so-called 'lead soaps', which are often seen under the microscope in samples

Fig. 16 Detail from *Judas returning the 30 Pieces of Silver* (Cat. 1)

as pale-coloured, often striated minute lumps or inclusions; *Belshazzar's Feast* (Cat. 8) and *The Adoration of the Shepherds* (Cat. 11) provide clear examples.[13] Since it is a lead-based pigment, lead-tin yellow registers strongly in X-ray images. Good examples of its use by Rembrandt in *Belshazzar's Feast* are in the lightest opaque yellow paint of the embroidery on Belshazzar's cape and in the lettering on the wall and it is used also in the high-key passages at the left side of *Judas returning the 30 Pieces of Silver* (Fig. 16); it is also present in the embroidered waistband in *Saskia van Uylenburgh as Flora*. Lead-tin yellow forms the impasto lights and darker yellow touches to the gold chain in the *Portrait of Philips Lucasz*. On a more modest scale it is used for the background highlights in *The Woman taken in Adultery* (Cat. 10), and for the child's swaddling blanket in *The Adoration of the Shepherds*. Occasionally Rembrandt used lead-tin yellow to modify flesh tones, and he made opaque greens based on a mixture with blue mineral azurite. *Saskia as Flora* reveals examples of both practices.

Vermilion

Seventeenth-century Holland was famous for the manufacture of vermilion,[14] another key artists' pigment. In the form of ground natural cinnabar, it had been used for painting since the earliest times. Chemically it is a sulphide of mercury (HgS). Its synthetic equivalent, produced by direct combination of mercury and sulphur in heated retorts followed by sublimation, was an ancient technology introduced into medieval Europe from China, via the Islamic world. Vermilion, either natural or manufactured, is generally bright scarlet and very opaque. More orange or crimson varieties are possible. Because it was a moderately expensive manufactured pigment, specimens adulterated with red lead (minium) were sold in the seventeenth century, which may account for contradictory assessments in the painting treatises regarding its stability. Recent research, however, has suggested that the presence of red lead may in fact improve the stability of vermilion.[15] Dutch dry-process vermilion was a major export, and a great deal found its way to England.[16]

Rembrandt did not make much use of vermilion. The paintings discussed here did not call for large areas of bright red, and where Rembrandt did require an opaque intense red, he generally achieved it with a bright red ochre, heightened by the admixture of red lake, giving a rather more subtle, more easily modulated colour. The large area of scarlet in *A Young Man and a Girl playing Cards* (Cat. 24) is composed of vermilion, but the work cannot be attributed to Rembrandt himself. A few particles of vermilion are sometimes added to enhance a flesh tone, but the only striking case of its use is for the opaque red and orange-red highlights of the woman's dress in *Belshazzar's Feast*. The Virgin's bodice in *The Adoration of the Shepherds* also contains a little vermilion, but here used only to strengthen red ochre mixed with white. Rather more of the pigment was added to both colour and solidify the hot brown background depths in *The Woman taken in Adultery*.

Earth pigments

Rembrandt's palette is rich in the earth pigments. As a group they provide the greatest range of the more muted warm colours of red, orange, yellow and brown. All the earth colours used by Rembrandt would have been from the naturally occurring sources that are abundant in many parts of Europe,[17] particularly in Italy, France and England, and were an established part of the pigment trade. Further afield, sources in Cyprus and what is now Turkey supplied specialised grades and colours, particularly of the umbers.

The great advantages of earth colours to the painter are that they are entirely stable in all painting media and do not interact with more chemically sensitive pigments – making them suitable for any kind of pigment mixture – and that they dry perfectly well in oil after a time. Some, like the umbers, are particularly effective driers. Their disadvantage, perhaps, is lack of intensity of colour, but what they offer in range of colour and choice of translucency must have suited Rembrandt well. Certainly the artist used earth pigments in great profusion and for many purposes in his paintings.

Natural earth pigments are loosely classified as ochres, siennas and umbers, but all contain natural ferric oxide (Fe_2O_3) as the essential colouring matter. The dividing lines are not clearly drawn, but in general ochres are earthy deposits of fairly pure hydrated or anhydrous ferric oxide, and may be yellow, orange, brown or red. Red ochre in its best form is almost entirely anhydrous ferric oxide, while the yellows and browns contain varying proportions of several hydrated iron oxides. Ochres are the most opaque of the earth colours.

Siennas are essentially ochreous pigments which contain greater proportions of mineral impurities in addition to the iron oxide, particularly alumina and silica, which renders them more transparent. Siennas were used as pigments in the raw state, or gently roasted (burnt sienna) to produce a warmer shade. Analytically, aluminium and silicon as well as iron are always detected in this group of pigments, arising from the colourless mineral matter which is part of the deposit. Calcium, magnesium and titanium are often also detectable.

Just as there is a large variety of earth colours and of their sources, the pigments go under a great number of names which often describe their colour and supposed origin. The treatises refer to materials such as Venetian red, Roman ochre, Prussian ochre, Indian red, English red and Spanish brown.

The umbers are rather more distinct, containing, in addition to ferric oxide, a variable proportion of black manganese dioxide. In their natural condition they fall in the colour range from dark brown to almost black, with differing transparencies. The manganese dioxide component gives these pigments a dark tone, and also has a drying effect on the oil medium. For this reason umbers are useful not only for their colours, but also as additions to ground layers to assist their drying. The thin brown *primuersel* found over the chalk grounds of Rembrandt's panel paintings is revealed by analysis to contain a little umber, as are some

of the upper grounds of the canvas paintings. As with the siennas, warmer-toned burnt umbers were made by gentle heating.

Another variety of transparent brown found in Rembrandt, sometimes treated as an earth colour since it is dug up from deposits in the ground, is known variously as Cassel or Cologne earth,[18] and later as Vandyke brown. Strictly, it is an organic pigment of peaty or lignitic origin, but it often also contains some inorganic mineral matter. Rembrandt uses it for deep brown background glazes, mixed with a variety of other pigments, particularly earths and lakes, and also in the shadows of flesh in some of his portraits, in ways similar to the practice of Rubens and Van Dyck.[19] The pigment is a poor drier in oil but, because he combined it with other materials, this potential defect is not apparent in Rembrandt's work.

The occurrence of earth pigments in Rembrandt's paintings is exceptionally widespread. Mainly they are used in mixture for every kind of application: for the opaque tints for flesh and details of costume or jewellery, and everywhere as modifying components for the translucent background paints of red, brown and black. Occasionally, pure touches of opaque red, orange or yellow ochre are used to highlight a detail, as in the cloak on the

Fig. 17 Detail from *The Woman taken in Adultery* (Cat. 10), showing Rembrandt's rare use of red lake as a glaze

riverbank in *A Woman bathing in a Stream*, or the yellow reflection on the arm of the chair in the *Portrait of Hendrickje Stoffels* (Cat. 13); here the colours are at their strongest and brightest. Often, red and yellow ochres are intensified by adding a strongly coloured pigment such as red lake to achieve a greater vibrancy. Examples are the red highlight defining the edge of the tablecloth in *Hendrickje Stoffels*, and the almost scarlet stirrup strap in the *Portrait of Frederik Rihel on Horseback* (Cat. 20), where in each case red ochre has been enhanced by the admixture of a deep red lake pigment. The technique is also used in *Belshazzar's Feast*.

Lakes

Rembrandt made much use, too, of lake pigments. These are a specific category of manufactured glazing pigments, for which the source of colour is a natural dyestuff of plant or animal origin. In the case of the red lake pigments, the dye material would commonly have been co-precipitated on to a substrate of amorphous hydrated alumina by the addition of potash alum to a solution of the dyestuff in aqueous alkali. The lake pigment forms as a precipitate in which the dye attaches itself to the substrate. The product thus formed can be collected, washed and dried as a solid coloured pigment. Because the substrate itself is translucent when mixed with the painting medium, lakes have traditionally been used for richly coloured transparent glazes over opaque underlayers.[20] Rembrandt used lakes in exactly this way in *The Woman taken in Adultery* (Fig. 17), but this is a

rare example. Instead, he commonly added them to warm, dark glaze-like mixtures of bone black with earth pigments for translucent background shadows, and used them also to reinforce the colour of otherwise duller ochres in more opaquely painted passages. Sometimes particles of red lake appear in the flesh tints, but still not as glazing pigments.

In Rembrandt's time, red lake pigments were prepared from the red dyestuff extracted from the madder plant (*Rubia tinctorum* L.; Fig. 18) for which the Netherlands was a renowned source. The dyestuff contains anthraquinone dyestuffs such as alizarin, pseudo-purpurin and other constituents in the form of glycosides (sugars); these are hydrolysed by enzymatic action or during processing to give the free colouring matters. If ground madder root is stored for a time, pseudopurpurin gradually loses carbon dioxide and forms purpurin.

A number of scale insects were sources of crimson-red dyes, of which Mexican cochineal (*Dactylopius coccus* Costa, containing carminic acid) was by this time the most important. The dyestuff from the Indian or south-east Asian lac insect (containing laccaic acids) was also used; that from the southern European kermes insect (kermesic acid), so important for previous generations of painters, was by this time infrequently used.[21] Lakes were also made from brazilwood, imported from South America (*Caesalpinia echinata* Lam. and other species) and widely used for dyeing, in spite of the poor permanence of the dyestuff; rasping the blocks of wood was a task given to prisoners in the Amsterdam prison.[22] The brilliant scarlet or rose pink lake pigments were, like the textile dye, very fugitive.

Red lake preparation has always had a close association with textile dyeing, and it seems that at this time the principal source of dye for the cochineal and probably the madder lakes was shearings of dyed cloth or other textile waste, rather than the raw materials themselves.[23] Brazilwood lakes were made directly from the wood, however.

Brazilwood dyestuff is present, with that of cochineal, in lake pigment mixed with smalt and Cassel earth in the dark-coloured layer beneath the yellow paint of Frederik Rihel's coat in the *Portrait of Frederik Rihel on Horseback*. More often, however, Rembrandt used the bluish-crimson cochineal and orange-red madder lakes: a red lake based on madder has been identified in *Belshazzar's Feast* for the deep red glaze of the dress worn by the woman to the right of the composition. Sometimes cochineal lake is used alone, or in complex mixtures with earths and other pigments to give browns, but often Rembrandt used both lakes together, giving the possibility of a great range of translucent reds: a little madder is present with the cochineal lake in the *Portrait of Jacob Trip*, the *Portrait of Hendrickje Stoffels* and the *Self Portrait at the Age of 63* (Cat. 21). In the last two cases the red lake was sometimes found to have been mixed with a yellow lake pigment, a technique which seems to be fairly common in Rembrandt's work and is also seen in the work of other painters.[24] In the *Self Portrait* the lake used may contain the dyestuff extracted from unripe buckthorn berries.

The dyestuffs for yellow lakes are unfortunately often more difficult to identify than the reds, partly because they are so fugitive; yet yellow lakes were important as artists' pigments in seventeenth-century Dutch painting. They provided yellowish-green and yellowish-brown

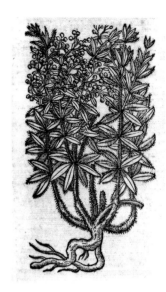

Fig. 18 Madder, *Mee of Rotter*. Woodcut from Rembert Dodoens, *Cruyde boeck . . .*, Antwerp, 1644, p. 571.
London, British Library, inv. 442.k.5

pigments of good translucency for glazing and mixing, used, for example, as glazes in flower painting and mixed with blue and other pigments for landscape and foliage greens. In addition, yellow lakes were used in an inconspicuous way to lift other pigments, particularly ochres, and to provide good translucent brown mixtures. Their preparation is similar to the red lake pigments, although all the yellow dyestuffs are derived solely from plant sources. Painting treatises refer to *schietgeelen* (yellow lakes), once thought to be an abbreviation for *verschietgeelen* – literally 'disappearing yellows' – conjecturally referring to the fading of these glazing pigments on exposure to light.[25] However, the term has a more prosaic origin and seems instead to come from the Dutch word for excrement (*schijt*) pertaining to an alleged correspondence in colour with the pigments.[26] Both yellow and red lakes are, in fact, vulnerable to fading by photo-oxidation, the yellows particularly so. However, when used as tinting pigments, as Rembrandt does, rather than as surface glazes, lake pigments are generally rather more stable.

Certain translucent yellows based on plant dyestuffs were true lakes prepared on hydrated alumina by precipitation methods similar to those employed for the red lakes. Very much more commonly the substrate of yellow lake pigments incorporated a calcium salt, as chalk was frequently included as an ingredient; indeed, the pigment was often made by the addition of chalk and alum to a solution of the dyestuff without the use of another alkaline solution. The seventeenth-century English name for these pigments was *pink* or *pinke* – used as a noun, not descriptively: the adjective meaning a tint of red acquired its meaning more recently.[27] Traditionally plants such as weld (*Reseda luteola* L.) and dyer's broom (*Genista tinctoria* L.) were often used to make lakes and these were widely used in Rembrandt's time;[28] these colours tend often to be slightly acid lemon or primrose yellows. The unripe berries of

buckthorn (*Rhamnus cathartica* L. and other species) give a warmer, more golden yellow, which appears to have increased in popularity later in the seventeenth century.[29] Towards the end of the century this pigment had become something of a Dutch speciality: the French pharmacist Pierre Pomet wrote that the pigment made from the berries (*graines d'Avignon*) was exported to France from the Netherlands under the name *stil de grain* (Fig. 19).[30] By this time buckthorn-based pigments were made on a very large scale. The buckthorn dyestuff might be mixed with other plant dyes, such as fustic (the European *Cotinus coggygria* Scop. or possibly the American species, *Chlorophora tinctora* (L. Gaud.), which would make the colour of the final pigment browner or more orange, or weld.[31] In his later years at least, Rembrandt seems to have preferred the warm buckthorn yellows; there is some evidence that the yellow lake used in the *Self Portrait at the Age of 63* contained buckthorn dyestuff. Rembrandt's glazes often combine yellow and red lake pigments, occasionally with each other alone, but more often together in elaborate mixtures with earth pigments, bone black and even smalt, to create a great range of colour and texture.

The consistency with which Rembrandt used such translucent pigment mixtures can be judged from subjects as different as the small-scale panel painting of 1654, *Woman bathing in a Stream*, and the large pair of canvas portraits, *Jacob Trip* and *Margaretha de Geer*, painted seven years later.

Bone black and charcoal

Darks were of the greatest importance to Rembrandt. Although the dark-coloured umbers might have been almost enough for background shadows, the black clothes worn by his sitters called for an intense black pigment. This was almost always provided by bone or ivory black, prepared, as the name suggests, from animal bones or waste ivory by charring in a closed crucible. The product is a warm, deep black composed of carbon and calcium phosphate, $Ca_3(PO_4)_2$, the residue of the structural material of which bone is built. In samples of paint containing bone black the phosphorus is readily detectable by analysis, which confirms the use of the pigment in many of Rembrandt's darks.

Bone black is found everywhere in the paintings: it is frequently a component with other pigments of dark-coloured glazes for backgrounds and costumes; often the mixture includes lake pigments, smalt and earth colours in ever-changing proportions. It forms the main pigment of sketchy underlayers used to define the principal parts of a composition, and it is occasionally used to shadow flesh. Studies of several paintings by Rembrandt using the technique of neutron activation autoradiography have shown the widespread use of the pigment in the initial wash-like sketch over the ground layer.[32] Unusually, unmixed bone black pigment was used to paint the darkest parts of the clothing in the portraits of Aechje Claesdr (Cat. 3) and Philips Lucasz. (Cat. 5).

Wood charcoal, the other common black pigment available to Rembrandt, was found not to have been widely used, except to tint the grey upper ground layers in canvas grounds. The *Elderly Man as Saint Paul* (Cat. 16) is a good example of this. The slightly bluish-black cast of charcoal when mixed with white enhances the cool half-tones of the flesh painting in *A Woman bathing in a Stream*, as well as in the bluish-grey streaks on the white fur stole and cuff in the *Portrait of Hendrickje Stoffels*. A rather unusual technique for the deepest green foliage of the bouquet in *Saskia as Flora* involves a charcoal-containing scumble drawn over a deep blue-green layer of azurite, while in *Judas returning the 30 Pieces of Silver* (Cat. 1) Rembrandt makes use of wood charcoal in the dark background.

Blue pigments

The Rembrandts in the National Gallery are not remarkable for their use of blue pigments, although in the history paintings of his early career blues and greens played a more important role. The only picture in the Gallery with an overall cool tonality is *Saskia van Uylenburgh as Flora*, for which Rembrandt used azurite in pigment mixtures of all kinds, imparting a greenish tinge to much of the composition.

Azurite is a natural blue mineral pigment, chemically a basic carbonate of copper, $2CuCO_3.Cu(OH)_2$. It occurs in nature with a closely similar green copper carbonate mineral, malachite, also used as a pigment, but this was not found in any of the samples examined here. Azurite is recognisable under the microscope, generally as quite large fractured mineral particles of deep blue or greenish blue. Much of the natural pigment used in European painting was from Hungary or Germany,[33] although sources in the New World are also mentioned in the seventeenth century. In addition to the mineral form, a synthetic azurite

Fig. 20 Detail from *Saskia van Uylenburgh as Flora* (Cat. 6)

called blue verditer (*aschen*, ashes, in Dutch) was available to the seventeenth-century painter,[34] and was used similarly. It is chemically identical to mineral azurite, but differs in the form of its particles, which are more rounded crystalline grains of pale blue or greenish blue.

The most striking instances of the uses to which Rembrandt puts azurite are to be found in *Saskia as Flora*. Mineral azurite forms the deep bluish-green streaks of Saskia's embroidered waistband; it is the main colouring component in the veil and sleeve; and it is used as the basis of the foliage greens and of the blue flowers in the bouquet (Fig. 20). In a rather unusual technique, Rembrandt mixed azurite into the cool brownish-green shadows of Saskia's hand. Small quantities are also used in the flesh painting of *Philips Lucasz.* and *A Woman bathing in a Stream*. *Belshazzar's Feast*, too, contains azurite: for the greenish embroidery on Belshazzar's under-robe and for the intensely blue-green jewels sewn on to the cape. A little is used with lead-tin yellow and other pigments for the Virgin's skirt in *The Adoration of the Shepherds*. The later pictures contain no azurite as a colouring matter; if a blue pigment occurs, it is always smalt.

Because it is a copper-containing pigment, azurite will improve the drying of oil paint by chemical reaction with the medium. It is probable that Rembrandt used the pigment as a drier as well as a colouring agent, mixing small quantities of natural or synthetic azurite with dark glaze-like paints made up of pigments which otherwise do not dry particularly well in oil. The drying of paint films containing lake pigments and bone black is assisted in this way. In this case the proportion of pigment used is usually quite low, sufficient to influence the rate of drying but not enough to impart colour. Examples of the procedure are found in the background glazes of *The Adoration*

of the Shepherds, An Elderly Man as Saint Paul, A Franciscan Friar (Cat. 14) and the *Self Portrait at the Age of 63*, among others. A little blue verditer is used for the shadow glazes in *A Bearded Man in a Cap* (Cat. 15). Similarly, azurite mixed with yellow lake pigment forms the initial background glazes for *Saskia as Flora*; here intentional use was probably made of the colour of the pigment as well as of its drying quality. Rembrandt seems nowhere to have used natural ultramarine, the most valued of the traditional blue pigments. Like azurite it is a mineral blue, extracted by a laborious process from the semi-precious stone lapis lazuli, which was imported into Europe from Afghanistan, via Venice. No sample analysed was found to contain natural ultramarine, and no example of its use by Rembrandt has been published. Although scarce and costly, the pigment was certainly available in seventeenth-century Holland, as it was used extensively by Vermeer.[35]

Perhaps for reasons of economy or lack of easily available alternatives, certain Dutch seventeenth-century painters are known to have used an unusual earthy clay-like mineral as a pigment: a dull greyish-blue form of natural hydrated iron phosphate with the modern mineral name, vivianite. This may have been a locally available material. The pigment was first detected in the works of Aelbert Cuyp,[36] where it was used largely for foliage greens based on mixtures of pigment, and it has more recently been identified – also in foliage paint, mixed with other pigments – in a small Rembrandt panel of *Susanna and the Elders* in The Hague (Mauritshuis), painted in the later 1630s.[37] It is not known how widely Rembrandt or his studio may have used this material, but logically it would probably only be of much value in the depiction of foliage or landscape details, as it lacks sufficient colour strength and purity to be useful for skies or drapery painting.

Another blue pigment that quite commonly occurs in Rembrandt's painting is a manufactured one. It is a potash glass called smalt, coloured blue by the addition of cobalt oxide. Smalt has no fixed composition, but cobalt, potassium and silicon are its essential constituents; in addition, arsenic is generally detected as an impurity. The glass was coarsely ground for use as an artists' pigment. The history of smalt in European painting is not known with certainty.[38] It first occurred occasionally in the fifteenth century (earlier in wall paintings), although glass coloured blue with cobalt was made rather before this. The seventeenth-century source of cobalt was silver mines in Saxony, but the manufacture of smalt became a Dutch and Flemish speciality. At its best, smalt is a pure, deep translucent blue with a slightly violet undertone. Different grades were made however, the colours of which were influenced by the concentration of cobalt present in the glass melt. Painting treatises of the period refer to 'smalts', suggesting a variety of qualities or colours.[39] Since it is a glass, it covers poorly. Sometimes smalt can discolour or blanch in oil medium, particularly if used as a glaze. This is because the potassium content of the glass is leached from the pigment by the oil medium, with which it interacts to form soaps,[40] and the result is considerable browning of the paint medium as well as loss of the blue colour from the glass. The colour change has occurred in several of Rembrandt's works in the National

Gallery,[41] to such an extent that the paint appears extremely dark and brown, probably much more so than it did originally: an example is the background in the *Portrait of Margaretha de Geer* (Cat. 18). The appearance and overall colour balance of the works as we see them today must be, therefore, somewhat distorted. In these circumstances it is ironic that smalt was in fact recommended for use as a drier, as the cobalt content is sufficiently available from the glassy particles for the pigment to exert a strong siccative effect on oil paint; the long-term effects were, of course, unknown at that time.

Rembrandt employed smalt very widely in several ways:[42] as a blue pigment on its own and in combination with others; as a bulking agent for texture in thickly laid glazes; and as a drier. The last two functions are interrelated, since most glazing pigments dry imperfectly in oil when heavily applied.

The patch of greyish-blue sky in the *Portrait of Frederik Rihel on Horseback* uses smalt for its colour, as a glaze, now rather discoloured, over a solid layer of lead white mixed with further smalt. The picture also contains the pigment in the dark brownish-green glazes used in the background foliage and landscape, where it is mixed with yellow lake. Smalt forms part of the palette for *Belshazzar's Feast*: in the background greys, and with lake pigments for the deep shadows of the woman's red sleeve, where some blanching of the paint seems to have occurred. The small pale blue impasto touches to the feathers of the headdress worn by the woman to the left are in smalt mixed with chalk and lead white. *An Elderly Man as Saint Paul, Jacob Trip* and *Margaretha de Geer* all provide good examples of smalt used to constitute texture in dark-coloured translucent paints also containing lake pigments.

Ashok Roy and Jo Kirby

Rembrandt's paint medium

The main purpose of the artist's medium is to bind together individual pigment particles in a form that can be applied to and retained by a surface: in other words, to make a paint (Fig. 21). We can readily see and comprehend the range of painterly effects that Rembrandt was able to achieve in terms of colour with the pigments at his disposal. The role of the medium in this process is less conspicuous, but it is the painter's choice of medium, and crucially, the combination of pigment and medium that determines both the handling properties of the paint and the final optical effect. However, the increase over time in the refractive index of the oil medium leads to an increased translucency of the paint and thus a darker appearance, seen in Rembrandt's work today as in that of other painters. In addition, chemical interaction between medium and pigment results in a darker and warmer tonality that the artist is unlikely to have foreseen (see below).

Before the nineteenth and twentieth centuries artists were restricted to materials from nature: oils from seeds and fruits, resins from trees, waxes, glues from animal and fish sources, and gums from plants. Only with advances in chemistry during the last hundred years have synthetic materials become available as paint binders.

Analytical studies conducted on a variety of northern European paintings have shown that by the thirteenth century, artists were using a sophisticated, drying oil-based painting technique, for the most part choosing oil derived from linseed. By contrast, in Italy many artists were using egg tempera until the mid-fifteenth century, although the application of drying oil paint vehicles became progressively more common during the course of that century.

In the fresh state, such oils are free liquids capable of wetting and absorbing the powdered pigment. The mixture solidifies not merely by simple evaporation (as the name might suggest) but, rather, by a process of polymerisation in which the molecular units of the oil are linked together so that the pigment becomes firmly embedded in a solid organic matrix, whose optical properties are for many purposes superior to those of egg tempera. Such binders offer the combined advantages of good handling properties for the paint during application and the eventual production of a tough, durable film after drying.

Three main drying oil types are used in easel paintings. The strongest drier, that is the oil that dries best with a range of different pigments and most rapidly, is extracted from linseed. Walnut oil, much favoured by the Italian masters at one time, is somewhat slower in drying

and is more sensitive in the short term to the effects some pigments have in inhibiting drying. Much the same may be said of poppyseed oil; however, this, and to a slightly lesser extent walnut oil, is considered to yellow less during ageing. As a result both have often been recommended for the lighter colours. Artists were quick to appreciate that pigments such as lead white and red lead are good driers, whereas the black pigments and the lake pigments tend to inhibit the drying process of the oil binder.

The recent examinations of a wide range of seventeenth-century paintings by both Dutch and Flemish painters, in the National Gallery Scientific Department and elsewhere, has enabled us to build up a more comprehensive picture of the binding media in general use at that time.[1] When the results of these analyses are compared, the surprising simplicity of Rembrandt's binding media stands out. It has even been suggested that such a simple substance as linseed oil was not a sufficiently versatile vehicle to achieve the range of subtle optical transitions and texture observed – even in the works of such an experienced and consummate master as Rembrandt.[2]

Nearly all the analyses published, both here and in the first edition of this catalogue, have been obtained using the technique of gas chromatography coupled with mass spectrometry (GC–MS; see Glossary).[3] Analyses of works by artists in Rembrandt's circle – former pupils and assistants – have revealed several instances where resinous components were mixed with the drying oil. GC–MS is an extremely sensitive technique and can detect minute amounts of the natural constituents of the original drying oil, including plant mucilage and protein, or additives such as resins, as well as a whole range of other materials. These may be part of the original paint or might be present as the result of the subsequent history of the painting. The problem for the analyst is then how to interpret these findings in the light of what, if anything, is known of this later history – including conservation treatments. It is important

Fig. 21 Jan Baptist Collaert (after Jan van der Straet), *Colour Olivi (from the Nova Reperta Series)*, about 1590. Engraving. Amsterdam, Rijksmuseum, inv. RP-P-1904-1038

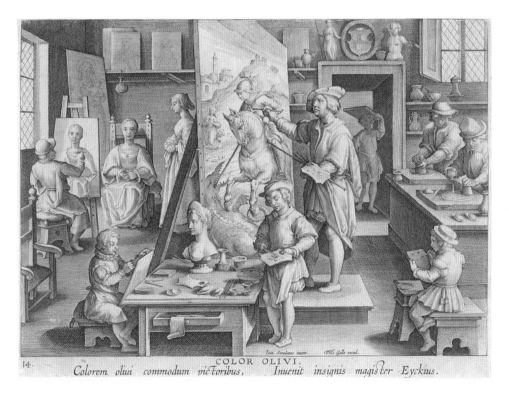

to note that most of the works by Rembrandt in the National Gallery Collection are, on the whole, in good condition and appear not to have undergone numerous conservation treatments.[4] As a result there has been little scope for the contamination that can arise from such interventions and give rise to complex and confusing results.

Since the original analyses were published in the first edition of this catalogue, another technique, Fourier transfer infrared spectrometry (FTIR), has become available to the Scientific Department of the National Gallery (in 1991). This is a visual examination that can be carried out even on a tiny spot within the pinprick-sized paint sample before GC–MS is employed. It provides partial information about chemical components within the sample, which allows possible sources of contamination from conservation treatments to be identified and helps to interpret the results of subsequent GC–MS analysis more accurately. FTIR and GC–MS are complementary analytical techniques, which, when used in conjunction, provide far more information about the paint fragment being tested than either does individually, and it has allowed us to reexamine and in some cases correct the results of analysis published in 1988.[5]

Study of the works by Rembrandt in the National Gallery (see Table 2, pp. 226–7) – a range covering much of Rembrandt's career – reveals that, for the most part, Rembrandt showed a marked preference for linseed oil. There is no evidence to suggest that he used resinous materials and other similar additives to modify the handling and optical properties of the final paint layers; he made far greater use of the possibilities of pigment/oil combinations in his paint. In addition, he rarely used heat-bodied (heat-prepolymerised) oil – that is, oil thickened by heating. The use of bodied oils made by leaving the oil to stand and thicken in the light is perfectly feasible, and was indeed a method of thickening oil that was widely used in the seventeenth century.[6] Rembrandt may well have used this type of oil, but unfortunately this method of thickening is undetectable by instrumental means.

Any of these modifications – thickening, or the addition of resin in the form of varnish – would increase the refractive index of the medium, thereby increasing colour saturation and the transparency of the paint layer. These treatments also give the paint more body and modify its flow properties. But of course these are not the only ways to achieve such results; for example, transparency of the paint is also influenced by the refractive index of the pigment used relative to that of the medium, so the choice of translucent pigments may result in an effect acceptable to the painter. An impasto can be achieved by the addition of pigment, notably pigments such as lead white or lead-tin yellow, although this impasto, when freshly painted, is of a different character to that given by a thickened oil. Rembrandt's work has often stimulated special comment upon his brushwork and liberal use of impasto. This could have been obtained by using a heat-bodied oil, perhaps with the addition of some varnish. However, the survey of Rembrandt's paint media seems to suggest this is generally not the case, apart from certain passages of white impasto in *Belshazzar's Feast* (Cat. 8) and the *Portrait of Frederik Rihel on Horseback* (Cat. 20).

The presence of smalt in many of Rembrandt's paints has already been noted (see p. 46), sometimes merely as a few particles mixed with other pigments, where it would enhance the drying characteristics of the oil medium and counter the effects of poorly drying pigments. In paint containing white or the lighter pigments, a greyish-blue colour is imparted by the smalt and the paint itself is thick and well-bodied, with excellent drying properties. In some other cases, smalt is a major constituent, particularly in glaze-like layers also containing lake pigments. Its presence offsets the poor drying characteristics of the lake pigments and also gives body to the paint while retaining translucency, allowing darker and lighter passages of the paint below to contribute to the overall visual effect. Over time, the paint becomes increasingly transparent. In addition, the medium develops a marked brownish discoloration, with the unfortunate consequence that the formerly cool, bluish-toned paint is transformed to a warm, or even golden-brown, colour, and there is a general deepening of the darker passages.

The presence of significant amounts of smalt and its reaction with, and degradation within, the paint medium can cause problems. It causes the depletion of certain chemical indicators used in distinguishing aged egg-based lipids from those of drying oils.[7] This introduces the risk that chemical analysis may suggest the presence of egg tempera binding media in the paint. An example of this is the paint of the brownish background in the *Portrait of Margaretha de Geer* (Cat. 18): in 1988 the medium was described as 'oil + egg (?)'. Now that the consequences of the reaction of smalt with the paint medium are better understood, it is quite clear that oil alone was employed as the medium in this area.

It is now apparent that, of the various drying oils available to them, Rembrandt and the circle of painters associated with him preferred to use linseed oil. Rembrandt used walnut oil sporadically, but not specifically for whites or pale-coloured passages, where the fact that it yellowed less, at least initially, might seem to offer some advantage. Ferdinand Bol, for example, who worked in Rembrandt's studio from the late 1630s to 1641–2 but had the greater part of his training in Dordrecht, used walnut oil for white paint and linseed oil elsewhere.[8] Unlike Rembrandt himself, painters of his circle sometimes did add a little varnish – and thus resin – to their medium, generally where increased translucency, gloss or extra body were required; and some, like Rembrandt, occasionally used smalt for this purpose.[9] They also seem to have used heat-bodied oils rather more often, but in this they were no different from other Dutch artists of the period.[10] In their choice of paint medium, Rembrandt and his associates were typical of the Dutch and, indeed, Flemish painters of their time.

Raymond White, with assistance from Catherine Higgitt

CATALOGUE

Works by Rembrandt

1 Judas returning the 30 Pieces of Silver, 1629

Oak, 78.8 × 102.3 cm
Signed bottom right: RL (in monogram: Rembrandt Leidenensis) 1629
Private collection
L952

The story of the repentant Judas is told in the Gospel of Saint Matthew (27:3–5).
Overcome by remorse following his betrayal of Christ, Judas returns to the
Temple to give back the 30 pieces of silver he has received in payment. Rembrandt
shows the moment when the repentant Judas is kneeling in front of the chief
priests and the elders with the pieces of silver strewn across the floor. The
High Priest, however, immediately turns away from Judas and distances
himself and the other priests from any involvement ('What is *that* to us? See
thou *to that*.'). Seventeenth-century depictions of Judas are extremely rare
because of the overwhelming disrepute in which his character was held, yet
precedents for the iconographic tradition of the subject of the return of
the pieces of silver can be found as far back as the Middle Ages. Usually
found in architectural decorations, these images were often combined with
gruesome images of Judas's death.[1] After the fourteenth century, however,
the subject all but disappeared. In Rembrandt's time the story of Judas's
repentance seems to reappear for the first time in a woodcut bible illustration
by Christoph Murrer of about 1600, and there are a few further isolated
instances of seventeenth-century illustrations of the story of Judas, though
many of these post-date the present painting.[2] It is not clear where Rembrandt
may have found the inspiration for the scene in this painting, but it is worth
bearing in mind that he, much like his teacher Pieter Lastman and the other
artists belonging to the generation immediately before Rembrandt, the so-called
Pre-Rembrandtists, frequently developed new pictorial solutions for otherwise
rarely depicted biblical subjects.[3] How unpopular the theme of Judas must
have been is exemplified by the partial copy of Rembrandt's figure of the
sinner in a print by Jan Joris van Vliet (1600/10–1668) of 1634 that actually omits
any reference to the much-disliked disciple. It is now known simply as a *Bust
of a Man grieving*.[4]

This, the best documented of all Rembrandt's early paintings, was seen, admired
and described at length by Constantijn Huygens (1596–1687; Fig. 22), the influential
secretary and artistic adviser to the Stadholder, Prince Frederik Hendrik of Orange
(1584–1647). Huygens wrote about his visit to two young artists in Leiden, Jan
Lievens and Rembrandt, and their relative strengths and weaknesses, in his
manuscript autobiography, which must have been composed between May 1629

Fig. 22 Thomas de Keyser, *Portrait of Constantijn
Huygens and his (?)Clerk*, 1627.
Oil on oak, 92.4 × 69.3 cm.
National Gallery, London, NG 212

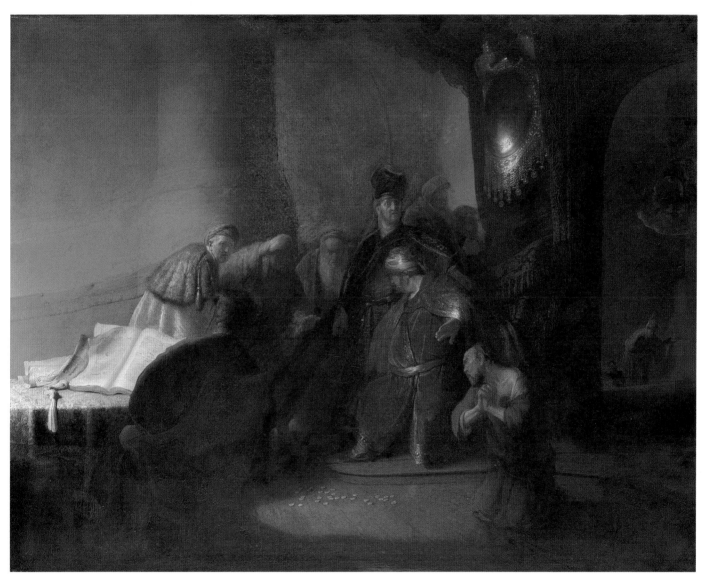

Fig. 23 *Judas returning the 30 Pieces of Silver*, 1629. Private collection, L952

and April 1631. His account of Rembrandt's *Judas*, written in Latin, merits quotation in full:

> The picture of the penitent Judas, and the pieces of silver, the price of the betrayal of our innocent Lord to the high priest, I would have stand as the example *par excellence* of all his works. Summon all Italy, summon whatever remains from remotest antiquity that is beautiful or wonderful, the portrayal of the despairing Judas alone, leaving aside so many other stupendous figures in this one single work, the figure of Judas only, I repeat, a Judas demented, wailing, beseeching forgiveness but not hoping to receive it or displaying any hope in his features, the awful face, the torn hair, the clothes rent to shreds, the twisted limbs, the hands clenched so hard that they bleed, the knee outstretched in an impulsive surge forward, the entire body contorted in pitiable anguish, I set against all the elegance of the ages, and I am eager that even those most unenlightened should know it, those men who (and I have attacked them for it elsewhere) reckon that nothing can be either done or said today which antiquity has not already said or done before. For I maintain that nobody, not Protogenes nor Apelles nor Parrhasius, ever conceived, or if they returned to life ever could conceive, the things which (I am struck dumb as I tell of them) a mere youth, a Batavian, a miller, a beardless boy has brought together one by one in a single human being and given expression to as a universal unity. In truth, friend Rembrandt, honour is yours: the bringing of Troy, of all Asia Minor to Italy had not such importance as the fact that the highest honour which belonged to Greece and Italy has now been carried off for the Dutch by a Dutchman who has still hardly ever left the confines of his native town.[5]

This painting – possibly the masterpiece of his early career in Leiden – reveals Rembrandt's abilities and ambitions as a history painter. He clearly understands and manages to convey the wide range of extreme human emotions that are part of the unfolding drama: the tormented anguish of Judas, the High Priest's complete rejection and the wide-eyed astonishment of the elders. Echoes of some of the figures can be found in a number of other works by the artist, including his *Belshazzar's Feast* of around six years later (see Cat. 8).[6] Interestingly, the figure of Judas may have been based on a drawing of an equally tormented *Christ in Gethsemane* by Jan Lievens of about 1627/8 (Fig. 24).[7] The emotional drama of the scene is heightened by Rembrandt's use of pronounced chiaroscuro. The focused beam of light from the upper left sharply illuminates the central part of the story – Judas with his clenched hands, bleeding head and bare shoulder, the (exactly) 30 pieces of silver in front of him and the figure of the High Priest with his dramatically outstretched hand – while lesser parts of the scene are left in deep shadow. In order to emphasise the spatial illusion Rembrandt creates a powerful *repoussoir* by setting the scribe in the left forground against the brightly illuminated book and

Fig. 24 Jan Lievens, *Christ in Gethsemane*, 1627/8. Pen, brush in brown and black; brown and grey wash, 32.1 × 21.7 cm. Staatliche Kunstsammlungen Dresden, Kupferstichkabinett, inv. C1437

 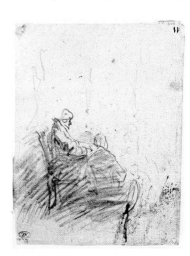

Above, left to right

Fig. 25 *Study for Judas returning the 30 Pieces of Silver*, 1628/9.
Pen and wash, 11.3 × 14.5 cm.
Private collection

Fig. 26 *Study for group of figures in Judas returning the 30 Pieces of Silver*, 1628–9.
Pen and wash, 22.6 × 17.7 cm.
Amsterdam, Rijksmuseum, Inv. RP-T-1930-54(V)

Fig. 27 *Two Figures sitting*, 1628–9.
Black chalk, 19.3 × 14.8 cm.
Rotterdam, Museum Boijmans Van Beuningen,
R-89 verso

table in front of him. The lighting also serves to emphasise Judas's pitiful state by contrasting him and his torn clothes with the sumptuous and gleaming attire of the High Priest. A further light source, hidden behind the pier with the metal shield, softly illuminates the deeper reaches of the cavernous space.[8]

There are three preparatory drawings for this painting. One (Ben. no. 8; Fig. 25), in pen and wash, is a compositional drawing which shows Rembrandt working out the disposition of the figures and their relationship to the architectural setting. The other two (Ben. nos 9 recto and 6 verso; Figs 26 and 27), respectively in pen and wash and black chalk, show the group of figures in the centre in slightly different positions.

Rembrandt made many changes in composition and in detail during the course of the painting's execution. The most significant of these can best be shown in diagrammatic form (Fig. 28). There are two principal areas of change: the architectural background and the figure group, particularly the figures in the left-hand half of the composition. A careful study of the painting, on the surface of which many *pentimenti* are visible, the X-ray (see Fig. 30), paint samples and the three preparatory drawings make it possible to identify the principal stages in the creation of this complex, intriguing and powerful work:

Rembrandt, or one of his studio assistants, prepared the panel, creating a smooth surface by applying a chalk ground, followed by a thin *primuersel* or priming, the toning layer, using lead white and brown earth pigments in an oil medium (see Fig. 29).

He then laid in the preliminary architectural elements. The arch that can now be seen apparently springing from the head of the central standing priest in a tall turban and curving to the left was put in at this stage. The column towards the right, of which the High Priest's throne is a part, was probably also roughly sketched in at this stage, as was the original, lower profile of the arch on the right.

Fig. 28 Drawing showing the first completed stage of Cat. 1

After this initial laying-in, Rembrandt made the compositional drawing (Fig. 25), in which he worked out the disposition of the figures within this architectural setting.

Rembrandt then transferred these ideas from paper to panel. He changed the architectural background in order to stress the centrality of the standing, turbaned priest. The first arch springing from his head was suppressed and two arches springing from points on either side of his head created. The figures of the standing priest, Judas, a standing priest on the left (who was subsequently painted out but can be clearly seen in the drawing and in the X-ray) and a chair to his right (also painted out later but visible in the X-ray) were painted in at this time. The heads of two figures behind the standing priest's shoulder at the right also correspond to this early stage of working. The seated High Priest may have been painted at this stage or added slightly later over the already completed figure of the standing priest. Intriguingly, in the very light part of the X-ray image of the background, left of centre, there is a very faint shape of a seated figure, possibly the enthroned High Priest set high up, that was abandoned in favour of the present arrangement. An important compositional element on the left-hand side of the painting was also painted in at this time: it was a tasselled curtain, painted in dark grey-blues (of smalt and charcoal), which begins about a quarter of the way along the top edge of the panel, curves inwards and then billows out again over the area which now contains the yellow tablecloth and the open book.

Rembrandt's original idea was to make the left-hand side of the painting very dark, so increasing the drama of the fall of light on the figure of Judas: this, as we shall see, was later abandoned. At the foot of this tasselled curtain Rembrandt painted a stool, which can clearly be seen in the bottom left-hand corner of the X-ray. It also seems that it was at this stage in the evolution of the painting that the arch on the right was raised. Under this arch, beneath which a staircase clearly descends away from us, a larger figure appears in the X-ray – a figure that was replaced, possibly at this stage, by smaller figures set lower down.

Rembrandt was troubled by the left-hand side of the painting and in particular by the group of priests, and he experimented with this group on paper in the two other extant drawings. Both show him working out the interrelationship of these figures. In the pen and wash drawing (Fig. 26) – which shows quite clearly the tasselled curtain on the left – the seated figure is seen in lost (or three-quarter) profile and the dominant figure of the tall standing priest is moved into the centre of the composition. It is fascinating to note that this figure, having been drawn in pen by Rembrandt, was then removed by him from the composition: he went over the outlines of the figure in chalk, whiting it out. It is only with the wearing away of the chalk that the pen figure has re-emerged. In the second, black-chalk drawing (Fig. 27) the seated figure is seen in strict profile with a second seated figure seen from the back. It is tempting to think that at this relatively early stage in the composition Rembrandt intended to use

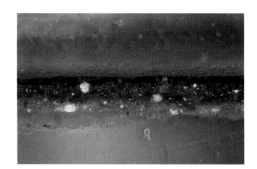

Fig. 29 Paint cross-section from dark grey paint of arch, upper-right corner of Cat. 1, where the paint structure is straightforward and unmodified. A little of the chalk ground and the *primuersel* are visible under a single layer of blackish paint.
Magnification 200X

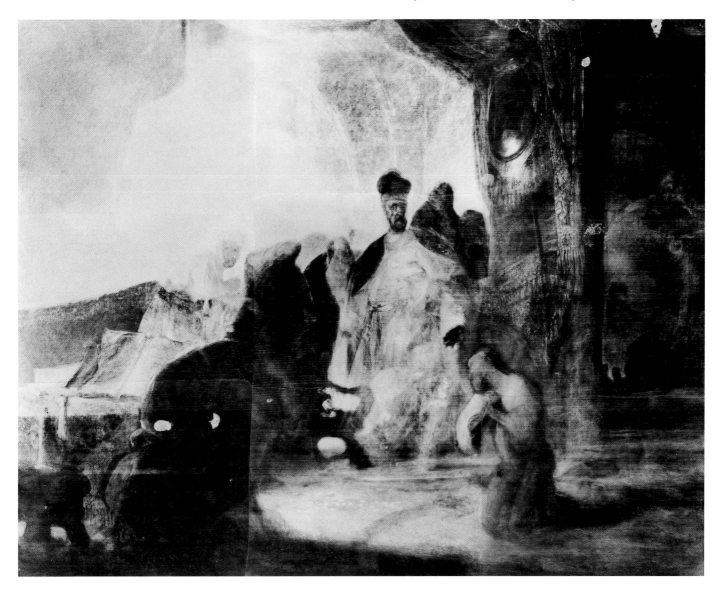

Fig. 30 X-ray mosaic of Cat. I

these figures to close off the figure group on the left-hand side, an idea he later abandoned.

As a result of these experiments on paper, Rembrandt decided to dispense with the standing priest with his back to the spectator left of centre. He scraped this figure out and also removed the chair on the immediate right of the priest, parts of the curtain at the left and the stool in the bottom left-hand corner.

Rembrandt next painted in the seated priest seen from the back left of centre and suppressed the entire curtain, replacing it with the column on the back wall, the grey-green fringed hanging (painted in pale-coloured azurite mixed with lead white, see Fig. 31) attached to the back wall which, as can be seen clearly in the X-ray,

originally went around the curve of the column, the table and the open book that stands on it. These were radical changes and none more so than the new lightness of tone on the left-hand side of the painting. Replacing a sombre curtain with a brightly lit table and book had the effect of completely altering the tonal balance of the picture, creating a light area to balance that which highlights the central drama. The pigments used for the higher-key passages are lead-tin yellow (Fig. 32), vermilion and lead white with touches of azurite.

Rembrandt then painted the figures of the three standing priests above the seated one. They all lean forward to observe Judas. The one furthest to the left is painted over the fringed hanging.

Finally, he corrected the outline of this fringe in the area immediately to the left of the standing priest, who is the furthest of the three to the left. This caused Rembrandt considerable difficulty in the perspective. Formerly encircling the column, the hanging was painted as if seen by the spectator from a high viewpoint, but now, by painting it to disappear halfway up the back of the priest, he made the spectator's viewpoint very low down: it is a distinct lapse in the picture's perspective scheme.

The figure group which forms a semicircle in front of the despairing Judas was admired by Huygens and there can be no doubt that the suppression of the central figure of a standing priest seen from the back and the consequent opening up of the composition, which gave greater prominence to the High Priest who turns away from Judas, were great improvements. More important, the 30 pieces of silver themselves assume their crucial importance in the drama. In earlier versions they would have been far less visible just to the right of the standing priest.

A number of other minor alterations visible in the X-ray were made to increase the dramatic impact of the scene; for example, Judas's money-bag was originally beside his knees, but this would have distracted from the silver thrown on the floor and so was painted out and shown discarded on the stairs in the shadows behind Judas. Similarly a curved step visible in the X-ray in front of Judas would also have complicated the floor in this area and was not included. The painting's architectural background which, as has been seen, caused the artist so much trouble, is the least satisfactory aspect of the composition. The unfortunate craquelure on the picture surface on the right side of the column is the result of the heavy overpainting needed to make the numerous changes in the shape of the arches on top of which the column was painted. The space within the Temple is unsatisfactorily defined, the pillar that forms the High Priest's throne is unrelated to the rest of the architecture, and the single column at the back with its massive base and indeterminate moulding belongs to no recognisable architectural order. Rembrandt wanted to convey the immense cavernous space within the Temple but instead created considerable spatial confusion. In *The Woman taken in Adultery* (Cat. 10), painted fifteen years later, Rembrandt convincingly

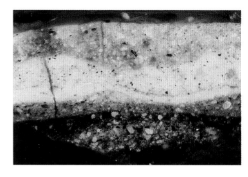

Fig. 31 Paint cross-section from grey-green curtain pinned to the wall at left edge in Cat. 1 and painted in several layers containing azurite, over earlier layers of dark paint, showing that there was considerable modification in this area.
Magnification 145X

Fig. 32 Paint cross-section from impasto touch on tablecloth, to the left of Cat. 1, showing the use of lead-tin yellow. There is a discontinuity or pause in painting between the upper layer and the earlier paint layers beneath.
Magnification 165X

conveyed the awesome grandeur of the interior of the Temple.

The extensive changes in *Judas returning the 30 Pieces of Silver* are a fascinating testimony to the young Rembrandt's tentative method of creating a complex multifigured composition. He made radical changes both in the background and in the central figure group while at work on the painting in order to give the scene the greatest possible dramatic effect. Some of these changes he tried out on paper during – rather than before – his work on the panel. He may well have been aware of the importance of the painting: he could have known of Huygens's visit some time in advance and lavished particular care on the *Judas* in order to impress the influential secretary of the Prince of Orange. As we have noted, Huygens was immensely impressed by the painting, but ironically it was the figure of Judas, one of the few which had remained unchanged during the evolution of the painting, that elicited the highest praise: 'The portrayal of the despairing Judas alone . . . I set against all the elegance of the ages . . .' The painting so admired by Huygens was much copied and imitated by Rembrandt's contemporaries, among them Salomon Koninck, Jacob de Wet the Elder (in 1636), Abraham van der Hecken (in 1654) and, in a drawing, Claes Cornelisz. Moeyaert.[9]

REFERENCES
Collins Baker 1939, pp. 179–80; Bauch 1966, no. 47; Bredius 1969, no. 539A; Haak 1973, pp. 155–8; Guratzsch 1975, pp. 250–1; *Corpus*, vol. 1, 1982, no. A15; Schwartz 1984, no. 65, p. 75; Amsterdam 1985, no. 5; Tümpel 1986, no. 40; London 1988, pp. 36–41, no. 1; Leiden 1991–2, pp. 122f., Fig. 75; Amsterdam 1996, no. 9; van de Wetering 1997, pp. 76–7, figs. 103–6; Boston 2000, pp. 32–5, 60f.; Kassel and Amsterdam 2001, no. 33, pp. 226–9.

NOTES
1 Schiller 1972, vol. 2, pp. 79–80, figs 274, 275, 277.
2 *Corpus* (vol. 1, 1982, p. 191). There is also a series of prints of sinners of the Old and New Testaments by Willem Swanenburgh after Abraham Bloemaert (Holl., vol. 2, p. 69, nos 549–54); see also Pigler 1974, vol. 1, pp. 344–5.
3 For more see the entry for *Anna and the Blind Tobit* (Cat. 2).
4 Kassel and Amsterdam 2001, p. 228, fig. 33b.
5 Heesakkers 1987, p. 86. Huygens's account is an exceptionally accurate description of the picture. For a discussion of the frequently alleged inaccuracies (most recently in Schama 1999, p. 267) see Kassel and Amsterdam 2001, under no. 33, p. 229, note 6.
6 Other works include *Tobit and Anna with the Kid*, of 1626 in the Rijksmuseum, Amsterdam (*Corpus*, vol. 1, 1982, no. A3); *The Raising of Lazarus*, 1630/1, Los Angeles County Museum of Art (*Corpus*, vol. 1, 1982, no. A30); and with regards to the composition of the group *The Anatomy Lesson of Dr Nicholaes Tulp*, 1632, Mauritshuis, The Hague (*Corpus*, vol. 2, 1986, no. A51).
7 See Kassel and Amsterdam 2001, no. 23, pp. 190–1, though the entry does not make any mention of the similarities between the two figures. See also Rüger 2002, p. 180.
8 The shield seems uncharacteristically large and lacking certain details for it to be clearly identifiable as a Torah shield, as Simon Schama has suggested; Schama 1999, p. 266.
9 For examples see *Corpus*, vol. 1, 1982, p. 193.

2 Anna and the Blind Tobit, about 1630

Oil on oak, 63.7 x 47.7 cm
Traces of a false signature (no longer visible) were recorded on the varnish at the left: Re.bra.
Bought from Denis Elliot Watson, 1926
NG 4189

The story depicted in this painting derives from the apocryphal Old Testament
Book of Tobit. A devoted Jew and father of Tobias, Tobit had been blinded by
sparrow droppings falling into his eyes (2:9–10). While enduring his fate with great
fortitude, he eventually sent his son on a journey to collect some money he had
left with Gabael in Media (4:20). Tobias was accompanied on his journey by the
archangel Raphael. Following the attack of a large fish Raphael asked Tobias to keep
its heart, liver and gall. Upon his return home he used the gall to restore his father's
sight (11:11–13). According to an inscription on a print after the painting made by
Willem van der Leeuw (see Fig. 35), the moment shown here is Tobit's meditation on
the vanity of human desires and the ephemeral nature of pleasure as told in Book
2.[1] However, this episode precedes Tobit's blindness, and it seems more likely that
the painting shows a later – unspecified – moment in the story when the blind Tobit
and his wife, who is earning the family's living through spinning, are awaiting their
son's return (10:1).[2]

In the seventeenth century the books of the Old Testament and Apocrypha
were a rich source of subjects for depiction in paintings and prints by Dutch artists.
Although the Calvinist church in the Netherlands had certain reservations about
the reliability of the apocryphal texts, it endorsed their didactic value. The story of
Tobit in particular was appreciated for the protagonist's simple everyday piety and
the model character of his marriage to Anna.[3] Pieter Lastman and his followers, the
so-called Pre-Rembrandtists (see p. 54), were the first Dutch artists to choose often
rather obscure Old Testament and apocryphal stories that had rarely or never been
illustrated. Rembrandt, who had studied with Lastman in Amsterdam in 1625–6,
and his pupils continued this tradition.[4] For them the Book of Tobit seems to have
been particularly interesting, as there are a considerable number of drawings, prints
and paintings that take their subjects from this source. It has been argued that it was
the subject of blindness and being able to see, which is central to the story of Tobit,
that was of special interest to Rembrandt and his circle (Fig. 33).[5]

One of the most vexing aspects of *Anna and the Blind Tobit* is its authorship. At
the time of its acquisition by the National Gallery in 1926, the picture carried an
attribution to Rembrandt's Leiden pupil Gerrit Dou (1613–75), which it had had since
its first public appearance in the sale of the collection of John Bell of Glasgow in
January 1881. The earliest mention of the picture, however, goes back to 1776, when

Fig. 33 *The Blind Tobit advancing to welcome his Sons*,
about 1651.
Etching, 16.1 x 12.9 cm.
Amsterdam, Museum Het Rembrandthuis, inv. 028

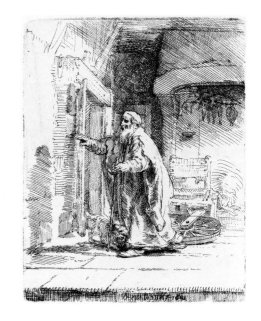

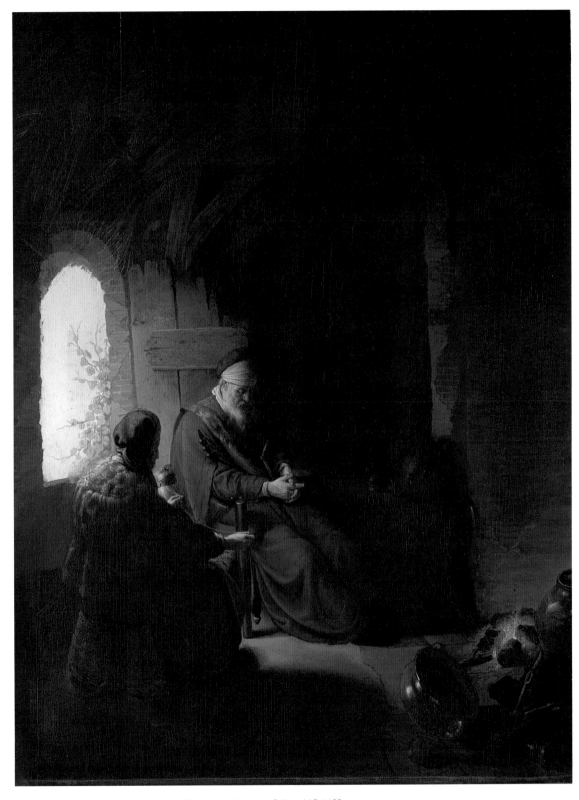

Fig. 34 *Anna and the Blind Tobit*, about 1630. London, National Gallery, NG 4189

it is described in Antonio Ponz's *Viage de España* as a painting by Rembrandt in
the collection of the Unshod Carmelites at the Convent of San Hermenegildo in
Madrid.[6] The identification of the Madrid painting with the one now in the National
Gallery has long been doubted because of the inaccuracy of Ponz's description.[7]
More recently, Isadora Rose-de Viejo discovered a later, more detailed description
of the picture in the convent by José Folch y Costa (1768–1814), published in 1804.[8]
This account leaves little doubt that the painting in Madrid is this one and, once
again, its author identifies it as a Rembrandt. Two years later – probably following
considerable coercion – the picture, together with a number of other masterpieces
from the convent, was given by the friars to the powerful politician and collector
Manuel Godoy (1767–1851), the Prince of Peace.[9] Upon entering Godoy's collection
the picture was probably cleaned and restored. It is mentioned by Frédéric Quilliet
in his catalogue of the collection of 1807, albeit without any reference to its subject.
A short while later Godoy was forced into exile, and during the subsequent French
occupation of Madrid the picture disappeared.[10]

Following the reappearance of the painting in the late nineteenth century under
the name of Gerrit Dou, authors such as John Smith, Hofstede de Groot and Willem
Martin, reintroduced an attribution to Rembrandt.[11] All three had based their
opinions on the faithful print after the painting by van der Leeuw (Fig. 35), which is
inscribed 'Rembr. Van Rijn fecit'. Charles Holmes, in an article in 1926, was the first
to put forward the idea that it could be a joint work by Rembrandt and Dou,[12]
whereas van Gelder maintained an attribution to Dou in his article on Rembrandt's
early career of 1953.[13] On the other hand, Neil MacLaren, in his
catalogue of the National Gallery's Dutch paintings of 1960, argued that
there were stylistic and qualitative differences within the picture, with
some passages being 'too dry and niggling to be Rembrandt's work',
while others were 'too good for Dou', and consequently upheld the
attribution to both artists ('it seems likely that the picture was
painted after his [Rembrandt's] design, by Dou and retouched by
Rembrandt').[14] Kurt Bauch accepted this attribution in his book of the
same year and in his catalogue of Rembrandt's works of 1966.[15] More
recently, a collaboration between these two artists has been identified
in the painting of *Prince Rupert of the Palatine and his Teacher as 'Eli
teaching Samuel'*, of about 1631 at the Getty Museum in Los Angeles.[16]
In 1964, however, Julius Held rejected the idea of a joint authorship and
gave the picture wholly to Dou.[17] He relates the figure of Tobit to a
drawing by Rembrandt of his father (Oxford, Ashmolean Museum).[18]
This was taken up in 1982 by the authors of the first volume of the
Corpus, who relegated the painting to its C-category, also suggesting
an attribution to Rembrandt's pupil.[19] This was followed by Werner
Sumowski in his comprehensive catalogue of the works of Rembrandt's
pupils. Sumowski attributed the picture wholly to Dou, albeit noting

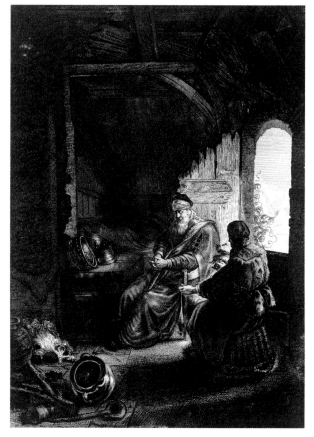

Fig. 35 Willem van der Leeuw, *Anna and the Blind Tobit*,
about 1630–65
Engraving, 18 × 13 cm.
Amsterdam, Rijksmuseum, inv. RP-P-OB-46.506

corrections on Tobit's head and right shoulder, Anna's back, the window frame and the fire as by Rembrandt.[20] Because of this attribution the picture was excluded from the first edition of *Art in the Making: Rembrandt*. In both the subsequent exhibition catalogue of *Rembrandt: The Master and his Workshop* of 1991, and the revised edition of MacLaren's catalogue of the same year, Christopher Brown argued in favour of an attribution to Dou as he did not perceive any of the stylistic discrepancies some of the earlier authors had described.[21]

In her monographic study of Dou's oeuvre of 1990 Ronni Baer had already argued against this attribution.[22] While the author accepted that some passages, such as the carefully painted wrinkled hands (reminiscent of Dou's *Old Woman reading a Lectionary* of about 1631; Fig. 36), the wicker basket and the copper pot, are 'Dou-like', she argued that the stippled effect in Anna's headdress and the 'impressionistic' brushstrokes in her costume cannot be found elsewhere in Dou's early paintings. Likewise, the objects in the foreground do not emphasise the depth of the pictorial space as they usually do in Dou's pictures, when they act as a *repoussoir*. Most important, however, is the dramatic chiaroscuro and the large size of the figures relative to the space, both wholly uncharacteristic of Dou. Baer concluded that the painting is 'already assured', whereas Dou's early works are still 'aspiring'.[23] Consequently, rather than basing the attribution of *Anna and the Blind Tobit* on some of Dou's earliest works (Fig. 37), as had been assumed by Brown and others, Baer suggested that those pictures were actually based on the knowledge of the National Gallery painting.[24]

Fig. 36 Gerrit Dou, *Old Woman reading a Lectionary*, about 1631.
Oil on panel, 71 × 55.5 cm.
Amsterdam, Rijksmuseum, inv. SK-A-2627

Fig. 37 Gerrit Dou, *Man writing by his Easel*, about 1631–2.
Oil on panel, 31.5 × 25 cm.
Private collection, inv. AGN 35468

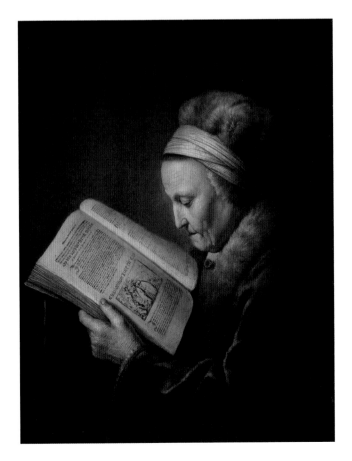

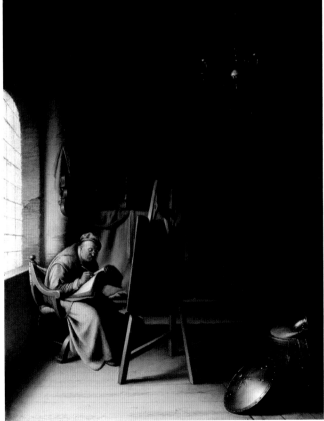

Shortly after the 1991 exhibition several authors, including Brown, agreed with Baer that the attribution to Dou could no longer be maintained and that the painting in its entirety should be given to Rembrandt.[25] In his reviews of the exhibition Walter Liedtke at first argued for an attribution to Jan Lievens, comparing the picture to the artist's *Job in Distress* of 1631 at the National Gallery of Canada, Ottawa.[26] A few years later, however, it appears that the author revised his opinion and accepted the Gallery's reattribution to Rembrandt as well.[27] Recently, in his extensive study of Dou's painting technique, Jørgen Wadum reverted to the pre-1991 assessment and concluded that *Anna and the Blind Tobit* 'shows all the virtues of the upcoming *fijnschilder*' that is Gerrit Dou.[28] Wadum argued that the hatching in the hands and faces and the small dots in Anna's headgear and the bold brushstrokes in the undermodelling of her back are more characteristic of the pupil than of Rembrandt. Finally, the authors of the catalogue to the 2005 exhibition in Leiden reverted to the idea of a joint authorship by Rembrandt and Dou.[29]

In the light of this debate about attribution, the authors have examined this painting very closely. The support is an oak panel, with vertical grain, consisting of two planks with an almost vertical join running down the centre. The panel was cradled in the late nineteenth or early twentieth century. As expected for a Dutch panel painting of this period, it has a standard ground of natural chalk and a thin, brown oil-based *primuersel* or priming containing some lead white and translucent brown Cassel earth (Figs 38 and 39). The warm tones of the *primuersel* show through in places – most prominently in the tilted earthenware pot in the foreground.

The X-ray image of the painting (Fig. 40) shows a significant change of composition: originally, there was a spinning-wheel between the two figures. Its dark circular form can clearly be seen near Anna's right hand and, from the top of it, the light line of a thread runs diagonally down to the left across the hanging sleeve of Tobit's cloak. As the painting developed the spinning-wheel was painted out – and now a thread from a skein situated near Tobit's elbow simply runs between Anna's hands and passes to a spindle hanging below her right hand. The significance of the suppressed spinning-wheel is that in an earlier painting of Anna and Tobit by Rembrandt (see Fig. 41) a partly visible spinning-wheel was also painted out. In a version by Gerrit Dou (Paris, Louvre) an entire spinning-wheel is prominently visible.[30]

In other areas of the X-radiograph generous reserves for the outlines of the figures can be seen, as is often the case with Rembrandt at this period. There is a much larger outline, for example, along the top of Tobit's shoulder and around his head: this was filled in with paint approximating to the colour of the wooden shutter behind, but is still clearly visible on the paint surface. The window was also intended to be a little longer, or to have a deeper sill, but was shortened at a late stage of painting: however, the pale green vine leaves still continue below the present line of the sill.

Fig. 38 Paint cross-section from pale blue sky seen through the window in Cat. 2, showing the presence of smalt and lead white. The chalk ground and *primuersel* are present beneath.
Magnification 190X

Fig. 39 Cross-section from thin dark shadow of Tobit's cloak in Cat. 2, consisting largely of lampblack with a little white. The layer beneath results from an overlap with Tobit's dull mauve garment and contains red lake pigment, white and black.
Magnification 280X

Fig. 40 X-ray mosaic of Cat. 2

There is considerable variation in paint texture across the picture. The general impression is of fine, richly textured, descriptive brushwork. The figures and objects are painted with precise strokes of fairly thick paint, varying in dimension with the material or surface being depicted. Tobit's hands, for example, are carefully detailed, while his face is indicated with bolder strokes. The stitches securing the patch on his right shoulder consist of fine scratch marks in the wet paint. The fur on Anna's jacket and Tobit's collar is laid in with short dabs of brown, overlaid with threads of thicker cream paint where it catches the light. Other areas are more smoothly painted – Tobit's cloak, for example, or much of the shadowed background – but, even here, thicker impasto is used for the rough wall and roof beams that loom out of the darkness.

The thin black background of the interior is simply painted in a mixture of fine black pigment and umber, extended with a little chalk. The detection of copper in the paint layer suggests the addition of a copper-based drying agent (siccative), and both this and the thinness of the paint have ensured its well-preserved state. The paint medium of this background has not been analysed, but linseed oil, unmodified and without additions, has been identified elsewhere in the picture.

Tobit's mauveish cloak consist of a single layer of a mixture of white pigment, red lake and a fine black, probably lampblack (see Fig. 39). In spite of the colour of this paint layer, no blue pigment is present and the muted purple tone arises from the optics of this particular combination of pigments, seen also in other Northern baroque paintings, for example other works by Rembrandt – the *Portrait of Hendrickje Stoffels* (Cat. 13) in this catalogue is a case in point – and paintings by Rubens and Van Dyck. The light greyish-blue paint of the sky seen through the window contains white pigment lightly tinted with smalt (see Fig. 38) and the tendrils of foliage at the window's edge have been shown to contain lead-tin yellow and natural azurite.

It is generally accepted that *Anna and the Blind Tobit* must date from around 1630 or shortly thereafter, corresponding to Rembrandt's last years in his native Leiden. At that time the only other artist capable of achieving the quality of work in the painting was Rembrandt's pupil, the young Gerrit Dou. Therefore the attribution has oscillated between these two painters. Perceived discrepancies of style and quality within the work have also led some authors to suggest that both artists had a hand in the painting. The display of *Anna and the Blind Tobit* alongside two early works by Dou in 1991 and similarly in an exhibition of 2005 (see above) has led scholars to agree that the comparison did not stand up and that the quality of this painting was far too high for it to have been by the young Dou.[31]

Following the close examination of the painting in preparation for this volume the authors also feel that the slightly coarser surfaces throughout the picture, the

Fig. 41 *Anna and Tobit with the Kid*, 1626. Oil on panel, 40.1 × 29.9 cm. Amsterdam, Rijksmuseum, inv. SK-A-4717

noticeably thin paint application in the figures and the loose handling of the bricks and plaster bear little resemblance to Dou's brushwork, while the hatching in Tobit's hands is too insignificant to be taken as a clear indication of Dou's authorship. It seems that until more convincing evidence to the contrary comes to light the attribution to Rembrandt should remain.

REFERENCES

Bauch 1960, pp. 220–1; Bauch 1966, no. A6; Sumowski 1983–90, vol. 1, 1983, no. 243, p. 525; *Corpus*, vol. 1, 1982, no. C3; Baer 1990, pp. 14–19; Berlin, Amsterdam and London 1991–2, vol. 1, no. 55, pp. 300–3; MacLaren and Brown 1991, vol. 1, pp. 109–12; Amsterdam and Jerusalem, 1991, pp. 16–17, fig. 10; Wadum 2002, p. 74; Rose-de Viejo 2002; Leiden 2005–6, no. 60, pp. 191–6.

NOTES

1 Berlin, Amsterdam and London 1991–2, vol. 1, no. 55, p. 300, with quotation of the inscription; MacLaren and Brown 1991, vol. 1, p. 110 (under 'Engraving').

2 This identification of the subject was suggested by Julius Held (Held 1991, p. 126) and is also repeated in Amsterdam and Jerusalem 1991, p. 16. Held also mentioned a picture of the same subject in Rotterdam (Museum Boijmans Van Beuningen) that is now no longer accepted as a Rembrandt (p. 126, fig. 20) and that bears striking similarities in the placement and poses of the figures to the National Gallery painting.

3 See Volker Manuth, 'Tobias, Anna und das Böckchen: Variationen über ein Thema aus dem Buch Tobias von Rembrandt und Gerbrand van den Eeckhout', in Manuth and Rüger, pp. 89–105, esp. pp. 97–101.

4 See Christian Tümpel, 'Pieter Lastman and Rembrandt', in Amsterdam 1991, pp. 54–84, esp. pp. 60 and 82–4.

5 Jacqueline Boonen, 'Verhalen van Israëls Ballingschap en Vrijheidsstrijd', in Amsterdam and Jerusalem 1991, pp. 106–21, esp. p. 114; Manuth in Manuth and Rüger 2004, p. 97; Held 1964, republished in Held 1991, pp. 118–43.

6 Ponz 1772–94, vol. 5, p. 263.

7 MacLaren and Brown 1991, vol. 1, p. 110 (under 'Provenance').

8 Folch y Costa 1804, pp. 235–43; quoted in Rose-de Viejo 2002, pp. 618, 621.

9 Rose-de Viejo 2002, p. 620, and note 35. On Godoy's collection see also Rose 1983.

10 Rose-de Viejo 2002, pp. 620–1.

11 Smith 1829–42, vol. 7 (Rembrandt), no. 49; HdG, no. 66; Martin 1913, p. xv.

12 Holmes 1926, pp. 55–61.

13 Van Gelder 1953, p. 21.

14 MacLaren 1960, p. 339.

15 Bauch 1960, pp. 220–1; Bauch 1966, no. A6, p. 29.

16 Kassel and Amsterdam 2001, no. 66, pp. 324–31.

17 Held 1964, p. 27.

18 Kassel and Amsterdam 2001, no. 66, pp. 324–31 and fig. 45.

19 *Corpus*, vol. 1, 1982, no. C3, pp. 461–6.

20 Sumowski 1983–90, vol. 1, no. 243, p. 525; and vol. 6 ('Corrigenda und Addenda'), p. 3595.

21 Berlin, Amsterdam and London 1991–2, vol. 1, p. 302; MacLaren and Brown 1991, vol. 1, pp. 109–12.

22 Baer 1990, pp. 14–9.

23 Ibid., pp. 18–19.

24 Ibid., p. 19.

25 White and Kirby 1994, p. 75, note 7.

26 Oil on canvas, 170 x 145 cm; see Sumowski 1983–90, vol. 3, no. 1191, p. 1780. Liedtke 1991, p. 358, and 1992, p. 144.

27 New York 1995, vol. 2, p. 24 and p. 37, n. 95.

28 Wadum 2002, p. 74.

29 Leiden 2005–6, no. 6, pp. 191–6.

30 Gerrit Dou, *Anna and Tobit*, about 1645–50, panel, 60.5 x 46 cm, Paris, Musée du Louvre, inv. no. 1221.

31 Here Wadum suggests that *Anna and the Blind Tobit* was unfairly compared to the 'weak' *Old Woman peeling Apples* from the Gemäldegalerie in Berlin. The latter picture, however, was not included in the exhibition and *Anna and the Blind Tobit* was compared to the much stronger *Old Man writing by his Easel* from the Ivor Foundation in New York and *Old Woman eating Porridge* from a private collection (Wadum 2002, p. 74). For the two pictures by Dou see also Berlin, Amsterdam and London 1991–2, vol. 1, nos 56, 57). In the 2005 exhibition the picture could be compared to Dou's slightly later *Old Woman reading* (Fig. 36) and the *Old Man smoking a Pipe* of about 1635 from a private collection (Leiden 2005–6, nos 19, 58).

3 Portrait of Aechje Claesdr, 1634

Oak, oval, 68.7 × 53.8 cm
Signed right centre: Rembrandt. f/1634; inscribed on the left centre: AE.SVE.83
Bought from Lady Eastlake, 1867
NG 775

The sitter was once thought to be Françoise van Wassenhove, the widow of Eduard Poppius, a Remonstrant preacher,[1] on the basis of a drawing in the British Museum by Jan Stolker (1724–85) after a lost original by Hendrik van Limburg (1661–1759).[2] Stolker omitted this almost certainly incorrect identification – Françoise van Wassenhove was only about 60 years old in 1634 – from the mezzotint he made from the drawing. He gave the mezzotint the title *Avia*, literally 'grandmother', but here presumably intended to signify merely 'an old woman'.[3] Because of this title, however, Gustav Waagen erroneously referred to the sitter as the painter's grandmother,[4] More recently it has been possible to identify the sitter as the 83-year-old Aechje Claesdr (1551–1636), widow of the Rotterdam brewer Jan Dammasz. Pesser (died 1619).[5]

The Pessers were one of the leading families in Rotterdam's Remonstrant community. In the year of Jan's death the Synod of Dort banned the Remonstrants and persecuted many of their preachers. Two of Aechje's sons-in-law were Remonstrant preachers and she hid one of them, Hendrick Niellius (died 1621), in her house. The Pessers escaped persecution. In 1634 Rembrandt came to Rotterdam to paint not only Aechje's portrait but also those of her son Dirck Jansz. Pesser (1587–1651; Fig. 42) and his wife Haesje van Cleyburgh (1583–1641; Fig. 43).[6] It has been suggested that the famous preacher Johannes Wtenbogaert (1557–1644), whose portrait Rembrandt had painted in 1633 (Rijksmuseum, Amsterdam),[7] and who at that time was living in Rotterdam, introduced the painter to the Pesser family.[8]

Rembrandt's first oval portraits date from his earliest years in Amsterdam: the shape was fashionable in the city at that time. This portrait is fluently and freely painted, and the loose modelling and broad application of paint represent a significant change in style from the tightly painted portraits of only a year or two earlier such as the *Portrait of Maerten Looten* of 1632 (Los Angeles County Museum of Art).[9]

The panel consists of a single piece of oak, its grain vertical. Its oval shape was extended by 2 cm at a later date. This extension is attached by glueing edge-to-edge and reinforced by wooden blocks at the top and bottom (which can be seen as light rectangles in the X-ray, Fig. 46). The original part of the panel is probably much the same size and shape as when it was painted, unlike the *Portrait of Philips Lucasz.* (Cat. 5), but it is possible that it was trimmed and bevelled slightly when the additions were fitted; since the edges are hidden by the added pieces, it is difficult

Fig. 42 *Portrait of Dirck Jansz. Pesser*, about 1634. Oil on panel, 64.7 × 50.5 cm. Los Angeles County Museum of Art, Frances and Armand Hammer Purchase Fund, inv. M.69.16

Fig. 43 *Haesje van Cleyburgh*, 1634. Oil on panel, oval, 68.6 × 53.4 cm. Amsterdam, Rijksmuseum, inv. SK- A-4833

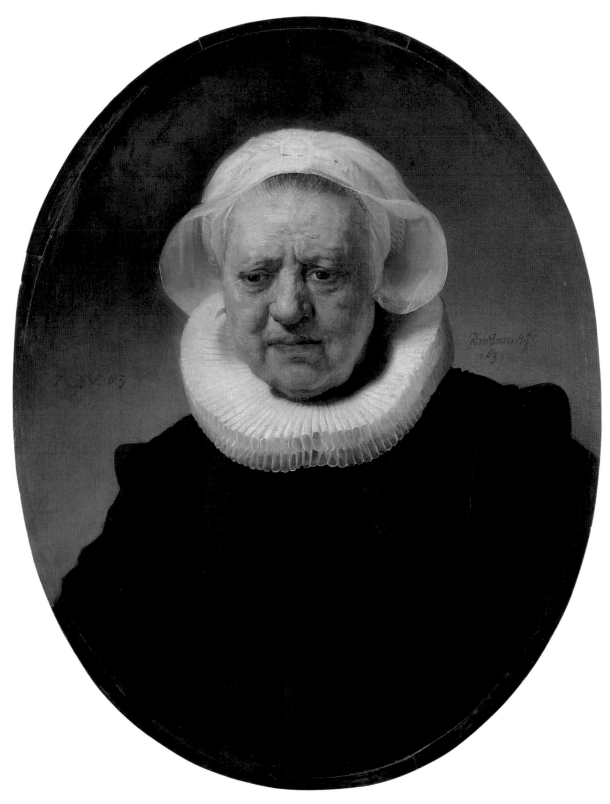

Fig. 44 *Portrait of Aechje Claesdr*, 1634. London, National Gallery, NG 775

to be sure. The *Portrait of Dirck Jansz. Pesser*, although now made into a rectangular painting by addition of the later sections, was originally oval, so it seems reasonable to conclude that Rembrandt painted all three Pesser portraits in the same format.[10]

The grain of the original panel is visible in the X-ray because the ground which covers and fills it is slightly opaque to X-rays. The grain is barely visible on the additions because the preparation here is almost transparent to X-rays. Within the limits of the original panel, the X-ray image of the grain seems to disappear in an irregular way as it approaches the edge. This is because the ground was abraded around the original edges when the additions were being prepared and smoothed down.

The original ground is of the standard type for a panel painting of this period, consisting of a layer of natural chalk bound in animal glue and finished with a lightly applied *primuersel* containing a little lead white, yellowish-orange and brown earth pigments and a trace of black (see Fig. 48). The ground and *primuersel* are very thin and the colour, a warm beige, is clearly influenced by the colour and grain of the wood beneath. This uncovered preparation is visible in a small rectangle between the ruff and the woman's right cheek (viewer's left) and at the junction of ruff, headdress and background at the right: it also shines through in thinly painted areas, and the underlying wood grain can be seen, as in the shadowed side of the face (Fig. 45).

The paint is applied in a manner which is fluid, but at the same time beautifully controlled. There is a highly conscious use of raised brushstrokes and impasto in the lights and highlights which give liveliness and sparkle, while the half-tones and shadows are painted thinly and smoothly and seem to recede. The very darkest shadows at the nose, mouth and under the chin are, by contrast, applied in thick dark paint, almost carelessly: these are characteristic Rembrandt finishing flourishes seen in many of his portraits.

The short, curved brushstrokes of the face are in a variety of colours, and the X-ray image shows the structure of the brushstrokes distinctly, and how they are combined into almost sculptural masses to form the forehead, cheeks, eyes, nose and mouth, and run mainly along the line of the form; they cross, blend and mix

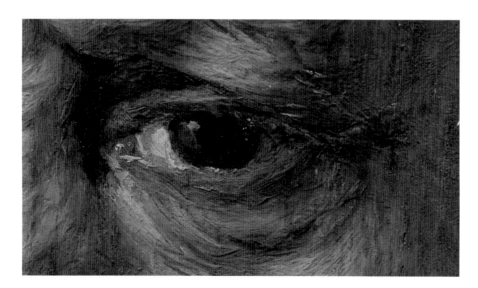

Fig. 45 Detail of the face in Cat. 3

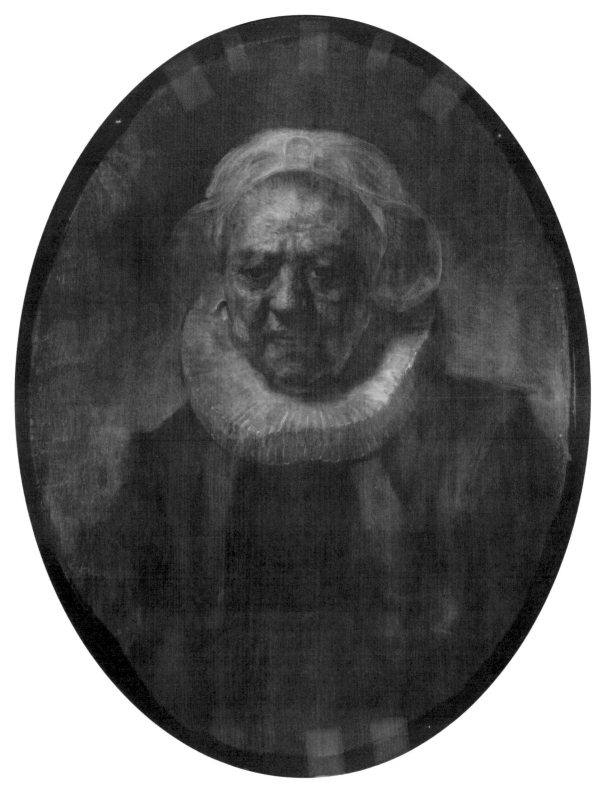

Fig. 46 X-ray mosaic of Cat. 3

and were clearly done rapidly, wet-into-wet. The thickly applied lead white has been tinted with vermilion and red iron oxide, and then modified with thin scumbles of yellow earth drawn across the surface for the yellowest tones, and a mixture of vermilion, red ochre and a little black for the ruddier passages (Fig. 47).

The dress is painted directly over the ground as a solid layer of virtually pure black pigment incorporating just a little white for the deep neutral grey of the sleeves and ribbons (Fig. 48). The structure is closely similar to that of the tunic in the *Portrait of Philips Lucasz.* No other pigments are used in the black of Aechje Claesdr's dress, although in the darks of many of Rembrandt's pictures small quantities of coloured pigment, often blue or red, are added. The black dress has been identified as an overdress known as a *vlieger,* or *bragoenen*,[11] with its characteristic rounded shoulder coils. Three gold pins hold together her cap. The X-ray also makes clear the broad sweeping lay-in for the ruff and the cap, both painted in lead white of great purity. The shadow on the ruff is left as a reserve and glazed with a dark tone directly on the ground. The lower part of the ruff overlaps the already painted black dress, which is thus visible through the translucent white fabric. The highlights on the ruff and cap were added across the underlying paint when it was already fairly hard, since they have not disturbed the brushstrokes beneath.

The background is painted around the figure and does not appear to pass under the cap or ruff, both of which are painted directly on the ground. The paint of the background has been brushed broadly around and away from the figure, towards the edges of the panel. Initially the background was thinly brushed in with a translucent dark brown containing yellow earth and brownish black, with the admixture of a significant amount of cherry-coloured lake pigment to add depth and warmth to the underlying stone colour of the wood panel and ground. Over this layer the more opaque greyish khaki to the left and right has been directly applied, with white and black pigment adjusted with yellow ochre, and blended into the warmer paint beneath.

Fig. 47 Top surface of an unmounted fragment of reddish paint from the woman's forehead in Cat. 3. Magnification 145X

Fig. 48 Paint cross-section from dark grey of the sleeve in Cat. 3, containing mainly bone black with a little lead white. The white ground and yellow-brown *primuersel* are also clearly visible. Magnification 390X

REFERENCES
HdG no. 856; Bauch 1966, no. 476; Bredius 1969, no. 343; Schwartz 1984, no. 139, p. 152; *Corpus*, vol. 2, 1986, no. A104; London 1988, no. 3, pp. 48–51; MacLaren and Brown 1991, vol. 1, pp. 341–3; Berlin, Amsterdam and London 1991–2, vol. 1, no. 19, pp. 176–7; Dudok van Heel 1992; Giltaij 1992; Dudok van Heel 1994, p. 337; Kassel and Amsterdam 2001, no. 83, pp. 380–1; Copenhagen 2006, no. 7, pp. 192–3.

NOTES
1 Remonstrants were Dutch Calvinists who, in 1610, published a protest against Calvin's teachings in the so-called Remonstrance.
2 Berlin, Amsterdam and London 1991–2, vol. 1, p. 176.
3 Sepia and wash drawing, see Hind 1915–31, vol. 4, pp. 173–4, no. 3; for the print see Charrington

1923, no. 165; also in *Corpus*, vol. 2, 1986, no. A104, p. 576–7.
4 Waagen 1854, vol. 3, p. 311.
5 Dudok van Heel 1992 and Dudok van Heel 1994, p. 337. The date of Aechje's death was recently found and has been published in his PhD thesis; Dudok van Heel 2006.
6 *Corpus*, vol. 2, 1986, nos A102 and A103.
7 *Corpus*, vol. 2, 1986, no. A80; see also Amsterdam 2000, no. 59, pp. 95–8.
8 Dudok van Heel 1992, p. 15; and Kassel and Amsterdam 2001, p. 380.
9 *Corpus*, vol. 2, no. A52.
10 *Corpus*, vol. 2, 1986, no. A102, X-ray, p. 559, fig. 2; see also Kassel and Amsterdam 2001, p. 380 and note 1.
11 *Corpus*, vol. 2, 1986, p. 571 (under 'Description').

4 Ecce Homo, 1634

Paper, stuck on canvas, 54.5 × 44.5 cm
Signed beneath the clock in the right background: Rembrandt. f./1634
Bought from the executors of Lady Eastlake, 1894
NG 1400

These events are described in the Gospel of Saint John 19:13–16: Pilate shows Christ to the people, who, urged on by their priests, demand his condemnation. The title by which depictions of this moment are known, 'Ecce Homo' (Behold the man!), come from Pilate's words earlier in the chapter (19:5). The subject has been frequently depicted in European paintings and prints, and the compositional type with Christ and Pilate beside each other on an asymmetrically placed dais, surrounded by a large crowd cut off by the edge of the picture, had been popular in northern Europe since the last quarter of the fifteenth century.[1] Few artists, however, have stressed the urgency of the scene to the degree Rembrandt has. Christ as a Man of Sorrows stands isolated among a dense group of soldiers who are keen to persecute him further. With his hand outstretched, one of the priests tries to control the tightly packed crowd in the square below baying for Christ's blood, while in the foreground a group of priests implores the reluctant Pilate – one is even grabbing his cloak – to accept the rod of judgement and pass the death sentence.[2]

This is a preparatory study for an etching by Rembrandt, the first (unfinished) state of which is dated 1635, and the second state (see Fig. 49) 1636. The print, which is reversed, is of the same size and varies slightly from this grisaille: the principal differences are that in the etching, the crowd in the square below and the figures above next to Christ have been elaborated, as have many of the accessories; while the clock has been omitted. This is the only known case in which Rembrandt produced such an elaborate full-scale study for an etching.[3] It can be seen that it was used for this purpose when the painting is studied in a raking light, as many of its outlines have been indented with a stylus to transfer the design to the etching plate (see Figs 54–5).

Since the nineteenth century authors have suggested that the etching is a collaboration between Rembrandt and another artist, Jan Joris van Vliet (1600/10–1668), who etched eleven plates after designs by Rembrandt in the 1630s.[4] One of them, an equally ambitious project, is van Vliet's reproductive print of 1633 after Rembrandt's *Descent from the Cross* (see Fig. 50) from the Passion cycle that he had painted for the Stadholder Prince Frederik Hendrik, now in the Alte Pinakothek, Munich.[5] This and the *Ecce Homo* are usually considered to be pendants.[6]

Scholars agree that in both cases van Vliet was the principal engraver and

Rembrandt added corrections only during the latter stages of the preparation of the plates.[7] More generally, the production of these two prints was in deliberate emulation of the reproductive engravings made of Rubens's work by engravers who were closely supervised by the painter.[8] Although the two prints were eagerly collected during Rembrandt's lifetime as well as later, the painter apparently abandoned his collaboration with van Vliet, presumably because he was unhappy with the quality of the engraver's work.

Whereas with the *Descent from the Cross* van Vliet followed a finished painting, in this case Rembrandt produced a detailed grisaille as a guide for the print. The lack of *pentimenti* in the grisaille has led some scholars to think that it may follow a lost finished painting by Rembrandt of which he wanted a reproductive print.[9] In the inventory of Rembrandt's goods made in 1656 there is an item (no. 121) referred to as 'Een excehomo in't graeuw, van Rembrant' (An Ecce Homo in grisaille, by Rembrandt).[10] It has been suggested that this might refer to the Gallery's work, though, as Martin Royalton-Kisch has pointed out, it may also refer to an original, larger painting by Rembrandt.[11]

Ecce Homo is painted on paper which has subsequently been laid down on to stretched canvas. There is some wrinkling and a little tearing of the paper, which presumably occurred during this process. There is also extensive foxing of the paper – black spots of mould growth originating from the adhesive used for mounting it – but these have been reduced by retouching so that they no longer disturb the image.

Fig. 49 *Ecce Homo*, 1636.
Etching, 2nd state, 54.9 × 44.7 cm.
London, British Museum, inv. B.77

Fig. 50 Jan van Vliet
The Descent from the Cross, 1633.
Etching, 2nd state, 51.8 × 40.2 cm.
London, British Museum, inv. 1973 U 934

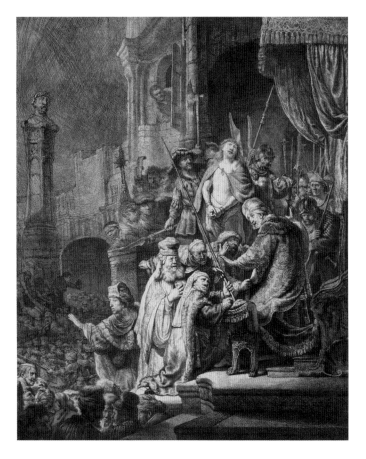

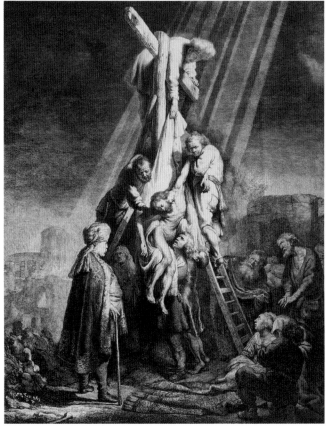

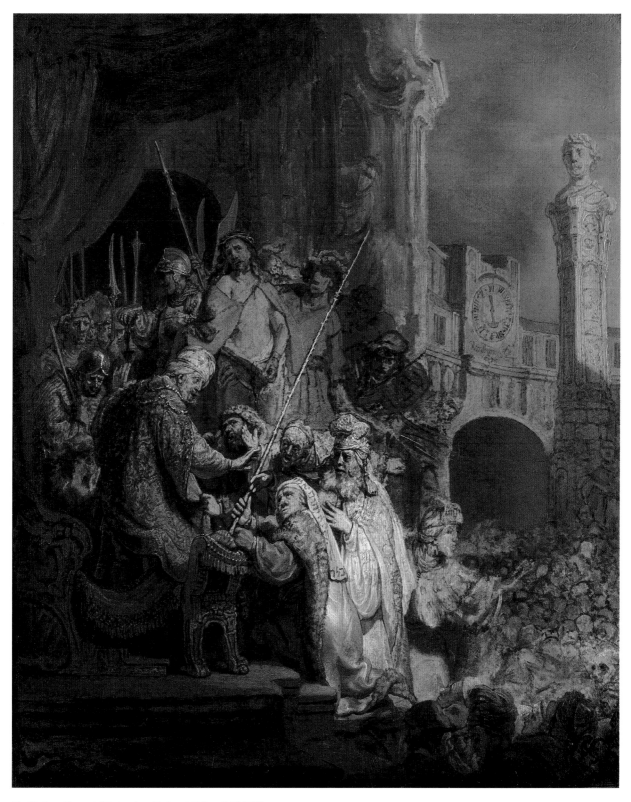

Fig. 51 *Ecce Homo*, 1634. London, National Gallery, NG 1400

There seems to be a very thin layer of some preparation present. The X-ray image (Fig. 53) shows both the structure of the paper and, to a lesser degree, that of the canvas. It is possible that the adhesive between the two is faintly radioabsorbent and hence makes visible the pattern of both; however, samples taken from the right side of the picture show that there is certainly a thin cream-coloured coating of white lead on the front of the paper beneath the blue-grey sky (see Fig. 52), beneath the yellowish architecture and beneath the brown glaze of shadow of the foreground crowd.

The first stage of working appears to have been a drawing, probably in ink, of the principal elements of the composition. This was followed by a much broader lay-in with a brush using dark earth colours with a little black: there were probably rather dull colours also sketched in at this point, which could perhaps correspond to a 'dead-colour' stage. Some parts of the picture were not, in fact, developed further than this stage, as can be seen clearly in the figures to the right of Christ, in the curtains and architecture at the upper left and in the steps at the lower left. What is not immediately clear is whether Rembrandt ever intended to finish these parts or whether they were always intended only as a rough guide for the etching (but see below): they are worked up in much greater detail in the etching, but correspond almost exactly in position. It is interesting to note that the X-ray shows a reserve left in the paint of the archway for the head of the outermost figure in the group to the right of Christ (the black boy in the etching): this head is virtually unpainted and the prepared paper is almost bare, but Rembrandt was clearly so conscious of its importance as the pivot of the group that he carefully painted the background around it.

The main figure group and the architecture at the right are worked up into a highly finished state over the lay-in in tones of grey and brown, lead white and lead-tin yellow. The contrast between the group of priests and Pilate in front of Christ and the unfinished figures to the right of Christ could not be more striking. The meticulous detailing of the finished figures is characteristic of Rembrandt's precision and tight control in the early 1630s: the sketched figures show how his brilliant improvisation was always, literally, just below the surface.

The palette here is necessarily extremely limited. The greyish-blue sky contains no blue pigment but exploits the bluish tinge of charcoal black when mixed with white (Fig. 52). The sketchy brown shadows in the less finished parts contain translucent brown pigment, a little black, red earth, yellow-brown lake pigment and even a trace of lead-tin yellow.

It has always been clear that this painting on paper is directly linked to the reversed etching. The identical size, the positioning of the figures and other details place the connection beyond doubt. Royalton-Kisch earlier pointed out the existence of incised lines in the paint that follow the main design elements.[12] Some had always been obvious – notably those in the clocktower and archway, delineating the lines of the architecture – but it had been assumed that they were

Fig. 52 Paint cross-section from blue-grey of sky in Cat. 4, showing the presence of lead white and charcoal over a thin cream-coloured ground. The paper fibres below are clearly visible. Magnification 225X

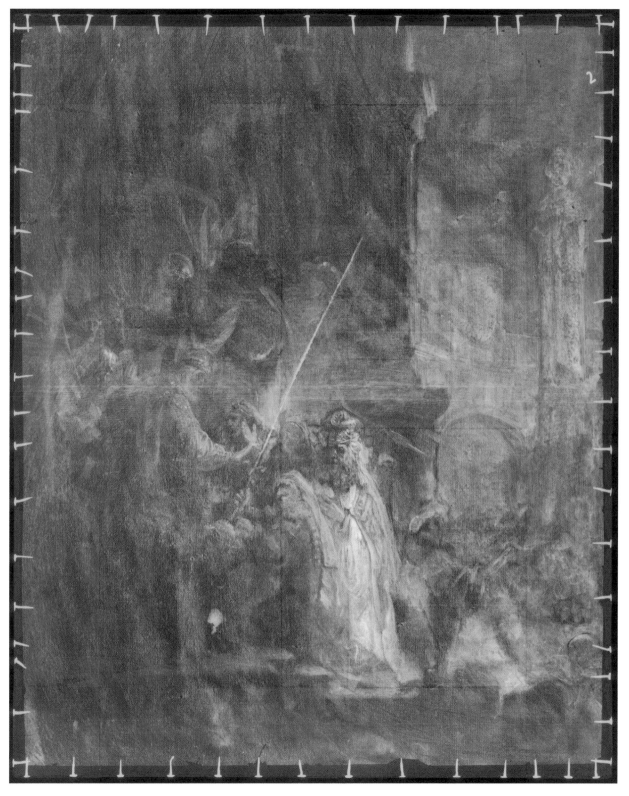

Fig. 53 X-ray mosaic of Cat. 4

simply guidelines or scratched emphases solely connected with the painting process. However, cleaning in 1987 revealed incised lines everywhere on the picture surface, following figure outlines, architecture, draperies and such minute details as Christ's hair and hands and hatched shadows on his body (Figs 54 and 55). It is now clear that the painting was traced or incised directly for transfer of the design to the etching plate.

There are several possible methods of doing this. A tracing made with slightly translucent paper might have been used to transfer the design; or a sheet of paper with a blackened (perhaps with charcoal) reverse side placed below the painting and the design pressed through to the plate with a stylus. A third possibility was that the back of *this* piece of paper was blackened and it was placed directly on the plate: only removal from its present lining canvas would confirm or disprove this. Any one of these methods would result in the incised lines as we now see them. It is clear that the paint was still relatively soft when the process was carried out. In one or two places in the architecture the scoring has broken through the paint layers to the prepared paper, perhaps indicating the use of a stylus directly on the paint surface: but in most places the paint is merely dented, which could be caused either by direct contact or by indirect tracing.

Fig. 54 Macro detail of Christ's hair from Cat. 4, photographed in raking light (approx. 10X magnification).

Fig. 55 Detail of Christ from Cat. 4

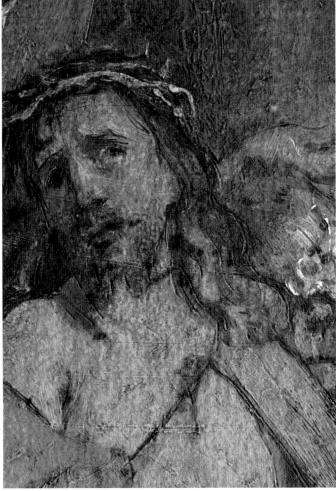

There is a much greater concentration of incising in the more finished areas of the painting than in the sketchy unfinished parts. In the detailed areas almost every feature is incised – individual locks of hair, fingers and folds of drapery – but in the sketched areas only broad outlines are incised. This is an important indication of Rembrandt's intentions with regard to the etching. The main figure group was worked out in every detail before the etching stage; but clearly Rembrandt always intended to develop the secondary figures only once the etching process was under way.

REFERENCES

HdG no. 128; Bredius 1969, no. 546; Royalton-Kisch 1984, pp. 3–23; Schwartz 1984, no. 104, p. 112; *Corpus*, vol. 2, 1986, no. A89; London 1988, no. 2, pp. 42–7; MacLaren and Brown 1991, vol. 1, pp. 346–9; Berlin, Amsterdam and London 1991–2, vol. 1, pp. 164–6; Royalton-Kisch 1995, pp. 216–18; Amsterdam 1996, no. 16c, pp. 71–2; Rome 2002–3, p. 112, with no. 24; Boston and Chicago 2003–4, no. 48, pp. 115–18.

NOTES

1 *Corpus*, vol. 2, 1986, p. 467, with example of an engraving by Jacques Callot after Jan van Straet, called Stradanus (fig. 7, p. 466); repeated in MacLaren and Brown 1991, vol. 1, p. 384.
2 Berlin, Amsterdam and London 1991–2, vol. 1, p. 166. Pilate's gesture warding off the rod of judgement is highly unusual in the iconographic tradition of the subject (*Corpus*, vol. 2, 1986, p. 467).
3 Boston and Chicago 2003–4, p. 115.
4 Royalton-Kisch 1984; Berlin, Amsterdam and London 1991–2, vol. 2, p. 161; Boston and Chicago 2003–4, pp. 115 and 117–18. For the fullest account of their collaboration see Amsterdam 1996.
5 Bredius no. 550.
6 Royalton-Kisch 1994, pp. 4–5.
7 Berlin, Amsterdam and London 1991–2, vol. 2, p. 161. See Amsterdam 1996, pp. 70–1, for a detailed analysis of the changes between the first and second states and Rembrandt's interventions. In Boston and Chicago 2003–4, p. 118, it is suggested that Rembrandt himself considerably reworked the plate of the *Ecce Homo* after the first state.
8 Berlin, Amsterdam and London 1991–2, vol. 2, p. 161; Amsterdam 1996, p. 72; Boston and Chicago 2003–4, p. 115.
9 See Royalton-Kisch 1994, pp. 8–11; Amsterdam 1996, p. 72; and London 2001, p. 136, with cat. no. 24.
10 Strauss and van der Meulen 1979, doc. 1656/12, no. 121.
11 Royalton-Kisch 1994, pp. 8–10.
12 Royalton-Kisch 1984, p. 6. The authors of the *Corpus* (vol. 2, 1986, no. A89, p. 465) did not notice these when they examined the picture: 'One cannot so far be certain as to the procedure followed in transferring the composition onto the etching plate; there are no traces on the front surface of the sketch of lines having been pressed through . . .'.

5 Portrait of Philips Lucasz., 1635

Oak, oval, 79.3 × 59 cm
Signed on the right towards the bottom: Rembrandt/1635
Bought with the Peel collection, 1871
NG 850

Philips Lucasz., whose family came from Middelburg, was in the service of the Dutch East India Company (V.O.C.). From 1625 until 1631 he lived on the island of Amboina, for the last three years as Governor. In 1631 he was appointed Councillor Extraordinary of the Dutch East Indies. Two years later, in December 1633, he commanded a trading fleet of the Dutch East India Company on its return journey to the Netherlands. On 4 August 1634, shortly after arriving in Holland, he married Petronella Buys (born about 1605) at The Hague. They returned to the East Indies, leaving the Netherlands on 2 May 1635 and arriving in Batavia by 20 September. In September 1640 Philips Lucasz. was given command of an expedition to Ceylon during which he fell ill and died on board his ship, the *Santvoort*, on 5 March 1641. His wife returned to the Netherlands in that year and settled on the Keizergracht in Amsterdam; in 1646 she married her second husband, Joan Cardon, in Vlissingen and died there in 1670.[1]

A pair of portraits of Philips Lucasz. and his wife by Rembrandt is recorded in the collection of Jacques Specx (1588/9–1652), the husband of Maria Odilia Buys (died 1636), Petronella's sister, in 1653 and 1655.[2] They were painted early in 1635, shortly before Lucasz. and his wife left for the East Indies. On the back of an oval portrait of a young woman (Fig. 56), which has the same shape, size and support as the National Gallery painting, is an old inscription which identifies her as Petronella Buys and implies that there was a companion portrait of her first husband. The pictures also correspond in composition and style, and the identification of the National Gallery painting as the companion – first made by Hofstede de Groot in 1913[3] – has never been questioned. The heavy gold chain is further evidence for the identification of the sitter as Philips Lucasz.; gold chains, not a common item of dress, were often given by the Directors of the East India Company as a reward for service to commanders who had successfully brought home their merchant fleets, as Philips Lucasz. had done in 1634. The archives of the company reveal that on 31 January 1635 Philips Lucasz. received 1,000 *ricxdaelders* for his services.[4]

Jacques Specx had himself been in the service of the V.O.C.[5] He had established the Company's trade with Japan in 1609 and had served as Governor of Batavia. He had taken his wife and her sister, Petronella, to Batavia in 1629 and it was there that Philips Lucasz. had met her.[6] Specx appears to have been an important early patron of Rembrandt as no fewer than five paintings by the artist, all probably painted

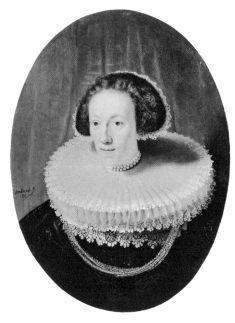

Fig. 56 *Portrait of Petronella Buys*, 1635.
Oil on panel, oval, 76 × 58 cm.
Private collection, with Wildenstein, New York, 1985

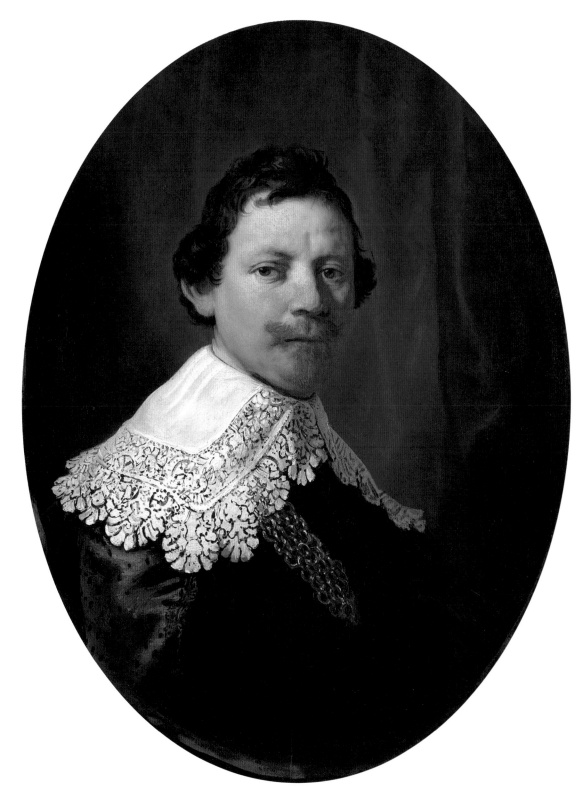

Fig. 57 *Portrait of Philips Lucasz.*, 1635. London, National Gallery, NG 850

between 1631 and 1635, appear in his inventory of 1653. In addition to the portraits of Philips Lucasz. and his wife, Specx possibly owned the *Saint Paul in Prison* of 1631 (Staatsgalerie, Stuttgart);[7] the *Abduction of Europa* of 1632 (J. Paul Getty Museum, Los Angeles);[8] and a 'Saint Peter's Boat', which may be the *Christ on the Sea of Galilee* of 1633 (Isabella Stewart Gardner Museum, Boston).[9] It seems likely, therefore, that it was Specx who commissioned the portraits of Philips Lucasz. and his wife.

It has been suggested that a substantial part of the portrait of Philips – the lace collar and the bust – and the whole of the portrait of his wife are not by Rembrandt himself, but by an assistant or close imitator.[10] The arguments concerning the treatment of Philips's lace collar are discussed below in detail, but there are no significant differences in style, technique or paint handling to support this idea. Both paintings, in their entirety, appear to be by Rembrandt. Any weaknesses in the paintings can be paralleled in other portraits from these hectic years of portrait painting in Amsterdam and explained by the speed at which these and other portraits were painted.

Examination of the *Portrait of Philips Lucasz.* reveals that it was once substantially different in appearance, although when the changes to its present state were made is difficult to establish. At first sight it appears to be one of Rembrandt's standard oval portraits of the early Amsterdam period, similar to the *Portrait of Aechje Claesdr* (Cat. 3). But the oak panel has straight bevelling on the back, widest at the bottom, narrower at the sides and with none at all at the top. This indicates that it has been cut down from a rectangle and has lost most at the top, some at the sides and least at the bottom – assuming equal bevelling on all four sides. There are other indications that the portrait has been cut down. For example, the brushstrokes of the background and coat continue fully up to the edge, whereas normally they would diminish and tail off as they approached the true edge of a panel. Also there are signs that the paint at the very limits of the panel has flaked and crumbled a little, as if dislodged by the act of cutting. Thus at some stage the rectangle was altered to an oval. But when? Scraps of paper stuck to the back of the panel and dating from the later seventeenth century follow the oval shape: they could indicate a fairly early date for the cutting-down, but the evidence is not conclusive.

The X-ray image (Fig. 59) raises new questions which may also have a bearing on the change in format of the panel. The most obvious feature of the X-ray that does not show in the present portrait is the sitter's left hand, apparently touching the gold chain across his chest. The position of the hand does not fit well with the oval format and the present edge cuts through the light-coloured cuff at the wrist: it is not unreasonable to assume, therefore, that the hand was in place when the portrait was rectangular. It is likely that it was planned at an early stage in the composition since a cross-section shows a thin sketching layer in bone black beneath the brownish-yellow paint of the flesh (see Fig. 60). When the portrait was cleaned in 1941 and 1977, it was noted that the paint covering the hand was not original, and it was removed in 1977 to reveal the hand (Fig. 58). This does not exclude the

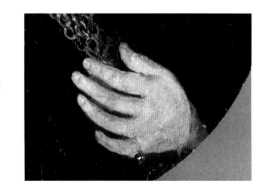

Fig. 58 Detail of the painted-out hand from Cat. 5 photographed during cleaning.

Fig. 59 X-ray mosaic of Cat. 5

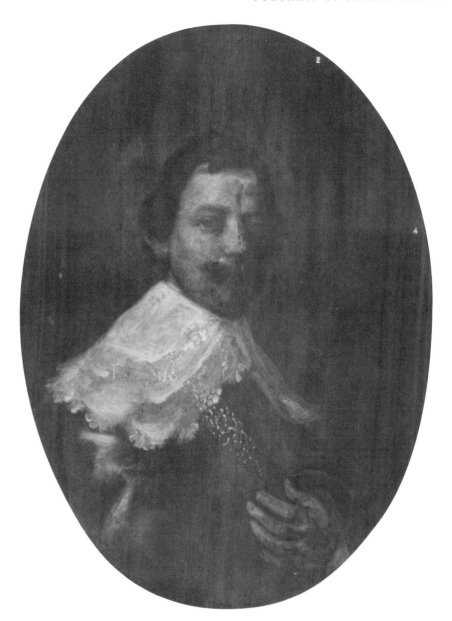

possibility that the hand might originally have been painted out by Rembrandt himself, since any original black paint covering it could have been scraped away by a curious or ruthless restorer at any time in the last two or three hundred years. The hand that emerged in 1977 was clumsy and shapeless and much yellower in tone than the paint of the face. The curious shade of the concealed flesh paint, however, is found elsewhere in Rembrandt, for example in the hands and some of the mid-tone features of the faces and necks of the figures in *Belshazzar's Feast* (Cat. 8).

Various possibilities have been considered. Is the hand unfinished, or damaged, or possibly not by Rembrandt? It was clearly worked up to some degree, since the

ring on the finger was painted, and there is a distinct layer structure to the flesh paint. In the shadows, which are fairly dark in the X-ray image, a translucent undermodelling in a mixture mainly of chalk and yellow-brown earth pigment with only a little lead white is completed in a thin mid-yellow layer made up of rather more lead white and yellow ochre. The final shadows are put on as thicker strokes of yellow ochre mixed with umber and black (Fig. 61). A sample from a concealed highlight shows a much more solid paint containing lead white (Fig. 60), which therefore registers as a light area on the X-ray. Analysis has shown that all the pigment materials used in the painted-out hand were in common use in the seventeenth century. The highlights on the fingernails are present and would have been among the last touches to have been painted. Nevertheless, the formlessness does suggest a lack of final modelling – or, alternatively, the loss of upper layers by scraping (the outlines are undoubtedly damaged) – or both.

It is not possible to establish beyond doubt the authorship of the hand, given its present condition. There is no reason to think that, simply because its shape is unsuccessful, Rembrandt could not have painted it. Rembrandt's difficulty in portraying hands is evident in a number of undisputed paintings from the 1630s. Whatever its status, it seems highly probable that the painting-out of the hand coincided with the reduction of the panel to an oval. The awkwardness of the hand and wrist, now disembodied by the new edge of the panel, would have been only too apparent. As for *when* the alteration occurred, it seems clear that the paint was quite hard and brittle when the panel was cut and so a date later than the 1630s is indicated: at any rate, it now seems unlikely that Rembrandt altered it himself. The hand is now covered up again: after the 1977 cleaning it was considered so unsatisfactory in appearance that, once it had been photographed, it was painted out. If the picture is viewed against the light, the outlines can be seen clearly under the present paint surface.

Another area of the portrait that has been questioned is the lace collar. It has often been pointed out that the collar is not so detailed or successful as those in other portraits of the period. The technique is clearly seen by studying the picture and X-ray together. Rather than by painting the individual lobes of lace over the black of the coat, the collar has been laid in with broad sweeps of white and grey paint and the black detailing painted on top; pastose highlights and the edges of the lace are applied last in pure lead white (Fig. 62), together with the thick yellow paint representing the links of the underlying gold chain.

While it is generally agreed that Rembrandt painted finer, more controlled lace in other portraits, we should not leap to the conclusion that this collar must be by another hand. The key to interpreting the whole picture is that it was painted in a great hurry. It had to be done before Philips Lucasz. went abroad in May 1635. If the portrait was to be painted rapidly, two courses of action were open to Rembrandt: either he could paint it himself very quickly, or he could employ an assistant to paint parts of it for him. The assistant theory is an attractive one, because it

Fig. 60 Paint cross-section from concealed highlight on the painted-out hand in Cat. 5, showing a thin layer of bone black directly over the *primuersel*. Chalk ground missing from sample.
Magnification 290X

Fig. 61 Paint cross-section from concealed shadow of the painted-out hand in Cat. 5 in two layers.
Magnification 270X

explains away the weaker passages that we are reluctant to attribute to Rembrandt. It also explains the discontinuity where the flesh of Philips's neck meets the collar: the two were clearly painted in separate operations and superficially joined by a highlight and shadow afterwards. But this in itself does not exclude Rembrandt's authorship of both parts, especially if he painted under great pressure. It is our view that the whole collar is by his hand and that it should be viewed as if painted in a kind of brilliant shorthand. It is difficult to imagine a worthy but pedestrian assistant supplying these flourishes to the lace: it is more plausible to say that here is a great painter working at speed, perhaps not trying very hard.

The gold links of the chain are also painted in a shorthand manner, the shadows and half-tones worked wet-into-wet over the black tunic beneath. The deepest tones contain bone black, while the dark yellow body colour, mainly of yellow ochre, is close in composition to the paint of the concealed hand. The reflective highlights are put on as impasto touches of pure lead-tin yellow, and in consequence register clearly on the X-ray, as does the initial lay-in for the collar; once larger on the shadowed side, the lower part was subsequently covered by the black coat. The X-ray also shows the difference in technique between the broadly underpainted lace and the small, fluidly worked brushstrokes following the form of the face.

The painting of the flesh is markedly similar to that of the *Portrait of Aechje Claesdr* of the previous year. Over an undermodelling in warm brown, a variety of colours is blended wet-into-wet to form the main paint of the flesh. The pigment combinations chosen for the flesh tones are subtle and complicated: in the cool mid-tone shadow at the temple the main pigment of lead white is mixed with small quantities of red earth pigment, vermilion, charcoal, yellow lake and a few particles of blue mineral azurite; while for the pinker cheek, the colour is imparted mainly by red ochre and vermilion with a trace of bone black. Here, as in the other portrait, there is a conscious use of raised and lively brushwork for the lighter areas while the shadows are smoother and seem to recede. The final

Fig. 62 Detail of the lace collar from Cat. 5

touches are the very hard, thickly painted shadows at the nose, mouth and neck.

The ground is the usual one for Rembrandt's panels, consisting of a chalk underlayer with on top a thin warm brown priming containing umber (see Figs 63 and 64). It may be seen uncovered at a few points in the hair and around the eyes. However, as an optical device, its luminosity is hardly exploited at all. The whole portrait is painted opaquely; the background is unusually dense and does not rely on thin glazes with the ground colour showing through as is so often the case in Rembrandt's work. Instead, the curtain which forms a backdrop for the sitter is painted in two fairly solid layers of grey, warmer beneath and cooler above, but in both cases containing substantial amounts of opaque lead white tinted with bone black and adjusted with a little red lake pigment (Fig. 63). To the extreme right and left edges the dark paint is warmer, suggesting the addition of rather more of the red lake to the background shadows. The black tunic and grey spotted sleeve are painted entirely without addition of a warm-coloured pigment, much in the way of the dress of the *Portrait of Aechje Claesdr*, the darkest areas being in pure bone black, with only lead white combined to make the grey (Fig. 64).

The sequence of painting is complex. A reserve has been left in the background paint for the hair: the ends of some parts of the hair then pass over the background, but in other places are clearly covered by it. At the right side of the face (Philips's left cheek) the background is painted over the outline of the flesh, but the back of the neck and the collar clearly pass over the background. For a rapidly painted work such as this, the overlapping of adjacent areas of paint in an unsystematic way and the constant adjustment of outlines are not unusual.

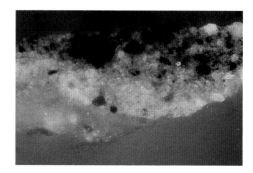

Fig. 63 Cross-section of warm grey paint from the left-hand background in Cat. 5, which incorporates red lake pigment in the two layers.
Magnification 290X

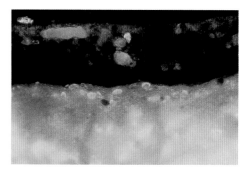

Fig. 64 Paint cross-section from grey of left sleeve in Cat. 5, showing the use of bone black and a little lead white. The chalk ground and *primuersel* are visible.
Magnification 300X

REFERENCES
Hofstede de Groot 1913, pp. 236–40; HdG No. 660; van Eeghen 1956a; Bauch 1966, no. 376; London 1988, no. 4, pp. 52–7; Bredius 1969, no. 202; Schwartz 1984, no. 162, p. 164; *Corpus*, vol. 3, 1989, no. A115; MacLaren and Brown 1991, vol. 1, pp. 343–6.

NOTES
1 Coolhaas 1973, pp. 49, 54–5, 63–4; *Corpus*, vol. 3, 1989, no. A115, esp. p. 181; MacLaren and Brown 1991, vol. 1, pp. 344–6, and notes 5–7 for further literature.
2 For the inventory of 13 January 1653 see Coolhaas 1973, pp. 54–62. Jacques Specx's belongings were divided up in a document of 31 August 1655 and his daughter Maria inherited the two portraits (see van Eeghen 1956a, p. 116; also cited in MacLaren and Brown 1991, vol. 1, p. 346, notes 7, 15).
3 Hofstede de Groot 1913, pp. 236–40.
4 MacLaren and Brown 1991, vol. 1, p. 346, note 12, with further literature.

5 For a detailed account of his career see Coolhaas 1973, pp. 29–62.
6 Van Eeghen 1956a, p. 116; Coolhaas 1973, pp. 49.
7 Coolhaas 1973, p. 57, no. 13: 'Een St Paulus van Rembrandt', though it is not certain whether it is the Stuttgart picture. The *Corpus* (vol. 1, 1982, no. A11, p. 149) does not mention Specx in the provenance of the picture. The identification of Rembrandt's *Saint Peter in Prison* of 1631 (private collection, Belgium; *Corpus*, vol. 2, 1986, no. A36) in London 1988 (p. 52, fig. 39) is erroneous. There is no such picture in the inventory.
8 Coolhaas 1973, p. 58, no. 27: 'Een Europa van Rembrant [*sic*]'; *Corpus*, vol. 2, 1986, no. A47.
9 Coolhaas 1973, pp. 56–7, no. 8: 'Een scheepgen Petri van Rembrandt'; *Corpus*, vol. 2, 1986, no. A68.
10 *Corpus*, vol. 3, 1989, no. A115, esp. p. 178. On Rembrandt's painting of lace see also van der Wetering 1986b, pp. 63–76.

6 Saskia van Uylenburgh as Flora, 1635

Canvas, 123.5 × 97.5 cm
Below on the left between Saskia's skirt and her staff, are the worn remains
of a false signature and date: Rem[…]a[.]/1635
Bought from the 8th Duke of Buccleuch with a contribution from the
National Art Collections Fund, 1938
NG 4930

During his early years in Amsterdam Rembrandt painted a group of five life-size representations of biblical and mythological heroines. These include *Bellona* (1633, Metropolitan Museum of Art, New York), *Artemisia* (1634, Museo del Prado, Madrid), *Saskia as Flora* (see Fig. 65) and *Minerva* (1635, Otto Naumann, New York).[1] There are evident similarities between the woman in this painting and those in *Artemisia* and *Minerva*. They all have long blond hair and wear sumptuous dresses with wide sleeves and elaborate brocade trimming. This type of imaginary dress, a mixture between exotic and sixteenth-century costume, in Rembrandt's time was usually referred to as *à l'antique* to denote the historical role of the character. The woman in the Gallery's painting is further adorned with jewellery and – much like the St Petersburg *Flora* – with an abundance of flowers. The circlet around her head includes forget-me-nots and scarlet pimpernels with a spray of rosemary tucked in at the side. In her hands she is holding a bouquet of flowers that include marigolds, cuckooflowers, tulips, carnations and buttercups.

The model for the painting is traditionally identified as Saskia van Uylenburgh, the daughter of a burgomaster of Leeuwarden in Friesland. Born on 2 August 1612, she later came to live in Amsterdam with one of her sisters. There, in the house of her cousin, the painter-dealer Hendrick van Uylenburgh (1587–1661), she met Rembrandt. In 1631 Rembrandt had lent van Uylenburgh a thousand guilders and in 1632 he had gone to live in van Uylenburgh's house in Amsterdam. Saskia was betrothed to Rembrandt in June 1633 and they married on 22 June 1634 in the Sint Annaparochie near Leeuwarden.[2]

The identification of the woman in this painting – as well as in some of the other paintings in the above-mentioned group – is based on perceived similarities between these pictures and a silverpoint drawing of Saskia by Rembrandt, now in Berlin, made three days after their betrothal (see Fig. 66).[3] Below her portrait Rembrandt wrote: 'This is my wife made when she was 21 years old three days after our betrothal on 8 June 1633.' It is often said that Saskia brought Rembrandt a large amount of money, but in fact Saskia's father upon his death in 1625 had left her little except debts and no hope of a substantial dowry. The valuation of her estate upon Saskia's death at more than forty thousand guilders must have been largely the income of her husband.[4] Of their four children only Titus, born in September 1641, was alive at the time of her death on 14 June 1642. While there is certainly a passing

resemblance between Saskia's features in the drawing and the face in this painting, it seems that the features are too generalised to be a specific portrait of Saskia. She may, however, have served as the model for the painting.[5]

Another, more contested issue, is whether the woman in the painting is a shepherdess in the contemporary Arcadian fashion[6] or Flora, the Roman goddess of spring. The identifications are not mutually exclusive and it is possible that Rembrandt had both traditions in mind. The low neckline of her dress adds an element of eroticism appropriate to both Flora and a shepherdess.[7] Following the example of pastoral plays such as Pieter Cornelisz. Hooft's immensely successful *Granida and Daifilo* of 1605, Arcadian subjects began to appear in the early 1620s in pictures by Utrecht artists: particularly popular were half-length figures of shepherds and shepherdesses, and portraits in idealised pastoral dress. By the 1630s or perhaps earlier, the fashion had spread to Amsterdam: Dirck Santvoort's *Shepherd* and *Shepherdess* of 1632 (Boijmans Van Beuningen Museum, Rotterdam) are typical examples. This kind of picture also appears in Rembrandt's circle at that time, and a *Saskia as Shepherdess* of 1636 by Govert Flinck at the Herzog Anton Ulrich-Museum in Brunswick has a companion *Shepherd* in the Rijksmuseum with the features of Rembrandt himself. Usually, however, the shepherdesses in these pictures wear straw hats and carry a shepherd's staff (recognisable by its metal 'spoon' at the top). Both attributes are absent from the National Gallery's painting. Instead, the dress, which is more historicising than Arcadian, and the emphasis on the flowers make it more likely that Rembrandt intended a depiction of the Roman goddess Flora.[8] At various points it has been suggested that the artist's choice of subject was inspired by Titian's *Flora* (Galleria degli Uffizi, Florence), which was in the collection of Alfonso López in Amsterdam before 1641.[9] When comparing the two pictures, however, it becomes immediately apparent that the woman in the Gallery's painting is far more reserved in character and displays hardly any of the sensuality of the courtesan evident in Titian's *Flora*. The influence of Titian's painting on works by Rembrandt seems more plausible in relation to other Floras by him such as the *Saskia as Flora* of 1641 (Gemäldegalerie Alte Meister, Dresden) and his *Flora* of around 1654 (Metropolitan Museum of Art, New York).[10]

The date on this picture has often been read as 1633 but it is certainly 1635. Like the signature, it is obviously false but it may well have been copied from a genuine inscription since it is not incompatible with the style of the painting, although it could conceivably be a year or two later.

It is possible that the painting has been reduced in size: the evidence, which is confused and to some extent contradictory, suggests that any reduction was slight. The most important evidence is provided by a drawing in the British Museum, which Sumowski attributed to Ferdinand Bol – but which the authors of the *Corpus* have subsequently designated as 'Rembrandt workshop'.[11] This drawing shows the composition extended a little at the top and to the right and fractionally on the left, and is presumably an accurate copy of the painting made shortly after it was

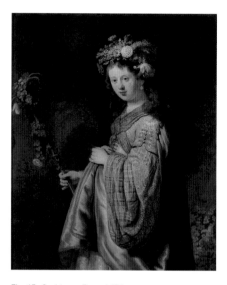

Fig. 65 *Saskia as Flora*, 1634.
Oil on canvas, 125 × 101 cm.
St Petersburg, State Hermitage Museum, inv. GE-732

Fig. 66 *Saskia in a Straw Hat*, 8 June 1633.
Silverpoint on vellum, 18.5 × 10.7 cm.
Staatliche Museen zu Berlin-Preussischer Kulturbesitz,
Kupferstichkabinett, inv. KdZ 1152

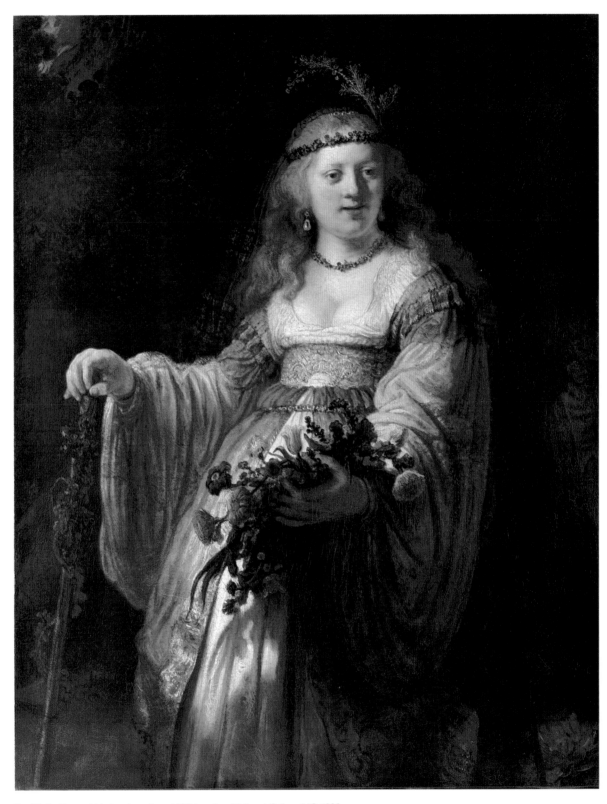

Fig. 67 *Saskia van Uylenburgh as Flora*, 1635. London, National Gallery, NG 4930

painted. Several old painted copies, none apparently older than the eighteenth century, and an engraving of 1763 have different proportions. In two of the copies (those formerly in the collections of Baron Bonde in Ericsberg, Sweden, and of Dan Cevaat in the Netherlands) the field of the composition is extended a little to the right but otherwise corresponds with the National Gallery picture.[12] William Pether's mezzotint of 1763, however, shows the composition extended substantially on all sides and the figure continued to about half-way between knee and foot.[13] The print is rather carelessly executed and this difference may have been Pether's invention. Finally, in the copy formerly in the Lechmere collection and now in that of Dr Heinz Kisters, there is about twice as much space between the figure and the edges on both sides and at the top, and the figure is continued to the ground. While it is true that almost all the known full-length life-size portraits by Rembrandt were painted around this time, the additional part in this copy is empty and the lower part of the figure has been partially hidden by plants in a clumsy way that suggests it was not taken from an original by Rembrandt but is the invention of a copyist. It seems most likely, therefore, that the British Museum drawing is an accurate copy of the painting's original appearance and that the present canvas edge has been cut down along the top and right edges and minimally along the left edge. It is worth noting that the National Gallery picture is approximately the same size as the Hermitage painting of *Saskia as Flora* (see Fig. 65) made the year before. Unfortunately there is no clear technical evidence that confirms whether or by how much the composition has been reduced, but a repair to the canvas may have been carried out using a piece trimmed from the edge (see below).

Detailed examination of the X-ray (Fig. 69) shows that the canvas has too fine and regular a weave to be considered Rembrandt's own. Van de Wetering has suggested convincingly that the painting has been transferred to a new canvas.[14] However, unlike the *Self Portrait at the Age of 34* (Cat. 9) which may also have been transferred, the imprint of the original canvas in the back of the ground layers (and therefore its image in the X-ray) has been almost entirely lost here. Presumably the back of the ground was sanded or scraped down during the transfer. The new canvas was then applied with an X-ray opaque ground or adhesive, and it is consequently the image of the replacement canvas that we see. It is just possible to see faint remains of the original canvas weave image superimposed on the new weave in the few areas where it was not entirely scraped away.

A particularly interesting area in which to study the canvas weave in the X-ray is the triangular repair at the left of Saskia's neck. Presumably there was a bad tear here which was at some stage cut out and replaced by an insert. On this new piece of canvas a false curl was painted and can be seen in many early photographs of the painting (including the one in the first edition of Bredius's catalogue). The false curl was removed when the painting was cleaned in 1938 and the missing area was then restored to agree with the corresponding area in the old copies. Close inspection shows that the regular weave of the transfer canvas underlies the more irregular

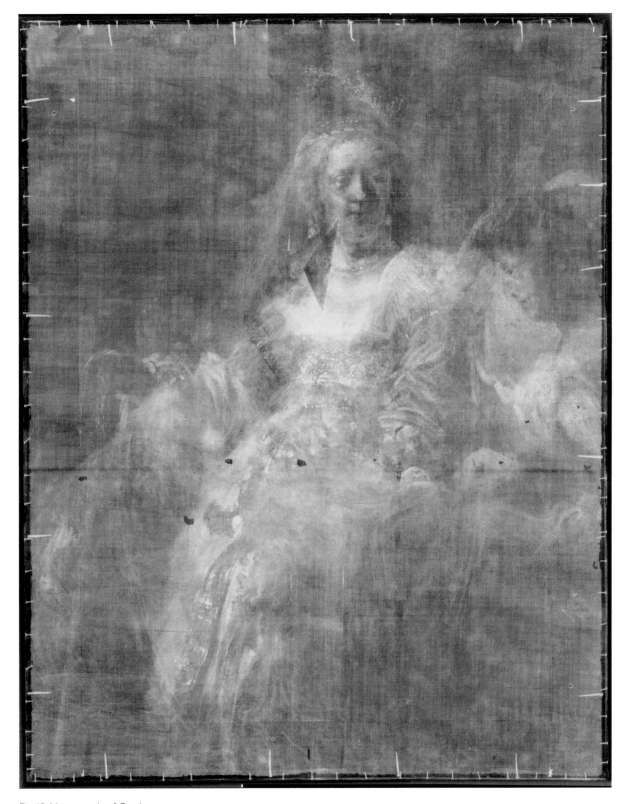

Fig. 68 X-ray mosaic of Cat. 6

weave of the inserted piece, which is inclined at a slight angle to it. The intriguing possibility arises that the insert may have been cut from a trimmed-off piece of the original canvas (see above). A cross-section from this area confirms that this is indeed highly likely: below layers of later paint is one layer of old paint on top of a double ground apparently the same as that found elsewhere on this painting. In this small area, therefore, we are probably seeing the only well-preserved image of the original weave. The repair must be an early one, since it clearly pre-dates the transfer; the canvas was probably removed from the back of the insert as well during the transfer process, but the back of the ground layers was not scraped down so drastically in this fragile area.

The canvas is prepared with a double ground rather similar to that of *Belshazzar's Feast* (Cat. 8), with some charcoal black incorporated into the upper layer, and a little earth pigment. The lower ground is of a coarse, impure orange-red earth, while the second layer is a rather cool grey (Fig. 69).

The most important feature of the paint layers, which profoundly affects the painting as we see it now, is that Rembrandt at first had an entirely different subject in mind. The radiographs reveal extensive changes: on the right-hand side a second figure, wearing a flat hat and with eyes cast down, can clearly be seen. A cross-section shows the paint of the lips of the concealed figure (Fig. 70). Saskia's right hand was originally lower and did not hold a staff. There are further changes in the confused area of her left arm and hand, which make it probable that she was not originally holding flowers. There are other, smaller, changes in her bodice and skirt. Christopher Brown argued that Rembrandt originally intended to portray a different subject, Judith with the head of Holofernes (Judith 13: 1–5), freely based on Rubens's interpretations of the subject now in Brunswick (Fig. 71) and in the Palazzo Vecchio in Florence.[15] The figure standing on the right would be Judith's servant, and Judith's hand would originally have carried a curved sword (indicated by long curving strokes at the lower left). The unresolved area on the right between Saskia's left hand and her servant's hand, which includes several downward strokes, may have indicated the bag in which Holofernes' head was contained or perhaps the head itself. It is related to a drawing of the subject by Rembrandt in the Louvre (Fig. 72). If this hypothesis is correct, Rembrandt became dissatisfied with the Judith, based on Rubens's composition, at a quite advanced stage and in her place painted Saskia as Flora.

There is nothing inherently unlikely in Rembrandt depicting his wife in the guise of the great Jewish heroine. However, it might seem that this transformation from Judith to shepherdess was too radical and that it is more likely that the original composition was another Arcadian subject such as Vertumnus and Pomona. But Vertumnus and Pomona do not seem to fit the original composition, as the woman on the right does not appear to be old and the two women are usually given equal weight in the composition, as, for example, in the painting of the subject by Hendrick Goltzius in the Rijksmuseum. No other pastoral subject fits the key

Fig. 69 Paint cross-section from the shadowed area of white skirt at bottom edge of Cat. 6. This shows the complexity of the layer structure due to the reworking of the design of the picture; the double ground is visible as the lower two layers of the cross-section. Magnification 160X

Fig. 70 Paint cross-section from brown glaze of right-hand background in Cat. 6 concealing the paint of the lips of the hidden figure. A single particle of vermilion is visible in the underlayer to the right. Incomplete layer structure. Magnification 125X

features of the composition. Brown's hypothesis, however startling at first, seems to accord with the composition as we can see it on the X-ray.[16]

The composition underneath the present paint surface has obviously resulted in a much more complex paint structure in some parts. Generally the dark backgrounds in Rembrandt's pictures, particularly in his earlier works, are fairly straightforward in structure, with more or less translucent darks barely concealing the colour of the surface layer of ground below. The redesign of the composition in this painting has involved the background as much as any part, and what might be interpreted as light fawn or grey ground, glimpsed through the translucent blackish-brown paint of the swirls of formless foliage to the right edge, is in fact an intermediate opaque layer of lead white that totally covers an earlier glaze of a dark khaki green (see Fig. 73), and must arise from Rembrandt's reworking of the composition in the area. By contrast, to the upper left, a light greyish-brown underlayer can be seen through a thin dark glaze of bone black; but at this point beneath the opaque paint there is no intermediate glaze, and the underpaint lies directly on the upper grey ground.

Broad brushstrokes that bear no relation to the finished picture show through the paint in many areas. For example in the lower part of the dress and in Saskia's right sleeve great sweeps of paint cross and re-cross the form and are only thinly covered by the uppermost paint layers. Some indication of the complexity in layer structure can be seen in a cross-section from the lower part of the underskirt (Fig. 69), which shows thickly modelled lower layers of rich brown and yellowish brown under the final applications of paint. If the surface is viewed against the light, the vague outline of the second figure near the right edge can be seen, and the positions of the painted-out face and hands are made visible by the slightly altered paint texture on top.

The texture of the whole painting has undoubtedly been flattened considerably by transfer and lining, but enough is still present to indicate how Rembrandt

Fig. 71 Peter Paul Rubens, *Judith with the Head of Holofernes*, about 1617
Oil on panel, 120 × 111 cm.
Brunswick, Herzog Anton Ulrich-Museum, Kunstmuseum des Landes Niedersachsen, inv. GG 87

Fig. 72 *Judith and Holofernes*, 1632–4.
Pen and wash, 17.8 × 21.2 cm.
Paris, Musée du Louvre, inv. 22991

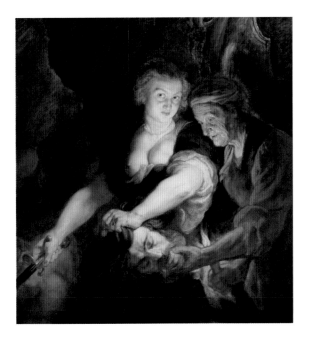

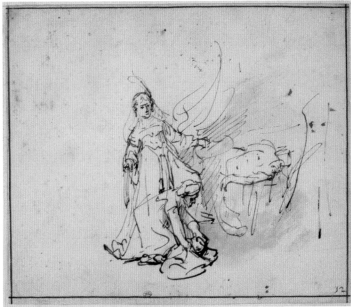

controlled the handling of the paint with great skill to suggest different features. The hair is the most fluid part, with the familiar trick of scoring the wet paint with a coarse brush and stylus (or brush-end) for the flowing form (Fig. 74). The waistband consists of almost abstract formations of piled impasto which recall similar passages in *Belshazzar's Feast*; although here, in addition to the highlight ridges of lead-tin yellow, yellow ochre and lead white, there are blue and blue-green strokes incorporating azurite, which create a distinctive range of colour contrasts (Figs 75 and 76). The earring is another pastose touch, the reflection and highlight seemingly casual, but perfectly placed, and the flowering spray in the headdress was also clearly intended to be raised up in relief. The paint of the dress and sleeves is different again. Here the texture is dragged with a drier brush and is almost granular in parts. The flesh is thickly painted, making very little use of ground or undermodelling colours, but with yet another kind of surface, essentially smooth but reworked into a rounded low relief in the lightest parts.

The use of colour in the present painting is unusual among the National Gallery Rembrandts in two respects. First, the whole painting has a cool greenish light not seen elsewhere, which cannot be attributed to the distorting effect of discoloured varnish as the painting was cleaned about 70 years ago. Second, the construction of colour, allowing for the reworking of the composition, often follows a more traditional method than we generally see. Here Rembrandt makes uncharacteristically frequent use of opaque light-coloured underpaints with final surface glazes to achieve richness and depth. A good example is in the muted dark red of the rose in Saskia's bouquet, which is underpainted in vermilion then simply glazed with

Fig. 73 Thin cross-section by transmitted light from concealed intermediate khaki-coloured glaze at upper-right corner of Cat. 6, with lead white layer over, and a final dark brown glaze on top. The painted-out glaze layer contains yellow lake, earth pigments, chalk and finely ground azurite.
Magnification 150X

Fig. 74 Detail of the hair from Cat. 6

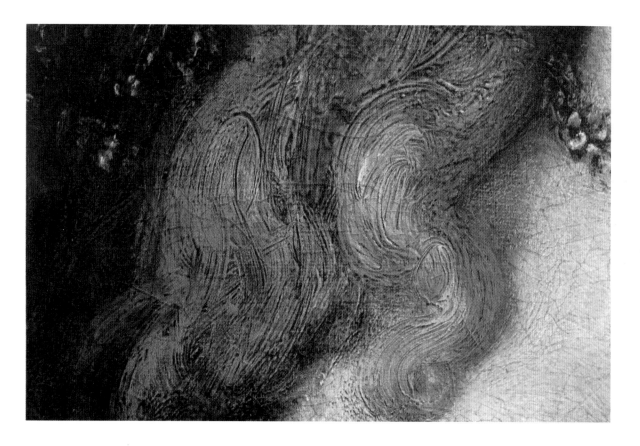

Fig. 75 Paint cross-section from yellow impasto touch on Saskia's waistband in Cat. 6. Lead-tin yellow at the surface, with azurite in the underlayers. Incomplete layer structure.
Magnification 160X

a thick layer of translucent pure red lake pigment. Similarly, the bluish-green overskirt relies on scumbles of blue mineral azurite drawn over a pale body colour, then glazed with yellow. The deepest blue of the flowers is done in the same way, but without the final modifying glaze. In addition to these quite traditional ways of painting, there are also some unconventional techniques employed. The deepest greens of the foliage in the bouquet involve no green pigment at all, but are produced by a thin surface film of intense black pulled over a deep blue underlayer of azurite (see Fig. 78), prefiguring the method for the dark green gems on the cloak in *Belshazzar's Feast*. The lighter, yellower greens in the bouquet are different again, with combinations of azurite and lead-tin yellow as well as yellow lakes.

The overall greenish cast of the picture has much to do with the use of blue mineral azurite in many areas. It is present in quantity in the now scarcely visible, very dark brownish-green veil that hangs to the right of Saskia's head, and in some of the background glazing layers as well. Finely ground azurite was combined with yellow lake pigment and earth colours to produce a dark greenish khaki for the initial glaze of the background to the right (Fig. 73). The presence of azurite in the flowers and foliage of the bouquet and in the waistband and overskirt have already been mentioned, and its use can be inferred from the colour of the paint in the embroidery of the sleeves, and Saskia's circlet and plume of foliage. The pigment even appears as a significant component in the cool shadows of the left hand (see Fig. 77). Smalt, the other blue pigment sometimes found in Rembrandt's work, also occurs in the picture, but only in underlayers that form part of the earlier composition. The smalt content seems to have no relation to the final surface colours.

Fig. 76 Detail of the waistband from Cat. 6

The colouring of Saskia's face and neck is of a delicacy and sensitivity quite unlike the broad yellow expanses of the faces in *Belshazzar's Feast*. Here the cool half-tones are subtle and understated but work perfectly in achieving sculptural form. The effect is practically all on the surface: the X-ray does not reveal the massive underlying structure of lead white that Rembrandt was later to evolve. Rather, the form is quietly built up with a variety of pigments which, overall, give a relatively flat X-ray image. Only at the end are heavy lead white highlights applied selectively to the forehead, nose and right eye. The open mouth is delineated with a characteristic pastose dark line.

The shadow on the hand bearing the bouquet is painted in an unusually complex mixture of pigment made up of azurite, yellow lake, a little vermilion, a crystalline red earth, white and a trace of black, lending a greenish tinge of reflected light from the foliage to the flesh (Fig. 79). The painting of Saskia's hands is less successful than that of her face. Tonally they are quite different, and no real structure shows in the X-ray. They bear eloquent witness to the struggle that even a great painter like Rembrandt could have in capturing the human hand convincingly.

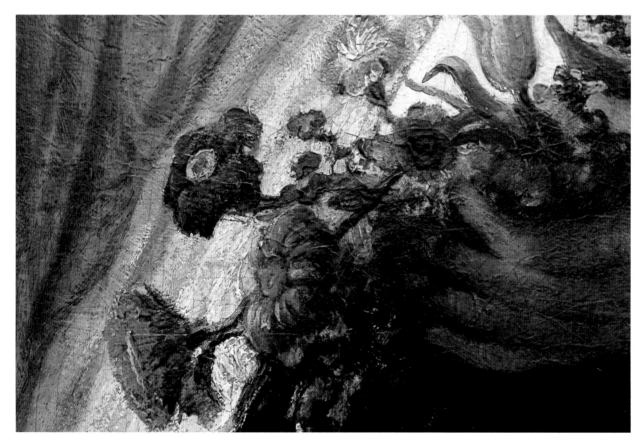

Fig. 77 Detail of Saskia's left hand and the bouquet from Cat. 6

Fig. 78 Top surface of an unmounted fragment of paint from deepest green foliage of the bouquet in Cat. 6, showing the scumble of black pigment over a layer of natural azurite.
Magnification 180X

Fig. 79 Top surface of an unmounted fragment of paint from greenish shadow of Saskia's left hand in Cat. 6. The pigment mixture incorporates azurite with yellow lake, vermilion, earth colours, black and white.
Magnification 115X

REFERENCES

HdG no. 205; Bauch 1966, no. 261; Bredius 1969, no. 103; Brown 1983, pp. 49–51; Kettering 1983, pp. 61–2 (with previous literature); Schwartz 1984, no. 119, p. 126; London 1988, no. 5, pp. 58–65; *Corpus*, vol. 3, 1989, no. A112; MacLaren and Brown 1991, pp. 353–8; Edinburgh and London 2001, no. 36, pp. 116–17; Rüger 2003, pp. 30–3; Vienna 2004, no. 77, pp. 184–5; Amsterdam 2006, pp. 116–23.

NOTES

1 *Corpus*, vol. 2, 1986, nos A70 (*Bellona*), A94 (*Artemisia*), A93 (*Flora*); vol. 3, 1989, no. A114 (*Minerva*).

2 For a recent detailed biography of Rembrandt and Saskia see S.A.C. Dudok van Heel, 'Rembrandt: His Life, His Wife, the Nursemaid and the Servant', in Edinbugh and London 2001, pp. 19–27.

3 MacLaren 1960, p. 333.

4 Edinburgh and London 2001, p. 23.

5 Much of the literature remains equivocal on this subject. The authors agree with the opinion expressed in the recent entry on the painting in Edinburgh and London 2001, no. 36, p. 116 and followed by Rüger 2003, p. 32. The authors of the *Corpus* entry (vol. 3, 1989, no. A112, p. 156) called it an 'unlikely suggestion', and Schama sharply disagreed: 'The London *Flora* is without question a completely different model' (1999, p. 367).

6 This identification has been maintained consistently in National Gallery catalogues beginning with Neil MacLaren (1960, p. 334).

7 The suggestion that the depiction includes traces of both traditions has been put forward by, among others, Kettering 1983, pp. 61–2; cited in MacLaren and Brown 1991, vol. 1, pp. 355–6, notes 16, 18.

8 *Corpus*, vol. 3, 1989, no. A112, esp. p. 156 (the *Corpus* refers to the picture as *Flora*); Berlin, Amsterdam and London 1991–2, vol. 1, no. 23, pp. 188–91, esp. pp. 190–1 and note 3; Edinburgh and London 2001, p. 116; Manuth and de Winkel [2003], p. 3 and fig. 4; Dickey 2002, pp. 30–3.

9 Edinburgh and London 2001, p. 116 and note 9.

10 For more on this comparison see the entry for the New York *Flora* in Edinburgh and London 2001, no. 119, p. 208, with illustrations of the Dresden painting and the Titian (figs 144, 145). See also Jan Kelch's entry on the same painting in Berlin, Amsterdam and London 1991–2, vol. 1, no. 41, pp. 250–3, esp. pp. 252–3; and New York 1995, vol. 2, p. 70.

11 Pen and brown ink, Indian wash, 21.9 x 17.3 cm, British Museum, London. See Sumowski 1979–92, vol. 1, Bol no. 127, pp. 278–9; and *Corpus*, vol. 3, 1989, p. 157, fig. 6. See also Copenhagen 2006, pp. 109–10, fig. 4.

12 For a discussion of all copies after the painting see *Corpus*, vol. 3, 1989, no. A115, pp. 156–7; MacLaren and Brown 1991, vol. 1, p. 356.

13 Charrington 1923, no. 126.

14 This was first suggested by Ernst van de Wetering to the authors of London 1988.

15 Brown 1983, pp. 49–51. Rüdiger Klessmann, formerly director of the Herzog Anton Ulrich-Museum, Brunswick, kindly informed the authors of the last edition of this publication in 1988 of his discovery that the Brunswick version of Rubens's painting was in Leiden in the 1620s and so easily accessible to Rembrandt. For the Florence version see Berlin, Amsterdam and London 1991–2, vol. 1, p. 188, fig. 23b.

16 For further speculative arguments surrounding the change in the picture see Dickey 2002, pp. 31–3, rightly dismissing Svetlana Alpers's suggestion that the transformation was designed to render Saskia less threatening.

7 The Lamentation over the Dead Christ, about 1635

Paper and canvas, mounted on an oak panel measuring 31.9 × 26.7 cm; the top
corners are rounded
Sir George Beaumont Gift, 1823/8
NG 43

The Lamentation over the body of the dead Christ at the foot of the Cross is not
described in the Gospels. There was, however, a well-established iconography of the
subject long before Rembrandt represented it in this small painting. In accordance
with that traditional iconography Rembrandt shows Christ's head cradled by the
Virgin in her lap and his feet embraced by the Magdalen. In the centre is the Good
Thief on his cross and on the left is the Bad Thief. In the distance is a fanciful view
of Jerusalem. This subject caused Rembrandt considerable difficulty. He made many
changes in the course of creating this painting. These changes are discussed below
and a detailed chronology of its genesis is proposed. Here it is sufficient to note
that there were three distinct stages (see Fig. 84): Rembrandt painted a grisaille
on paper; that grisaille, with sections cut out by the artist, was laid onto a canvas
slightly larger than the original paper, and the composition reworked; finally,
further canvas additions at the top and bottom were made which had the effect
of transforming the format of the painting from horizontal to vertical. It was
presumably during this third and final stage, which was not carried out by
Rembrandt himself, that the painting was laid down on to an oak panel.

There is a drawing in the British Museum (Fig. 80), undoubtedly by Rembrandt,
which seems not to be a preparatory drawing in the usual sense but a drawing
which Rembrandt worked on at the same time as he was reworking the grisaille.[1]

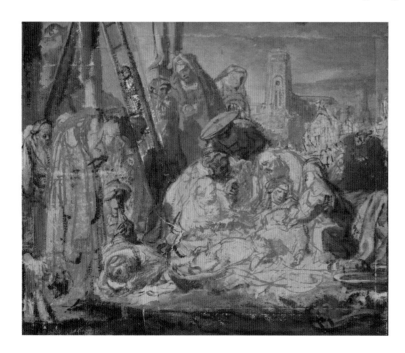

Fig. 80 *The Lamentation*, about 1634–5.
Brown, grey and white oil colours and pale brown ink
over red chalk, 21.3 × 25.4 cm.
London, British Museum, inv. 00.9-103

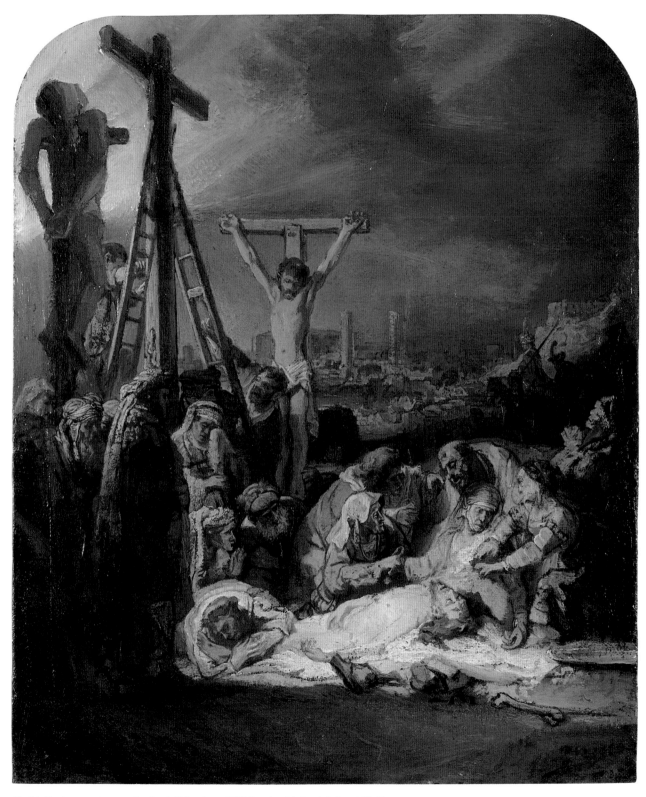

Fig. 81 *The Lamentation over the Dead Christ*, about 1635. London, National Gallery, NG 43

It is a study for the lower part of the composition, in a horizontal format, in brown, grey and white oil colours and pale brown ink over red chalk. Rembrandt made many drastic alterations to this drawing, which at some stage he cut into two irregular parts and mounted, with several additions, on a large sheet. The group around the dead Christ and the figures at the foot of the Cross are more or less as in the painting, while the figures behind and the background are different. In an inscription on the back of the British Museum drawing (which was copied by Sir Joshua Reynolds and pasted on to the back of the National Gallery painting, which he briefly owned, Fig. 82) the collector Jonathan Richardson the Younger noted: 'Rembrant has labour'd this study for the lower part of his famous descent from the Cross graved by Picart & had so often changed his mind in the disposition of the clair obscur, which was his Point here, that my Father & I counted I think seventeen pieces of paper.' This is an exaggeration, but it gives some idea of the complexity of the sheet. The engraving to which Richardson refers was made by Bernard Picart in 1730 when the painting was in a collection in Amsterdam.[2]

The British Museum drawing seems to be the starting-point for the second stage of the painting, in other words, after Rembrandt had painted the grisaille and worked out the composition further in the various stages of the drawing. He then cut the grisaille, placed it on canvas and transferred the composition worked out in the drawing to the grisaille. After this he again made further changes to the grisaille, because, as is noted below, elements in the drawing included in the second stage of the painting were subsequently suppressed, for example the church tower in the right background, faintly visible in the X-ray and on the picture surface. A second drawing (Fig. 83), in a private collection in Germany, records the composition at the end of the second stage and before the third.

In the third stage the format was changed by the addition of two sections of canvas: a thin strip at the bottom and a larger piece at the top which contains the upper part of the empty Cross and the whole figure of the Bad Thief, the lower part of which is painted over the man climbing the ladder. This thief and the top

Fig. 82 Note written by Sir Joshua Reynolds and now pasted to the back of Cat. 7

Fig. 83 Ferdinand Bol, *The Lamentation* (*copy after Rembrandt*), about 1635
Brush and brown ink over a sketch in black chalk, 16.3 x 24.5 cm.
Private collection, Germany

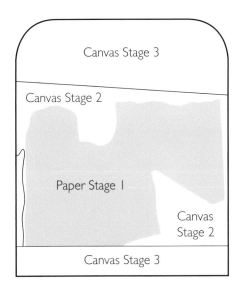

Fig. 84 Diagram of Cat. 7 showing the different stages of the work.

of the Cross are very coarsely painted and there is a clumsy attempt to match the half-tones in the rest of the painting. It has been suggested that one of Rembrandt's pupils, Ferdinand Bol, was responsible for this section,[3] which alters the format of the composition, but it may be that this addition is of a later date.[4] It is possible that the work was acquired as an unfinished picture and then extended and finished – but certainly before Picart made his print after it in 1730. The drawing in Germany has been convincingly attributed by Sumowski to Bol and dated around 1643–5.[5] It therefore records the composition presumably after its completion, inasmuch as it was completed, by Rembrandt. There is no reason why the changes made by Rembrandt in the painting and the British Museum drawing need have been made over a number of years, as has been suggested. They are stylistically homogeneous and were probably the result of a single campaign of work.

The painting seems to have been intended as a modello for an etching that was never made,[6] though others have suggested that it may also have been a sketch for a painting in Rembrandt's Passion series for the court in The Hague.[7] A telling detail noted by the *Corpus* is that the thief on the left is presumably the Bad Thief, as the other thief hangs in the light and his body is not twisted.[8] For the Bad Thief to hang on Christ's right would be iconographically incorrect, but this would have been corrected when the composition was reversed in a print. The only grisaille modello which was completed and used for this purpose is the *Ecce Homo* of 1634 (Cat. 4). There are, however, other grisaille paintings which Rembrandt may have intended to use thus, for example *Joseph telling his Dreams* (Rijksmuseum, Amsterdam)[9] and *Saint John the Baptist preaching* (Fig. 85).[10] All these grisailles date from the mid-1630s, so it is possible that Rembrandt was planning an ambitious series of engravings which was never carried out. The *Lamentation* belongs with this group; it should – in the second stage, the horizontal form recorded in the drawing attributed to Bol – be dated around 1635.[11] In the sequence of Rembrandt's work,

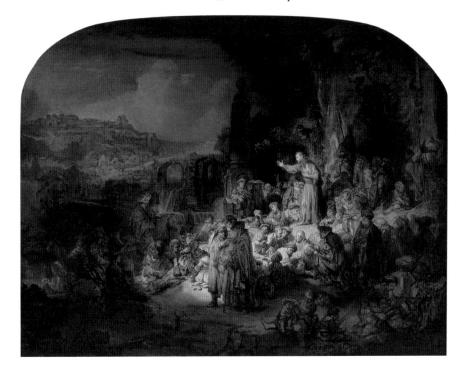

Fig. 85 *Saint John the Baptist preaching*, 1634/5.
Oil on canvas, 62.7 x 81.1 cm.
Staatliche Museen zu Berlin-Preussischer Kulturbesitz,
Gemäldegalerie, inv. 828K

it can be placed shortly after *Saint John the Baptist preaching*, which can be dated approximately 1634/5. There is also a painting of the same subject by Rembrandt's pupil Govert Flinck, dated 1637, whose composition seems to presuppose knowledge of *The Lamentation*.[12]

It may reasonably be asked why this composition caused Rembrandt so much difficulty. It has usually been thought that the problem was technical, that is to say that Rembrandt was concerned about the compositional balance of the figures and was trying to avoid placing figures too close together within a small space. This may be the case, but van de Wetering has a different suggestion.[13] He believes that Rembrandt's problems were iconographic rather than compositional. There is, as has been noted, no biblical text describing the Lamentation and Rembrandt conflates a number of separate scenes from the Passion in this small image in what is, iconographically, a highly original manner. It has a strong narrative element. The men descending from the ladders refer to the Deposition; the central group shows the Lamentation; and in the background the figures on the right are on horseback and one, an older man with a feathered headdress, may refer to the encounter between Pilate and Joseph of Arimathea in which Joseph requests permission to bury the body of Christ. (This figure is certainly not, as has been suggested, Longinus, as he is not dressed in Roman armour, neither does he carry a lance: the lance is carried by the accompanying figure on foot.) Their presence leads on to the next event in the Passion, the Entombment. In this way the painting refers to three distinct events in the Passion and it is this iconographic complexity – with a richness of detail which would have been entirely appropriate in a print – that caused Rembrandt to rework the composition. The question then arises why, if it was intended to be used for a print and incised on to the plate, like the *Ecce Homo*, he attached the original paper to canvas. Canvas could not, of course, be laid on to a plate and the design incised through it, as it is far too thick for this purpose. Rembrandt must have felt that paper which had been cut and rejoined was too fragile to lay on a plate and so have decided to consolidate the paper by attaching it to an odd piece of canvas which had been cut from another painting (which has been identified; see below) and was lying in a corner of the studio. He may have intended to make another grisaille on paper for transfer, but the project was presumably abandoned, as an etching of this composition was never made. However, while the composition was never etched, it is worth noting that there are reminiscences of individual figures and figure groups in the *Descent from the Cross* etching of 1642 (B. 81) and the oval plate of *Christ Crucified between the Two Thieves* (B. 79) of about the same time (about 1641).

The *Lamentation* is the smallest picture by Rembrandt in the National Gallery collection and, structurally, by far the most complex. Of the composition as it now stands, only the central part is by Rembrandt: the top and bottom parts were painted by a later hand. The complex evolution of the picture is made clear by a study of the paint surface, the X-ray (Fig. 86) and cross-sections taken from key

Fig. 86 X-ray mosaic of Cat. 7

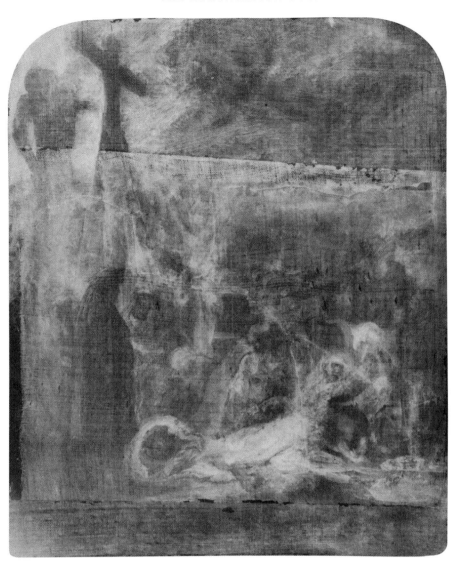

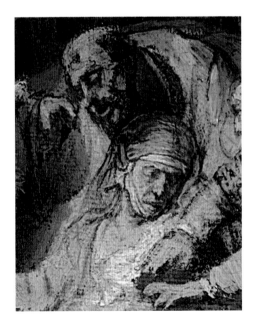

points. Instead of the usual description of technique by systematic consideration of layer structure, it is more instructive here to consider chronologically the evolution of the work carried out by Rembrandt himself, in his studio and, then, somewhat later, by the further hand.

The first stage of the development of the *Lamentation* was a lay-in done directly on the paper in tones of brown. This thin wash of colour contains black, transparent brown, traces of red and yellow earth and a trace of white. There appears to be no other sort of preparation on the paper. The brown tone is still visible in several areas, and was used directly for shadow and half-tone in the first painting stage. It can be seen in the shadowed side of the man's head immediately above the Virgin (Fig. 87) and in the middle-ground landscape above that (see Fig. 88); the dark standing figures in the left foreground are also composed largely of this brown

Fig. 87 Detail of the group around the Virgin from Cat. 7

lay-in with a few lighter scumbles on top. The first true painting stage of the grisaille used this brown tone directly. Over it, grey and white lights and highlights were applied, leaving blocks or lines of brown wash in between; this was a highly economical way of working. Deepest shadows and linear details were then added in darker browns and black.

There is no indication as to precisely how large the piece of paper was on which this first stage was painted because Rembrandt decided he was only interested in using part of it for the next stage. Presumably it was a rectangle not a great deal larger than it is now, but Rembrandt then cut and tore away the parts with which he was dissatisfied to leave an irregular shape, now clearly visible in the X-ray. The right and left edges run fairly straight, more or less parallel to the edges of the present composition. The top edge is curved at the left side; next to this it is cut away in an approximate rectangle (containing the ladder, the head and torso of the right-hand thief and the head of the man moving the ladder); then it continues irregularly at a higher level to the right side. The bottom edge is lowest at the left side, rises slightly under Christ's body and then is cut away in a large triangle to exclude most of Christ's head and the Virgin's body and face.

The trimmed and torn paper was next mounted on a slightly larger piece of canvas. This, too, is easily visible in the X-ray. Its upper edge slopes down towards the right and passes just above the Good Thief's hands; its lower edge is approximately horizontal and runs just below the main figure group. The canvas can be seen to have cusping at the top and left, indicating that it was cut from a large stretched piece. A cross-section shows that it is prepared with a typical double ground, on which the paper is directly mounted (Fig. 89). The upper layer contains lead white, a little umber and a fine-grained black (not wood charcoal); the lower layer is the usual reddish-orange earth. The canvas was undoubtedly part of a batch present in Rembrandt's studio. Van de Wetering has pointed out that its thread-count and weave characteristics match those seen in other canvas paintings of 1634/5.[14]

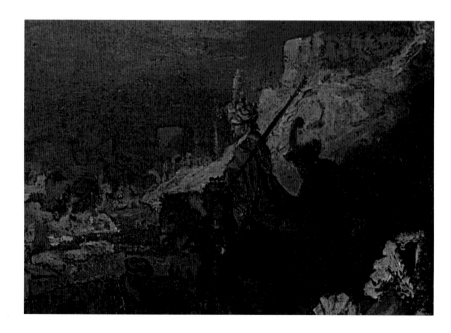

Fig. 88 Detail of the background from Cat. 7

Fig. 89 Paint cross-section from dark grey paint at right-hand edge of Cat. 7, showing the double ground of the central canvas. The sample is from an area where no paper is present.
Magnification 175X

Once the paper was mounted on canvas, the work could be developed further. This stage of painting is done more opaquely than the first, since Rembrandt had now to overlap both paper and canvas to complete the parts that had been cut away. Whereas the brown tone of the lay-in was allowed to show for shadows and half-tones in the initial grisaille, he now had to paint over the grey-brown ground on the canvas, the edges of the paper and the paint that was already present in order to continue. The paint of this stage is therefore more densely worked, and shadows and half-tones are painted opaquely on the surface. This may be seen most clearly in those parts applied directly on the underlying canvas – the head and torso of the right-hand thief, Christ's head and the Virgin's face and upper body – but many parts of the initial grisaille were now also developed further and it is not easy to distinguish the two stages in some areas.

Although they differ somewhat in density and handling, the finish and detail of these two stages are broadly similar. However, there appears to be a final, quite distinct, stage in which Rembrandt added a few last flourishes: this is typified by the extraordinarily free figure at the right, in which he has suggested a head, arms and praying hands with just a few dragged, almost random brushstrokes of pure white (Fig. 90).

It must be remembered that, so far, the painting was only on the paper stuck to one piece of canvas. The canvas was then stuck to a larger oak panel which had rounded top corners, together with two other pieces of canvas, one above and one below. This arrangement can be seen clearly in the X-ray. It is probable that the canvases were overlapped at the joins and then cut through along a straight-edge: this would explain both the precise joins and the slight crumbling of the paint layers at the upper and lower limits of the central piece, visible in the X-ray.

The question that must be addressed is when this mounting of the canvas pieces on panel took place and when the upper and lower parts were painted. The mounting on panel certainly appears to have been done in Rembrandt's studio, since the upper and lower pieces also have standard double grounds, identical to each other, although slightly different from that on the central piece: they have the same orange-red earth pigment below, but the upper layer is yellowish brown, containing a more granular lead white, splintery wood charcoal particles, some yellow earth and possibly also some yellow lake pigment (see Fig. 91).

The painting of the upper and lower parts, however, seems to have been done later, although how much later is difficult to determine. The evidence for this is partly stylistic – the handling of paint bears no resemblance at all to that on the central part – but also technical. Cross-sections from the upper part show a distinct discontinuity – probably a thin, discoloured varnish layer – between the upper ground layer and the paint. Moreover, one cross-section shows a crack in the ground layers which does not continue into the paint (see Fig. 93). Both these observations suggest that some time had elapsed before the painting was completed. We can therefore propose an intermediate state in which the central

Fig. 90 Detail of the figure at the right-hand edge of Cat. 7

part was finished, but the upper and lower parts were simply unpainted grey-brown ground: the entire structure was varnished in this state, and only somewhat later was the rest of the painting carried out over the varnish layer.

It is very difficult to be sure when this later painting was done, but it is most certainly not by Rembrandt and quite possibly not even from his studio. The later paint overlaps the original sky appreciably at the upper join, and the horizontal bar of the Good Thief's cross is also partly of this stage. The left edge of the original part is overpainted: the two figures at the extreme left are not original and are partly painted on the bare wood of the panel beyond the limit of the canvas. The figure of the Bad Thief is also entirely composed of later paint, the legs covering a substantial amount of Rembrandt's original. The reddish tone seen between the Bad Thief's legs is repeated on the underside of Christ's Cross and, in places, on the lower addition. The later painter has also added small touches to Rembrandt's own figures: for example the creamy highlight on the upper arm of the richly dressed woman at the right is identical in composition to the cream sky paint at the top left, and its fluid handling is also precisely the same. A cross-section of the highlight on the sleeve shows the original warm greyish underlayers with white, Cologne earth and umber, and then a pronounced discontinuity containing varnish before the later cream-coloured paint applied on top (Fig. 94). Medium analysis has also shown that the original paint is linseed oil, while the added sky is in poppyseed oil.

There are some *pentimenti* in the original part of the painting which have a direct connection with the complex British Museum drawing (Fig. 80). For example a large tower in the centre right background, which is dimly visible both on the picture surface and in the X-ray, occurs in the drawing. In the painting it was clearly tried out and then painted over. Similarly, there is a woman in a large flat hat standing behind the main group of figures in the drawing: she is faintly visible in the X-ray of the painting, standing in a similar position.

It appears that the painted grisaille and the drawing were developed simultaneously – that the drawing was made, altered, cut and added to while the various stages of the grisaille were proceeding. Certain features from one were incorporated in the other and vice versa, as Rembrandt worked out his trial composition. The drawing was adapted as he went along, in order to visualise the next stage of the painting. It is significant, for example, that on the drawing two parts have been cut, moved apart and remounted in order to make room for the diagonal of the ladder: and on the painting the original paper has been torn and cut away in this very area and the ladder painted in directly on the canvas at the second stage. It appears that experimentation with one version led directly to alteration in the other.

Certain features of the drawing were not pursued in the painting. The middle-ground figures (of which, as we have seen, the woman shows dimly in the X-ray) were not developed: neither was the cityscape with the large tower. Exclusion of these elements in the painting allowed Rembrandt to move the Good Thief on

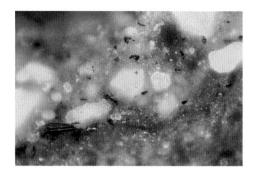

Fig. 91 Paint cross-section of double ground on added bottom strip of canvas in Cat. 7. The upper layer contains typical aggregate particles of lead white, with earth pigments and charcoal.
Magnification 360X

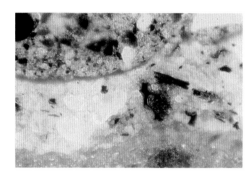

Fig. 92 Paint cross-section from interface between the sky paint on the upper added canvas strip of Cat. 7 and the upper ground layer, showing a thin film of intermediate varnish.
Magnification 315X

Fig. 93 Paint cross-section from warm grey sky paint, upper right corner of Cat. 7, over the double ground of the added canvas strip. Note the drying crack, which penetrates both layers of the ground, but not the overlying paint of the sky.
Magnification 160X

Fig. 94 Paint cross-section from later cream-coloured highlights on the sleeve of the kneeling woman to the right of the Virgin in Cat. 7, over the original greyish-brown paint. Note the discontinuity between the original and later paint.
Magnification 380X

his cross down into the central part of the composition: and, significantly, this too occurs where the paper of the first stage has been torn away.

That the different stages of the painted grisaille and the drawing echo each other is confirmed on the drawing itself. The parts proposed for the first stage of painting – those using the brown lay-in for shadows and half-tones – are done only in pen and ink on the drawing. In the second stage of painting – after the mounting on to canvas – the corresponding areas of the drawing are carried out in much coarser chalk and oil paint. The pen and ink lines on the drawing occur only before it was expanded to incorporate the ladder: all drawing lines thereafter are done in chalk and paint.

These observations could suggest the following overall sequence. The painted grisaille on paper was started first, but Rembrandt became dissatisfied with it. He made a copy of the existing composition on joined pieces of paper in pen and ink. He then experimented by cutting the drawing diagonally and remounting it; this allowed room for the ladder which he then included, along with other alterations carried out in chalk and paint. He then cut and tore the original grisaille to eliminate whatever was in this area, mounted it on canvas and painted the second stage including the ladder which he had developed in the drawing. However, he now developed the grisaille further by painting the Good Thief in a lower position: as we have seen, he chose to do this rather than pursue further the middle-ground figures or the larger cityscape which he had tried out in the drawing.

REFERENCES
HdG no. 136; Stechow 1929, pp. 217–32; Bauch 1966, no. 69; Bredius 1969, no. 565; Harris 1969, pp. 158–64; van Gelder 1973, pp. 193–4; Schwartz 1984, no. 109, p. 116; London 1988, no. 6, pp. 66–73; *Corpus*, vol. 3, 1989, no. A107; MacLaren and Brown 1991, vol. 1, pp. 321–8; Boston and Chicago 2003–4, no. 43, pp. 109–11.

NOTES
1 21.3 x 25.4 cm; Hind 1915–31, vol. 1, 1915, p. 29, no. 60; see Harris 1969 for a detailed discussion of the drawing.
2 MacLaren and Brown 1991, vol. 1, p. 326 and note 33.
3 Van Gelder 1973, pp. 193–4.
4 MacLaren and Brown 1991, vol. 1, p. 325.
5 Sumowski 1979–92, vol. 1, Bol no. 146x, pp. 316–17.
6 *Corpus*, vol. 3, 1989, no. 107, p. 94.
7 Boston and Chicago 2003–4, p. 111.
8 *Corpus*, vol. 3, 1989, no. A107, 1989, pp. 96–7.
9 *Corpus*, vol. 2, 1986, no. A66.
10 *Corpus*, vol. 3, 1989, no. A106.
11 For the different attempts to date the pictures see MacLaren and Brown 1991, vol. 1, pp. 322 and 325.
12 Govert Flinck, *The Lamentation*, signed and dated 1637, canvas, formerly with dealer Le Goupy, Paris; see Sumowski 1983–90, vol. 2, no. 612, p. 1019.
13 *Corpus*, vol. 3, 1989, no. A107, p. 99. See also Boston and Chicago 2003–4, no. 43, pp. 109–11.
14 *Corpus*, vol. 3, 1989, p. 97.

8 Belshazzar's Feast, about 1636–8

Canvas, 167.6 × 209.2 cm
Signed and dated on the right: Rembrand./F 163[?][1]
Inscribed top right-hand corner in Hebrew: Mene mene tekel upharsin
Bought from the Earl of Derby with a contribution from the National Art Collections Fund, 1964
NG 6350

The subject is taken from the Old Testament book of Daniel, chapter 5. During the 'great feast to a thousand of his lords' Belshazzar used the golden and silver vessels that had been looted from the temple in Jerusalem by his father, Nebuchadnezzar. Rembrandt, who focuses the action on the king and a small group of guests, shows the moment when the 'fingers of a man's hand' came forth and wrote upon the palace wall (5:5) – even though here it is seems that the letters are set against a cloud and a nimbus of light. Only Daniel was able to interpret the inscription, which foretold the king's death that night and the division of his kingdom (5:25–8: 'God hath numbered thy kingdom and finished it . . . Thou art weighed in the balances, and art found wanting . . . Thy kingdom is divided, and given to the Medes and Persians.').

It is well known that the Hebrew formula for the inscription is the same as that used by the Jewish scholar Menasseh ben Israel (1604–57) in his *De termino vitae libri tres* of 1639 (Fig. 95).[2] The date of the publication of ben Israel's book cannot, however, be regarded as a *terminus post quem* for the execution of the painting.[3] Rembrandt could have obtained the formula from Menasseh before the publication of his book. It is clear that Rembrandt had known Menasseh earlier, for he had etched the scholar's portrait in about 1636, though the often repeated suggestion that the two lived close together in the Sint Anthonisbreestraat is a myth. As Dudok van Heel explained in an article in 1993, Menasseh never lived in that street but rather in an area called Vlooienburg on the banks of the Binnen Amstel.[4] Rembrandt rented a house in that area, known as the 'Suyckerbackerij' (sugar refinery), between May 1637 and May 1639.

There are two *pentimenti* in the painting that may well suggest that Rembrandt did not have the formula for the inscription in its published form in front of him when he began work. The lettering of the painted and printed inscriptions do not exactly correspond, and it has been pointed out that Rembrandt made a mistake with the last (bottom left) letter.[5] The unusual feature of the inscription is that it is to be read vertically from right to left rather than horizontally.[6] The precise nature of the encryption of the *Mene tekel* is an essential aspect of the story, for there must be a plausible reason why Belshazzar and his astrologers and soothsayers were not able to decipher it (Daniel 5:7–8); a matter of considerable debate among the ancient rabbis.[7] While not a frequently depicted subject in Dutch art, in the seventeenth century the story of Belshazzar's Feast was seen as a warning against excessively

Fig. 95 Menasseh ben Israel, *De termino vitae libri tres*, Amsterdam, 1639, p. 160.
London, British Library, inv. 1020.a.19(1&2)

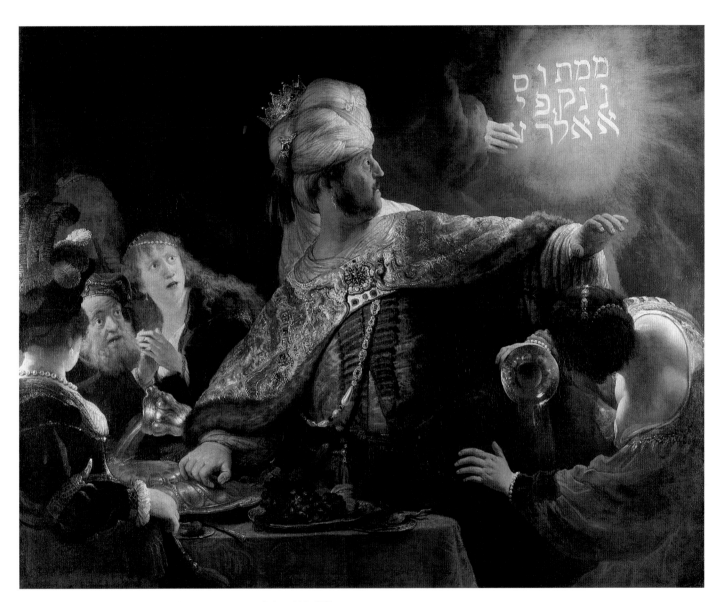

Fig. 96 *Belshazzar's Feast*, about 1636–8. London, National Gallery, NG 6350

sumptuous feasts – an 'evil delight that ends in sorrow' – and against the desecration of sacred objects in pursuit of one's own pleasure.[8] For obvious reasons the subject was often used for paintings that decorated dining rooms.[9]

In scale and in violence of expression and gesture as well as in the dramatic light effects, the painting recalls *The Blinding of Samson* of 1636 in Frankfurt (Fig. 98). There are analogies with individual poses from *The Angel taking Leave of Tobias* of 1637 in the Louvre[10] and *The Wedding Feast of Samson* of 1638 in Dresden (Fig. 99). Further stylistic parallels can be found in the *Artemisia* of 1634 (Museo del Prado, Madrid) and *Minerva* of a year later (Otto Naumann, New York).[11] A date of about 1636–8, therefore, seems most likely for the work. There is no clear prototype for this composition, but it has been suggested that the pose of Belshazzar may have been adapted from Pieter Lastman's Ahasuerus in *Ahasuerus's Fury* in Warsaw.[12] The recoiling woman in the lower right may have been inspired by the woman helping Europa keep her seat on the bull in Paolo Veronese's *Rape of Europa* in the Ducal Palace in Venice, of which the Amsterdam merchant Joan Huydecoper seems to have had a copy.[13] The woman has also been compared to the man centre left, seen from the back, in Rembrandt's etching of *Christ driving the Money Changers from the Temple*.[14] More generally, the close-up view of the large half-length figures silhouetted against a dark background calls to mind the work of the Utrecht Caravaggists. This group of painters, active in Utrecht, was inspired by the work of Caravaggio, particularly his use of half-length figures and pronounced and dramatic light effects, and they in turn influenced Rembrandt during the early years of his career.[15]

The support of *Belshazzar's Feast* consists of two equal widths of canvas, joined by a central vertical seam. Presumably the warp threads are vertical, and so the width for each piece is about 104.6 cm: however, allowing for the seam overlap, tacking edges and canvas lost by trimming (see below) the original loom width must have been somewhat more, perhaps corresponding to the standard '1½ ell' width of about 107 cm.

Several important observations have been made about this canvas by Ernst van de Wetering. First, there is the same distinct vertical weave fault about 20 cm in

Fig. 97 *Abraham's Sacrifice*, 1636. Oil on canvas, 195 × 132.3 cm. Munich, Alte Pinakothek, Bayerische Staatsgemäldesammlungen, inv. 438

Fig. 98 *The Blinding of Samson*, 1636. Oil on canvas, 205 × 272 cm. Städelsches Kunstinstitut, Frankfurt am Main, inv. 1381

Fig. 99 *The Wedding Feast of Samson*, 1638. Oil on canvas, 126.5 × 175.5 cm. Staatliche Kunstsammlungen Dresden, Gemäldegalerie Alte Meister, inv. 1560

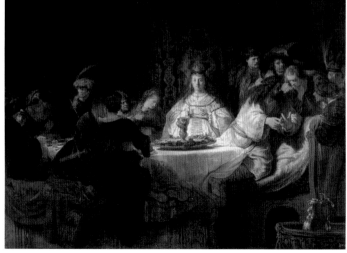

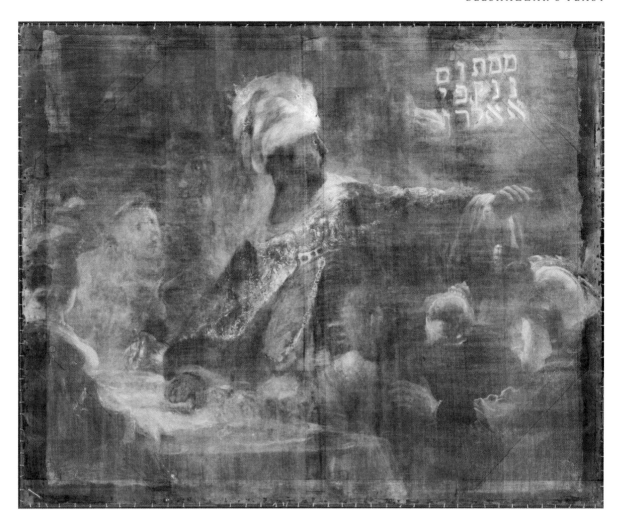

Fig. 100 X-ray mosaic of Cat. 8

from each vertical edge, made visible by the X-ray (Fig. 100). This tells us that the two pieces were cut from the length, placed one on top of the other in the same orientation, seamed along one edge and then opened out flat. But it tells us more besides. The same weave fault, thread count and general weave characteristics are found in other paintings – for example *Minerva* and *Abraham's Sacrifice* in Munich (Fig. 97).[16] In *Abraham's Sacrifice*, however, two widths are similarly joined with a vertical seam, but along the opposite edges so that the faults are 20 cm from the centre line. Thus it would seem that the canvases for these two paintings came from the same bolt of cloth, and were probably seamed and prepared at the same time.[17]

The second important point about the canvas of *Belshazzar's Feast* is that at some stage narrow wedge-shaped pieces have been cut from all four sides, perhaps during lining. This was detected by study of the cusping, which becomes progressively shallower along each side, and by measuring the widths of each canvas piece, which differ at top and bottom. The result of this is that the whole picture is now twisted

slightly anticlockwise. The seam slopes to the left, the table runs uphill and the wine spilt by the woman at the right falls towards the right instead of vertically. If the missing pieces were replaced (although there are no plans to do so) these small misalignments would be corrected.

The canvas is prepared with a double ground similar to that in *Saskia van Uylenburgh as Flora* (Cat. 6) and the *Self Portrait at the Age of 34* (Cat. 9). The lower layer infilling the canvas weave is of a fairly pure orange-red earth with on top a light fawnish grey consisting of granular lead white combined with some umber and black pigment (Figs 101–2 and 104), although not wood charcoal as in the upper ground of *Saskia*. The umber content has been confirmed by analysis.

The paint layers, although superficially colourful and bright in many areas, have a strikingly dense and dark tonality about them. The reason for this is seen by studying the craquelure on much of the picture surface: showing through almost everywhere is a dark underlayer. It is a particularly prominent feature of the slightly greenish-grey background glare that surrounds the writing on the wall (Fig. 101), even occurring beneath the heavy impasto of the lettering itself and the thickest parts of the brocade cloak (Fig. 103). Dark translucent paint underlies the flesh painting as well, lending a morbid tonality to the surface colour; in the paint of Belshazzar's outstretched hand for example (Fig. 106), it is present as a most substantial layer (see Fig. 104). Dark underpaints occur in the shadows of the woman's red dress and sleeve, where they form a complicated part of the construction of light and shadow (Figs 102 and 105), and, surprisingly, the deep translucent black dress of the woman to the far left has a thin rich brown underlayer for the bone-black glaze that completes the paint structure. These dark preliminary paint layers, which in all cases lie directly on the upper greyish ground, are so general in the picture that there must be a fairly complete composition laid out in sombre tones beneath the more colourful opaque paint of the flesh and drapery at the surface. In this case we can conceive of the underpainting as evidence of a fully realised 'dead-colouring' stage, created before the composition was worked up into its finished form, and involving what seems to be a painted sketch executed mainly in translucent browns. These are composed of bone black, extended with chalk, and adjusted with small quantities of coloured pigment, usually red lake, and the darker earth pigments. Several of these dull underlayers contain the blue cobalt-glass pigment smalt; but whether for its colour, as a bulking agent or perhaps as a drier is not certain. It is only the glazed-in deep-black background to the upper left and the greyish tablecloth in the foreground that have remained uncovered from this first stage of painting.

As a result of the very dark underpaint, the colours are painted thickly and opaquely, relying on their own brilliance rather than on any reflected light from underneath except where the underpaint is intended to reinforce shadow, as in the red sleeve of the woman to the right. The texture of the paint varies enormously from huge encrustations of impasto in Belshazzar's cloak (see Fig. 108) and clasp

Fig. 101 Paint cross-section from thick dark underlayer of the greenish-grey background wall over the double ground, at the right of Cat. 8. The surface paint contains smalt.
Magnification 170X

Fig. 102 Paint cross-section from dark red shadow of the sleeve of the woman's dress at the right of Cat. 8. There is a black underlayer glazed with deep red lake over the double ground. A final scumble of vermilion is drawn across the surface.
Magnification 160X

Fig. 103 Paint cross-section from pale yellow impasto of Belshazzar's cloak in Cat. 8. The thick upper layer is lead-tin yellow, and the underlayers make use of a variety of earth colours, bone black, chalk and yellow lake. The double ground is visible beneath.
Magnification 170X

Fig. 104 Paint cross-section from shadow of Belshazzar's outstretched hand in Cat. 8. The flesh paint, of yellow earth, yellow lake, white and vermilion, is underpainted with a thick layer of translucent dark brown, laid over the double ground. Magnification 160X

Fig. 105 Paint cross-section from opaque orange highlight on sleeve of woman's dress at the right of Cat. 8. Vermilion combined with lead-tin yellow forms the surface paint, over a semi-glaze of red and yellow lakes mixed with vermilion. Note the dark under-modelling layer over the fragment of double ground. Magnification 160X

and the writing on the wall to the relatively smooth, but still substantial, flesh and background passages, and the delicate use of the brush-end to scratch out the curls of Belshazzar's beard (see Fig. 107).

The use of colour in *Belshazzar's Feast* has no counterpart among the National Gallery Rembrandts other than in *Saskia as Flora* and, on a much smaller scale, in *The Woman taken in Adultery* (Cat. 10). Not only is the range of pigments much greater than in most of the other pictures, but they are used in daring technical ways to produce quite specific effects of colour. In some ways the paint layer structures are easier to interpret than for *Saskia*, since there is no major change in the composition to contend with, as in that picture. Perhaps the piece of painting most striking for its unconventional technique is of the red dress of the woman spilling wine. In the deepest shadows it makes use of a powerful purplish-red lake glaze over a compact layer of bone black. Final scumbles of scarlet and orange-coloured vermilion are dragged over for the highlights (Fig. 102). The more orange-toned opaque lights incorporate lead-tin yellow with the vermilion, but over a rich translucent orange-brown of red and yellow lakes containing suspended particles of vermilion (Fig. 105). Elsewhere the technique is modified yet again, with yellow ochre, vermilion and white drawn across a dark brownish-purple glaze-like paint of red and yellow lakes containing quantities of smalt. This underlayer of a highly unusual combination of pigments is also to be found in the late portrait on canvas of *Margaretha de Geer* (Cat. 18).

Belshazzar's brocaded cloak (Fig. 108) and under-robe are painted in an equally rich palette. The fundamentally opaque technique of the impasto of the cloak recalls the embroidered band at Saskia's waist and, less elaborately worked, the painting of the gold chain in the *Portrait of Philips Lucasz.* (Cat. 5). The thickest highlights of the embroidery of the cloak and jewelled clasp are of pure lead-tin yellow (Fig. 103), exactly like the raised bright yellow paint of the lettering on the wall. The highlights have been worked wet-into-wet over applications of pure yellow ochre and over brown, somewhat translucent mixtures of dark-coloured earth pigments, chalk and lead white. Overall the choice of pigments is wide

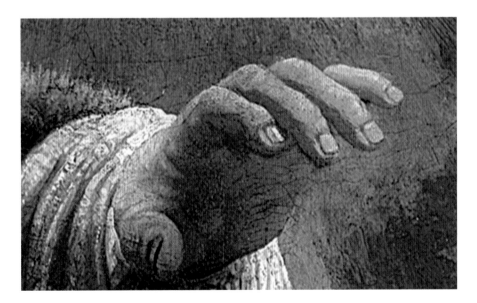

Fig. 106 Detail of Belshazzar's left hand from Cat. 8

ranging, with a variety of yellow and orange-coloured ochres as well as yellow lake used at the surface for the mid-tones, and both underpainting and glazing layers containing bone black combined with chalk.

For the dark claret shadow of the under-robe to the right, the technique is quite distinct from the construction of the equivalent colours of the woman's red sleeve: there is an orange-red lower layer comprising earth pigments, red lake, vermilion and white, glazed over with one of Rembrandt's usual dark glazing mixtures of bone black and red lake containing just a little yellow ochre and lead white. A similar translucent mixture is present beneath the horizontal bands of greenish-grey embroidery on the under-robe (Fig. 109). Blue and green pigments used for their colour alone are not a common feature of Rembrandt's painting after his Leiden years, but in the striking touches of these colours, both *Belshazzar's Feast* and *Saskia as Flora* are exceptional. There is no pure green pigment at all in either painting, but the colour is achieved with mixtures of blue mineral azurite with yellow earths or yellow lake, and in combination with black. The deep green jewels sewn into the cape and the intense blue-green beads make use of these pigments, while the greenish embroidery on the under-robe has lead white mixed with the azurite (Fig. 109). There is also a second blue pigment, used as a dramatic contrast with the surrounding darks, for the feathers of the headdress of the woman to the left. Here the pure mid-blue touches are of fine-quality smalt mixed with chalk and lead white.

Fig. 107 Detail of Belshazzar's beard from Cat. 8

The flesh paints in this painting contrast strikingly with those in the *Saskia* of only a year or two before. In *Saskia* Rembrandt has observed scrupulously the painter's convention of the cool half-tones, and the sensitivity of the three-dimensional modelling in her face is remarkable. In *Belshazzar's Feast*, the warm–cool–warm sequence moving from light to shadow in the flesh areas is hardly observed at all. Almost everywhere warm shadows are placed directly beside warm lights; the result is strangely flat, unmodelled and linear. It must be deliberate, consciously sought, aiming perhaps for a two-dimensional, almost theatrical tableau. Clearly the painting, with its broad handling, was not meant for close inspection but for a distant, grand effect; and that, presumably, is the key difference, both in intention and technique, between it and the more intimate portrait of Saskia.

It is unclear whether some of these idiosyncrasies in the paint handling are the stylistic inconsistencies between the central character and the 'peripheral figures' that Arthur Wheelock perceived recently, and which led him to suggest that the picture is not entirely by Rembrandt's own hand, but was painted with the help of studio assistants.[18] For the reasons given above the authors – as well as other scholars[19] – believe that these stylistic differences can be easily explained within the context of the painting and that they are not

Fig. 108 Detail of Belshazzar's cloak from Cat. 8

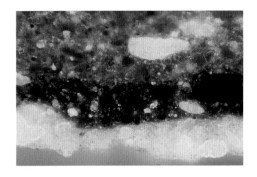

Fig. 109 Paint cross-section from greenish embroidery on Belshazzar's under-robe in Cat. 8, showing the use of a mixture of natural azurite with a little yellow ochre and white. The lower layer combines red lake pigment, bone black and a trace of white. Lower ground layer missing from the sample.
Magnification 315X

sufficiently uncharacteristic to necessitate the attribution to a different hand.

For the flesh paint in general, opaque yellow and yellow-brown layers overlie darker underpaints, which are probably initial 'dead colouring'. These early parts of the painting of the flesh tones vary in composition, with greyish browns containing smalt beneath yellowish surface layers for the shadows of the necks of the two women to the left, and a rich brown under the reddish shadow of the palm of Belshazzar's outstretched hand (Fig. 104). The mid-brown of Belshazzar's neck involves a similar method of painting. The yellow and yellow-brown, relatively unmodelled surface paint for flesh makes use of various combinations of earth pigment, lead white and yellow lake to which a little vermilion has sometimes been added (see, for example, Fig. 105).

The X-ray shows some changes made during the painting process. Belshazzar's turban was higher at the back before the crown was added. To his right (our left) is the shadowy face of a man, subsequently painted out. Belshazzar's right hand was apparently open, the fingers straighter and not clenched; and the dish beside it was taller. There is some highlighted drapery at his waist which has been subsequently glazed over. The writing has been slightly modified; but only the size of the letters, not their forms. The X-ray also shows us the reserve left for the back of Belshazzar's neck. This was presumably originally intended to be light-coloured background, but was then transformed into the flowing turban. The shadowy musician at the back does not register at all in the X-ray and must be painted in earth colours alone.

REFERENCES
HdG no. 52; Hausherr 1963, pp. 142–9; Bauch 1966, no. 21; Bredius 1969, no. 497; Washington, Detroit and Amsterdam 1980, no. 26, pp. 144–5; Schwartz 1984, no. 182, p. 174; London 1988, no. 7, pp. 74–9; *Corpus*, vol. 3, 1989, no. A110; Berlin, Amsterdam and London 1991–2, no. 22, pp. 184–6; MacLaren and Brown 1991, vol. 1, pp. 362–4; Amsterdam and Jerusalem 1991, p. 111; London 2003–4, pp. 35, 176–7, no. III; Amsterdam 2006, pp. 156–62.

NOTES
1 The signature and date can be best seen in ultra-violet light; there is a damage after the 'd'; much of the penultimate digit of the date is damaged so that only the top of the '3' remains; the last digit is lost.
2 Hausherr 1963, pp. 142–9, esp. p. 144.
3 See also *Corpus*, vol. 3, 1989, no. A110, p. 132; Berlin, Amsterdam and London 1991–2, vol. 1, p. 186; MacLaren and Brown 1991, vol. 1, p. 363.
4 Dudok van Heel 1993, pp. 28–9.
5 Littman 1993, p. 296. He observes that the last letter is in fact a *zayin* rather than what it should be, a *nun*. The error may have occurred when Rembrandt adjusted the letter in the final paint layer to make it seem that the hand is still in the process of writing it.
6 Hausherr 1963, p. 142; based on Landsberger 1946, p. 151.
7 Nadler 2003, pp. 125–6; for Rembrandt's relationship with Menasseh ben Israel see also pp. 126–8.
8 Berlin, Amsterdam and London 1991–2, vol. 1, p. 186; *Corpus*, vol. 3, 1989, p. 132.
9 *Corpus*, vol. 2, 1986, p. 132.
10 *Corpus*, vol. 3, 1989, no. A121.
11 The catalogue numbers for these works in the *Corpus* (vol. 3, 1989) are: *The Blinding of Samson* (A116); *The Angel taking Leave of Tobias* (A121); *The Wedding Feast of Samson* (A123); *Minerva* (A114); and in vol. 2, 1986: *Artemisia* (A94).
12 Białostocki 1969, vol. 1, p. 221, with ill.
13 Washington, Detroit and Amsterdam 1980, no. 26, p. 144. For the connection with Veronese's work see Clark 1966, p. 109 and fig. 95; recently republished in New York 2000, pp. 28–41, esp. p. 30. The argument has been reiterated in Berlin and Amsterdam, London 1991–2, vol. 1, p. 186.
14 Holl. B69; MacLaren and Brown 1991, vol. 1, p. 363.
15 *Corpus*, vol. 3, 1989, p. 130. On this subject see also Amsterdam 2006.
16 Ibid., under no. A108, copy 2.
17 Ibid., p. 125.
18 Wheelock 1995, p. 209, note 24.
19 Liedtke 2004, pp. 57–8 and p. 72 note 73, who disagrees with Wheelock's assessment.

9 Self Portrait at the Age of 34, 1640

Canvas, now with arched top, 102 × 80 cm
Signed on the sill bottom right: Rembrandt. f 1640 and inscribed below this: Conterfeycel[1]
Bought from Comte de Richemont, Vicomte de Richemont and Baron de Richemont, 1861
NG 672

In this picture, one of Rembrandt's most distinguished self portraits, the artist
shows himself at the height of his fame as the most successful history and portrait
painter in Amsterdam. His wealth is proclaimed in his elegant clothes: he is dressed
in velvets and furs, a gold chain lies across his chest and jewels sparkle in his cap.
The painting closely follows a design for a self-portrait etching made by Rembrandt
in 1639. It is a well-established tradition to assume that both the print and the
painting are based on two great Italian Renaissance portraits, Raphael's *Portrait of
Baldassare Castiglione* (Fig. 110) and – more importantly – Titian's portrait of a *Man
with a Quilted Sleeve* (Fig. 111), whose sitter was in the seventeenth century thought to
be the great Italian poet Ludovico Ariosto.[2] Rembrandt certainly knew the Raphael,
as he made a sketch of it (see Fig. 113) at or shortly after the sale of Lucas van
Uffelen's pictures in Amsterdam in April 1639, when it was bought by Alfonso
López. (Rembrandt noted on his drawing that the painting had fetched 3,500
guilders.) He could have also seen the 'Ariosto' in Amsterdam since it (or a copy of
it) was in Lopez's collection there at some time between 1637 and November 1641.

The suggestion that the Titian is the more important model of the two is based
on perceived similarities of the poses of the figures: their bodies are facing to the

Fig. 110 Raphael, *Portrait of Baldassare Castiglione*,
1514–15.
Oil on canvas, 82 × 67 cm.
Paris, Musée du Louvre, inv. 611

Fig. 111 Titian, *A Man with a Quilted Sleeve*,
about 1510.
Oil on canvas, 81.2 × 66.3 cm.
London, National Gallery, NG 1944

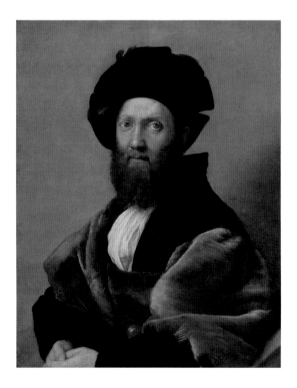

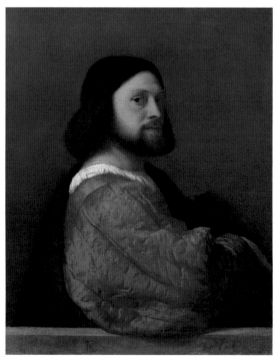

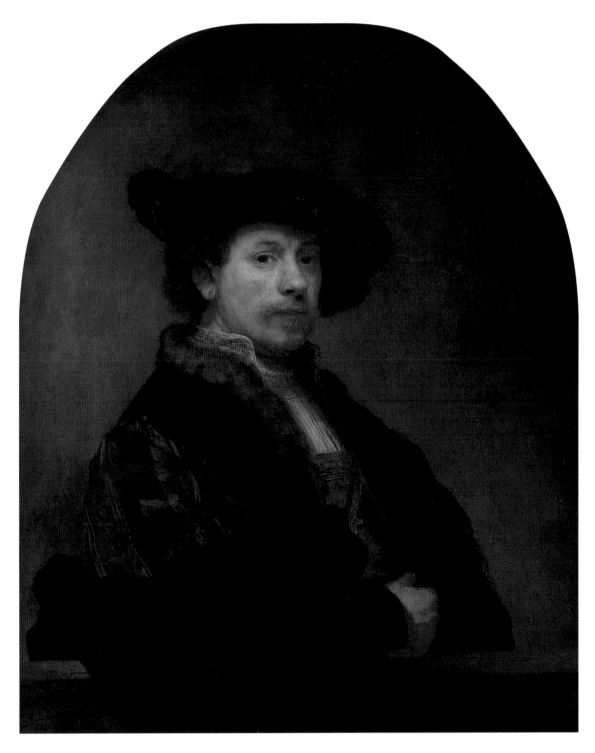

Fig. 112 *Self Portrait at the Age of 34*, 1640. London, National Gallery, NG 672

right; the angle of their heads and bodies are seen as similar; and both pictures are concerned to stress the richness of the material of the sleeve.[3] The parallels with Raphael's painting, however, are at least as striking. Not only do Rembrandt and Castiglione's clothes bear certain similarities, but also the colours and contours of the figures and the position of their bodies – both are turned more towards the viewer – are comparable. The key difference is that Castiglione does not rest on the ledge in the foreground as Rembrandt does. Much has been made of the notion that both Titian's man and Rembrandt 'lean' on the parapet. When one considers the anatomy of Titian's sitter more carefully, however, it becomes evident that his elbow must actually be hovering several centimetres above the ledge with the bulky fabric of the quilted sleeve loosely filling the space in between; if he were leaning on the ledge the fabric would be more compressed. This, combined with the lighting that falls mainly on his neck and the back of his shoulder and only partly illuminates his face, gives Titian's sitter a more dynamic pose – he seems to be turning away from us – than Rembrandt's self-confident stance.[4]

More recently another – perhaps more compelling – comparison has been suggested for the self portrait. As Marieke de Winkel has indicated, Rembrandt's dress in this painting, particularly the beret with its raised brim, clearly derives from costume of the earlier part of the sixteenth century.[5] In this picture Rembrandt wears a type of housecoat, known as a *tabbaard*, with a fur-trimmed collar and brown, striped sleeves.[6] The jerkin underneath has a square neckline, characteristic of sixteenth-century dress, and a braid trim. This is worn over a doublet with a high-standing collar and a white shirt that is smocked at the neck and has a small ruche.[7] It has often been said that Rembrandt would have made use of a large collection of costumes he is supposed to have had in his studio, yet in the inventory of his possessions that was drawn up in 1656 there is no trace of any such collection. Instead Rembrandt must have taken his inspiration from various

Fig. 113 *Sketch of Raphael's Portrait of Castiglione*, 1639.
Pen and bistre, 16.3 × 20.7 cm.
Vienna, Albertina, inv. 8859

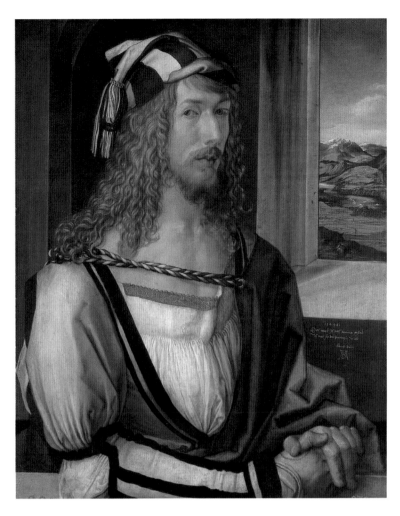

Fig. 114 Albrecht Dürer, *Self Portrait*, 1498.
Oil on wood, 52 × 41 cm.
Madrid, Museo Nacional del Prado, inv. 2179

sixteenth-century prints of artists' portraits, such as that of Lucas van Leyden (about 1494–1533).[8] However, as Stephanie Dickey and Volker Manuth have independently observed, for the composition of his self portrait Rembrandt seems to have had the self portrait of Albrecht Dürer of 1498 (Fig. 114) in mind.[9] Here one can draw close comparisons between the poses of the sitter and the placement of their arms on their respective parapets. In Dürer's painting the artist also included his proper left hand, an idea that Rembrandt had toyed with and later abandoned (see below). It is possible that Rembrandt would have seen the Dürer when Thomas Howard, Earl of Arundel (1584–1646), travelled with it through the Netherlands in 1636 on his way back to England. (The picture was a gift from the city of Nuremberg to King Charles I of England.) Moreover, there is clear evidence that Rembrandt greatly appreciated Dürer's work and collected great numbers of his prints.[10]

It seems clear that Rembrandt is here self-consciously emulating the art of his most famous predecessors. Whether by following Titian's 'Ariosto' and thus implying a distinction between his own art of painting and Ariosto's art of poetry, as de Jongh has suggested, Rembrandt intended to take part in the contemporary debate in which the relative status of the two arts was endlessly discussed – the so-called *paragone* – remains debatable.[11] Rather, with his approach, Rembrandt more obviously places himself in the tradition of the great European artists, northern and southern, who had preceded him and whose tradition he saw himself perpetuating.[12]

The half-length composition and the pose of the sitter were extremely influential and were adopted by a number of Rembrandt's pupils, among them Govert Flinck (see Fig. 115), Gerbrand van den Eeckhout (1621–74)[13] and Aert de Gelder (1645–1727).[14] Ferdinand Bol (1616–80) also painted himself in this pose in 1647 – and, interestingly, depicted himself with his left hand resting on the parapet at the lower right of the painting (see Fig. 116).[15] The significance of this is that Rembrandt similarly included his left hand in this self portrait, but as we can confirm from the X-ray (see Fig. 117) then suppressed it: Bol was, therefore, basing his self portrait on Rembrandt's composition at an intermediate stage of painting, which he must have seen in Rembrandt's studio. This is just one example of a pupil or associate reproducing Rembrandt compositions while still in progress: another is the version of Rembrandt's *Self Portrait in Oriental Costume* of 1631 in which a pupil – possibly

Isaac Jouderville – made his copy before Rembrandt had added the poodle in front of his feet.[16]

The shape of the canvas support has been altered more than once since the portrait was painted. It was probably originally rectangular and then, somewhat later, cut down to an arched format. The remains of the curved tacking edge can be seen clearly in the X-ray near the top corners (Fig. 117): the fact that this tacking edge bears original paint and ground continuous with that on the main part of the canvas is a sure sign that the picture has been cut down, and makes it unlikely that this was the original shape of the portrait. Later still, extra pieces were added to the bottom and at the top corners, to make a larger rectangle. The true lower edge of the picture is visible in the X-ray as a white line just above the stretcher bar. The canvas was removed from this stretcher in the 1970s and is now marouflaged on to a synthetic panel.

The condition of the canvas support is problematic. While the X-ray shows the image of a weave that is undoubtedly original, it is clear that the original canvas is no longer present: all that we are seeing in the X-ray is the memory of the canvas weave imprinted in the dense ground layers. Two observations suggest that this is the case. First, the paint surface has the slightly sunken, wrinkled texture that is often associated with a transferred picture subsequently relined. Second, cross-sections show a highly unusual layer of black paint or adhesive between the lower layer of a conventional double ground and the present canvas (see Fig. 118). In one section it is possible to see the curved imprint of a coarse canvas thread on the bottom surface of the original ground filled by the black paint which, in turn, bears the multiple imprint of a finer canvas weave. In another place there is an equally unusual grey filler below the original ground, which can be explained only if thin or missing areas of the original ground were filled from the back during the transfer process.

Why is it not obvious when the original canvas is missing? Can its absence not be detected by simple examination? The answer is that an old transfer from canvas to canvas results in a structure almost indistinguishable from the original; and subsequent relinings which conceal the back of the canvas make it impossible to compare its weave with that seen in the X-ray. Unless the layers of canvas are removed from the back of the painting it is very difficult to be sure, except where unusual evidence such as that found here comes to light. The transfer probably took place before the reduction to the arched format, since it is unlikely that the fragments of tacking edge would have survived the process. The transfer certainly took place long after Rembrandt painted this self portrait, and therefore has no direct bearing on his technique. However, interpretation of the technical evidence depends on a realisation that such changes may have occurred.

The original canvas had a double ground, consisting of a heterogeneous lower layer of coarse red earth, with a thinner fawnish-grey priming of lead white, brown earth and a little charcoal on top (see Fig. 119); these layers have survived the

Fig. 115 Govert Flinck, *Portrait of a Man*, 1643.
Oil on panel, 72 × 53 cm.
Private collection

Fig. 116 Ferdinand Bol, *Self Portrait*, 1647.
Oil on canvas, 101 × 88 cm.
Toledo Museum of Art, Ohio. Gift of George P. MacNichol, Jr, inv. 1980.1347

Fig. 117 X-ray mosaic of Cat. 9

transfer. The ground colour plays almost no direct part in the finished painting. The whole picture is painted in a smooth, meticulous technique and covers the ground completely. This is Rembrandt at his most precise and controlled; there is virtually no impasto, no contrast of thick or thin paint, no use of open brushwork to suggest form, texture and the play of light. Everything is achieved with blended colour quite unlike the fluid portraits of the mid-1630s or the massed lead-white underpaints of later years. Perhaps the only texture trick in the picture is the by now familiar one of suggesting the hairs at the back of the neck by scratching with a stylus or brush-end in the wet paint; in the adjacent fur collar, Rembrandt resists the temptation to repeat the trick and paints the fur in the normal light scumbles of brown and black over the dark cloak.

The X-ray shows two notable *pentimenti*. First, as already mentioned, the artist's left hand was originally included, the fingers resting on the parapet next to the other hand. The composition is clearly a more powerful one without it and the painting-out is undoubtedly original. A cross-section through the right side of the cloak just above the parapet shows a thin layer of black paint from the sitter's garment concealing the painted-out hand (Fig. 119). The flesh paint itself is executed as two substantial layers of lead white, yellow and red ochres, with a little vermilion and a translucent brown pigment, probably Cologne earth, laid over a thin sketching layer of mid-brown paint, which may well represent the initial design for the hand. The high lead-white content of the paint ensures that this hidden feature is readily revealed in the radiograph. By contrast, the dark glaze on top is the thinnest covering of bone black, charcoal and red lake pigment, of much the same composition as the surface paint at the shoulders, where no redesign of the figure has been carried out.

The second *pentimento* reveals that the coloured collar was once a more rounded shape and extended further to the right, and that the shirt front was longer. These alterations can be seen if the picture surface is examined closely. The X-ray also shows that the reserve left in the background for the left arm was smaller than the present silhouette, which thus extends over the background paint. Intriguingly, there does not seem to be a correspondingly clear reserve left for the artist's hat: this must therefore be painted over the paint of the background, or be in paint of almost identical density.

The face was probably modelled in the conventional sequence: the brown lay-in of the shadows, followed by flesh mid-tones, highlights and final details of shadow, beard, eyes and so on. However, it is constructed so smoothly and opaquely of blended tones that the underlayers seem to play no part in the final appearance. The half-tones, for example, are cool surface layers, rather than the warm undertones showing through semi-transparent flesh paint that we see in other portraits.

The background colours and parapet are painted rather solidly, in a less glaze-like technique than comparable paintings. A single fairly thick layer of yellow and red earth pigment, black and translucent brown combined with white is used

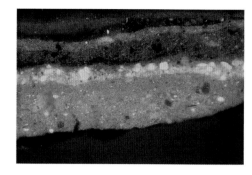

Fig. 118 Paint cross-section from lower part of the parapet in shadow, at right in Cat. 9. The double ground and a thin layer of black transfer adhesive beneath the orange lower ground are visible. Magnification 155X

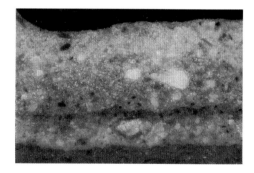

Fig. 119 Paint cross-section from the painted-out hand beneath the cloak to the right in Cat. 9. Magnification 360X

Fig. 120 Paint cross-section from greenish-grey background just above parapet to the right in Cat. 9. Magnification 400X

(Fig. 120). The lower part of the parapet makes use of two layers: an undermodelling of warm brown consisting of ochre, red lake, bone black, chalk and lead white, with a thinner, lighter yellow-brown on top (Fig. 118). The yellow ochre of the upper layer here seems to have been much extended with chalk which would provide additional translucency.

REFERENCES

HdG no. 550; Bauch 1966, no. 316; Clark 1966, pp. 123–7; Bredius 1969, no. 34; de Jongh 1969, pp. 49–67; London 1980 (with further references); Schwartz 1984, no. 231, p. 215; Raupp 1984, pp. 168–71; London 1988, no. 8, pp. 80–5; *Corpus*, vol. 3, 1986, no. A139; Chapman 1990, esp. pp. 74–8; Berlin, Amsterdam and London 1991–2, no. 32, pp. 218–21; MacLaren and Brown 1991, vol. 1, pp. 339–41; Melbourne and Canberra 1997–8, no. 13, pp. 127–9; London and The Hague, no. 54, pp. 173–5; London and Sydney 2005–6, no. 16a.

NOTES

1 The signature and date have almost certainly been repainted and the flourish between the 't' and 'f' of the signature is a later addition; the word 'Conterfeycel', which until the 1690s was the usual Dutch term for portrait, seems to be by a different hand.

2 Clark 1966, pp. 123–7; Raupp 1984, pp. 168–71; *Corpus*, vol. 3, 1989, no. A139, pp. 379–80; Chapman 1990, pp. 74–8; Berlin, Amsterdam and London 1991–2, vol. 1, no. 32, pp. 218–21; MacLaren and Brown 1991, vol. 1, pp. 339–41; Melbourne and Canberra 1997–8, no. 13, pp. 127–9; Berger 2000, pp. 464–73; D. Rosand, 'Titian's Dutch Disciple', in New York 2000, pp. 8–21, esp. pp. 10–11; Dickey 2004, pp. 90–2. On the painting by Titian see most recently London 2003, no. 5, pp. 82–3.

3 London 1988, p. 80.

4 A painting that follows the pose, lighting and composition of Titian's man much more closely is a *Self Portrait* by Frans van Mieris of 1777 at Polesden Lacey, Surrey (Naumann 1981, vol. 2, no. 66, p. 81 and plate 66). The general influence of Titian's picture on van Mieris is mentioned in passing by Nicholas Penny in London 2003, p. 82.

5 London and The Hague 1999–2000, p. 68, *Corpus*, vol. 4, 2005, p. 71.

6 For more on the *tabbaard* in Dutch painting see de Winkel 1995.

7 London and The Hague 1999–2000, p. 68.

8 Ibid., pp. 68–70.

9 Dickey 1994, pp. 123–7; Dickey 2004, pp. 93–4; London and The Hague 1999–2000, p. 44 and under no. 54, p. 173; London 2002, p. 265.

10 Volker Manuth touched on this in his lecture at the Holbein-Symposium in Basel in 1997; see Manuth 1998.

11 De Jongh 1969, pp. 49–67; *Corpus*, vol. 3, 1989, p. 380. Berger 2000 refers to NG 672 as 'The Courtier' (p. 464). This is based on the remarkable notion that Rembrandt in his emulation of Raphael and Titian is trying to outdo them by 'transforming himself into one of their courtly patrons', yet ultimately – and deliberately – failing to do so (pp. 472–3).

12 London and The Hague 1999–2000, p. 44.

13 *Self Portrait at the Age of 16*, 1647, grey and black ink, grey wash over a sketch in black chalk, the background elaborated in black chalk, Paris, Institut Néerlandais, Frits Lugt Collection; see London and The Hague 1999–2000, no. 91, p. 240.

14 Aert de Gelder, '*Self Portrait*' with *Hundred Guilder Print*, St Petersburg, Hermitage; see Sumowski 1983–90, vol. 2, no. 811. Here it must be added that doubts have been raised about the identification of the picture as a self portrait.

15 For a discussion of Bol's self portraits in this mode see London and The Hague 1999–2000, under no. 87, pp. 234–5.

16 For these two pictures see also London and The Hague 1999–2000, nos 29a and b, pp. 137–9.

10 The Woman taken in Adultery, 1644

Oak, top corners rounded, 83.8 × 65.4 cm
Signed bottom right: Rembrandt. f. 1644
Bought with the Angerstein collection, 1824
NG 45

The story of Christ's forgiveness of the adulteress is told in the Gospel of Saint John, chapter 8. Rembrandt shows the moment when the Scribes and Pharisees, hoping to trap Jesus, bring the adulteress before him and ask whether the sentence of the Mosaic law, which condemned adulteresses to be stoned, should be carried out. One of them points to the kneeling woman. Christ replies, 'He that is without sin among you, let him first cast a stone at her.' (John 8:7).

This depiction of the scene is an outstanding example of Rembrandt's small-scale religious works of the 1640s. It reveals his great gifts as a colourist, an aspect of his art which is sometimes forgotten. The figures are dwarfed by the cavernous temple, their drama heightened by the fall of light on the ornate gilded altar and by the rich robes of the priest. The form of the altar may have been suggested by the type of ornamentation found in the work of Dutch silversmiths of the seventeenth century, such as that designed by Jan Lutma (1624–89), whose portrait Rembrandt etched in 1656 (B. 276). In the elaborately detailed, decorative treatment of much of the background the picture recalls Rembrandt's style of the early 1630s – for example the *Simeon praising Christ* of 1631 (Fig. 121)[1] – in a way that is otherwise unparalleled in the 1640s. The freely drawn foreground figures are, however, entirely consistent with his style in the mid-1640s. Rembrandt's ability in this painting to work simultaneously in two different styles is a valuable corrective to any attempt to define his stylistic development too rigidly.

Benesch identified six preparatory drawings for *The Woman taken in Adultery* (nos 531–5 and A42) but, with the exception of a study for the Adulteress (no. 535), they seem not to be by Rembrandt himself and should be placed among the large group of drawn and painted derivations as well as full and partial copies of this influential composition, such as, for example, *A Woman weeping* by an anonymous follower (see Fig. 128).[2] It has been observed that the figure of the adulteress follows that of a weeping Mary Madgalene at the foot of the Cross by Tintoretto, which Rembrandt might have known from an engraving by Johann Jenet of 1623.[3] The wide-ranging influence of the composition is also apparent in a painting by the Dordrecht painter Cornelis de Bisschop (1630–74), datable 1650/60, that follows the example of Rembrandt's painting remarkably closely.[4]

Rembrandt returned to the subject of Christ and the Adulteress years later in two bold drawings (Ben. nos 1046 and 1047), which show him abandoning the

Fig. 121 *Simeon praising Christ*, 1631.
Oil on panel, 60.9 × 47.9 cm.
The Hague, Mauritshuis, inv. 145

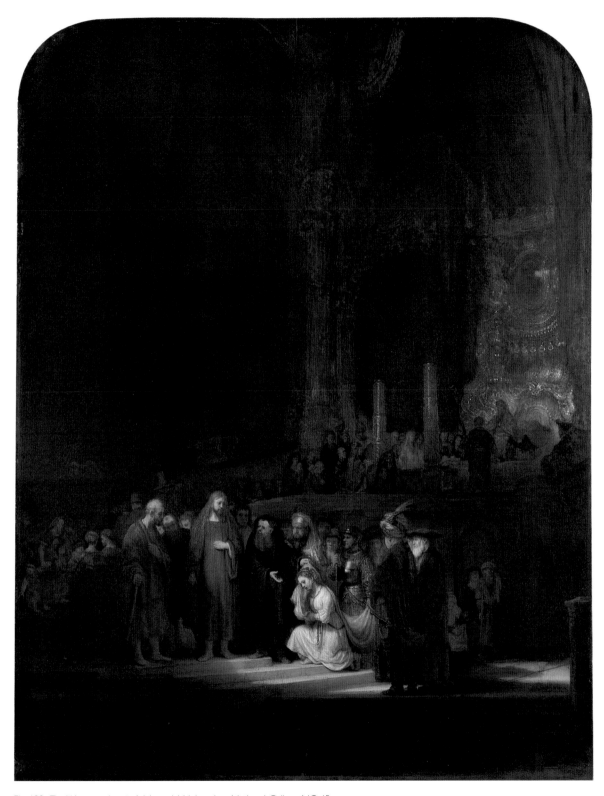

Fig. 122 *The Woman taken in Adultery*, 1644. London, National Gallery, NG 45

spaciousness of the composition of the National Gallery painting, and concentrating on the figure group and reworking it. The second of these drawings can be at least approximately dated, as it is drawn on the reverse of a death announcement of 14 May 1659. It also carries a quotation from the biblical text in Rembrandt's own hand. It seems likely, therefore, that around 1659/60 Rembrandt was working on a new version of the composition, but if these drawings were intended to be preparatory to a painting or an etching, such a work was never executed.

There are a number of *pentimenti*: one, perhaps two, figures on the extreme right, beside the man with the crutch, have been painted out. Other changes are in the face of the man in red in the right foreground, in the top of Christ's head and in the headdress of the man in yellow above the Adulteress.

The oak panel is very thick and heavy, and in fine condition except for a repaired split running down from the top edge. It was probably originally rectangular and had the top corners rounded off later. The evidence for this is twofold: the brushstrokes at the rounded edges are interrupted and fractured as if they have been cut and the bevelling on the back is right-angled, not curved. In addition, a black border, which may not be original, runs more or less continuously around the painted surface, but is absent at the rounded corners. The distinctive grain of the oak is made visible in the X-ray because the ground layers were able to absorb some of the X-rays (Fig. 125). As with Rembrandt's earlier panel paintings, the ground consists of a layer of chalk finished with a warm light brown *primuersel* of lead white combined with a little yellowish-brown earth pigment. Some of the lead white in this upper ground layer is present as large aggregate nodules of very pure pigment (Fig. 124), and it is mainly responsible for the visibility of the ground in the X-ray.

There is a prominent knot in the upper left centre which has been filled (probably during a subsequent restoration) with a dense filler. To the right of the knot is a large area which appears dark in the X-ray, the image of the wood grain apparently absent; there is a similar smaller area to the left of the knot. This gives a fascinating insight into the preparation of the panel before painting, because clearly the ground layers have been scraped away in these areas. Presumably the combination of prominent wood-grain and rough ground gave an unacceptable surface around the knot and it was necessary to scrape it and smooth it down. Whether Rembrandt himself or a specialist primer carried this out can of course only be guessed at, but the painter clearly needed the smoothest possible surface for a painting of such high finish. The absence of a complete ground in these areas has been confirmed by a cross-section from the thin paint of the central pillar which showed only a lightly applied brown glaze of pigments that do not absorb X-rays, principally bone black and red lake, over a trace of the chalk lower ground layer. The final *primuersel* containing lead white is not present here.

The painting of much of *The Woman taken in Adultery* is of a detailed, meticulous style using rich colours that echo Rembrandt's paintings of the previous decade. He

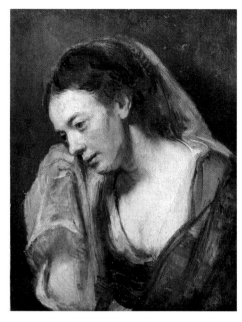

Fig. 123 Follower of Rembrandt, *A Woman weeping*, 1654–5. Oil on uncradled oak panel, 21.6 × 17.1 cm. Detroit Institute of Arts, Michigan. Founder Society Purchase, Mr and Mrs Henry Ford II Fund, inv. 56.183

Fig. 124 Paint cross-section of warm brown glaze at upper right corner of Cat. 10. The *primuersel* contains large aggregate particles of lead white. The glaze incorporates vermilion with earth pigments, lakes and bone black.
Magnification 195X

Fig. 125 X-ray mosaic of Cat. 10

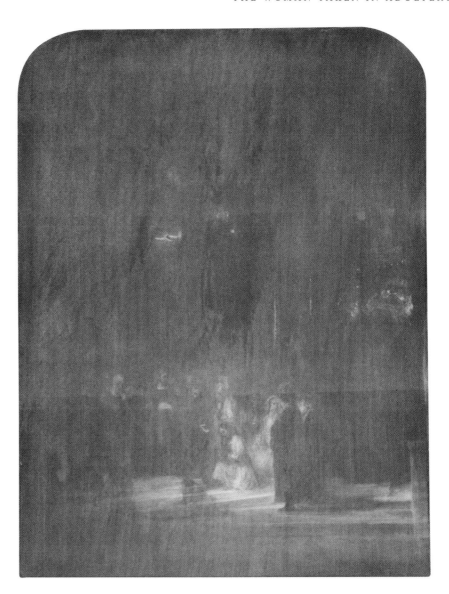

Fig. 126 Top surface of an unmounted fragment of paint from impasto highlight of pure lead-tin yellow on the throne in Cat. 10. Magnification 180X

seems to have consciously painted the principal figure group in the highly finished manner of the early 1630s and, although the background and secondary figures are handled more sketchily, there is still a marked contrast with the rather slack handling of *The Adoration of the Shepherds* (Cat. 11) painted just two years later.

The rather mannerist range of colour is created in a number of ways. In some cases rather pure pigment is used, for example tiny impasto dabs of unmixed lead-tin yellow (Fig. 126) and pure lead white for the reflections on the elaborate throne to the right. Small areas of blue and green complement the warmer tones, but these rely on mixtures of pigment dominated by blue or greenish-blue mineral azurite. The deep crimson cloak of the turbaned standing figure employs a similar

Fig. 127 Infrared photograph of Cat. 10

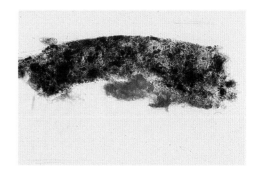

Fig. 128 Thin paint cross-section from warm brown glaze in Cat. 10 shown in Fig. 124 above, seen here by transmitted light. The transparent red and yellow pigments are evident, whereas the vermilion particles are so opaque that they appear black in transmitted light.
Magnification 145X

technique to the red dress of the woman to the right in *Belshazzar's Feast* (Cat. 8), although on a smaller scale. The rich effect is achieved in a most unusual way, with red lake glazes over a black underlayer in the shadows. The colour of the priming is used directly for the highlights of the architecture in the centre background (Fig. 129) and shows through the paint in the background figures and elsewhere. The main figures are painted thickly and opaquely with only minor adjustments of outline. The reserve left for the red-cloaked figure is the most striking feature of the X-ray: his outline was determined first and the illuminated forms behind painted up to it. There is a *pentimento* in this man's face (it was once larger) and in the face of the black-hatted man immediately to his left: the X-ray shows much more prominent

Fig. 129 Detail of the background in Cat. 10

features than those of the slightly shadowy head that we see on the surface. Further to the left, the turban of the man above the kneeling woman was initially taller.

At the right, next to the man with the crutch, there was at first another figure which may be seen in the infrared photograph (Fig. 127) and, vaguely, on the picture itself, but not on the X-ray except for the reserve in the floor left for his foot. The scale of this figure is too large for its position in the middle ground, and it was clearly abandoned at an early stage after the initial lay-in.

The infrared photograph also makes clearer the very free vigorous brushwork with which the background is constructed. Penetration of the infrared rays to the reflective ground enhances the glaze-like quality of the background paint. The composition of the dark-coloured glazes in the foreground and background depths is remarkably sophisticated, with a number of transparent and semi-transparent pigments mixed in continuous variation to achieve subtle gradations of colour even in the darkest tones. The glazes applied in single layers over the ground vary in composition and thickness, but all are based on some combination of bone black, red and yellow lake, and small quantities of earth pigment and vermilion. Where a deep translucent black is required the paint is mainly bone black with some added red lake pigment, and where a warmer, more opaque result is desired, the proportion of vermilion in the mixture is increased (Fig. 128). In passages of intermediate warmth and translucency, yellow, orange and red earth pigments become significant components of the paint. Translucency within the background colours is partly provided by admixture of chalk with the tinting pigments.

The main puzzle of the X-ray is the dark form which seems to lie across the steps in front of Christ and the kneeling woman. The position of the light source suggests that it cannot be a shadow and it is clearly connected to some further silhouettes in the X-ray to the left of it. It seems that these are reserves left for figures in the immediate foreground which were never developed. Cross-sections show two layers of off-white lead-containing paint in an area of shadow on the X-ray, while three are present in the adjacent more opaque sections; but it is difficult to assess how the composition might have differed here. Rembrandt perhaps intended the stream of figures behind the main group to curve round in front of them at the left side. This would clearly have diminished the dramatic impact of the scene on the steps and was not pursued.

REFERENCES
HdG no. 104; Bauch 1966, no. 72; Bredius 1969, no. 566; Schwartz 1984, no. 248, pp. 228–9; Golahny 1987; London 1988, no. 9, pp. 86–91; MacLaren and Brown 1991, vol. 1, pp. 328–30; Golahny 1999–2000, pp. 128–9.

NOTES
1 *Corpus*, vol. 1, 1982, no. A34.
2 MacLaren and Brown 1991, vol. 1, p. 329. For a partial copy of the weeping woman's head by an anonymous Rembrandt follower in Detroit (MacLaren and Brown 1991, vol. 1, pp. 329–30, note 14); see most recently Keyes 2004, no. 73, pp. 180–1.
3 See Golahny 1987 and Golahny 1999–2000, pp. 128–9; for the engraving see the illustration on p. 129.
4 Sumowski 1983–90, vol. 3, pp. 1961, 1965, note 66, and 1982 (ill.); Brière-Misme 1950–3, vol. 57, pp. 181–2.

11 The Adoration of the Shepherds, 1646

Canvas, 65.5 × 55 cm
Signed bottom left-hand corner: Rembrandt. f. 1646
Bought with the John Julius Angerstein collection, 1824
NG 47

This picture is connected with a larger painting in the Alte Pinakothek in Munich
(Fig. 130). It has been suggested that the London painting is a loose copy of that
in Munich, but the differences are too great for this to be an accurate description.
There are many significant differences between the various figures and their poses,
and the composition of the Munich painting is also reversed, so that the group of
the Holy Family is on the right and the standing shepherds are on the left. Rather,
this is a variation on the composition used by Rembrandt in the Munich canvas,
which is almost certainly the earlier of the two.[1] The National Gallery painting has
a number of *pentimenti*, some of which show considerable changes to the design.
The Munich painting is also dated 1646 and was one of the last two of a series of
scenes from the life of Christ painted for the Stadholder, Prince Frederik Hendrik
of Orange: the other was a *Circumcision*, the original of which is now lost.[2]

 The canvas of the London painting is of medium weight, with fairly regularly
spaced thicker threads (showing in the X-ray as dark lines, see Fig. 135). There is
moderate cusping on three edges but not at the right: the canvas may have been
trimmed a little on the right, therefore, but the composition itself clearly has not
been cut. Possibly some trimming took place between the application of ground
and the painting stage. The ground has been identified as a rough-textured single
layer of quartz (silica) combined with a quantity of brown ochre (see Fig. 132) bound
in linseed oil. The composition is the same as several others of the canvas paintings
including the *Portrait of Hendrickje Stoffels* (Cat. 13) and the *Self Portrait at the Age of 63*
(Cat. 21), and is of a type that is generally agreed to have been used only within
Rembrandt's workshop. The paint medium has been shown to be linseed oil, and
many of the dark background tones incorporate small quantities of pale-coloured
azurite as a siccative.

 The painting is carried out very directly, but surprisingly little direct use is made
of the ground colour. It can be seen as a rich deep brown at the lower left corner
and clearly imparts an overall tone to the picture, but similar colours that occur
elsewhere in the composition have been painted on top. In the depths of the roof
recess the brown canvas preparation has been covered with a simple layer of
virtually pure bone black concealing the rough texture of the surface of the ground
beneath. The details such as the rafters and the broom to the left simply pass over
the dark underpaint (see Fig. 133). As the setting for the figure group implies, the

Fig. 130 *The Adoration of the Shepherds*, 1646.
Oil on canvas, 97 × 71.3 cm.
Munich, Alte Pinakothek, Bayerische
Staatsgemäldesammlungen, inv. 393

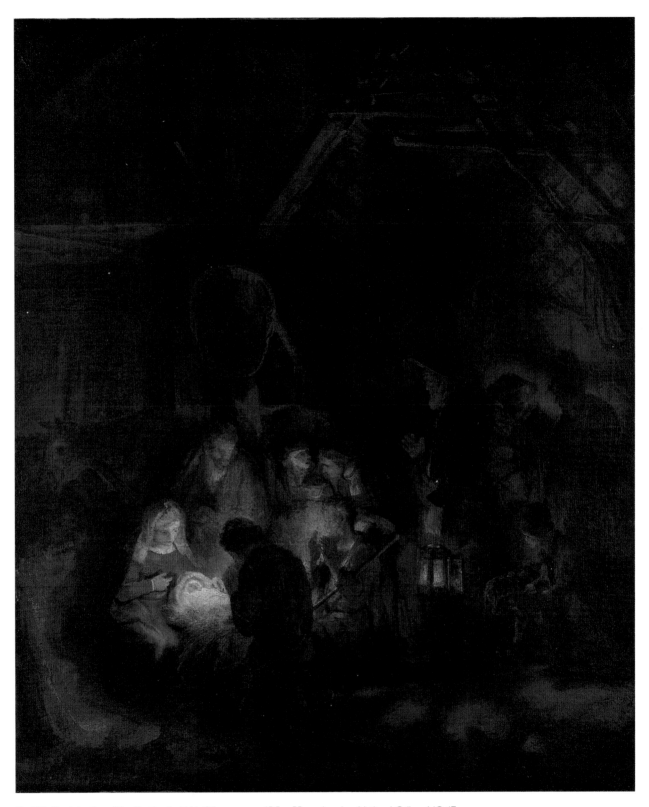

Fig. 131 *The Adoration of the Shepherds*, 1646. Oil on canvas, 65.5 x 55 cm. London, National Gallery, NG 47

pigments chosen are sombre: yellow ochre, bone black and chalk for the khaki rafters, and dull-coloured earth pigments for the handle of the broom. The flesh tones seem to be based on little more than red and brown earths mixed in varying proportions with white. But there are unexpected touches of colour: a little scarlet vermilion added to red ochre for the warm highlight on the broom handle (Fig. 133), and primrose-coloured touches of pure lead-tin yellow for the baby's swaddling blanket. The Virgin's dress and bodice are similarly higher in key, with a striking mixture for the lower part of blue mineral azurite with lead-tin yellow, white, yellow ochre, red ochre and black (Fig. 134). The red bodice contains vermilion, again added for extra emphasis to the main pigments of red earth and white.

The style of painting is somewhat tentative. A fluid, broad handling more suited to a larger canvas seems to have been curtailed and scaled down. Brushstrokes are in general short and dabbed. The only freely painted strokes are in the upper right background: they show clearly in the X-ray and under the paint surface, but since they were covered by the background their function is not entirely clear.

On a dark ground such as this, a conventional lay-in of warm brown tones would be superfluous and difficult to see. There may be a few guidelines laid down in even darker paint, but the artist seems to have proceeded almost directly to the painting stage. The X-ray is useful in charting the evolution of the picture and revealing a number of small but significant *pentimenti*. The kneeling shepherd in front of the main group was clearly always intended to be the pivot around which the other figures are centred. The sharp outlines in the X-ray show that the reserve left for him was planned right from the outset and the illuminated figures behind were painted only up to his silhouette. Three small adjustments to the reserve outline were made subsequently: the hands were raised slightly, the line of his back was moved a little to the right and a knot of hair or a collar was painted out at the back of his neck. There are several other *pentimenti*, some only minor adjustments of outline. For example, the hat of the woman to the right of the man holding the lantern was initially taller and narrower (compare the reserve left for it in the X-ray); Saint Joseph's hand was at first a little lower; the face of the woman next to Saint Joseph was inclined at a different angle; and, perhaps most interestingly, the principal light source was originally a much smaller lantern to the left of the present one – but it is not clear how it was supported.

While earlier authors may have disagreed on the relative merits of the London and Munich paintings – and which one may have come first – they had accepted the attribution of both works to Rembrandt.[3] Schwartz also considered the London painting to be by Rembrandt, noting that the rendering of the space and the 'forms of the figures are considerably clearer' than in the Munich version – thereby following the argument Weisbach had made earlier.[4] More recently, however, the attribution has been contested. Tümpel preferred a pupil as the author of the picture,[5] and Ernst van der Wetering in the catalogue of a recent exhibition in Copenhagen as well as in the forthcoming fifth volume of the *Corpus* has also

Fig. 132 Paint cross-section from dark background, upper left in Cat. 11, showing the coarse-textured brown 'quartz' ground beneath. Magnification 215X

Fig. 133 Paint cross-section from broom-handle at left edge of Cat. 11. The surface paint contains red ochre with a little added vermilion, and the lowermost modelling layer is virtually pure bone black. Magnification 175X

Fig. 134 Top surface of an unmounted fragment of paint from greenish blue of the Virgin's skirt in Cat. 11. The main colouring component is mineral azurite combined with white and other pigments. Magnification 180X

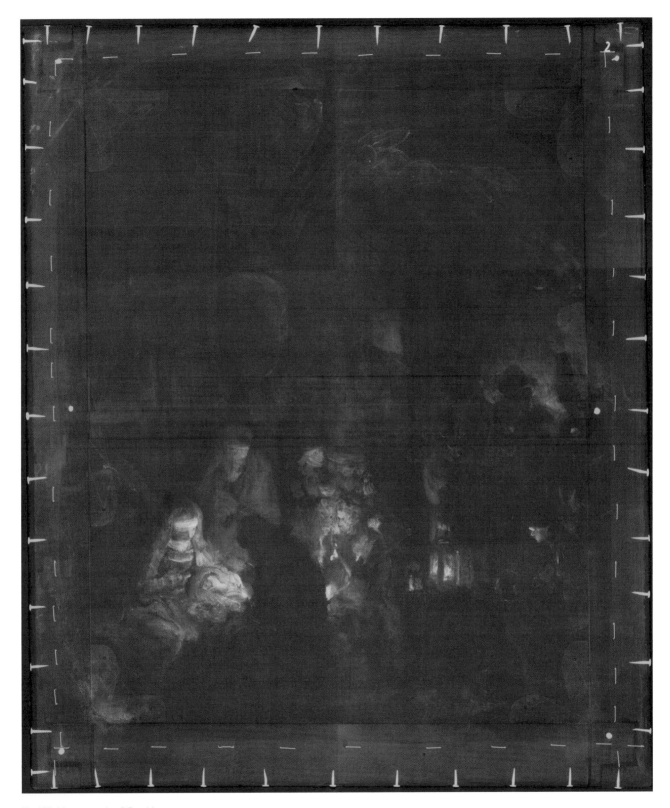

Fig. 135 X-ray mosaic of Cat. 11

rejected the traditional attribution to Rembrandt.[6] The principal argument is a perceived weaknesses in the execution of the painting. They note a sketchy, often rather flat application of paint and a lack of plasticity in certain passages, most notably in the Virgin's right arm and hand as well as her face. On the other hand, it can be argued that there are also strong and convincing passages, such as the figure of the kneeling shepherd with the staff and the two women with a small child between them behind him; the general handling of the light emanating from the different light sources and, more particularly, the soft glow of light around the fingertips of the kneeling figure in the foreground. In addition, the appearance of the signature does not give any immediate reason for doubting its authenticity.[7]

An important reason for believing that the picture was in Rembrandt's workshop during the execution of the Munich picture is the pose of the kneeling shepherd in the foreground. In the Munich painting he has his arms spread out, whereas the London figure has folded his hands in front of his chest. However, the X-ray of the Munich picture shows that an earlier version of the man also had his arms folded in front of his chest much like in the London painting. This strongly indicates that the author of the London painting, whoever it may have been been, had seen the Munich picture while it was being painted. The authors of the *Corpus* therefore suggest that it belongs to a group of works, possibly made by pupils or assistants as part of their training, based on prototypes by Rembrandt. In support of an attribution to a pupil they further argue that the picture is uncharacteristic of Rembrandt because of its lack of narrative focus. Rather than concentrating their attention on the Christ Child, as they do in the Munich picture, the figures have been broken up into smaller groups and converse with one another. While this concentration on the focal point of the story may well be predominant in the works of the Passion cycle, there are numerous other multi-figure compositions in Rembrandt's oeuvre where similar small groups of people interact with each other and pay no attention to the main event, such as his *Ecce Homo* (Cat. 4; the figures in the immediate foreground and the soldiers behind Christ); *Saint John the Baptist preaching* of 1634/5 in the Berlin Gemäldegalerie,[8] *The Woman taken in Adultery* (Cat. 10), as well as numerous etchings, for example the '*Hundred Guilder Print*' (B./Holl. 74). It is this human dimension and liveliness and the artist's understanding of a wide range of reactions to a particular event, that is one of the often praised strengths in Rembrandt's work.

A more problematic aspect that has cast doubt on the attribution of this canvas to Rembrandt is the existence of a drawing formerly in the Oppenheimer collection (present whereabouts unknown) that is closely related to it.[9] The drawing, which is clearly not by Rembrandt, has in the past been considered a study for this work or a copy of a lost Rembrandt drawing showing an earlier stage of the London painting. MacLaren came to the conclusion that it is more probably a variant based on the painting itself.[10] A close examination of the drawing in comparison to the X-ray of the London painting by the authors of the *Corpus* gives some clear indications

that the drawing indeed shows an earlier stage of the development of the painting. This suggests that another artist in the studio may have produced the drawing as a variant of the Munich painting, possibly in preparation for the London one, during the execution of which several details were changed. Alternatively, the drawing may have been produced while the London work was being painted, recording an earlier state. It is generally agreed, however, that the drawing cannot be a free copy after the painting. Whether the drawing and the London painting are actually by the same hand must remain a matter of conjecture.

In conclusion, on the basis of traditional connoisseurship and technical examination it is possible to argue for and against an attribution to Rembrandt himself, but, considering the close relationship between the Munich and London paintings, the relationship with the Oppenheimer drawing and the technical evidence, there can be no doubt that the London work was painted in Rembrandt's studio in 1646. Weaknesses in certain areas have convinced some recent authors that the painting cannot have been painted by Rembrandt himself, yet there are also several strong features in the composition, design and narrative structure that seem entirely characteristic of Rembrandt's approach – as well as the authentic signature and date. On balance, the authors prefer to retain the original attribution to Rembrandt until further evidence comes to light.

REFERENCES

HdG no. 77; Weissbach 1926, pp. 385–5; Bauch 1966, no. 78; Bredius 1969, no. 575; Gerson 1961, p. 92; Schwartz 1984, no. 263, p. 239; London 1988, no. 10, pp. 92–5; MacLaren, Brown 1991, vol. 1, pp. 330–2; Munich 1998–9, no. 13, p. 196; Tokyo 2003, no. 11, pp. 78–9; *Corpus*, vol. 5 (forthcoming), no. V10.

NOTES

1 MacLaren 1960, p. 311, and MacLaren and Brown 1991, vol. 1, p. 331.
2 For more on the commission of the Passion series see Gerson 1961. The Munich *Adoration* and the *Circumcision* were paid for in November 1646. See Strauss and van der Meulen 1979, doc. no. 1646/6.
3 For example Weisbach 1926, pp. 384–5, for whom it was a more successful later variant; Gerson 1961, p. 92; who considered it a more accomplished first version.
4 Schwartz 1984, p. 239.
5 Tümpel 1986, cat. no. A7.
6 Copenhagen 2006, p. 120, figs 23, 24; *Corpus*,

vol. 5 (forthcoming), no. V10. We are extremely grateful to Ernst van de Wetering for making the entry available to us. The *Corpus* refers to NG 47 as *The Birth of Christ*, presumably based on the inventory of Amalia von Solms, widow of Frederik Hendrik, of 1668, in which the Munich picture is mentioned with this title (inventory quoted in Berlin Amsterdam and London 1991, vol. 1, p. 156). The presence of a large number of humbly dressed figures inside the barn, however, indicates that the traditional title of the *Adoration of the Shepherds* is the more appropriate one.
7 The painting was examined by the authors in the Conservation Studio of the National Gallery on 10 December 2004 in preparation for this publication.
8 *Corpus*, vol. 3, 1989, no. A106.
9 *Corpus*, vol. 5 (forthcoming), ill. with no. V10; see also Valentiner 1925, no. 294. For further versions and literature see MacLaren and Brown 1991, p. 332, note 5.
10 MacLaren 1960, p. 311; MacLaren and Brown 1991, vol. 1, p. 331.

12 A Woman bathing in a Stream, 1654

Oak, 61.8 x 47 cm
Signed on the bank, bottom left: Rembrandt f 1654[1]
Holwell Carr Bequest, 1831
NG 54

The rich robe lying on the bank has given rise to the idea that the bathing woman in this picture is intended to be a biblical or mythological figure such as Susanna, Bathsheba or Diana. The picture displays a spontaneity and freedom in the handling of paint that have few parallels in Rembrandt's work. It appears unfinished in some parts, but was clearly finished to Rembrandt's satisfaction as he signed and dated it 1654. Its size and support might suggest that it was a sketch for a larger history painting but no such painting is known and, unlike Rubens, Rembrandt did not usually make preliminary oil sketches for larger projects. (The single exception is a group of sketches for etchings, made in the 1630s, of which *Ecce Homo*, Cat. 4, is one.)

The key to the painting may well be the identity of the model, who was probably the artist's mistress Hendrickje Stoffels. She is first mentioned as a member of Rembrandt's household in a document of 1 October 1649, in which she is said to be 23. She had been hired to help the sickly Geertge Dircx as the nurse of Rembrandt's son Titus – and quickly became the painter's mistress.[2] (Saskia van Uylenburgh, Rembrandt's wife and Titus's mother, had died in 1642.) In July 1654 – the year in which the picture was painted – Hendrickje was summoned before the Council of the Reformed Church in Amsterdam and admonished for living with Rembrandt 'like a whore' and banned 'from celebration of the Lord's Supper'.[3] Shortly thereafter Hendrickje bore Rembrandt's child, a daughter. She was named Cornelia after Rembrandt's mother and baptised on 30 October 1654.[4] Hendrickje remained in Rembrandt's household for the rest of her life. She died in 1663 and was buried in the Westerkerk on 24 July.[5]

There is no documented portrait of Hendrickje Stoffels but there are a number of paintings and drawings showing the same model and dating from the time when she was living with Rembrandt. The recurrence of this model and the affection and informality with which she is depicted point to her being Hendrickje.[6] There are at least five portraits of the same woman – one of which is known as *Portrait of Hendrickje Stoffels* (Cat. 13) – as well as this study. The others are the *Portrait of Hendrickje leaning at an Open Door* of the late 1650s (p. 146, Fig. 146), a portrait of about 1652 and the portrait as Venus with Cupid (both Louvre, Paris)[7] and the *Portrait of Hendrickje Stoffels* in New York (p. 146, Fig. 147), in which the sitter is possibly shown in the guise of a historical figure.[8] A drawing that has been related

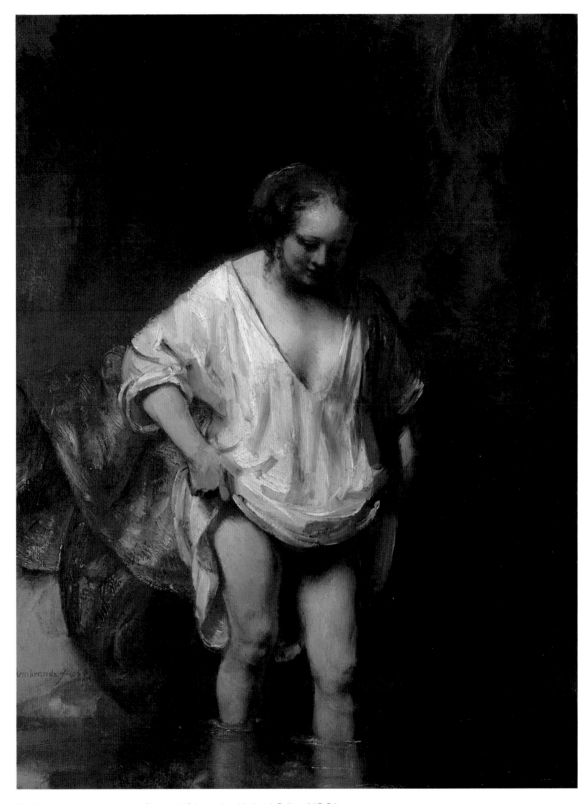

Fig. 136 *A Woman bathing in a Stream*, 1654. London, National Gallery, NG 54

to *A Woman bathing* is *A Young Woman sleeping* of around 1654 (British Museum, London).[9]

The picture is, as mentioned above, most unusual in the artist's painted oeuvre and it seems quite possible that this is an intensely personal work, a loving study of the painter's mistress – who may well have been pregnant with his child at this very moment – in the guise of an Old Testament heroine or a goddess. This would have been an entirely acceptable mid-seventeenth-century artistic convention. In this respect the painting recalls *'Het Pelsken'* (Fig. 137), Rubens's famous portrait of his young, second wife, Hélène Fourment, shown in the guise of Titian's Venus, naked but for a fur wrap. Rubens's life-size canvas is said to be based on the classical type of the *Venus pudica* (chaste Venus) – although she is powerfully erotic – whereas Rembrandt's picture seems to take its motif from an ancient sculpture of the *mulier impudica* (unchaste woman) which Rembrandt could have known through a print by G.F. Greuter.[10] More recently, Jan Leja proposed that the woman represents the clothed pregnant Callisto, wading in the water in front of a cave.[11] According to the Ovidian story, Callisto, one of the goddess Diana's nymphs, had been seduced by Jupiter and thereby transgressed the rule of chastity Diana had set for herself and her entourage. When the goddess discovered Callisto's pregnancy she turned the nymph into a bear and set her dogs on her, though Callisto was ultimately saved by Jupiter.[12] Leja argues that the picture is another example of *Herauslösung*, the concept introduced by Christian Tümpel, according to which Rembrandt removed single figures from their normal narrative context and represented them on their own. Yet it seems difficult to imagine that Rembrandt would have wanted to accuse Hendrickje of a lack of chastity when she was probably pregnant with their child. Instead the erotic tone of this scene appears moderated by the more tender and even lyrical mood, painted by Rembrandt with affection born of several years' companionship as well as sensual delight.

The panel is a single piece of oak, with vertical grain, the back edges chamfered as normal for a panel of this period. At some time the wood has split vertically along a line through the left eye and leg of the figure: the repair is imperfect and shows on the surface. The ground, in common with the other panel paintings, is chalk with a thin warm brown *primuersel* at the surface. This priming consists of yellow-brown earth pigment and a little umber combined with lead white, which shows a few quite large scattered nodules that protrude into the paint layer above (Fig. 138). The ground is clearly visible in many parts of the picture as a warm buff colour. Near the lower edge of the woman's shift, a whole curved strip is left unpainted and the preparation with the wood grain showing through can be studied directly (Fig. 140): it can also be seen along the upper edge of the arm and around the hand. Elsewhere it is used as a warm light tone beneath translucent

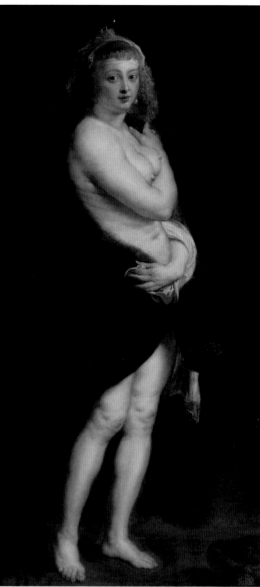

Fig. 137 Peter Paul Rubens, *Hélène Fourment in a Fur Wrap* (*'Het Pelsken'*), about 1635–40.
Oil on panel, 176 × 83 cm.
Vienna, Kunsthistorisches Museum, inv. 688

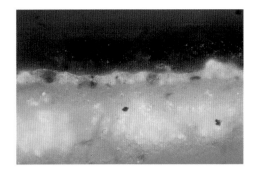

Fig. 138 Paint cross-section from reflection in the water at lower left edge of Cat. 12. The red lake glaze appears as a single layer over the chalk ground and thin yellow-brown *primuersel*. A large aggregate particle of lead white occurs in the *primuersel*. Magnification 300X

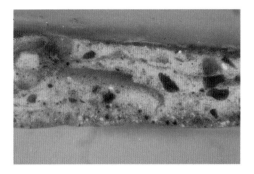

Fig. 139 Paint cross-section from orange-yellow impasto highlight on foliage in Cat. 12, showing yellow ochre reinforced with red lake. Magnification 145X

paint or between brushstrokes to suggest half-tones and form. The structure of the background is largely suggested by allowing the lighter colour to shine through swirling glazes of black and brown, an effect made dramatically clear by the infrared photograph (see Fig. 143). For example, to the left edge the thin dark brown shadow is a single layer of translucent black and brown pigment suspended in a matrix of red and yellow lake. Similarly, the transparent red reflection of the robe in the water is achieved mainly by a red lake glaze with red earth and yellow lake in small quantities. In the browner reflections the glazing mixture contains the same selection, but with the incorporation of a great deal more earth pigment in a variety of colours. For the opaque touches on the water's surface the ochre content of the paint predominates, and where it becomes very dark and crusty, the layer is mainly of bone black. The slightly thicker highlight strokes on background foliage are comparable in composition to the impasto of the foreground (Fig. 139).

At first glance the painting seems to be done with great spontaneity *alla prima*, or wet-into-wet, and most of what is visible was indeed painted at great speed with fluid paint and loaded brushes. However, there is evidence that many of the main shadows were sketched in first and had dried before the rest of the painting was done. A clear example is the wide reddish-brown strip along the bottom edge of the woman's shift extending into her left thigh, which was undoubtedly dry before the white material and the dark shadow of the leg were painted over it (visible in Fig. 140). Similar dark sketching can be seen under the paint elsewhere, and this may well correspond to the so-called 'dead-colouring' stage which was to precede the principal colouring. Indeed, the whole of the shadowed left sleeve appears to be unmodified dead-colour lay-in, with no superimposed paint layers at all except two diagonal highlights.

The painting of the woman's shift is a famous and outstanding example of Rembrandt's virtuoso handling of paint. The technique is direct and obviously broad, and appears deceptively simple: but the calculation of tone and texture is

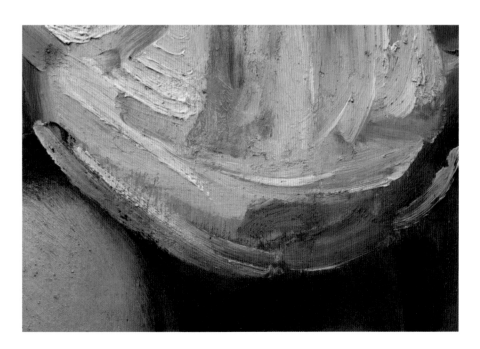

Fig. 140 Detail of Cat. 12 showing the unpainted, curved strip at the bottom edge of the shift.

both complex and exact (Fig. 142). The structure of the brushstrokes is even clearer in the X-ray than on the picture itself: the light-coloured preparation hardly registers in the radiograph, which reveals an image of the paint layers alone, unaffected by the lighter tone beneath (see Fig. 145). The freshness and immediacy in every movement of the brush conjure up the very act of painting. Where the brush hit the panel, where it twisted, lifted, cut across a highlight to make a fold or a shadow, where a brush was loaded or dry – all can be read directly from the X-ray.

Surface examination of the shift shows that some shadows were sketched in first (as described above), followed by a thick light grey and then the main colours. In many places the brush seems to have been dipped into several shades of white, unmixed on the palette, and these differently coloured strokes show side by side. Some of the cool half-tones are mixtures of white and black; others are produced by allowing the warm brown underpaint to show through with a mauve effect. In some places the mauve is actually achieved by admixture of red. Deepest shadows are marked by strokes of pure black dashed into the still wet brushstrokes of white and grey.

The flesh paints are, in general, more smoothly worked in a conventional sequence: shadows first, followed by mid-flesh colour forming cool half-tones where it overlaps the shadows; then heightening with thick, more colourful flesh tones; and finally the darkest shadows applied very thickly with deep transparent blacks and browns. This is the overall sequence, but so rapidly done that, in places, darks and lights overlap almost randomly. Some of the pigment mixtures for flesh paint are rather complex: for example at the figure's left breast the main component of lead white is tinted with small amounts of charcoal black, red, yellow and brown earths, red lake pigment, vermilion and even traces of blue in the form of a few grains of natural azurite. The cool tone of her shin also contains a range of earths, brown and black mixed into the matrix of white. Beneath the surface paint at both points, cross-sections show an underlayer of similar composition but more muted

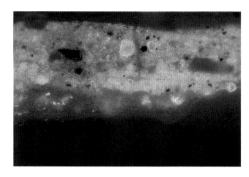

Fig. 141 Paint cross-section from flesh of the woman's shin consisting of more than one layer. Magnification 415X

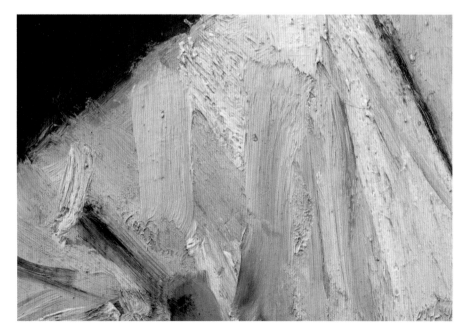

Fig. 142 Detail from Cat. 12

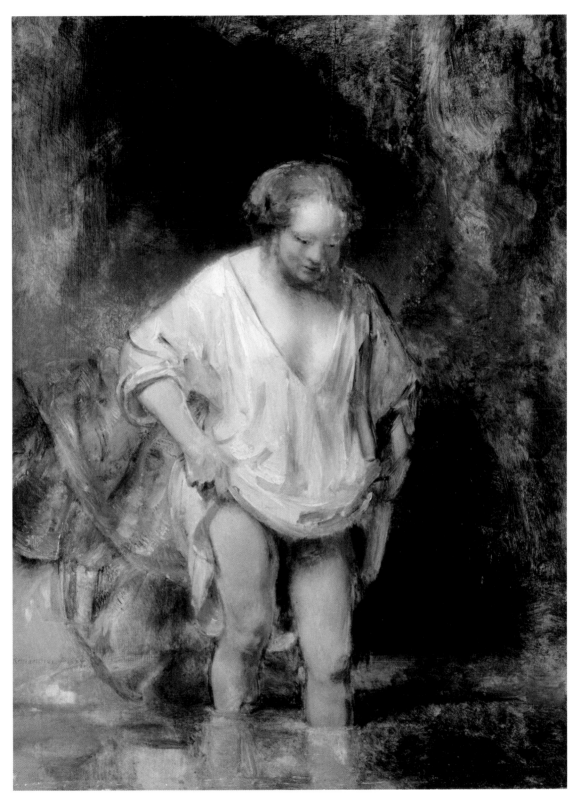

Fig. 143 Infrared photograph of Cat. 12

tone, corresponding perhaps to the dead-coloured initial sketch (Fig. 141).

The alternation of warm light tone, cool middle tone and warm shadow is observed fairly consistently. Only in two places are warm cast shadows directly adjacent to warm light colour, and it is instructive to observe how the recession into shadow fails to work at these points. One is where the shadow of the hand falls on the thigh and the other is where a narrow stroke of red-brown marks the shadow on the woman's right breast. Because Rembrandt was usually so careful to preserve the juxtaposition of warm–against–cool–against–warm, it is possible that there is some paint loss at these places.

There is, however, no paint loss at the woman's wrist, where the paint has been brushed and dragged with too dry a brush and the form is not completed (Fig. 144). This was thought at one time to be a damage across the wrist and was repainted last century by an overzealous restorer. The same restorer also remodelled the hand, giving it a more rounded, finished appearance. The repaint was removed when the picture was cleaned in 1946 and we now see Rembrandt's brilliant cursory modelling without 'improvements'.

The robe lying behind the woman is again painted with an apparently simple technique, but with great richness of effect. There are glazes of red and yellow lakes adjoining translucent blacks. The deep red lower layer appears again on top in places. Middle tones are of a cooler grey containing charcoal, lending a bluish tinge, and the brocade is suggested by a whole variety of irregular strokes and, finally, impasto lights of pure orange and yellow ochres.

Fig. 144 Detail of the right hand and wrist from Cat. 12

REFERENCES
HdG no. 306; Bauch 1966, no. 278; Bredius 1969, no. 437; Schwartz 1984, no. 328, p. 295; London 1988, no. 11, pp. 96–101; MacLaren and Brown 1991, vol. 1, pp. 332–3; Berlin, Amsterdam and London 1991–2, vol. 1, no. 40, pp. 246–9; Leja 1996.

NOTES
1 The last digit of the date has been read as a '5' but is undoubtedly a '4'.
2 Strauss and van der Meulen 1979, doc. 1649/9. For more on Geertje Dircx and Hendrickje Stoffels see also Edinburgh and London 2001, pp. 24–5.
3 Strauss and van der Meulen 1979, docs 1654/11, 12, 14, 15.
4 Ibid., doc. 1654/18.

5 Van Eeghen 1956b, pp. 144–6.
6 MacLaren and Brown 1991, vol. 1, p. 356, under no. NG 6432.
7 Bredius 1969, no. 117 Rembrandt, *Hendrickje Stoffels*, canvas, 74 x 61 cm, inv. no. 1751; after Rembrandt, *Hendrickje Stoffels as Venus*, canvas, 118 x 90 cm, inv. no. 1743.
8 For more information and literature on these pictures see the entry for the *Portrait of Hendrickje Stoffels* (Cat. 13).
9 Inv. No. 1895-9-15-1279; Edinburgh and London 2001, no. 118, pp. 206–7.
10 Berlin, Amsterdam and London 1991–2, vol. 1, no. 40, p. 248–9.
11 Leja 1996.
12 Ovid, *Metamorphoses*, book 2, pp. 401–53.

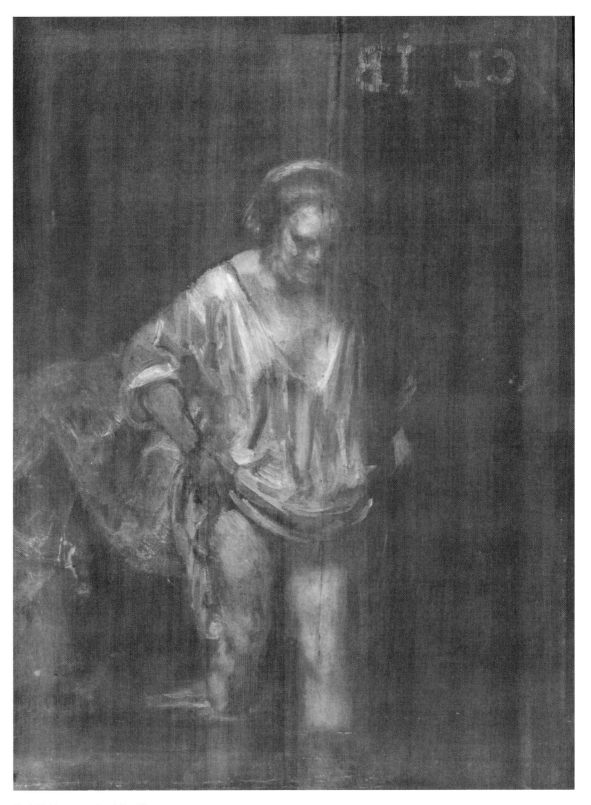

Fig. 145 X-ray mosaic of Cat. 12

13 Portrait of Hendrickje Stoffels, probably 1654–6

Canvas, 102.5 x 85.5 cm
Signed (falsely?) lower left: Rembrandt f 16[5 or 6]9
Bought by private treaty from the Trustees of the Walter Morrison Settlement with a
contribution from the National Art Collections Fund, 1976
NG 6432

Hendrickje Stoffels, who was born in 1625/6 or a little earlier, is first mentioned as a
member of Rembrandt's household in 1649. She was employed as a nurse for Titus,
Rembrandt's son by his marriage to Saskia van Uylenburgh. She became the artist's
mistress and their child, Cornelia, was born in 1654. Hendrickje remained with
Rembrandt until her death in 1663. There is no documented portrait of Hendrickje
Stoffels, but there are a number of paintings showing the same model which date
from the time when she was living with the artist.[1]

In his early catalogue of 1857 of art treasures in British collections Gustav
Waagen identified the sitter as Rembrandt's daughter.[2] Willem von Bode was the
first to point out the implausibility of this suggestion and instead proposed
Hendrickje.[3] The recurrence of this model and the affection and informality with
which she is painted seem to support this identification. In addition to this painting,
there are at least four portraits and a painted study that show the same model. They
are a portrait in the Louvre, painted in the early 1650s[4] and possibly a pair to the
Self Portrait in Kassel which is dated 1654; the *Portrait of Hendrickje leaning at an Open
Door* in the Gemäldegalerie, Berlin (Fig. 146),[5] painted in the late 1650s; the portrait
in the Metropolitan Museum of Art, New York (Fig. 147), which is dated 1660;[6] and
the study of *A Woman bathing in a Stream* of 1654 (Cat. 12). The *Portrait of Hendrickje
Stoffels* bears a signature and a date in the lower left-hand corner. After cleaning in
1976 three digits became legible: 16[]9. The third digit is either a '5' or a '6': there is
damage at the point where the two are differentiated. The second date, 1669, the
year of the artist's death and six years after Hendrickje's death, is impossible

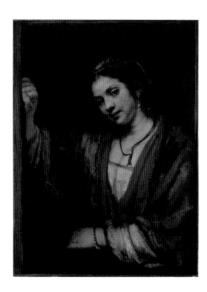
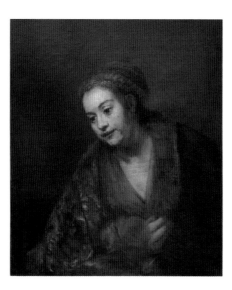

Fig. 146 *Portrait of Hendrickje leaning at an
Open Door*, 1656–7.
Oil on canvas, 86 x 65 cm.
Staatliche Museen zu Berlin-Preussischer
Kulturbesitz, Gemäldegalerie, inv. F 23.941

Fig. 147 *Portrait of Hendrickje Stoffels*, 1660.
Oil on canvas, 78.4 x 68.9 cm.
New York, The Metropolitan Museum of Art.
Gift of Archer M. Huntington, in memory of his
father, Collis Potter Huntington, 1926 (26.10.9),
inv. 26.101.9

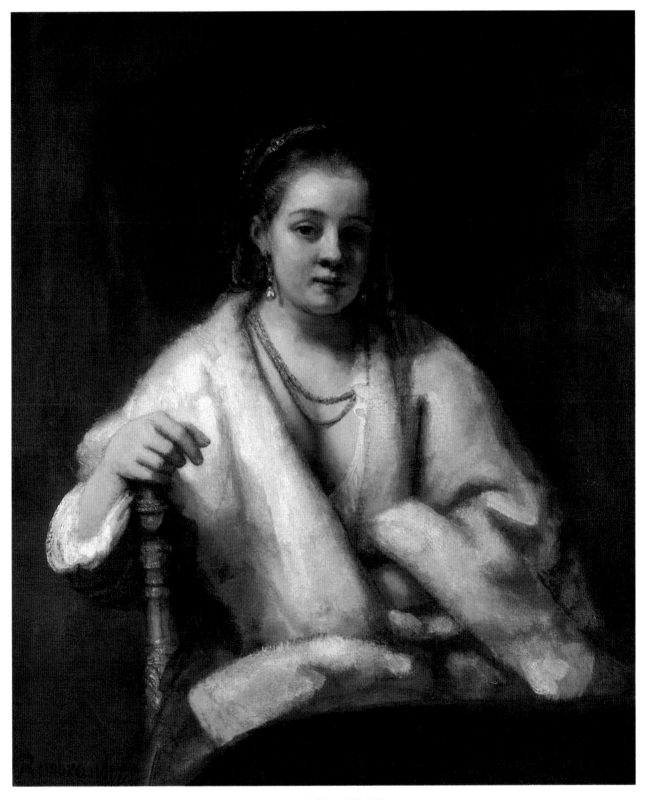

Fig. 148 *Portrait of Hendrickje Stoffels*, probably 1654–6. London, National Gallery, NG 6432

on stylistic grounds. The former, 1659, is therefore more plausible. The signature, however, is too large and uncharacteristically formed in comparison to other signatures of the 1650s. The most likely explanation is that it is not authentic, but was added to the painting later,[7] however, since the cracks run through both the painting and the signature not too great a period can have elapsed.

Stylistically the painting belongs to a group of three-quarter-length painted and etched portraits of the 1650s. In the 1651 etched portrait of *Clement de Jonghe* and the 1652 painting of *Nicolas Bruyningh* at Kassel[8] Rembrandt can be seen experimenting with the three-quarter-length pose and the complex spatial relationship between sitter, chair and picture space. Other near-contemporary examples of this portrait format are the etched portraits of *Jan Lutma* (B. 276) and *Arnold Tholinx* (B. 284). It seems likely that it was about this time that Rembrandt painted Hendrickje in the present informal portrait. The X-ray shows significant changes in the pose and the position of the hands (see Fig. 152). A drawing in the British Museum (Fig. 149) shows a woman seated in a chair, leaning slightly forward, her hands clasped together in her lap. This drawing which, it has previously been suggested, may represent Hendrickje, has been dated 1655/6. A comparison of the drawing with the X-ray of this portrait makes it possible that the drawing shows an early stage of the composition of the painting. Martin Royalton-Kisch, however, disputed such a direct relationship between the two works.[9] Julia Lloyd Williams in her recent catalogue entry on the picture reiterated these doubts, referring to 'marked differences between the dress and facial expressions'.[10] Nevertheless, based on stylistic grounds, a reasonable date for the present painting would be between 1654

Fig. 149 *A Seated Woman*, about 1655/6.
Red pen and brown ink with brown wash,
16.5 × 14.4 cm.
London, British Museum, inv. 1948-7-10-7

and 1656, when the sitter was aged between 30 and 32. It should be stressed that this is hypothetical and it is possible that the date 1659, although added by a later hand, has some basis in fact. The painting must date from before 1660: the portrait in the Metropolitan Museum (Fig. 147), which in style and technique has striking similarities to this portrait, shows that by then Hendrickje had aged markedly.

Certain formal aspects of the painting remain difficult to clarify: the precise nature of the material of Hendrickje's wrap (it has been suggested that it is fur) and the table sketched in the right foreground and the background. These are clearly unfinished, although it may be asked whether they were ever intended to be finished in view of the informal nature of the portrait. With regards to the mood of the picture and more specifically to the dress – if indeed it is meant to be a fur wrap – Willem von Bode had already observed parallels with Rubens's portrait of his wife Hélène Fourment in a fur coat, known as 'Het Pelsken' (p. 140, Fig. 137), though one cannot be sure that Rembrandt would have known the picture.[11]

The canvas weave, faintly visible in the X-ray against the stretcher bars, is fine and regular. The possibility cannot be excluded that it is a transfer canvas, but there is no real evidence that it is. The X-ray image of the support is faint because the ground is rather transparent to X-rays. The ground consists of a mixture of quartz (silica) and small amounts of brown-coloured ochre and lead white (see Figs 153 and 154). It is closely similar in constitution to the ground layer in the *Self Portrait of the Age of 63* (Cat. 21) and the *Portrait of Frederik Rihel on Horseback* (Cat. 20).

Fig. 150 Detail of the white wrap from Cat. 13

The dark brown colour of the ground is clearly visible in many parts of the painting, notably in the lower part of the white wrap (Fig. 150). It plays a significant

role in the overall tone of the picture – partly because the picture is unfinished, but perhaps now more than originally intended, since the paint layers are quite worn and thin in some areas. In fact, the condition of the picture is an important factor in the interpretation of its technique, because the overall wearing, cracking and subsequent retouching of the paint layers all affect the image to some degree and alter the perception of the way the image is constructed.

The X-ray (Fig. 152) shows distinct phases in the evolution of the composition. It can be divided essentially into two parts: Hendrickje's head, shoulders, and left side form a coherent image echoing closely the visible portrait. The structure in these areas is clear and conforms reasonably well to a typical Rembrandt foundation. The X-ray image of Hendrickje's right arm and hands is, by contrast, a confused swirling mass of broad, light strokes quite unrelated to the visible painting but overlying a more coherent structure: clearly some major reworking has occurred in this area.

It seems that Rembrandt originally painted Hendrickje with folded arms or with her hands clasped in her lap as in the British Museum drawing. The left arm was across the body, as now, but not tucked into the wrap. The right arm dropped vertically from the shoulder and folded across to link with the left. This would have resulted in a rather slumped pose, and Rembrandt clearly decided to open up the figure by moving the right hand up and outwards, introducing the arm of the chair to support it, and to conceal the left hand within the folds of the wrap. In making these alterations, he seems to have obliterated the original image with vigorous

Fig. 151 Detail of the right hand and arm from Cat. 13

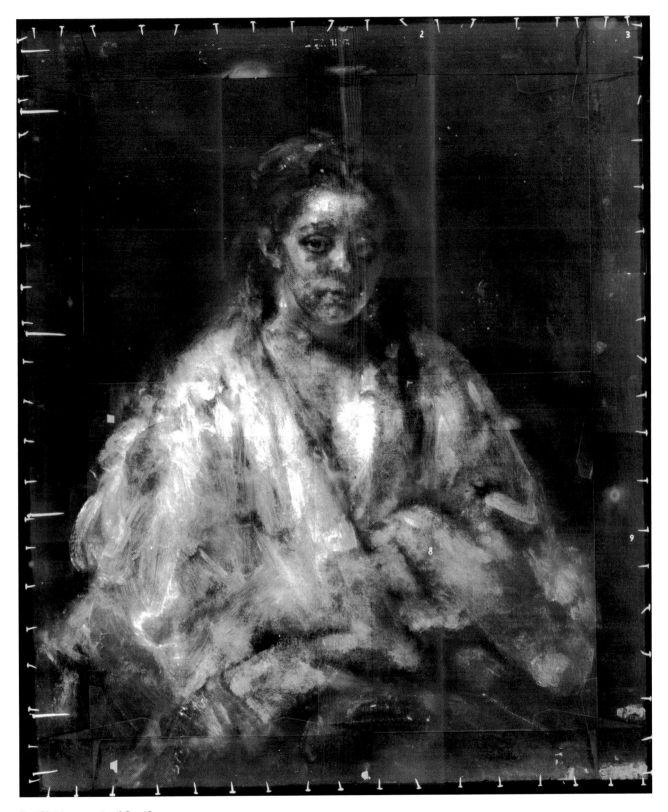

Fig. 152 X-ray mosaic of Cat. 13

scrubbed brushstrokes of lead white and then painted the present design on top. Even the most cursory inspection of the picture surface shows the broad brush-strokes of the obliterating paint underlying the right hand and the arm of the chair (Fig. 151). A cross-section from a golden-yellow highlight on the arm of the chair shows the thick initial lay-in of lead white directly over the ground from this earlier stage of the composition (Fig. 153). Some part of the chair, however, was clearly meant to be shown in the first design since paint containing lead-tin yellow, with no intermediate layers, is present beneath the lilac patch of Hendrickje's dress (Fig. 154).

Once this sequence of construction is realised the X-ray becomes straight-forward. The X-ray image of the face is perfectly unambiguous, although broken up by severe cracking. The lights of the forehead, nose, cheeks, eyelids, lips and chin are laid in with lead white lightly tinted with vermilion directly on to the brown ground (there is no evidence of any underdrawing or lay-in underneath). Beneath the cool pink paint of the flesh, as the shoulder passes into shadow at the edge of the wrap, there is an area of translucent brown made from Cassel earth, white and black, over which the lighter tone is worked; but the dark layer is not a general feature of the flesh painting. The appearance of the eyes in the X-ray is slightly unusual. Rembrandt seldom left such a pronounced oval around the eyelids as here – usually the construction is more subtle. But comparison with the somewhat fainter image of the right eye in the *Self Portrait at the Age of 34* (Cat. 9) shows a similar, if narrower, continuous dark oval.

The ground colour is not much used in the face, except for parts of the shadowed side. Around the eyes, the shadow and half-tone is apparently all achieved on the surface, although there is a good deal of retouching here. The right hand and arm are also worn and retouched, but their flat and unconvincing shape cannot be ascribed solely to condition. They provide a telling demonstration of how tonality must be manipulated in order to suggest recession and form. Painted at a late stage in the composition, they appear to have almost no half-tones between light and shadow, and there is no variation in tone as the arm recedes (Fig. 151). This gives the effect of flatness, and the arm appears not to project from the sleeve but to lie in front of it. Some of this is undoubtedly due to wearing, but Rembrandt has clearly not worked at the form of this late alteration in as detailed a way as on the head – which, despite its worn state, has a more realistic structure.

The *Portrait of Hendrickje Stoffels* displays some rather striking uses of colour. The tablecloth in the foreground is represented with a warm brown underlayer similar in colour to the densest parts of the background, and contains a mixture of earth pigments, a little white, red lake and black; it is then glazed with a thick layer of mixed red lake pigments, probably with the addition of yellow lake in light areas.[12] In the darkest shadow to the left, black is incorporated into the upper layer. Recent analysis suggests that the red lake present contains cochineal and madder dyestuffs, a mixture found in other works by Rembrandt and from his studio. Probably two

Fig. 153 Paint cross-section from yellow ochre highlight on arm of chair, Cat. 13, passing over a warm brown underlayer. Beneath this is a thick layer of pure lead white laid over the brown coarse-textured 'quartz' ground, which represents the initial arrangement of Hendrickje's sleeve or arm.
Magnification 170X

Fig. 154 Paint cross-section from lilac patch of Hendrickje's dress, lower left in Cat. 13. This contains red lake, charcoal and white over a layer of lead-tin yellow belonging to the initial painting of the chair. The 'quartz' ground is visible as the lowest layer.
Magnification 180X

Fig. 155 Paint cross-section from detail of the opaque red highlight on the table-cloth in Cat. 13. This shows orange-red ochre reinforced with red lake pigment. Magnification 405X

Fig. 156 Paint cross-section from opaque orange-brown background, left edge of Cat. 13, painted in two layers. The paint mixture makes great use of earth pigments with red lake and black, with a greater proportion of the translucent pigments in the upper layer. Magnification 350X

lake pigments are present, the mixture of crimson cochineal and more orange-red madder lake providing a wide range of translucent reds. The yellow lake remains to be identified. The opaque red highlight that marks the edge of the table-cloth is painted in a thick streak of pure orange-red ochre intensified by admixture with further transparent red and perhaps yellow lake pigment (Fig. 155), anticipating the technique used for the most powerful reds in *Frederik Rihel on Horseback*.

The muted lilac of Hendrickje's dress is an unusual colour for Rembrandt, and although a violet tone might be expected to contain a mixture of red and blue pigment, the paint actually consists only of a mixture of lead white, charcoal black and red lake. A similar colour occurs in *Anna and the Blind Tobit* (Cat. 2). The mauve colour results from the bluish reflection of charcoal combined with white, together with the reflection of red light by the lake pigment. This technique for a violet or purple-coloured pigment mixture is also known for paintings by Rubens and Van Dyck;[13] no pure violet pigments were available in the seventeenth century. The bluish cast of wood charcoal when mixed with white is exploited here in the bluish-grey tones of Hendrickje's wrap and the cuff of her sleeve. The light-coloured reflections on the arm of the chair are in small dabs of pure yellow and orange ochres, with lead-tin yellow for the palest touches.

The opaque part of the background is painted in two layers: underneath, a hot orange-brown mixture of red and yellow ochres, red lake pigment and a little black; over this, a layer of the same kind, but richer and more translucent owing to a higher proportion of lake pigment (Fig. 156). In the darker background to the right, only a single translucent layer of red lake pigment, earths and black passes over the 'quartz' ground. The construction of these layers is remarkably similar to that of the background structure in *An Elderly Man as Saint Paul* (Cat. 16).

REFERENCES
HdG no. 715; Bauch 1966, no. 521; Bredius 1969, no. 113; Brown and Plesters 1977; London 1988, no. 13, pp. 106–11; MacLaren and Brown 1991, vol. 1, pp. 364–7; Edinburgh and London 2001, no. 125, pp. 218–19.

NOTES
1 For more on the subject and literature see the entry for *Woman bathing in a Stream* (Cat. 12).
2 The picture was then in the collection of James Morrison, Basildon Park, Berkshire: 'a female portrait which passes for that of his daughter'; see Waagen 1857, p. 304 (also quoted in Brown and Plesters 1977, p. 287).
3 Van Bode 1883, pp. 551–2 (also quoted in Brown and Plesters 1977, pp. 287–8).
4 *Hendrickje Stoffels*, canvas, 74 x 61 cm, Paris, Musée du Louvre, inv. no. 1751.
5 See also Edinburgh and London 2001, no. 126, pp. 220–1.
6 See most recently Washington and Los Angeles 2005, no. 5, pp. 84–8, where it is suggested that the painting shows her as the Sorrowing Virgin. On the painting see also Edinburgh and London 2001, no. 127, pp. 222–3.
7 See also Brown and Plesters 1977, p. 288–9.
8 Schnackenburg 1996, vol. 1 (Text), p. 243, no. GK243.
9 Royalton-Kisch 1989, pp. 137–8.
10 Edinburgh and London 2001, no. 125, p. 218.
11 See von Bode's description of the picture in Brown and Plesters 1977, pp. 287–8, and again in Edinburgh and London 2001, p. 218.
12 Kirby 1977, pp. 40, 42.
13 Plesters 1983, pp. 45, 48–9, Roy 1999a, pp. 53–5; Roy 1999b, p. 94.

14 A Franciscan Friar, about 1655/6

Canvas, 88.5 × 65.8 cm
Signed right edge centre: Rembrandt. f. 165[?] [1]
Presented by the Duke of Northumberland, 1838
NG 166

Rembrandt painted his son Titus in a Capuchin habit in 1660 (Fig. 157) [2] and in the following year painted a portrait or study of a Franciscan (Fig. 158). It has been suggested on several occasions that the monk in the Helsinki picture may be Saint Francis but, as Peter Sutton rightly pointed out, there is little evidence to support this identification. [3] Based on this, it is equally improbable that the Gallery's painting should be a depiction of the saint.

Before the removal of thick brown varnish in 1952, the date on the present painting was not visible and the style hard to judge. It was grouped by Hofstede de Groot and Bredius with two other pictures of monks and so dated about 1661. However, as MacLaren stated in his 1960 catalogue, it is certain that the third figure of the date is a '5' and the style would seem to be of around 1655/6. [4]

This is a damaged and much treated painting. Structurally it is on canvas marouflaged to a synthetic board: however, various signs suggest that it has in fact been transferred to a new canvas and that, in the process, part of the original ground seems to have been removed. The paint surface has the characteristic appearance of a transferred picture: the fragile paint layers have shrunk and collapsed into voids caused by the transfer process. Typically for a canvas painting, these voids follow prominent weave lines in the original, or weave faults in the new canvas. They can also be caused by imperfect application of the new ground on the reverse of the original paint or ground. Here they are principally horizontal and occur notably in the area of the head.

Each cross-section taken shows a layer of granular lead white containing a little colourless smalt beneath the first paint applications (see Fig. 162). Under this lead white ground there is a further light-coloured layer of gypsum (calcium sulphate dihydrate). However, at several points sampled, the interface between the two layers bears traces of orange-coloured earth pigment. Gypsum is not a material found in the original grounds of Dutch seventeenth-century pictures, and must represent a layer of additional ground or adhesive applied to the back of the surviving part of the original ground during the transfer to a new canvas support. It seems probable that the original canvas had a double ground, with orange-red earth for the lower layer, and the lead-white-containing layer over that. For the transfer, the lower orange ground would have been removed, but vestiges of it survive here and there.

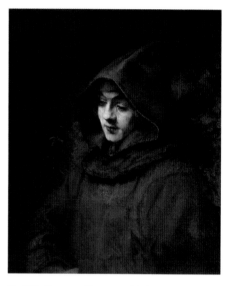

Fig. 157 *Titus as a Franciscan*, 1660.
Oil on canvas, 79.5 × 67.5 cm.
Amsterdam, Rijksmuseum, SK-A-3138

Fig. 158 *A Monk Reading*, 1661.
Oil on canvas, 82 × 66 cm.
Helsinki, Sinebrychoffin Art Museum, Kok. Linder
Collection, inv. A 1410

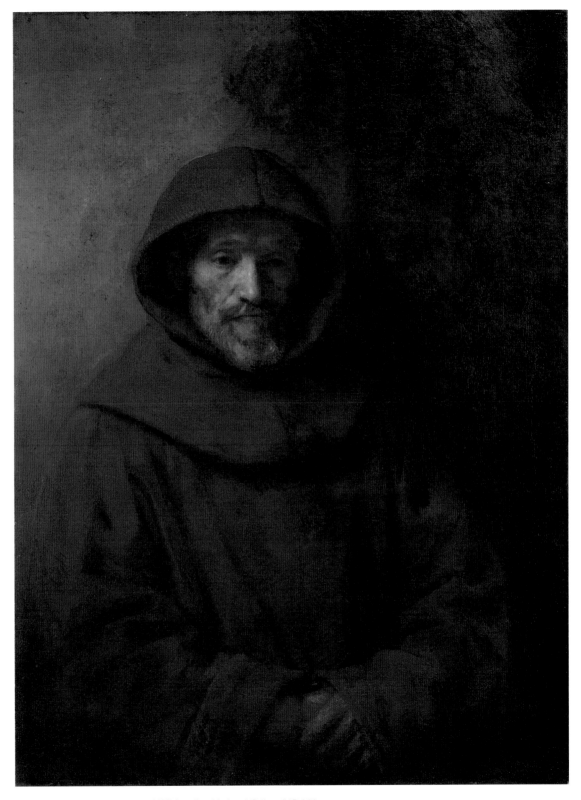

Fig. 159 *A Franciscan Friar*, about 1655. London, National Gallery, NG 166

The X-ray image (Fig. 160) is confused and unhelpful, although the canvas weave visible in it is probably that of the original, its imprint preserved in what remains of the original ground layers. The ground layers are now very uneven and they obscure most of the detail. Very little information regarding the paint layers can be derived from the X-ray, except for the presence of lead white in both the background and the figure.

The face is painted in opaque colours, all the modelling being on the surface. The mid-tones of the face contain lead white tinted with earth pigments, red lake and a little black. The highlights are quite flat with no impasto, but the radical nature of the transfer would probably have flattened any texture that may originally have been present. The mouth is painted in the usual dark line, applied last. There is a *pentimento* in the hands: the left cuff has been painted over the back of the left hand. The hands are painted in a regular sequence, with a mid-brown lay-in, followed by the deepest shadows, and the relative lights finally brushed on top (Fig. 161). For the fingers, the middle-tone reddish browns involve red and yellow ochres, red lake pigment, black and white in the lower and in the upper layers, while the shadow is rich in bone black, warmed with a little red lake and red earth pigment. Unusually, the brushstrokes of the hand cut across the form of the fingers, rather than follow it.

A second *pentimento* is visible at the top of the cowl: it was at first a little higher, and the paint of the background has been continued across the outline. The habit is painted in a mixture of earth colours, bone black with red and yellow lakes. The paint above and to the left of the friar's head is the thickest remaining paint on the picture. The background at the right is badly damaged and heavily repainted, although the original glazing technique can still be assessed. In the darkest sections a double glaze containing mainly bone black is used, with smalt in the lower layer and red earth in the upper layer. Where the background to the right becomes much warmer, the principal pigment is a red lake, darkened with a little black and containing a few particles of azurite as a drier. The opaque light greyish khaki to the left comprises a mixture of lead white, Cologne earth, yellow ochre and black, over a thick, dark underlayer of black, mixed with a little red earth and white, and containing in addition traces of blue verditer (Fig. 162).

REFERENCES
HdG no. 191; Bauch 1966, no. 205; Bredius 1969, no. 308; Schwartz 1984, no. 349, p. 309; London 1988, no. 12, pp. 102–5; MacLaren and Brown 1991, vol. 1, pp. 334–5.

NOTES
1 Although worn and faint, the signature and the first three figures of the date are legible by ultra-violet light.
2 Washington and Los Angeles 2005, p. 126 and fig. 2, under no. 16.
3 Ibid., p. 128, with further literature.
4 MacLaren 1960, p. 316; see also MacLaren and Brown 1991, vol. 1, p. 334.

Fig. 160 X-ray mosaic of Cat. 14

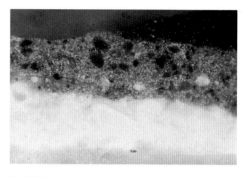

Fig. 161 Paint cross-section from shadow of hand in Cat. 14, containing red lake, bone black and red earth over a lighter tone that also contains lead white. A trace of the original orange-red lower ground layer, removed from much of the picture during transfer, is visible.
Magnification 305X

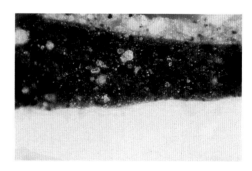

Fig. 162 Paint cross-section from greyish-khaki background, left edge of Cat. 14, showing a mixture of earth pigments, black and white over a thick dark underpainting. The dense upper ground layer is original and contains lead white mixed with colourless glass particles. The lower gypsum layer relates to the transfer of the picture.
Magnification 340X

15 A Bearded Man in a Cap, about 1657

Canvas, 78 × 66.3 cm
Signed left below the level of the shoulder: Rembrandt. f. 165 [7?]; the last digit is covered by a *pentimento* of the outline of the right arm
Bought 1844
NG 190

Fig. 163 *Aristotle contemplating a Bust of Homer*, 1653. Oil on canvas, 143.5 × 136.5 cm. New York, The Metropolitan Museum of Art. Special contributions and funds given or bequeathed by friends of the Museum, 1961 (61.198)

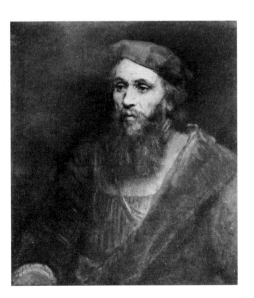

Fig. 164 *A Bearded Man in a Cap*, 1661. Oil on canvas, 71 × 61 cm. St Petersburg, State Hermitage Museum, inv. GE-751

As with other studies of this kind by Rembrandt, the sitter has been described as 'A Jewish Rabbi'. In this case, this title cannot be traced further back than 1844.[1] In 1798 the picture had simply been described as 'An Old Man's Head'.[2] The man may possibly be Jewish and is bearded; there is no other reason for supposing him a rabbi. The identity of the man is unfortunately unknown but it seems convincing to assume that Rembrandt painted him from life.[3] The same man may well have served as the model for other paintings by Rembrandt and his pupils, for example *Aristotle contemplating a Bust of Homer* of 1653 (Fig. 163) and *A Bearded Man in a Cap* of 1661 (Fig. 164), and also the so-called *Portrait of a Rabbi* of 1657 (San Francisco Museum of Fine Art), although the attribution of this last to Rembrandt has occasionally been doubted.[4] Further comparisons have been drawn with the *Man with a Falcon* of the early 1660s (Göteborgs Konstmuseum; p. 183, Fig. 200)[5] and the *Apostle Paul* of about 1657 (National Gallery of Art, Washington).[6]

The date has often been read as 1657, but the last digit is not legible. Its resemblance to a '7' is an effect due only to a brush mark in the overlying paint. The minute portion of the digit now visible could only be the top of the horizontal stroke of a '3' or a '7'; judging by the placing of the digits in the dates on Rembrandt's paintings of 1653 and 1657 it could be either: 1657 is more acceptable on stylistic grounds.

The canvas on which *A Bearded Man in a Cap* is painted is heavily cusped at the left and right edges, with very little cusping at the top and bottom. This suggests that the canvas was stretched tightly from side to side when being primed, with little tension in the vertical direction. It is possible that this may be an example of a canvas cut from a primed length stretched between two long battens and loosely secured at top and bottom.

The picture has a double ground with an orange-red ochreous underlayer containing many coarse silica particles, and an upper priming of lead white tinted with umber (see Fig. 166). The dark sand colour of the upper ground layer is visible at several points in the face – for example around the sitter's right eye – and also shows through the dark background at the upper right, where it is thinly covered by a glaze of bone black with a little red earth and red lake pigment. These sombre glazes also contain small amounts of fine pale-coloured blue verditer (artificial azurite), probably mixed in as a drier. The more solid mid-brown of the upper

left quadrant has a second layer of bone black over a warm version of the glaze to the right.

The picture is painted very directly with no significant *pentimenti* other than minor adjustments of outline, such as that which hides the last digit of the date. The technique is quiet, with few of the flourishes that characterise portraits from other periods. This is made clear by the X-ray (Fig. 165), which yields little information: the whole image is dominated by the dense ground filling the weave of the relatively coarse canvas. The only feature of the paint layers that shows clearly is the dense highlighting of the nose and cheek – and these are almost the only pastose parts of the entire picture. Here the flesh paint comprises a single application of lead white combined with yellow and red earth colours and just a little vermilion (Fig. 166). Subsequent adjustments to the shadows of the cheek to the left are made in the same paint enriched by a brownish-red lake pigment. The rest of the face is painted very smoothly, in a conventional sequence: the main shadows are sketched in a warm brown, followed by the duller mid-flesh tone which barely registers in the X-ray, with the highlights and deepest shadows applied last. The palette is controlled and limited, the only colourful touches appearing on the cheek and moustache.

The cap and coat are painted directly and simply in pigment mixtures which correspond closely to the composition of the darkest background colours. Bone black has been identified as the principal pigment, but some warmth and depth are lent to the dark-coloured paint by admixture with small amounts of red lake and red ochre. The more solid greenish grey of the sitter's tunic combines yellow, red and brown earth pigments with black and a little white. The background passes under the cap for a little way and the final outline is modelled over it.

Fig. 165 X-ray mosaic of Cat. 15

Fig. 166 Paint cross-section from the cheek in Cat. 15; painted as a single layer over the double ground. Magnification 165X

REFERENCES
HdG no. 392; Bredius 1969, no. 283; Schwartz 1984, no. 346, p. 308; London 1988, no. 14, pp. 112–15; MacLaren and Brown 1991, pp. 335–6; Washington and Los Angeles 2005, no. 1, pp. 70–3.

NOTES
1 Jeremiah Harman sale, London, 17–18 May 1844, lot 23; quoted in MacLaren and Brown 1991, vol. 1, p. 335, under 'Provenance'.
2 Quoted ibid.: Duke of Argyll sale, London, 25–6 May 1798, lot 104.
3 Washington and Los Angeles 2005, no. 1, p. 73.
4 MacLaren and Brown 1991, vol. 1, p. 335.
5 Washington and Los Angeles 2005, no. 17, pp. 129–31; where the falconer is identified as Saint Bavo.
6 Ibid., no. 2, pp. 74–7. For the comparison with *A Bearded Man in a Cap* see pp. 73 and 76; as well as Wheelock 1995, p. 244.

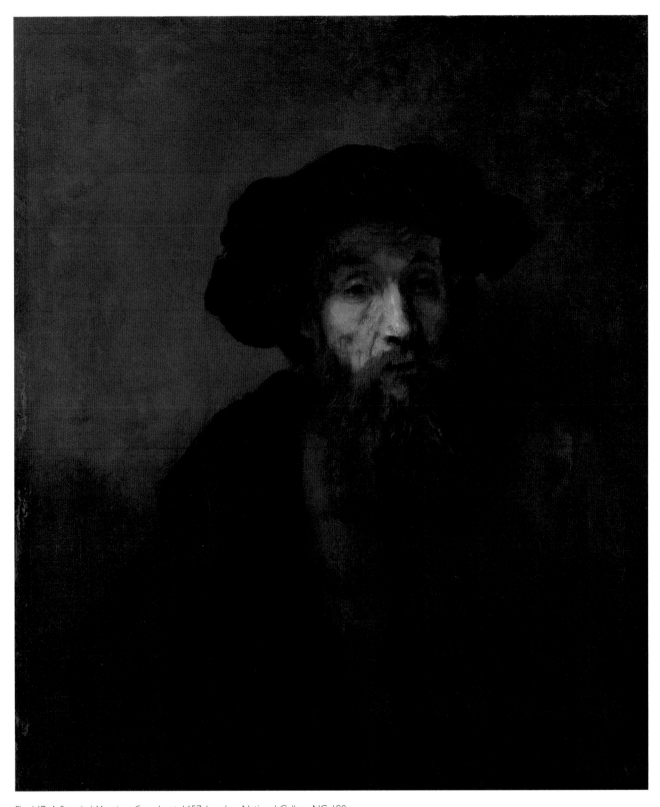

Fig. 167 *A Bearded Man in a Cap*, about 1657. London, National Gallery, NG 190

16 An Elderly Man as Saint Paul, probably 1659

Canvas, 102 × 85.5 cm
Signed, right, on the level of the head: Rembrandt/165[9?]
Bequeathed by Lord Colborne, 1854
NG 243

Images of Saint Paul occur with surprising frequency in Rembrandt's oeuvre.
In this picture the attributes of the book and the sword clearly identify the saint.
They symbolise the word of God and the saint's martyrdom respectively, and are
introduced in Rembrandt's other pictures of the same saint, for example those in
Stuttgart,[1] Nuremberg[2] and Washington.[3] The roundel of Abraham's Sacrifice in
this picture (Fig. 168) is additional evidence of the identification, as it often appears
as a prototype of the Crucifixion and is used as such in Saint Paul's discourse on the
nature of faith in his Epistle to the Hebrews (11:17). The roundel is very summarily
painted but is sufficiently clear to show that the composition is based (in reverse)
on Rembrandt's only etching of the subject, which he made in 1655 (Fig. 169).

In 1661 Rembrandt also used one of his many self portraits to depict himself in
the guise of the apostle,[4] thereby underlining the central role Saint Paul seems to
have played for him. As other authors have explained elsewhere in more detail, in
the Protestant Netherlands of the seventeenth century the apostles as the witnesses
of Christ's life and suffering and disseminators of his teachings remained a popular
subject for paintings.[5] Paul had, of course, never met Christ in person, but he
occupies a central role as an interpreter of Christ's teachings. Indeed, some see him
as the inventor of Christianity. While Rembrandt also painted several of the other
apostles, his depictions of Paul are the most numerous. Interestingly, however, he
never chose to show the dramatic scene of Paul's conversion, but instead focused
on the contemplative nature of Paul the scholar. It is impossible to ascertain what
may have motivated Rembrandt's preference for Paul – aside from his general
prominence among Protestants[6] – but it has been suggested that he saw in Paul a
fellow flawed human being who had received the gift of grace and found favour in
the eyes of God.[7]

How far this painting may be considered a portrait has been a matter of debate.
MacLaren observed that it had 'more the character of a portrait than most of
Rembrandt's paintings of saints',[8] yet Brown considered this notion unlikely.[9] More
recently, Arthur Wheelock observed the 'immediacy of the rendering of the figure's
features and expression', and convincingly concluded that the 'portraitlike quality
of this image […] strongly suggests that the painting shows one of the artist's
contemporaries in the guise of Saint Paul rather than an imaginative portrayal of
the saint'.[10]

Fig. 168 Detail of the roundel, just visible in
Cat. 16, depicting Abraham's Sacrifice

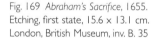

Fig. 169 Abraham's Sacrifice, 1655.
Etching, first state, 15.6 × 13.1 cm.
London, British Museum, inv. B. 35

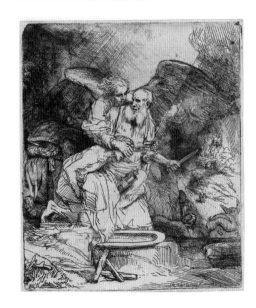

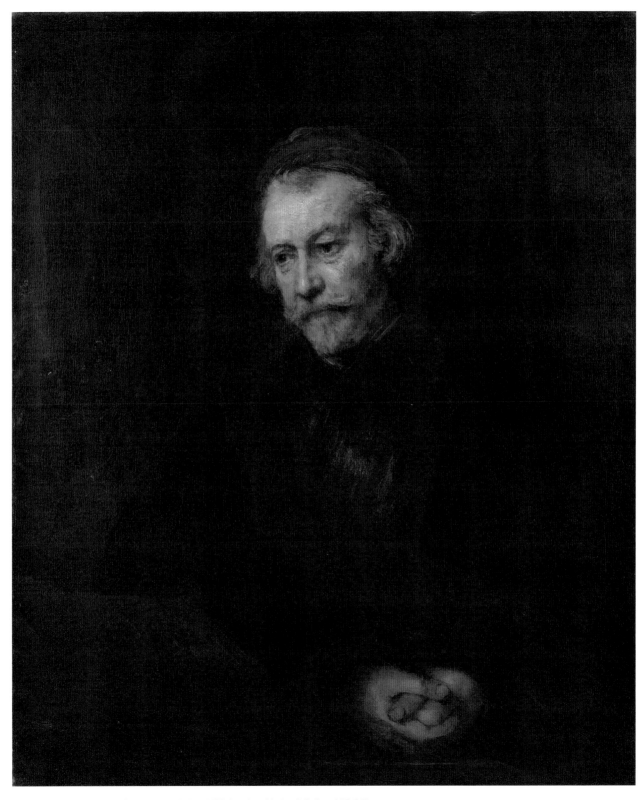

Fig. 170 *An Elderly Man as Saint Paul*, probably 1659. London, National Gallery, NG 243

The date on the painting should probably be read as 1659. All that remains of the last digit resembles a 'o', but there is a mark at the bottom of it to the right which is almost certainly the beginning of the downstroke of a '9'. The style accords well with securely dated works of the late 1650s. Gerson pointed to 'some obvious weak parts in the picture (the modelling of the hands, the unbalanced colour scheme), due either to heavy wear or to the fact that the picture is only an old copy'.[11] The picture may have been cut down a little on each side. The present left edge touches on the figures in the roundel in the top right-hand corner, and on the other side the last letter of the signature is rather near the edge of the canvas and there is no room for the 'f' which Rembrandt nearly always puts after his name on paintings. There is wearing in the roundel in the top right-hand corner and in the hands. A small damage above the sitter's left eye was repainted in 1972. Notwithstanding any wear or damage, Haak considered the picture the best of the group of half-length apostles and saints from the years around 1659/60.[12] As will be seen, there are no technical reasons for thinking this fine half-length apostle to be anything but an original painting by Rembrandt.

The X-ray image of the painting (Fig. 175) is dominated by the fairly irregular medium-weight canvas weave. Study of the cusping indicates that it may have been trimmed a little at the bottom as well as at the sides (see above), but not by a significant amount. The weave is made visible in the X-ray by the ground, which contains lead white in both layers. The picture is unusual among the National Gallery Rembrandts in having a double ground with a brown rather than reddish-orange underlayer, and a fairly thick upper layer of greyish brown. The first ground is composed of lead white, umber and black, while the second contains granular lead white mixed with coarse wood charcoal and a little umber (Fig. 171).

The half-length portrait is technically similar to others of the late 1650s. The whole painting is carried out simply and directly. Only the head is emphasised by vigorous, textured brushwork: all the rest, including the hands, is flat, quiet, under-stated. The head – and presumably the rest of the figure – was laid in with a brown sketch on the grey upper ground layer. This can be seen at the edges of the shadows below the sitter's left eye, in which the ground is left exposed. On top of the lay-in, the head was built up with rapid thick strokes of dense paint, first establishing the broad lights, then adding the detailed structure and finally the highest lights on the cheeks, nose and eyelids (see Fig. 172). In cross-section some intermediate darker paint is present beneath the highlights where they are adjacent to the shadows. Apart from lead white, the tinting pigments for the flesh seem exclusively to be finely ground earth pigments of reddish brown or brown. The profile at the left is seen to pass over the adjacent hair, and so must have been one of the final adjust-ments to the shape of the face. The fact that the X-ray image corresponds so closely with the painted image shows that the head was worked up without any hesitation or alteration: even the darks of the eyes and the shadows of eyelids, nose and mouth were determined with total precision from the moment of the first lay-in.

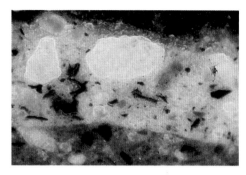

Fig. 171 Paint cross-section of the double ground in Cat. 16. The lower brown layer contains umber, and the greyish brown upper layer incorporates splintery particles of charcoal black and large aggregate particles of pure lead white.
Magnification 360X

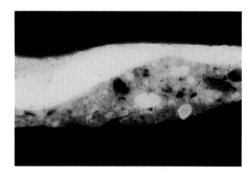

Fig. 172 Paint cross-section from warm shadow over the eyebrow in Cat. 16. Lead white tinted with earth pigments at the surface. The double ground is visible.
Magnification 160X

Fig. 173 Paint cross-section from warm deep brown translucent paint of the book cover in Cat. 16. A semi-glazing mixture containing lake pigments, red and yellow earth and bone black has been used.
Magnification 270X

Fig. 174 Paint cross-section from dark golden-brown book cover in Cat. 16. The upper layer contains earth pigments and black, with added vermilion. The darkest undermodelling layer combines bone black with pale-coloured smalt. Only the upper grey-brown ground layer is present.
Magnification 150X

The composition of the paint indicates that similar warm glazing mixtures were used in the background darks, the cover of the book (Fig. 173) and the figure's fur-edged robe. For the rich, deep semi-translucent reds and browns, combinations of bone black and red lake pigment, with added red ochre, form the basic mixture, with the proportions of the pigments varied to provide greater or lesser depth of colour and translucency. The hottest, most opaque browns, for example in the cover of the book, contain vermilion in addition (Fig. 174), while some of the darker rich semi-transparent blacks contain quantities of poor-coloured smalt and a high proportion of bone black.

The system for the warm brown glazes is very close to that used in *The Woman taken in Adultery* (Cat. 10); there, however, the paint is very thinly applied in the background depths. Here, although they do not rival the heavy applications for the flesh of the face, the translucent paint layers are rather thickly worked – particularly in the very dark paint, where coarse, neutral-coloured glassy particles of smalt are present in large amounts. The smalt was probably incorporated to bulk out and give body to the paint film as well as for its colour. It may also have been added for

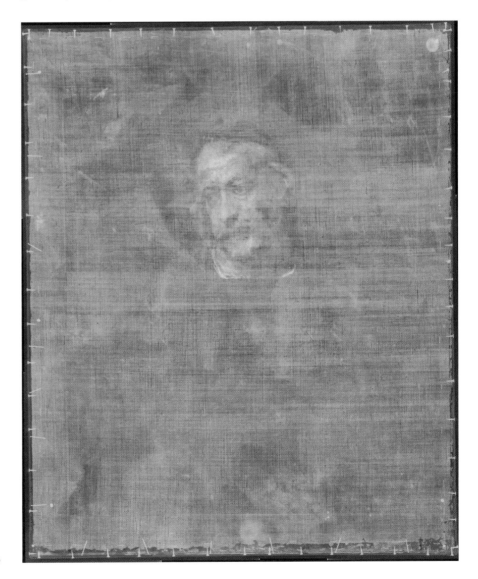

Fig. 175 X-ray mosaic of Cat. 16

its siccative effect: where pigments do not dry well in oil, for example bone black and the red lakes, such 'driers' can be used. Smalt with bone black and red lake are the main pigments in the very dark glazes to the right edge, in the concealed background beneath the cover of the book to the left edge (Fig. 174), and in the deepest shadow glazes on the book's cover. The deterioration of the smalt has resulted not only in loss of its own colour, but also in a pronounced darkening of the oil medium; the background is therefore markedly less cool in colour than it would originally have been. The use of smalt in this manner is comparable to the construction of glazes for the backgrounds and costumes in the later portrait pair of *Jacob Trip* and *Margaretha de Geer* (Cats 17 and 18). The warmer reddish-brown glazes contain small amounts of pale blue azurite in insufficient quantities to modify the colour of the red, black and brown transparent pigments with which it is mixed, so it is presumably included as a drier, in the way that smalt is used for the translucent blacker paints. These intense semi-glazes pass over rich mid-brown underlayers (for example in the robe), which are made up of more opaque mixtures of earth pigments, red lake and some white. The lower body-colour layers for the surface glazes are in turn underpainted in thin translucent browns which lie directly

Fig. 176 Detail of head from Cat. 16

Fig. 177 X-ray detail of head in Cat. 16 showing Rembrandt's original treatment of the collar

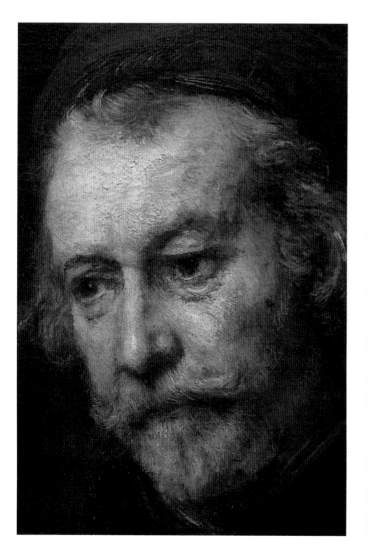

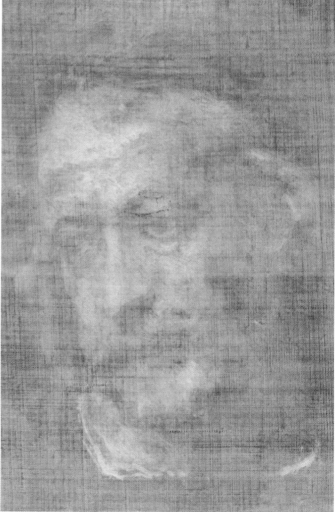

over the brownish-grey upper ground. The only touches of a higher key other than in the flesh paint are provided by fairly pure strokes of earth pigment (for example in the cap), which makes use of red and brownish-yellow ochres at the surface.

The only alteration of any significance is at the collar, where originally more white material seems to have been visible. To concentrate attention solely on the head, Rembrandt glazed it out to leave just a thin white highlight below the chin (Figs 176–7).

The hands do not have any of the raised, broken impasto of the face: they are, by contrast, painted in an entirely smooth manner. It is possible that there is some wearing of the paint here which may make the hands a little weaker than they were originally, but clearly the contrast in texture was deliberate.

REFERENCES
HdG no. 291; Bauch 1966, no. 224; Bredius 1969, no. 297; Haak 1969, p. 298; Schwartz 1984, no. 353, p. 310; London 1988, no. 15, pp. 116–19; MacLaren and Brown 1991, vol. 1, pp. 337–9; Washington and Los Angeles 2005, no. 11, pp. 108–10.

NOTES
1 *Saint Paul in Prison*, 1627, Stuttgart, Staatsgalerie; see Washington and Los Angeles 2005, p. 75, fig. 1.
2 *Saint Paul at his Desk*, about 1629/30, panel, Nuremberg, Germanisches Nationalmuseum, see *Corpus*, vol. 1, 1982, no. A26; also Kassel and Amsterdam 2001, no. 32, pp. 222–5.
3 *The Apostle Paul*, about 1657, Washington, National Gallery of Art, Widener Collection; see most recently Washington and Los Angeles 2005, no. 2, pp. 74–7.

4 *Self Portrait as the Apostle Paul*, 1661, Amsterdam, Rijksmuseum; see Washington and Los Angeles 2005, no. 11, pp. 108–10.
5 See Volker Manuth's essay 'Rembrandt's Apostles: Pillars of Faith and Witnesses of the Word', in Washington and Los Angeles 2005, pp. 38–55.
6 Ibid., pp. 45–6.
7 Washington and Los Angeles 2005, p. 109. See also Wheelock 1995, pp. 241–2.
8 MacLaren 1960, p. 319.
9 MacLaren and Brown 1991, vol. 1, p. 338. Brown also rightly dismissed a suggested identification of the figure as the poet Joost van den Vondel (see the engraved portrait of Vondel by Cornelis Visscher, Holl. 164).
10 Washington and Los Angeles 2005, p. 82.
11 Quoted in MacLaren and Brown 1991, vol. 1, p. 338 and note 8.
12 Haak 1969, p. 298.

17 Portrait of Jacob Trip, about 1661

Canvas, 130.5 × 97 cm
Signed on the right a little above the level of the sitter's left hand: Rembr [1]
Bought, together with its pendant (*Portrait of Margaretha de Geer*), 1899
NG 1674

The sitter in this portrait (and its companion, the *Portrait of Margaretha de Geer*, Cat. 18) was first identified by Hofstede de Groot.[2] Jacob Jacobsz. Trip (about 1576–1661)[3] was an immensely wealthy Dordrecht merchant. He was the son of the shipowner Jacob Jansz. Trip (1530–89) who lived in Zaltbommel, a small town between Dordrecht and Nijmegen. When Jacob Jacobsz. was still a child the family moved to the city of Dordrecht which at the time was the Netherlands' largest trading port. Later Jacob became a merchant and dealt in iron from Liège, as well as in coal, cloth, timber and salt. In 1603 he married Margaretha de Geer (1583–1672), the sister of the wealthy and powerful arms dealer Louys de Geer (1587–1652), who had established his business in mining and as a manufacturer and dealer of arms in Sweden.[4] Louys frequently worked with Jacob's brother Elias (about 1569/70–1636) who had moved his business to Amsterdam in 1614. After 1626 Jacob played a key role in that enterprise. Two of Jacob and Margaretha's sons, Louys (1605–84) and Hendrik (1607–66) learnt the trade by spending time with their uncle in Sweden and eventually became successful arms dealers and manufacturers. Their business was based in Amsterdam, but from 1646 Hendrik also owned a factory in Julita, Sweden.[5] Their immense fortune allowed them to commission the Trippenhuis (Fig. 178), a palatial house on the Kloveniersburgwal with a richly decorated façade of seven bays dominated by a giant Corinthian order, that was built for them by the architect Justus Vingboons (1620/21–98) between 1660 and 1662.[6]

Dudok van Heel has argued that the National Gallery's portraits of Jacob and Margaretha Trip were commissioned from Rembrandt by the two sons, presumably to hang in the Trippenhuis.[7] A date of about 1661 is likely on stylistic grounds. Jacob Trip died in Dordrecht in May 1661 and it is unclear whether or not the portrait was begun before his death. There is a marked difference between the two portraits: his is a hieratic image whereas hers appears more animated. Furthermore, unusually for pendant portraits, she is facing the viewer directly rather than turning towards her husband. This seems further to support the assumption that the portraits were painted after Jacob's death[8] and that his picture was therefore not from life but from another portrait. One interesting and unusual feature of both pictures is that these two wealthy and powerful sitters are shown in surprisingly informal clothes. Jacob's gown and shawl – much like his wife's gown – would have been worn in the bedroom or around the house rather than in the street.[9]

Fig. 178 Jan Vingboons, *The Trippenhuis, Amsterdam.* Engraving from Justus Vingboons, *Het Huys . . . Trip*, 1664.
Amsterdam University Library, inv. 957D15

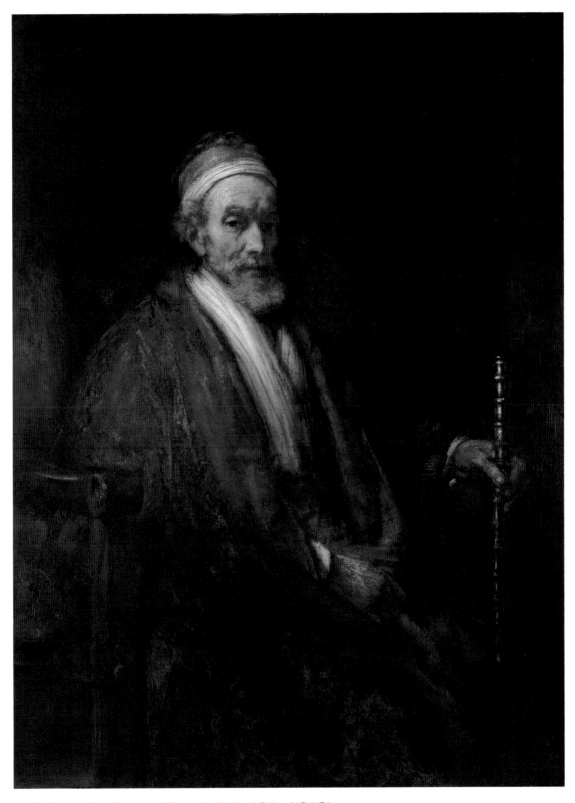

Fig. 179 *Portrait of Jacob Trip*, about 1661. London, National Gallery, NG 1674

The Trips had their portraits painted on numerous occasions. There is one set of portraits by Aelbert Cuyp of 1652[10] and eight by or after Nicolaes Maes between 1657 and 1669 (Fig. 180).[11] Furthermore there are two earlier portraits of Jacob Trip by Aelbert Cuyp's father Jacob Gerritsz. Cuyp.[12] Interestingly, Margaretha de Geer also seems to have had another portrait of her husband painted four years after his death.[13]

Trip and his wife spent their lives in Dordrecht, but one or both of them presumably sat to Rembrandt in Amsterdam. Rembrandt had had an earlier contact with the Trip family, having painted Aletta Adriaensdr (1591?–1656),[14] the widow of Jacob's brother Elias, and her daughter Maria Trip (1619–83) both in 1639, portraits which today are respectively in the Museum Boijmans Van Beuningen, Rotterdam, and the Rijksmuseum, Amsterdam.[15] The Trip family was one of the richest in Holland and these large-scale formal portraits, quite possibly destined for the grandest private residence in Amsterdam, were a major commission. They attest the continuing popularity of Rembrandt as a portrait painter in Amsterdam in the last decade of his life.

The truncated signature at the right edge and the lack of cusping indicate that the canvas has certainly been cut down on the right, possibly by about 5 cm. The partial cusping at the top and bottom, visible in the X-ray (see Fig. 185), suggest that these edges have been trimmed too, but not by so much. Allowing for turnovers, the original width of the canvas could well have corresponded to the standard '1½ ell' measurement.[16] The canvas has the same slightly uneven weave as that used in the companion portrait, but does not have the same prominent weave fault as found there.

The canvas is prepared with a double ground comprising a rather coarse-textured lower layer of orange-red earth pigment, covered by an upper layer of dull khaki. Both layers are rather heterogeneous, with silica particles and small quantities of red lake pigment in addition to the main ochreous component in the lower, and a mixture of coarse lead white, chalk, yellow ochre, umber and charcoal in the upper ground (Fig. 181). There are three factors which suggest that the grounds for this portrait and its companion were applied in Rembrandt's studio, rather than the canvases having been obtained ready grounded. The inclusion of red lake in a red earth lower ground is unlikely to have been a commercial practice, since lakes, particularly the reds, were costly pigments and would have had no function in a layer intended to be entirely concealed. It is more probable that the lake pigment is an accidental contaminant arising from the activities of a busy – and dusty – studio. Secondly, the interface between the two ground layers, as well as that between the upper ground and the lowermost paint layers, can be seen in cross-sections to merge together, suggesting that each layer was not entirely dry when the next layer was applied (Fig. 181). Perhaps Rembrandt was pressed for time in painting these commissions. In the majority of double grounds the junctions are quite sharp and distinct. Most significantly, there are layers of paint in the portraits

Fig. 180 Nicolaes Maes, *Portrait of Jacob Trip*, about 1660–1.
Oil on canvas, 88 × 68 cm.
Budapest, Szépmüvészéti Muzeum, inv. 233

Fig. 181 Paint cross-section from double ground in Cat. 17, with orange-red below and dull khaki above. Note the red lake pigment particle in the lower ground layer.
Magnification 152X

Fig. 182 Paint cross-section from Cat. 17; middle tone of right hand over shadow underlayers. The surface paint is lead white with a scumble of earth pigment. Incomplete layer structure.
Magnification 145X

Fig. 183 Detail of the face from Cat. 17

which are identical in colour, texture and, by analysis, chemical composition to the upper olive-coloured ground layer, suggesting these to have the same origin – that is, in Rembrandt's studio.

The upper ground layer is not used directly as a visible tone in the finished painting, since it appears to be covered in all areas with a further layer or layers similar in colour. It is this tone that Rembrandt is using as the basis for his mid-tone throughout the painting. It can be seen unmodified in the brown area below Trip's beard, between the sides of his shirt and, in the usual way, around the eyes (Fig. 183). It also forms much of the shadowed side of the face. Rembrandt has therefore used a much more economical style of painting here than in the *Portrait of Margaretha de Geer*, in which the brown underlayer is hardly exploited at all in the build-up of the face. Jacob Trip's hands, too, make use of dull greyish-brown and dark brown underpaints, which form the shadow structure, and can be seen through the touches of light-coloured impasto of lead white mixed with earth pigment dabbed on top (Fig. 182).

The texture of the paint in the male portrait is more direct, more fluid than in the female portrait, although both make use of a red lake pigment bulked-out with a greyish smalt to create ridges of translucent dark impasto (because the medium has become so discoloured the presence of yellow lake here cannot be confirmed). In *Jacob Trip* the technique is applied to the bolster on the chair (see Fig. 184); in

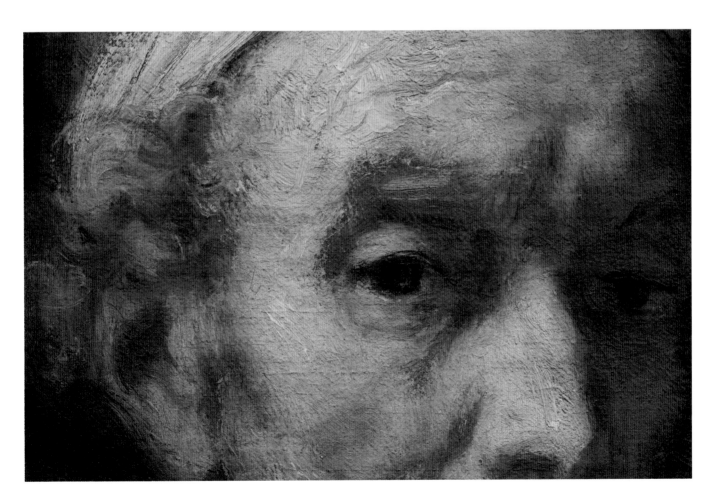

Margaretha de Geer it is the textured fur edging to her robe which is built from glazing pigments laden with smalt (see p. 177, Fig. 193). The fur lining and deep red-brown material of Jacob Trip's cloak are similarly worked, but the paint is less thickly elaborated than in his wife's portrait. Colour change in the smalt-containing paint has presumably resulted in colour changes in the picture, as in the companion portrait.

These subtle differences in handling and build-up between the two portraits give an instructive and cautionary lesson in interpreting Rembrandt's technique. They do not, of course, imply that the two portraits are by different hands or are not a pair: they show rather that the painter's approach could vary according to circumstances and the sitter, and could lead to considerable technical differences in the process of catching a likeness. But similarities in ground structure, palette and particularly in the construction of dark glazes containing smalt mixed with red (cochineal and madder) lakes show how closely the two portraits can be identified with one another in their essential method of painting.

It has often been remarked that in pairs of portraits by Rembrandt the male portrait is of higher quality: here it is not a matter of quality, but of complexity. Clearly the *Portrait of Jacob Trip* was achieved rapidly and easily, in a direct and more economical style. The *Portrait of Margaretha de Geer* is much more carefully worked, partly fluid and partly dabbed with drier paint covering the underlayers with repeated reworking. One is easy and straight-forward, the other more careful, painstaking and laboured. These differences are clearly explained if Jacob Trip was painted not from life but from another portrait – Rembrandt was simply reproducing an image, not responding to a real face as he was when he painted Margaretha de Geer.

There are two principal changes of composition in the *Portrait of Jacob Trip*. First, his right hand has been moved to a lower position: the earlier, slightly higher hand can be seen clearly on the picture surface and the X-ray shows faintly that it may have been holding the stick at this stage.

Second, the deep, high-backed wing chair in which Trip now sits was not the original design. The X-ray shows a quite different arrangement: Trip originally sat forward on a much simpler round-backed chair and was silhouetted against a light background. Cross-sections show the chair originally to have been lighter in tone, painted in mid-brown and dull orange colours, with a raised texture built up by the addition of colourless smalt to a mixture of reddish-brown earth, red lake and black (Fig. 186), perhaps initially to represent brocaded

Fig. 184 Paint cross-section from Cat. 17; deep orange-brown textured glaze of bolster on the left. The thick glaze contains a mixture of red and possibly yellow lake pigments, extended with pale-coloured smalt. The double ground is visible beneath a thin reddish-brown undermodelling layer.
Magnification 160X

Fig. 185 X-ray mosaic of Cat. 17

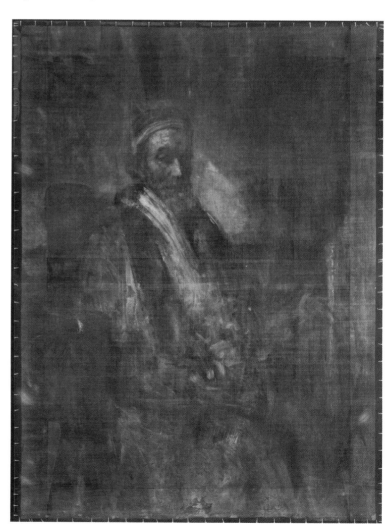

Fig. 186 Paint cross-section from dark area of the chair-back, left in Cat. 17. A scumble of bone black is laid over a textured paint of earth pigments, bulked out with poorly coloured smalt.
Magnification 165X

upholstery. The dense background paint around the head and left shoulder is clearly visible in the X-ray and at its lower edge, against the shoulder, it has been brushed up into a double ridge where the fluid paint has accumulated. Just above this, in the X-ray, some speculative scratch marks are just visible, as if Rembrandt was idly sketching in the line of Trip's collar in the wet paint of the background. The composition was then altered and these light areas glazed over with a mixture of smalt and bone black for the dark paint of the present chair (Fig. 186). Elsewhere, too, light features have been glazed down: the elaborately painted coat clearly had many more lights and highlights at one stage, but Rembrandt has subdued them to give emphasis to the sitter's head and hands.

Although now dominantly a dark picture stressed in warm colours, *Jacob Trip* makes use of surprisingly large quantities of smalt. It is found mixed with lake glazing pigments for the thick, translucent red-brown paints of the cloak and the bolster; in the underlayers for the chair back; with yellow ochre and black for the dull khaki of the cloak; and as a final glaze with bone black with or without lake pigments in the darkest colours of the background setting. This cobalt-glass pigment has become quite poor in colour, and would seem to have been incorporated as much for its textural and siccative properties as for its tinting effect. As with the pendant *Portrait of Margaretha de Geer* the overall tonality must originally have been cooler and more atmospheric.

REFERENCES
HdG no. 512; Bauch 1966, no. 429; Bredius 1969, no. 314; Dudok van Heel 1979, pp. 14–26; Meischke and Reeser 1983, esp. the contribution by Isabella E. van Eeghen, pp. 72–3; Schwartz 1984, no. 386, p. 334; London 1988, no. 16, pp. 120–5; MacLaren and Brown 1991, vol. 1, pp. 350–2.

NOTES
1 The signature has been interrupted by the present edge of the canvas; although certainly genuine, it is fully visible only in ultra-violet light.
2 Hofstede de Groot 1928, pp. 255–64.
3 The date of Jacob's birth is uncertain, but the most plausible suggestion seems to be that given by Dudok van Heel (1979, p. 15) as about 1576. See also Broos and van Suchtelen 2004, p. 149 and note 5.
4 He eventually became Lord of Österby and Finspång. For more on Louys de Geer see Dahlgren 1923.
5 Their joint business was set up under the name: 'Louis & Hendrick Trip kooplieden in waepenen, geschut, cogels & ammonitie van oorloge.' For more on the factory in Julita see van der Stan 2005.
6 For more on the Trip family see Klein 1965; on the Trippenhuis see Meischke and Reeser 1983.
7 Dudok van Heel 1979, pp. 19–26.
8 Dickey 1995, p. 355.
9 With thanks to Marieke de Winkel for the information on the costume.
10 See MacLaren and Brown 1991, vol. 1, p. 351, note 5.
11 See ibid., p. 351, note 6; and Edinburgh and London 2001, p. 234 and note 5 with further literature. For the Budapest portrait here illustrated see also Dordrecht 1992–3, nos 64–5, pp. 246–9.
12 See MacLaren and Brown 1991, vol. 1, p. 351, note 4.
13 Nicolaes Maes, *Portrait of Jacob Trip*, canvas, 121.5 x 100.1 cm; see Broos and van Suchtelen 2004, no. 33, pp. 149–52. The date of the picture is based on the assumption that it is the companion to a dated *Portrait of Margaretha de Geer*, formerly at Nederhemert Castle (fig. 33a). See also Németh and van Leeuwen 1992, pp. 8–9.
14 There seems to be some confusion around her birthdate, different sources give it as 1587, 1589 and 1591.
15 For the Rotterdam picture see *Corpus*, vol. 3, 1989, no. A132. For the Amsterdam portrait see *Corpus*, vol. 3, 1989, no. A131; and Edinburgh and London 2001, no. 85, pp. 167–8.
16 Van de Wetering 1997, p. 123. On the canvas supports see also van de Wetering 1986a. The Amsterdam ell was equivalent to about 68.8 cm.

18 Portrait of Margaretha de Geer, about 1661

Canvas, 130.5 × 97.5 cm
Bought, together with its pendant (*Portrait of Jacob Trip*), 1899
NG 1675

Margaretha de Geer, daughter of Louis de Geer, was born in Liège in 1583. She was the sister of the wealthy arms dealer Louys de Geer. Her family left Flanders in 1595, possibly for religious reasons, and settled first in Aken and then Dordrecht. She married Jacob Trip in 1603 and died in Dordrecht in 1672.[1] The couple had twelve children, five of whom were still living in 1660.[2] For details of the circumstances of the commission of these two portraits, which were probably painted in 1661, see the entry for the pendant to this picture, the *Portrait of Jacob Trip* (Cat. 17). The portrait of Margaretha is unsigned. It is the same size as the *Portrait of Jacob Trip* and is a pendant to it. It has recently been suggested that the two portraits were painted for the Trippenhuis in Amsterdam (see p. 166, Fig. 178), but they are first definitely recorded in the collection of the Lee family in England in the eighteenth century. They were then considered to be a pair and remained together until their purchase by the National Gallery in 1899.

Other portraits of Margaretha de Geer are known – by Jacob Gerritsz. Cuyp and Nicolaes Maes (Fig. 187), both Dordrecht painters, and one attributed to Rembrandt (Cat. 19).[3] Two drawings have been associated with this portrait (Ben. nos 757 and A10), but it is by no means clear that they show Margaretha de Geer and both, even if they are indeed by Rembrandt, must date from the 1630s.

The most striking feature of this portrait is the pose of the sitter. The picture departs 'from the marriage pendant formula'.[4] Instead of assuming the traditional pose turned towards (the portrait of) her husband – the 'time-honoured heraldic half-turn', as it has been referred to by Dickey[5] – Margaretha de Geer has been placed frontally, and fixes the viewer with a steady gaze. This departure from tradition may be a further indication that the two portraits were painted after Jacob's death, when she – literally – did not have a husband to turn to anymore. It has also been observed that the three-quarter-length format and the prominent armchair lend her the appearance of an enthroned ruler.[6]

It is often stated that Margaretha's clothes are old fashioned. Certainly, in this picture she is shown in clothes that were fashionable in the circles of the civic élite in the 1620s. Her peaked black cap had come into fashion in France after 1610. At that time the handkerchief was also a popular accessory, but a decade later had already been abandoned by fashionable young women. But in the 1650s and 1660s the carrying of handkerchiefs was considered to be a sign of dependable

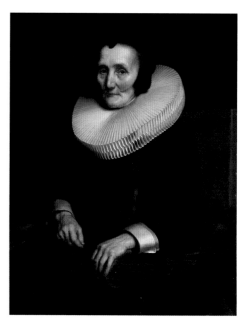

Fig. 187 Nicolaes Maes,
Portrait of Margaretha de Geer, about 1660–1.
Oil on canvas, 88 × 68 cm.
Budapest, Szépmüvészéti Muzeum, inv.231

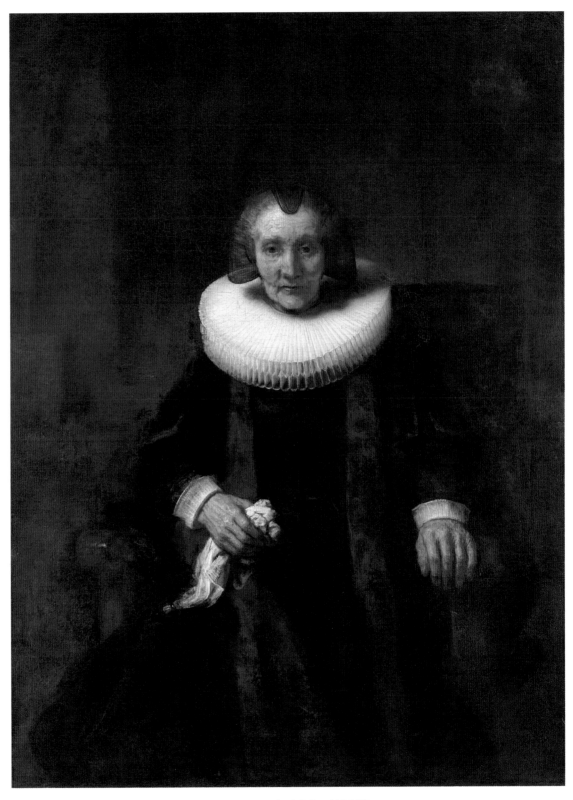

Fig. 188 *Portrait of Margaretha de Geer*, about 1661. London, National Gallery, NG 1675

old-fashioned stylishness by Mennonite women. Stephanie Dickey has suggested that, in the context of this picture, the handkerchief is far more than a fashion accessory. In her opinion the *zakdoek* (as it was then called) points to the grief and emotional fortitude of the recently bereaved sitter whose husband may indeed have died shortly before the two portraits were painted.[7] The wide pleated ruff the sitter wears also dates from the earlier part of the century, and was worn by wealthy women in the 1620s and 1630s. In short, Margaretha still wears the clothes of her youth, something that was not unusual for elderly Dutch patrician women.[8] Interestingly, her attire seems to contrast sharply with the almost regal image she projects. Her gown with its short sleeves actually indicates reasonably informal dress – much like her husband's costume – that would have been worn around the bedroom or the house rather than in the street. And yet Margaretha's image leaves little doubt about the gravitas and authority of the matriarch of one of the wealthiest and most influential families in the Netherlands of the seventeenth century.

Study of the cusping in the X-ray (Fig. 190) shows that this portrait, like its companion, has been trimmed somewhat at all four edges, the largest loss being at the right edge. It is most probable that both portraits have always remained together and were treated together: thus they have both been trimmed to the same size. However, there are marked differences in the two radiographs which suggest that this canvas was treated less expertly than its companion. In the upper half of the X-ray image are broad diagonal sweeps of a fairly opaque material, some of which, on close inspection, can be seen as ridges on the picture. These have nothing to do with the original painting, but are accumulations of lining adhesive on the back of the original canvas, roughly applied without any attempt to smooth them out. They are also quite distinct from a sickle-shaped curve of paint seen at the top of the X-ray against the upper stretcher bar: this plays no part in the composition, was painted out by Rembrandt himself and is difficult to interpret. In a cross-section, the dense paint beneath the dark surface glaze is a warm light brown. It can only represent some abandoned feature of the interior setting for the portrait.

The canvas, made visible by the ground in the X-ray, is of the same type and weight as that of the companion portrait. There is a very prominent weave fault running down through the right side of the sitter's head, with one very thick thread (dark in the X-ray) and some loose weave on either side of it. The canvas has a double ground identical to that of *Jacob Trip* (Fig. 189). As there, the structure and composition suggest that both layers of ground were probably applied in Rembrandt's studio and formed an integral part of the painting process. In general the paint, including the background colours, is laid so thickly on top that the upper layer of ground plays no part in the final colour composition.

In contrast to *Jacob Trip*, which has been changed only slightly, Rembrandt clearly had considerable difficulty in arriving at the final details of the *Portrait of Margaretha*

Fig. 189 Paint cross-section detail of the double ground in Cat. 18. Splintery particles of charcoal are evident in the upper layer, and the lower layer is notably heterogeneous.
Magnification 380X

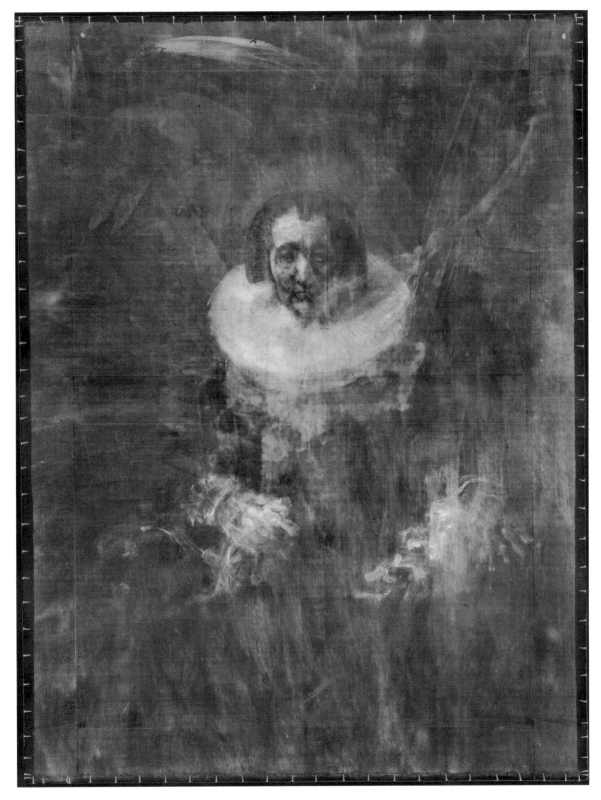

Fig. 190 X-ray mosaic of Cat. 18

de Geer. The most notable change is in the position of her left hand. It was first painted side-on, thumb and forefinger showing, resting in her lap; then resting on the arm of the chair to the right of the present position and finally as we see it now. Of these three attempts, the first and second show clearly in the X-ray; the third and final version lies between them and its X-ray image is lost in an accumulation of dense brushstrokes. The first placing of the hand can be seen in Fig. 192, which shows in cross-section the brownish-red shadow of the thumb concealed by at least six layers of rich, translucent dark-coloured paint representing the fur trim to the robe worked on top. It appears that the hand at this early stage was painted directly on to the upper layer of ground, with no preparatory sketching stage detectable.

There are other changes too: the great ruff was altered in shape more than once as it was being painted. At first it was tilted more towards us, the back higher and the front a little lower. The adjustment of outlines not only tipped it back a little to the present angle, but slanted it too, so that it is now slightly higher at the back right than on the left. The X-ray shows us that the sitter's white cuffs were originally trimmed with lace: this is just visible below the picture surface, too. Rembrandt glazed it out to the present severe, plain outline. The handkerchief in her right hand is slightly confused in the X-ray image, and an unexplained white fold drapes towards the left over the arm of the chair.

The overall structure of the head seen in the X-ray is very similar to that seen in *Jacob Trip* – the classic Rembrandt construction. Forehead, cheeks, nose, eyelids, top lip and chin are all modelled strongly in lead white. One would expect to see – as in the companion portrait – the ground or underlayer exposed in the usual way around the eyes and mouth: but these areas of shadow and half-tone have been mainly modelled on top in earth colours, dabbed over where the ground would normally show, but over underlayers similar in colour to the upper part of the ground (Fig. 191). Apart from the forehead, which is painted in the same fluid manner as Jacob Trip's, the whole face seems much more worked and reworked than his: the cheeks are dabbed to suggest skin tone and texture and the thin mouth

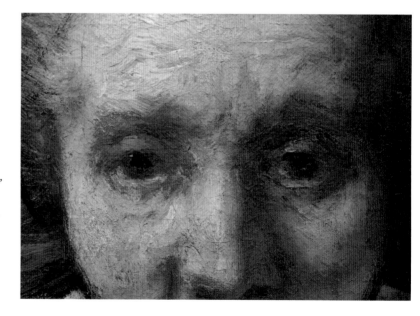

Fig. 191 Detail of the face from Cat. 18

is a pastose black line similar to those we have observed in earlier portraits, but absent from *Jacob Trip*.

Except for where there are *pentimenti*, as in the curved feature seen in the X-ray above the sitter's head, the background darks are fairly simply constructed, although the paint layers incorporate a multiplicity of pigments. For example, the very dark greyish-green wall to the left is achieved in two layers, with a dark brown underpaint comprising red, orange and yellow earth pigment combined with bone black and a trace of lead white, and then glazed with a mixture of smalt, red ochre and possibly also

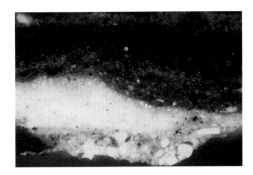

Fig. 192 Paint cross-section from fur trim of robe over the *pentimento* of the thumb in Cat. 18. The concealed flesh paint is brownish pink. Only the upper layer of ground is included in the sample.
Magnification 135X

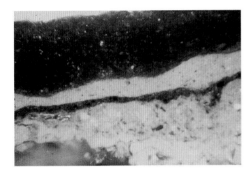

Fig. 193 Paint cross-section from the fur trim to the robe at lower edge of Cat. 18; translucent thick brown glaze over a khaki underlayer. The double ground is visible beneath a thin black lay-in.
Magnification 110X

Fig. 194 Detail by transmitted light of the glaze layer in Fig. 193. The thick translucent paint is built up of two applications containing smalt in discoloured medium, with a proportion of red lake pigment and perhaps chalk-based yellow lake in addition in the lower layer.
Magnification 160X

yellow lake pigment. As the wall passes into deeper shadow, a glaze of bone black adjusted with a little red lake and red ochre replaces the smalt-containing upper layer. Smalt is also present in the warmest translucent deep brown shadows to the left edge, where it is used to bulk out a thick glaze containing cochineal lake pigment laid over a thin underpaint of bone black.[9]

These combinations of smalt with mixtures of lakes are most comprehensively employed in the painting of Margaretha de Geer's robe. The garment itself is rather simply painted with a glaze of bone black and smalt, warmed with a little reddish-brown lake pigment. Similar glazes of smalt and lake, which now appear a warm dark brown, describe the edging to her robe, and find their counterparts in the textured sections of Jacob Trip's cloak and the bolster against which he is seated. The orange-brown of the fur trim here passes over a solid olive-grey underpaint; the translucent upper layers are painted in a mixture of red lake pigment, smalt and possibly a little chalk-based yellow lake, then glazed with a paint containing smalt and a little red lake (see Figs 193 and 194). It is probable that the smalt was incorporated to give texture and bulk to the glaze as well as to provide colour. The cobalt glass would also have exerted a siccative effect on the medium of a paint film containing lake pigments, which on their own dry poorly in oil, particularly when thickly worked. The smalt is not of a strong blue and many of the particles are entirely colourless. It is very probable that this cobalt glass pigment was not of the highest grade and the colour was never particularly strong. However, deterioration of the pigment has caused it to lose its colour and chemical reactions associated with this have resulted in the oil medium becoming extremely yellow, clearly seen in Fig. 194. In fact it has so far been impossible to confirm the use of yellow lake pigment here or in similar areas in *Jacob Trip*, although the presence of a small amount cannot be ruled out. These colour changes, seen also in *Jacob Trip*, and in other paintings where similar smalt mixtures have been used extensively, have resulted in the painting now appearing much darker and warmer in tone than was originally the case, an alteration that Rembrandt could not have anticipated.

REFERENCES
HdG no. 857; Bauch 1966, no. 523; Bredius 1969, no. 394; Schwartz 1984, no. 387, p. 334; London 1988, no. 17, pp. 126–9; MacLaren and Brown 1991, vol. 1, pp. 352–3; Dickey 1995, pp. 354–5; Edinburgh and London 2001, no. 137, pp. 234–5.

NOTES
1 For more information and literature on the family see the entry on the *Portrait of Jacob Trip* (Cat. 17). See also Edinburgh and London 2001, no. 137, p. 234.
2 Broos and van Suchtelen 2004, p. 149.
3 For the portraits of the Trips by Cuyp and Maes see the previous entry (notes 6, 7).
4 Dickey 1995, p. 355.
5 Ibid, p. 354; quoted in Edinburgh and London 2001, p. 234.
6 Edinburgh and London 2001, p. 234.
7 Dickey 1995, pp. 354–5.
8 The authors are grateful to Marieke de Winkel for the information on the dress.
9 In the first edition of this catalogue, the paint medium in the background was reported as containing some egg. It is now known that the presence of smalt in an oil medium appears to inhibit the formation of azelate to some extent, giving an anomalous analytical result suggesting the presence of egg. In fact the medium of the paint is conventional drying oil.

19 Portrait of Margaretha de Geer (bust length), 1661

Canvas, 73.5 × 60.7 cm
Signed on the left below the level of the shoulder: Rembrandt. f 1661
Presented by the National Art Collections Fund, 1941
NG 5282

This is the smaller of the two portraits of Margaretha de Geer in the National Gallery. The other, a three-quarter-length, is a pendant to a portrait of her husband, Jacob Trip, which is also in the National Gallery (see Cats 17 and 18). This portrait shows her in a different pose but also wearing a peaked headdress and a millstone ruff of a type first worn more than 30 years earlier. The pair of three-quarter-length portraits should be dated, as has been argued above, about 1661, which is the date on this painting. That Rembrandt should have executed two portraits of Margaretha Trip with different poses and in different formats within a short period is not in any way surprising. It has been cogently argued that the three-quarter-length portraits were commissioned to hang in the Trippenhuis in Amsterdam, the residence of the couple's sons,[1] and the smaller portrait could have been intended for the Trips' own house in Dordrecht or for presentation to another member of their large family. It is quite likely, however, that both paintings were based on a single sitting or series of sittings, as Margaretha would have had to come to Amsterdam from Dordrecht for this purpose. The smaller portrait could have been painted as a study for the larger version, or after it: in either case, it would be expected that it would be more confidently painted, with fewer *pentimenti* and a less complex paint structure. This indeed proves to be the case. There are, however, a number of unusual results from the technical investigation of the painting, and the possibility of its being painted by a follower of Rembrandt has been considered.

The painting was first recorded in the collection of Lord Charles Townshend in 1818, when he lent it to an exhibition at the British Institution. It was presented to the National Gallery in 1941 and was the first painting exhibited in the famous 'Picture of the Month' series, in which single works were brought back to London out of wartime exile to be shown in the Gallery.[2]

The canvas weave visible in the X-ray (see Fig. 197) is a regular tabby, like that of the larger version; but it has a different, somewhat thickened and blurred appearance. This is partly caused by thicker, more fibrous threads, but is largely due to the way the ground in this picture differs from that of the larger picture. The canvas bears a double ground with a lower layer of chalk and an upper layer comprising a mixture of granular lead white, chalk and charcoal black, with red and yellow earth pigments in small quantities (see Fig. 196). In the majority of Rembrandt canvas paintings that have a two-layered ground, the lower layer is not chalk but an orange

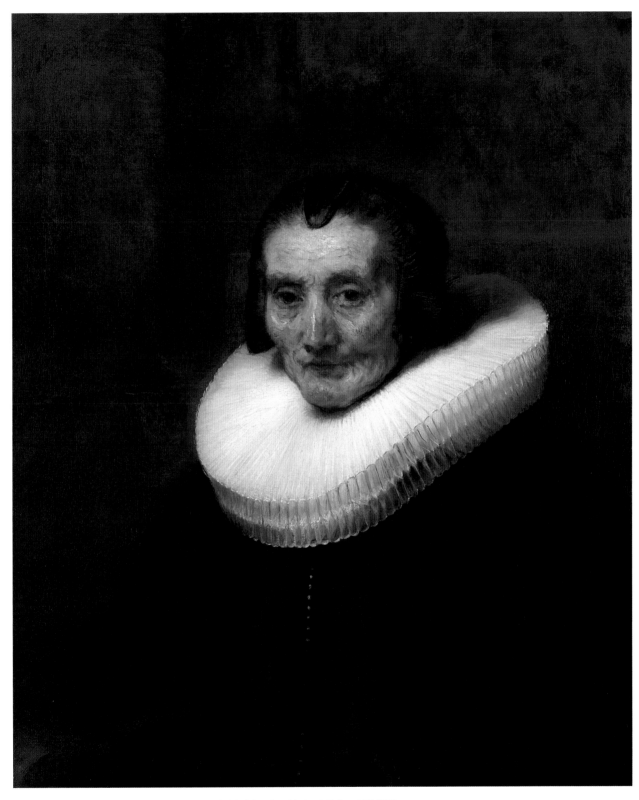

Fig. 195 *Portrait of Margaretha de Geer (bust length)*, 1661. London, National Gallery, NG 5282

or reddish-orange ochre, as in the larger *Portrait of Margaretha de Geer*. The particle form of the yellow earth pigment in the upper ground is unlike that of most specimens of yellow ochre in paint and ground samples examined for Rembrandt: it is present as yellow rod-like crystallites, rather than rounded particles, which are the common form. In the past these features have been highlighted as significant departures from Rembrandt's normal working practice. However, since the first edition of this catalogue, several examples of chalk grounds have been detected in undisputed canvas paintings by Rembrandt of the late 1650s or early 1660s, some of them with a double structure similar to that seen here. A notable example is the *Staalmeesters* of 1662, now in the Rijksmuseum, Amsterdam.

The ground is partly radioabsorbent and therefore makes the canvas structure visible in the X-ray. It can be seen that on all sides of the picture the outermost part of the canvas has been used as a tacking edge (although at the top, only fragments remain) which has now been flattened into a plane with the picture surface. The presence of this tacking edge is puzzling. It has ground on it, but is unpainted: two painted-out hands at the lower edge, which can be seen in the X-ray, do not extend on to it. A cross-sectional sample through the hidden proper right hand has shown a brownish-pink flesh paint concealed by a bone black glaze for the sitter's costume. Because the canvas which forms these margins is indisputably continuous with the main part of the picture, and because it is unpainted, it must be the *original* tacking edge: it cannot be the result of reducing the picture size and using some of the picture area for a new edge (as was the case with the *Self Portrait at the Age of 34*; Cat. 9). The survival of original tacking edges in a canvas picture of this age is unusual (making the overall dimensions 75.5 x 63.7 cm). In addition, the canvas near the edges does not appear to be cusped: this indicates that it was cut from a larger prepared piece and attached lightly to a conventional strainer before painting. It is highly unlikely that it was either prepared with ground in its present size or that it was painted in a stretching frame.

The light brown ground colour is used as a mid-tone in many places in the sitter's head. Around the eyes, beside the nose and between forehead and hair, the ground shows extensively (see Fig. 198). The technique here is quite different from that of the larger portrait, in which the ground colour is hardly visible at all. The handling of the paint is also different. The larger version is careful, painstaking and reworked, layer over layer, to achieve the final likeness. This smaller portrait is fluid, rapid, almost careless in its execution, for example the odd curved brushstroke on the upper part of the nose which gives it a strange dented shape unlike that in the larger version. The brushstrokes elsewhere in the face define form much more loosely than the technique demonstrated, in quite different ways, in the two Trip portraits.

In other parts of the portrait the paint is handled fairly conventionally. The X-ray image has a less forceful structure than that of the large portrait. In the ruff, shadows have been scratched into the wet paint with the brush-handle. At the

Fig. 196 Paint cross-section from translucent deep brown background, upper right of Cat. 19. The surface paint contains earth and lake pigments with bone black. The double ground has chalk as the lower layer, and lead white, charcoal and ochre as the upper layer. Magnification 165X

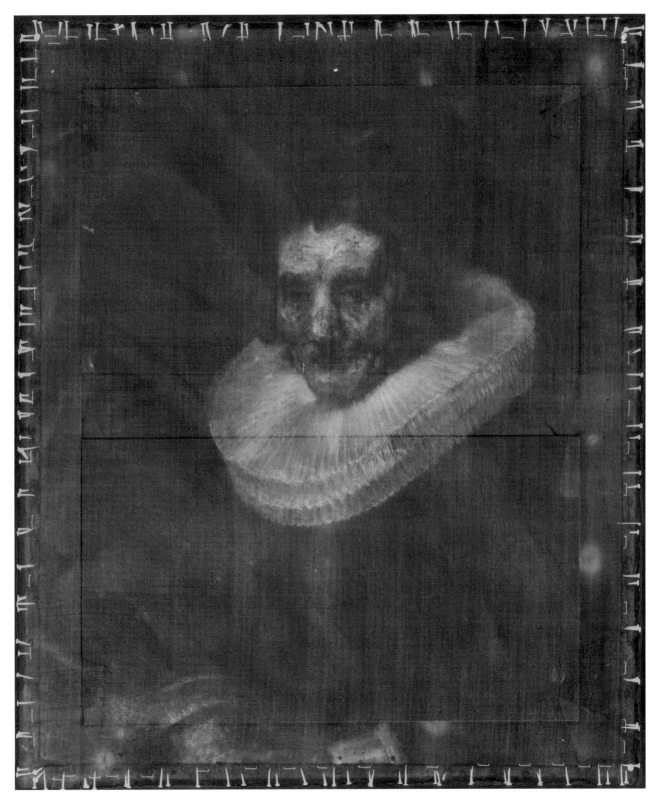

Fig. 197 X-ray mosaic of Cat. 19

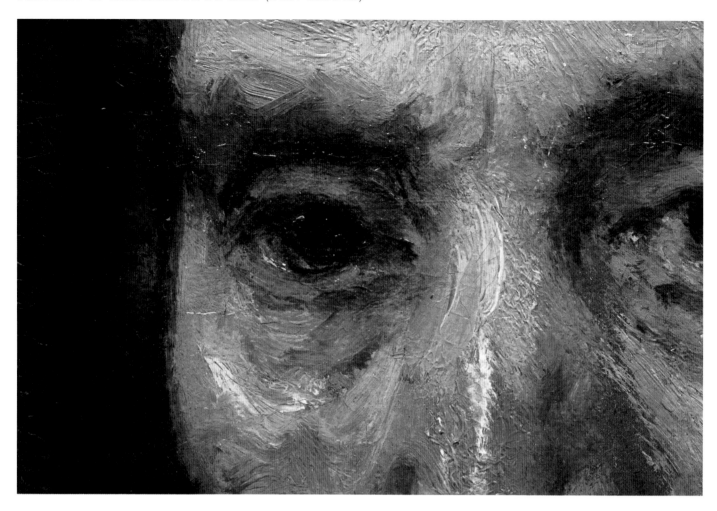

Fig. 198 Detail of the face from Cat. 19

bottom of the picture the hands, which were never more than glimpsed at the very edge, were painted out as the composition was finalised.

The palette required for a portrait of this type is clearly rather restricted, but the pattern of pigments used reflects Rembrandt's conventional painting practice. The translucent deep browns of the background employ the rather complicated glazing mixtures found in a number of pictures by Rembrandt, and contain bone black, red and reddish-brown lakes, combined with yellow, red and orange earth pigments (Fig. 196). Unlike those in the upper ground, in the paint layer the earth pigments have the usual rounded particle form found in naturally occurring ochres. The degree of translucency and the colour of the glazes reflect the varying proportions of each pigment component incorporated. The sitter's black dress is painted principally in a layer of bone black, but as in the darkest background shadows to the large *Portrait of Margaretha de Geer* and in the black coat of *A Bearded Man in a Cap* (Cat. 15) the paint is warmed by the addition of a little red lake and red earth pigment.

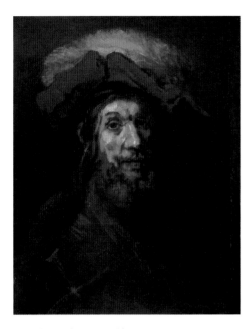

Fig. 199 *The Crusader*, 1659–61.
Oil on canvas, 68.5 × 55.5 cm.
Copenhagen, Statens Museum for Kunst, inv. KMS 1384

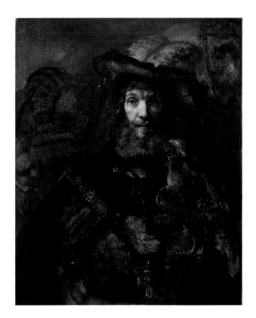

Fig. 200 *The Knight with the Falcon*, about 1662–5.
Oil on canvas, 98.5 × 79 cm.
Göteborgs Konstmuseum, inv. GKM 698

The presence of two portraits of Margaretha de Geer in the National Gallery collection allows an interesting appraisal of the technical criteria of authenticity and shows how new evidence can alter the case for or against attribution. The larger version has always been unquestioningly accepted as a fine and characteristic portrait of the early 1660s. As we have seen, the smaller picture differs from it in several respects and its authorship has in the past been considered problematic. However, as we have also seen, the materials and structure of the ground are no longer viewed as anomalous since other similar examples have been found. Moreover, the relationship between a sketchy bust-length figure study and a more finished three-quarter length portrait is intriguingly paralleled in another pair of paintings that has recently been reassessed. The so-called *Crusader* in Copenhagen (Fig. 199), is clearly related to the larger *The Knight with the Falcon* in Göteborg (Fig. 200),[3] but in the past has been dismissed as a nineteenth-century copy of it. However, as a result of technical and stylistic examination, the *Crusader* is now accepted as an authentic Rembrandt, possibly a study for the larger painting.[4] Similarities with the comparison of the two portraits of Margaretha de Geer are striking. In both cases the head in the smaller version is angled slightly, whereas the larger portraits are painted frontally. In both cases also a sketchy, abbreviated style in which the ground colour is prominent gives way to a more closely worked technique in which the ground is much less visible.

The notion of Rembrandt carrying out oil sketches for larger, more finished works is not one that has been commonly accepted up to now. However, such an explanation might be appropriate for the examples described here. Whatever the precise function of the smaller portrait of Margaretha de Geer, it has become clear that it should now be accepted as by Rembrandt's own hand.[5]

REFERENCES
HdG no. 492; Bauch 1966, no. 524; Bredius 1969, no. 395; Schwartz 1984, no. 388, p. 335; London 1988, no. 17, pp. 130–3; MacLaren and Brown 1991, vol. 1, pp. 367–9; MacGregor 1995; Edinburgh and London 2001, with no. 137, p. 234, fig. 160; Kyoto and Frankfurt 2002–3, no. 37, pp. 194–7; Copenhagen 2006, pp. 68, 203.

NOTES
1 For information on the family and the Trippenhuis see the entries for Cats 17 and 18.
2 See MacGregor 1995.
3 For this painting see also Washington and Los Angeles 2005, no. 17, where the man is identified as Saint Bavo; and Bergen 1992.
4 See Copenhagen 2006, pp. 67–9 and nos 16–17, pp. 200–5.
5 Ernst van de Wetering has also accepted the attribution to Rembrandt; see van de Wetering 1997, p. 226, caption with fig. 289.

20 Portrait of Frederik Rihel on Horseback, probably 1663

Canvas, 294.5 × 241 cm
There are faint remains of a signature, and date, lower left: R[…]brandt 1663 [?][1]
Bought with a special grant and contributions from the National Art Collections Fund and the Pilgrim Trust, 1959
NG 6300

The rider is taking part in a procession which winds around a stretch of water in the lower left, where the prow of a boat can be seen. On the left the façade of a building is roughly sketched. In front of it is a coach in which three occupants and a groom on the running-board can be made out: the heads of the driver and two coachmen at the rear are also visible. The coach is part of the procession, as are the two (or three) riders on horseback (all of whom wear hats) on the right behind the principal rider.

The identification of the rider as Frederik Rihel was first made by Bredius on the basis of an item in the inventory of Rihel's property drawn up after his death: 'Het conterfijtsel van de overleden te paert door Rembrandt' (The portrait of the dead man on horseback by Rembrandt).[2] Rihel was born in Strasbourg in 1621. His father was a paper merchant and his family were well-known printers in the city.[3] He had moved to Amsterdam by 1642, where he lodged with the Bartolotti family. He settled in the city and enjoyed a successful career as a merchant. Rihel lived on the Herengracht and became a *vendrig* (cornet) in the civic guard in 1677. He died in 1681 and was buried in the Nieuwe Lutherse Kerk.[4]

There is nothing in the known provenance of the painting to link it with Rihel – it is first documented in an Amsterdam sale in 1738 – but, on the other hand, there is only one other known equestrian portrait by Rembrandt, the so-called *Polish Rider* in the Frick Collection, New York, which dates from the mid-1650s.[5] There is no documented portrait of Rihel to confirm Bredius's identification, but a study of Rihel's inventory revealed that there are a number of items of dress and accoutrements similar to those worn by the rider.[6] The bachelor Rihel's great love of horses would explain the unusual – at least for Rembrandt – commission. Rihel, as a member of the Amsterdam civic guard, took part in the triumphal entry of Prince William of Orange into the city in 1660,[7] when he entered through the Heiligewegspoort. It seems probable that the portrait commemorates Rihel's participation in the procession and that the building sketched in the lower left is intended to represent the Heiligewegspoort. Luttervelt proposed a different identification of the horseman, namely Jacob de Graeff (1642–90), a *vendrig* in the guard of honour that accompanied the prince into Amsterdam. However, at that time de Graeff would have been too young to be the sitter in this painting and, moreover, there are no similarities between this man and extant portraits of de Graeff.[8]

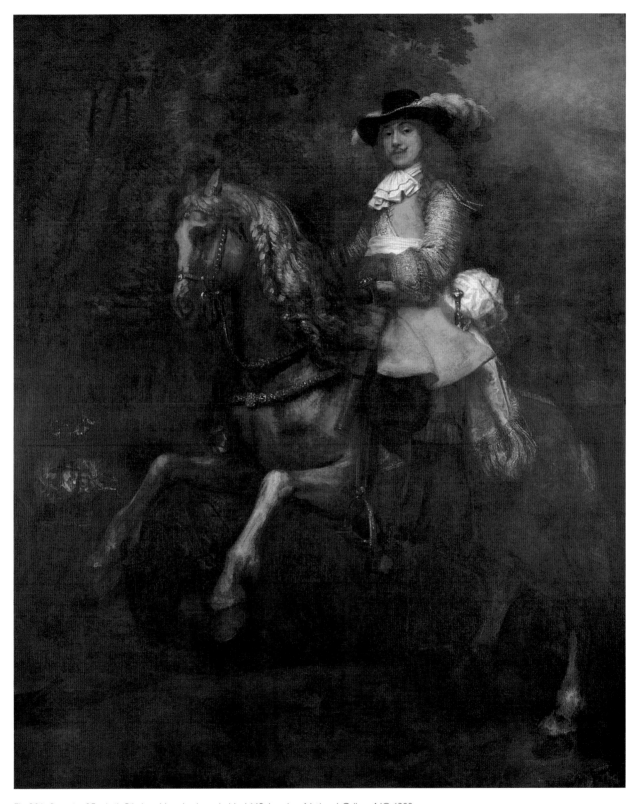

Fig. 201 *Portrait of Frederik Rihel on Horseback*, probably 1663. London, National Gallery, NG 6300

The date appears to read 1663, and this would be acceptable on stylistic grounds. A drawing of a coach in the British Museum (Ben. no. 756) has been associated with this painting, but in fact does not seem to have any real connection with it.

The large canvas consists of three pieces seamed together with a simple running stitch that shows clearly in the X-ray (Fig. 204). The upper seam runs horizontally through the horse's bit and the pommel of the sword below Rihel's elbow. The lower seam runs horizontally just below the horse's front right hoof and at the top of the front left hoof. The top strip of canvas is approximately 106 cm wide, the centre strip 114 cm and the lower strip 74.5 cm. From X-ray details they appear to have the same or similar weave characteristics. The top strip corresponds well to the standard '1½ ell' measurement; the centre strip is rather wide for this loom width, but might just fall within a generous interpretation of the range; the lower strip was presumably cut from a wider piece of canvas.

The canvas weave does not show very strongly in the radiograph because the ground is fairly transparent to X-rays. The ground is of the dark brown 'quartz' type, composed of silica with a little brown ochre (Figs 202 and 203), closely similar to that in, for example, the *Self Portrait at the Age of 63* (Cat. 21). The brown of the ground and similarly coloured underlayers form a visible tone in much of the painting, although rather little of this shows directly in the face and figure of Rihel himself, which are opaquely painted. The horse was probably completed before the rider was placed on top.

The design of the picture has been sketched in with broad strokes of blackish paint applied with a brush. This bold underdrawing is visible everywhere in the infrared photograph (Fig. 205) and seems to have been used to define both the horse and Frederik Rihel, as well as foreground and background features. The horse's legs are clearly outlined, including a *pentimento* of the right hind leg to the right of the present one passing over the foreground paint layer; and there are bold sweeps of drawing alongside Rihel's hair and the feather in his hat.

The infrared photograph shows changes made during the evolution of the portrait. Most obviously, Rihel's hat was initially taller in the crown and wider at the brim; this alteration can also be seen faintly on the picture surface. The hat is painted in a dense mixture of carbon black containing a small amount of red earth; the absorption of infrared by the carbon results in a dark image on the infrared photograph. In addition, several changes of outline in the horse's head and legs are visible.

At least one modification to the background design is not detected by infrared examination. In the lower section of sky Rembrandt initially laid in thickly painted

Fig. 202 Paint cross-section from yellow skirt of rider's coat in Cat. 20, painted over horse's flank. The dark underlayers contain smalt and red lake (containing cochineal and brazilwood dyestuffs) combined with other pigments, and the brown 'quartz' ground is also visible at the base of the sample.
Magnification 145X

Fig. 203 Paint cross-section from greyish-brown tasselled scarf in Cat. 20, painted over horse's flank. The splintered particles of smalt are readily seen in the multilayered paint structure of the horse. The 'quartz' ground is also visible.
Magnification 110X

Fig. 204 X-ray mosaic detail of Cat. 20

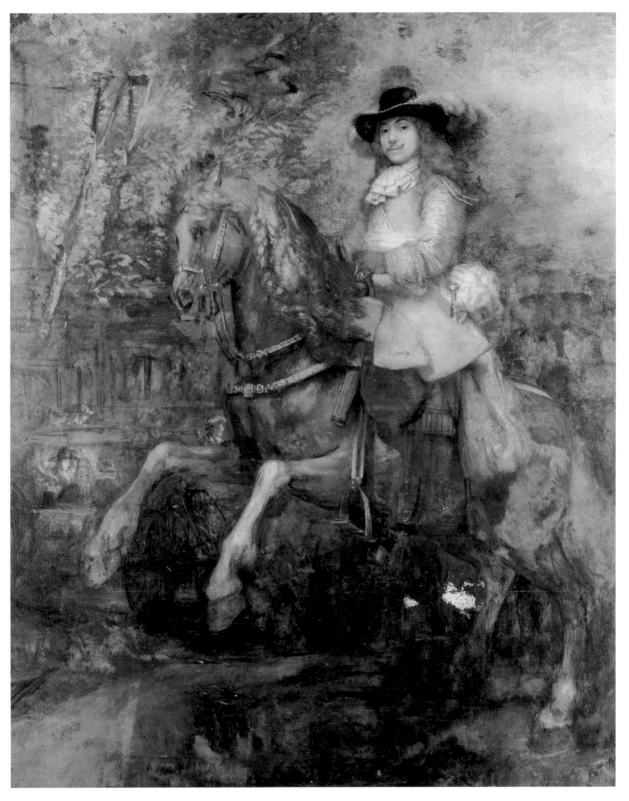

Fig. 205 Infrared photograph of Cat. 20

foliage greens, and later painted them out with the present sky, again thickly. A cross-section shows two solid layers of green and yellow-green, containing smalt, azurite and yellow ochre, obscured by several applications of smalt with lead white for the sky paint (Fig. 206). The lead white upper layers are too substantial for infrared photography to be successful.

The infrared photograph is also very useful in clarifying the image of the whole composition. It is undoubtedly the case that the picture is somewhat darker now than when it was painted – partly through varnish discoloration, but also partly because a dark ground always becomes more prominent as paint ages and increases in transparency. The infrared image shows features of the background barely visible in ordinary light, most notably the carriage and figures to the left of the horse, and the two (or more) riders behind Frederik Rihel at the right.

The application of paint in the *Portrait of Frederik Rihel* spans the whole range of textures and techniques found in Rembrandt's painting. The foreground and main elements of the background have been outlined with brush underdrawing and then thinly glazed and scumbled with local colour. The trees behind and the horse's mane are combinations of dabbed and fluid brushwork. The horse's left foreleg consists simply of one or two huge open brushstrokes of lead white with earth pigments and smalt on a darker underpaint. The figure of Rihel himself shows all of Rembrandt's accumulated mastery in handling paint and using it to suggest texture and relief. Many of the underlayers are bulked-out with smalt to assist the broad areas of impasto (Figs 202–3 and 208).

The yellow coat is thickly and relatively smoothly painted, but Rembrandt could not resist a flourish with the brush handle in the shadow at the lower left (Fig. 207). In the cravat and sash the paint begins to pile up following the highlights, but it is only in the left sleeve and cuff, the hat brim and sword hilt that Rembrandt fully exploits the thickness and shine of full impasto to convey the brilliance of metal and glittering fabric. Knowing that a painting such as this would hang high up and catch the light, he allows the highlights on sleeve and sword to achieve a double effect, to have both visual and actual texture, to combine the brightness of lead white paint with the sparkle of real reflected light.

Some interesting colour and textural effects are achieved with a fuller palette than Rembrandt generally adopts, but the scale and subject matter clearly require a wider range of colours than that of his indoor compositions. Smalt is used in great profusion: as the blue pigment for the patch of greyish-blue sky (Fig. 206); in mixture with white, earth pigments and red lake for the darks of the flank of the horse (Figs 202–3); and in association with yellow pigments for the dull landscape greens.

Fig. 206 Paint cross-section from greyish-blue sky, upper right corner of Cat. 20. The sky at the level of the rider's hat-brim conceals earlier thick green foliage paint containing yellow ochre, smalt and azurite. The sky is painted in several layers of smalt and lead white, with a final glaze of smalt. The lowermost layer for the sky incorporates a little red lake pigment. Magnification 135X

Fig. 207 Detail of the yellow coat from Cat. 20

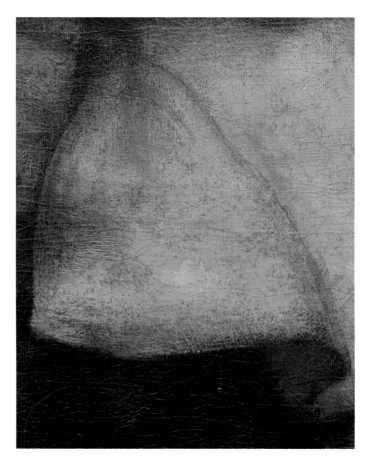

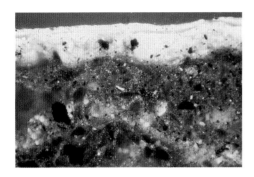

Fig. 208 Paint cross-section from greenish-grey highlight on horse's chest in Cat. 20. Each of the layers which make up the paint of the horse contains smalt. Incomplete layer structure.
Magnification 160X

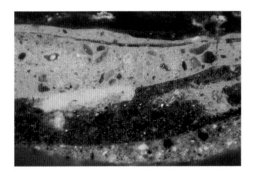

Fig. 209 Paint cross-section from brightest red impasto of stirrup strap in Cat. 20, worked in red ochre mixed with red lake pigment, over darker underlayers. Incomplete layer structure.
Magnification 160X

Coarsely ground smalt is also used to build texture in the brown paint of the horse's flank, and to add a cooler tone to the lighter patches of paint containing lead white drawn over the top (Fig. 208). The greyish blue of the sky is achieved with a glaze of smalt over two solid underpaints of the pigment mixed with lead white (Fig. 206), the lower of which is tinted with a little red lake. Smalt is vulnerable to discoloration in oil medium and this, together with yellowing of the varnish, has caused the loss of the subtlety in colour lent by the lake pigment to the sky. The landscape greens, fairly dark though they were probably always intended to be, have also been dimmed by discoloration. In common with other pictures by Rembrandt, no actual green pigment is used. The yellowest foliage greens to the upper left are based on mixtures of yellow lake pigment with smalt, here relatively thinly painted, but colour change of both pigments in the paint layer has allowed the brown ground to become more prominent. Some of the other duller brownish greens incorporate black pigment or Cologne earth in addition, so would have been dark to start with. It must be mainly contrast and definition rather than colour that has been largely lost in the background landscape.

The brightest of colour touches involve techniques familiar in Rembrandt's work. For the red of the stirrup strap, an almost pure red ochre is intensified by mixture with red lake pigment, and painted wet-into-wet over a series of warm dark underlayers (Fig. 209); while the reflective lights on the horse's bit are in pure lead-tin yellow.

Josua Bruyn has in the past suggested that the horse in this painting may have been painted by a different hand, attributing it and a group of other paintings to another painter in the studio, whom he tentatively identified as Rembrandt's son, Titus.[9] The technical analysis of the painting, however, shows that the picture in its entirety is consistent with Rembrandt's approach and that there are no discontinuities between the horse and the rest of the painting. As Brown has argued, the stiffness of the animal is probably 'better explained by Rembrandt's unfamiliarity with the format of the large-scale Baroque equestrian portrait'.[10]

REFERENCES
HdG no. 772; Bredius 1910, pp. 193–5; Bauch 1966, no. 440; Luttervelt 1957, pp. 185–210; van Eeghen, 1958, pp. 73–81; Luttervelt 1958, 1958, pp. 147–50; Bredius 1969, no. 255; Schwartz 1984, no. 391, p. 337; London 1988, no. 19, pp. 134–9; Held 1991, pp. 69–70; MacLaren and Brown 1991, vol. 1, pp. 358–62.

NOTES
1 Visible by means of infrared photography.
2 Bredius 1910, pp. 193–5.
3 The date of birth and information on Rihel's family were first published in MacLaren and Brown 1991, vol. 1, pp. 358–62.
4 For Rihel's life in Amsterdam see van Eeghen 1958, pp. 73–81; this article appeared in response to Luttervelt 1957, and Luttervelt replied to Miss van Eeghen's article in Luttervelt 1958.
5 Bredius 1969, no. 279; Julius S. Held, 'The Polish Rider', in Held 1991, pp. 59–98.
6 Van Eeghen 1958 and MacLaren and Brown 1991, vol. 1, p. 359.
7 For the identification of the event see Luttervelt 1957.
8 See MacLaren and Brown 1991, vol. 1, p. 359.
9 Bruyn in Rotterdam 1988, pp. 78–81.
10 MacLaren and Brown 1991, vol. 1, p. 360.

21 Self Portrait at the Age of 63, 1669

Canvas, 86 × 70.5 cm
Signed and dated lower left: [...]t f/1669
Bought 1851
NG 221

When this painting was cleaned in 1967 the fragmentary signature and the date 1669, the last year of Rembrandt's life, were revealed. The fact that only the 't' of the signature remains makes it likely that a strip of about 3 cm was cut from the left-hand side of the canvas. Cusping of the canvas threads, visible to some degree in the X-ray (see Fig. 215), confirms this: the cusps at the right are more complete than those at the left. Cleaning also revealed that the background had been extensively overpainted. The *Self Portrait* in the Mauritshuis (Fig. 210), in which the artist again wears a turban, is also dated 1669. Because of changes in the facial features it seems clear that Mauritshuis painting must have been painted after this one.[1] Rembrandt died on 4 October and was buried four days later in the Westerkerk in Amsterdam, where Hendrickje Stoffels had been buried in 1663. It has at times been argued – probably based on the roughness of their style – that the two self portraits from the last year of the artist's life show Rembrandt as a miserable and disappointed man whose artistic abilities were beginning to fail him.[2] Yet quite the opposite is true. While the faces certainly reveal the marks of old age, they 'still powerfully project [the] inner confidence and self-assurance' of a painter fully in control of his craft.[3]

As with so many of his self portraits, Rembrandt does not show himself in contemporary clothing but rather in historicising attire. In his *Self Portrait at the Age of 34* (Cat. 9) he depicted himself in sixteenth-century dress, but in this picture he looks to an earlier time. The fifteenth-century high-necked doublet with the little fur collar and button can be found in portraits by Dirk Bouts (1400?–1475) and Rogier van der Weyden (1399–1464), published by Domenicus Lampsonius in 1572. Rembrandt – once again – does not show himself as a painter of his own time but instead places himself in the tradition of the great masters who were his predecessors.[4]

The canvas is prepared with a single layer of coarse-textured brown ground, the main component of which has been identified as quartz (silica) tinted with a little brown-coloured ochre (see Figs 212–13), and is closely similar to the ground type in the *Portrait of Hendrickje Stoffels* (Cat. 13) and the *Portrait of Frederik Rihel on Horseback* (Cat. 20).

The paint layers vary enormously in texture and thickness. The face, turban and collar are constructed on a very thickly applied foundation of lead-white

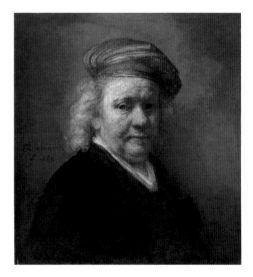

Fig. 210 *Self Portrait*, 1669.
Oil on canvas, 59 × 51 cm.
The Hague, Mauritshuis, inv. 840

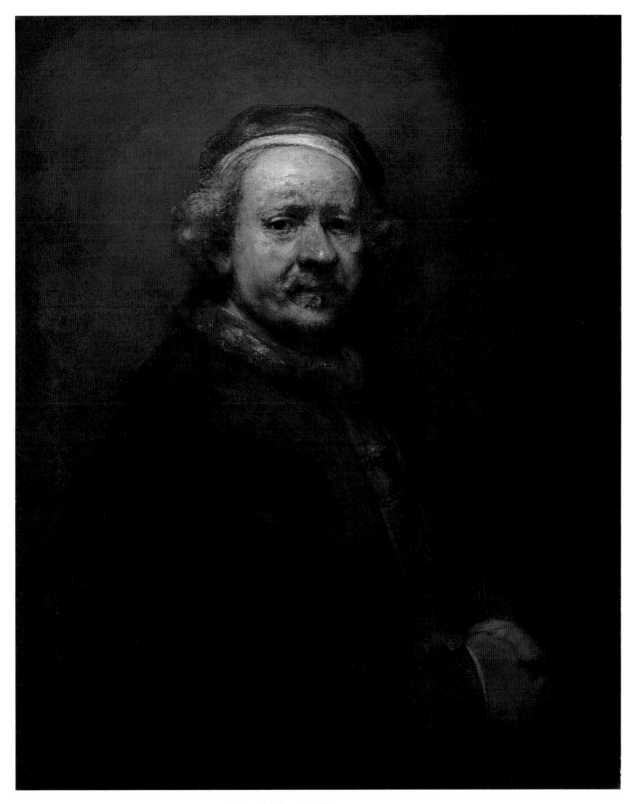

Fig. 211 *Self Portrait at the Age of 63*, 1669. London, National Gallery, NG 221

brushstrokes (Figs 212–13). In the X-ray image the forms appear almost sculptural in the way they are built up (Fig. 215). The lower sleeve and cuff are also fairly thickly elaborated in layers of earth colour. Both in the X-ray and on the picture surface we get the impression of depth and texture actually modelled in paint, piled up for the highlights on turban, forehead, nose and chin, brushed out for the mid-tones and absent from the receding shadows. Moreover, the very handling of the brush gives detail and texture: broad horizontal strokes for the front of the turban, short verticals and diagonals for the main structure of the face and then reworking, wet-into-wet, dabbing, twisting, dragging the paint into broken impasto to suggest the old man's pockmarked skin (Fig. 214). The heavy application at the cheek can be seen in Fig. 212, the mass of the paint of the light tone being lead white coloured only with a little reddish ochre and a translucent brown pigment over a brown undermodelling layer.

The modelled paint leaves the ground colour and perhaps a little undermodelling exposed around the eye-sockets and mouth, and also in the background and sleeve. Half-tones are achieved mainly superficially with cool paint mixtures, but there is some use of semi-transparent scumbles over darker undermodelling.

The remainder of the portrait is painted much more directly and smoothly. Even the hands are relatively untextured. As with many of the portraits, the heavier application of paint for the faces and highlight details on costumes is juxtaposed with the more glaze-like treatment of the darks of the background settings. For example the rich, almost black shadow to the right is a fairly thin single layer of translucent dark brown pigment containing some orange-coloured earth over the dark brown ground, which here must influence the surface colour. Where the paint is more opaque, above and to the left of the head, a second layer containing some white and a little red lake pigment as well as the earth colours has been applied over the translucent underpaint.

Fig. 212 Paint cross-section from thick impasto of cheek in Cat. 21, showing mainly lead white tinted with earth pigments, over a brown undermodelling. The brown 'quartz' ground is also visible.
Magnification 180X

Fig. 213 Paint cross-section from light greyish-brown background above the head in Cat. 21, which conceals the thickly worked white *pentimento* of the turban. Note the rough texture of the dried paint beneath the surface.
Magnification 170X

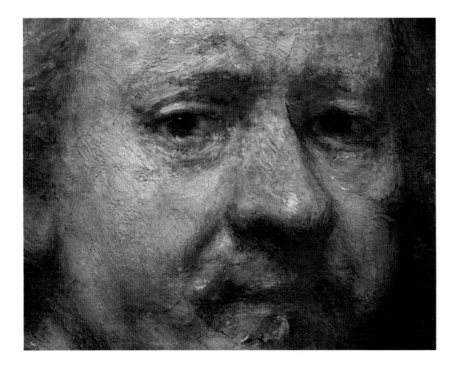

Fig. 214 Detail of the face from Cat. 21

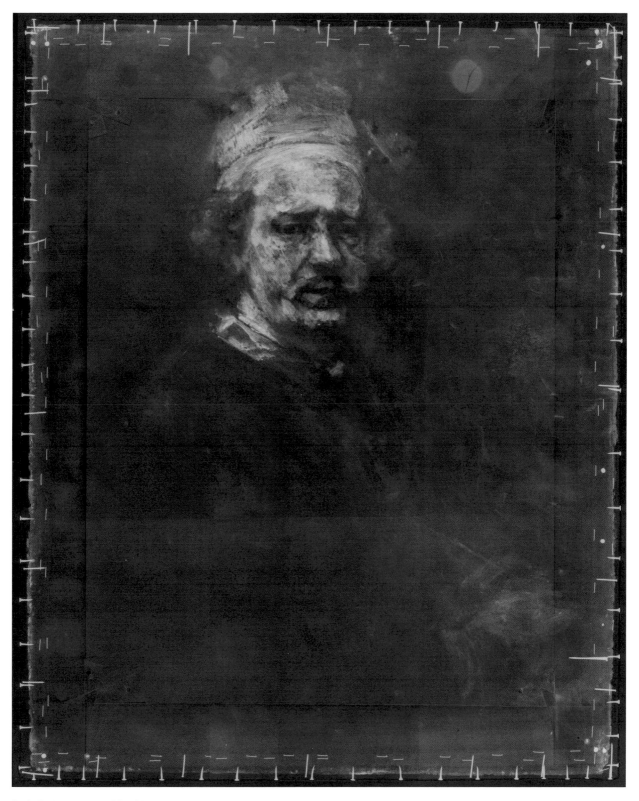

Fig. 215 X-ray mosaic of Cat. 21

The darkest plum-coloured shadows of the coat are equally glaze-like in treatment, with the richest depths thinly and directly applied to the textured ground in a mixture of red and yellow lake pigment intensified with black (Fig. 216). For the mid-tones of the central part of the sleeve there is only the lightest scumble of red earth and black enhanced with some red lake pigment, but as in the background there is no preliminary underpainting and the ground colour and texture show through. As the sleeve and cuff become elaborated towards the hand, the layer structure of the painting can be seen to become more complicated (Fig. 217), with a sequence of underpaints for the thicker surface highlights. For example the muted red impasto at the cuff is underpainted first in brown, then in a layer of orange-coloured earth, and over that a deep red glaze combining lake and red ochre. The upper paint layer incorporates a rich mixture of orange ochre, red and yellow lake pigments, and a little black as final, thickly applied strokes. The lightest tones of red and dull yellow make use of surface touches of earth pigment of a single pure colour. The use of bluish-crimson cochineal lake mixed with the more orange red of madder lake and, occasionally, a little yellow buckthorn lake, gives a wide variety of rich, warm translucent tones to model the coat. The way of constructing these warm colours shows interesting comparisons with the constitution of the various shades of red in *Hendrickje Stoffels* and *Frederik Rihel*, in which the same red lake mixture has been identified.

There are two major *pentimenti* visible in the X-ray. First, the hat was initially much higher and fuller and hung down more at the right; it appears also as if it was

Fig. 216 Paint cross-section from dark plum-coloured glaze, lower left in Cat. 21, containing red and yellow lakes mixed with black.
Magnification 180X

Fig. 217 Paint cross-section from multilayered structure of the red paint of the cuff in Cat. 21. The 'quartz' ground is visible as the lowest layer.
Magnification 360X

Fig. 218 Detail of the hands in Cat. 21

then entirely white – presumably much like the cap in the Kenwood *Self Portrait* (p. 19, Fig. 4). Later Rembrandt reduced it in height and width with broad strokes of background paint and coloured the upper part brown. A cross-section from above the head (Fig. 213) shows a thick layer of the lead white of the originally larger turban laid directly over the ground and pulled up into a jagged impasto. Two layers of the light khaki paint of the background have been drawn over this rough surface to alter the design, but the texture of the paint beneath can still be glimpsed. The paint of the hat must have been thoroughly dry before this alteration was made, since the brushstrokes have not been disturbed by the application of the background paint on top. Second, the hands were originally painted open, not clasped, and in the painter's right hand was a single brush or mahlstick (Figs 218–19). By closing them and removing the point of interest at the lower right-hand corner of the canvas, Rembrandt focused attention on the searching examination in paint of his own face.

REFERENCES
HdG no. 551; Bauch 1966, no. 339; Bredius 1969, no. 55; Martin 1967, p. 355; Schwartz 1984, no. 422, p. 355; London 1988, no. 20, pp. 140–3; Chapman 1990, pp. 128, 130–2; MacLaren and Brown 1991, vol. 1, pp. 336–7; London and The Hague 1999–2000, no. 86, pp. 223–5; *Corpus*, vol. 4, 2005, no. 27.

NOTES
1 Berlin, Amsterdam and London 1991–2, vol. 1, p. 290; London and The Hague 1999–2000, p. 229; *Corpus*, vol. 4, 2005, p. 311.
2 London and The Hague 1999–2000, p. 229.
3 Chapman 1990, p. 130; London and The Hague 1999–2000, p. 225.
4 London and The Hague 1999–2000, p. 71 and pp. 223–5; *Corpus*, vol. 4, 2005, pp. 76, 574–6.

Fig. 219 X-ray detail of the hands in Cat. 21

Works by Followers of Rembrandt

22 A Seated Man in a Lofty Room, early 1630s

Oak, 55.1 × 46.5 cm
Traces of a false signature along the handrail of the stairs at right: Rem[…]randt
Bought from John Davies of Elmley Castle, 1917
NG 3214

The depiction of alchemists and scholars in their studies was a popular subject in the Netherlands in the seventeenth century.[1] Throughout his career Rembrandt – as well as several of his pupils – devoted a number of paintings to this subject, showing both secular and religious scholars.[2] Examples include the *Disputing Scholars* of 1628 in Melbourne (National Gallery of Victoria);[3] *Saint Paul at his Desk* of about 1630 in Nuremberg (Germanisches Nationalmuseum);[4] *Scholar in a Vaulted Room* of 1631 in Stockholm (Nationalmuseum);[5] *Man writing by Candlelight* in the Bader Collection, Milwaukee;[6] the *Scholar in a Room with a Winding Stair* of about 1633 at the Louvre, Paris;[7] and *The Apostle Paul*, about 1657, at the National Gallery of Art, Washington.[8]

As with most of the other works in this book now designated 'follower of Rembrandt', this painting – one of the favourite works within the Gallery's collection of works by the master and his circle – was once attributed to Rembrandt. Indeed, when the attribution was first doubted by Josua Bruyn at a symposium in 1969,[9] several other scholars continued to defend it in the subsequent discussion.[10] Yet with the publication of the first volume of the *Corpus* by the Rembrandt Research Project in 1982 the picture finally lost its status.[11] The authors of the *Corpus* referred to it as 'a well-preserved and fairly old Rembrandt imitation, probably dating from the late seventeenth or early eighteenth century and painted in the southern Netherlands.' Although they pointed to certain resemblances with other works by Rembrandt, they noted a lack of refinement in the execution and 'an exaggeration aimed at effect'. They also deemed the use of colour as well as the scratch marks used to describe contours and lines of script as untypical.[12]

Unusually for a painting of this size and vertical format, the panel consists of three horizontal oak planks of very different widths, with the broadest running across the central part. The top plank is extremely narrow and the bottom one is of thicker wood than the other two. The horizontal joins that connect them are not butt-jointed as would be normal in a seventeenth-century Dutch panel, but have a type of overlapping tongue and groove construction, a so-called scarf joint, each visible in the X-ray as a pair of white lines (see Fig. 223). This was another reason why the authors of the *Corpus* questioned the attribution, for they found this construction 'unthinkable for a seventeenth-century Dutch panel of upright format'. Although such a construction has not been found in other panels by

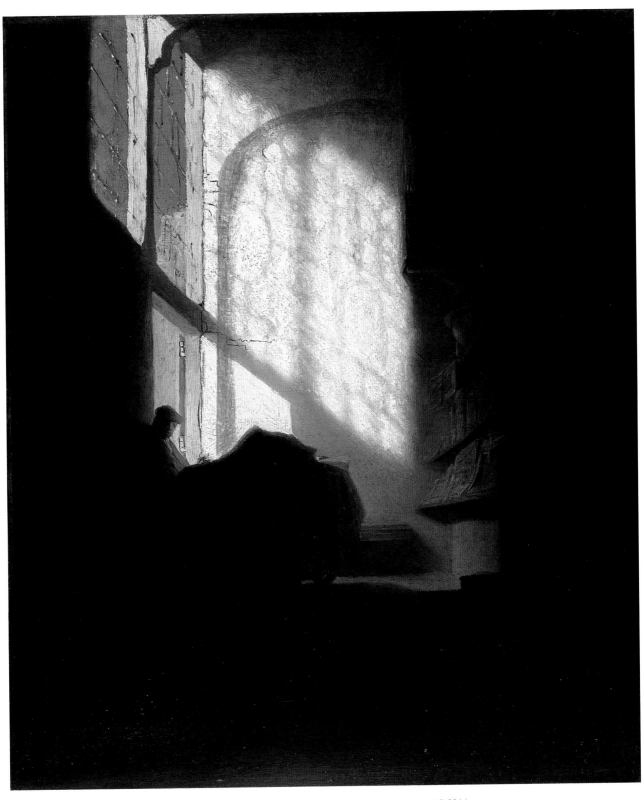

Fig. 220 Follower of Rembrandt, *A Seated Man in a Lofty Room*, early 1630s. London, National Gallery, NG 3214

Rembrandt, it is hardly evidence that the picture could not have been painted by him. Indeed, dendrochronological (tree-ring) dating does suggest that the panel is of the earlier seventeenth century. It is prepared with a conventional ground of chalk and a thin oil-based *primuersel*.

The initial appearance of the painting is somewhat Rembrandt-like, with its figure strongly silhouetted against a light background and vigorous scratching of details into the wet paint. However, closer inspection reveals weaknesses of structure and execution that rule out an attribution to Rembrandt. In an authentic Rembrandt even the darkest parts of a composition have a refinement of detail that is entirely absent here. The figure and the table in front of him are hardly defined at all, and the more detailed passage of the bookshelves at the right (showing as a light, confused area in the X-ray) is unconvincing. The arched recess on the back wall has no depth because the shadow of the window bar does not deviate on crossing it. Finally, the Rembrandt 'trademark' of scratching in the wet paint is crudely done, apparently for effect rather than to give the subtle illusionistic emphasis that Rembrandt usually intended when he employed the technique.

The paint layer structure is considerably more complicated than would be the case if the composition had been derived solely from a model provided by Rembrandt, and suggests an individually created work, the design evolving in the course of its making. The generally monochrome surface tone must always have been intended since cross-sections reveal that in many parts of the composition, the painter began with dark underlayers, or grey paints. In certain passages, for example the light upper part of the window and its frame, the initial paint layers are virtually black, consisting of black pigment and a little smalt, followed by a cool grey based on white, lampblack and some azurite. Here, the uppermost pastose application of paint is largely lead white with a little brownish pigment (Fig. 222). In this part of the composition, and elsewhere, there is some indication in the layer structure of a pause in the process of painting and then further elaboration of the surface. The paint medium is also somewhat different to that generally found in works by Rembrandt or from his studio: linseed and walnut oils thickened by heating and with a little pine resin varnish added to give a rich, glossy paint were identified in some areas, including the wall and tablecloth.

It is now generally agreed that this painting is not by Rembrandt, but by a near contemporary working in his manner, rather than a late seventeenth- or early eighteenth-century imitator as the *Corpus* somewhat unreasonably suggests.[13] The structure of the panel indicates that it may be of Flemish origin rather than Dutch, and the authors of the *Corpus* draw attention to the existence of similar Rembrandt imitations in seventeenth-century Antwerp.[14] In his catalogue *The Young Rembrandt* Ernst van de Wetering identified other paintings that have precisely the same coarse technique and the same rough, undescriptive scoring in the

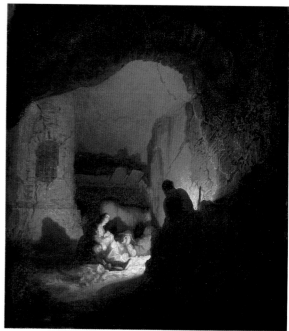

Fig. 221 Circle of Rembrandt, *Travellers resting (on the Flight into Egypt?)*, about 1629–30 Oil on paper on panel, 35.4 × 28.9 cm. The Hague, Mauritshuis, inv. 579

Fig. 222 Paint cross-section from off-white paint of stone moulding above the window, upper left in Cat. 22, over earlier paint layers of cool grey and black. Magnification 95X

wet paint. He grouped this painting with two others, the so-called *Rembrandt's Mother* from a private collection[15] and the *Travellers resting* in The Hague (Fig. 221)[16] in what he calls a 'mini-oeuvre' under the anonymous attribution of 'The Lofty Room Master' – which seems an appropriate designation for this unidentified imitator of Rembrandt.[17]

REFERENCES
Bauch 1966, no. 119; Bredius 1969, no. 427; MacLaren 1960, pp. 331–2 (Rembrandt); *Corpus*, vol. 1, 1982, no. C14; MacLaren and Brown 1991, vol. 1, pp. 373–6; Kassel and Amsterdam 2001, no. 63, pp. 312–5.

NOTES
1 For more on the subject see Kingston 1996–7 and Russell Corbett 2004.
2 See also van der Waal 1974, p. 143.
3 *Corpus*, vol. 1, 1982, no. A13; Amsterdam 2006, no. 7, pp. 47–9.
4 Ibid., no. A26; Kassel and Amsterdam 2001, no. 32, pp. 222–5.
5 *Corpus*, vol. 1, 1982, no. C17.

6 Ibid., no. C18; on this painting see also David de Witt's essay '*The Scholar by Candlelight* and Rembrandt's Early Transition', in Manuth and Rüger 2004, pp. 262–77.
7 *Corpus*, vol. 2, 1986, no. C51.
8 Washington and Los Angeles 2005, no. 2, pp. 74–7.
9 Josua Bruyn in Chicago 1973, p. 37.
10 Chicago 1973, pp. 43–4.
11 *Corpus*, vol. 1, 1982, no. C14.
12 See also MacLaren and Brown 1991, vol. 1, p. 374.
13 Kassel and Amsterdam 2001, p. 315.
14 *Corpus*, vol. 1, 1982, no. C14, p. 532.
15 Kassel and Amsterdam 2001, no. 64, pp. 316–19.
16 Ibid., no. 65, pp. 320–3.
17 Ibid., pp. 78–9.

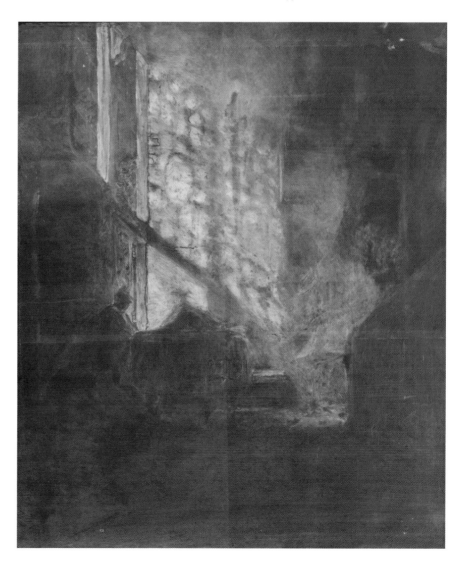

Fig. 223 X-ray mosaic of Cat. 22

23 Diana bathing, late 1630s

Oak, 46.3 × 35.4 cm
False signature bottom left: Rembran[...]
Salting Bequest, 1910
NG 2538

The identification of the subject as Diana, the goddess of the hunt, is usually based on the presence of the hounds. Unusually, here we see Diana bathing by herself rather than surrounded by her entourage of nymphs. Past authors have noticed a further figure in the scene, usually identified as a satyr or – occasionally – Actaeon.[1] During the recent close examination of the picture, however, the authors have been unable to make out any other figure.[2] A light patch between the trees that might be taken for a face is merely a small area of worn paint.

The subject of Diana appears once in Rembrandt's painted oeuvre, in a picture dated 1634, now in the Museum Wasserburg Anholt, in which the artist – unusually – combined the stories of Diana and Callisto and Diana surprised by Actaeon.[3] *Diana bathing* was also attributed to Rembrandt until 1960, when MacLaren rejected the attribution, arguing that 'both construction and execution are far too feeble for him [Rembrandt] and it is clearly by a pupil or follower'.[4] MacLaren found a 'slight resemblance' to the earliest work of Gerbrand van den Eeckhout (1621–74),[5] a suggestion that has been rejected by Sumowski.[6] Bauch suggested an attribution to Govert Flinck (1615–60).[7] This was supported by Sumowski, who compared the landscape to the backdrops in several of Flinck's works.[8] More recently both attributions have justifiably been rejected.[9]

The oak support carries the type of ground preparation typical of seventeenth-century panel paintings: a thin layer of natural chalk bound in glue, with a very thin warm brown *primuersel* of lead white tinted with Cassel earth, probably bound in oil. The colour of the priming is visible through the thinly applied worn paint of the sky in the upper central part of the picture.

The original format of the painted surface appears to have involved a truncated arched top, but at some stage in the picture's history a deep blue paint containing smalt (cobalt glass pigment) was added to the two spandrel-shaped areas at the upper corners producing a rectangular composition. The original paint of the central part of the sky also contains smalt, but there it has discoloured to a light greenish grey (Fig. 224); this colour has been reinforced later by the application of an extensive thin overpaint containing a variety of pigments including viridian green (transparent chromium oxide), the presence of which indicates that the overpaint must post-date the 1830s when viridian was first introduced as an artists' colour. It seems possible that the blue paint on the spandrels once matched the

Fig. 224 Paint cross-section from overpainted sky, top edge of Cat. 23, showing discoloured smalt below later repaint. The warm *primuersel* is visible beneath with a trace of chalk ground.
Magnification 280X

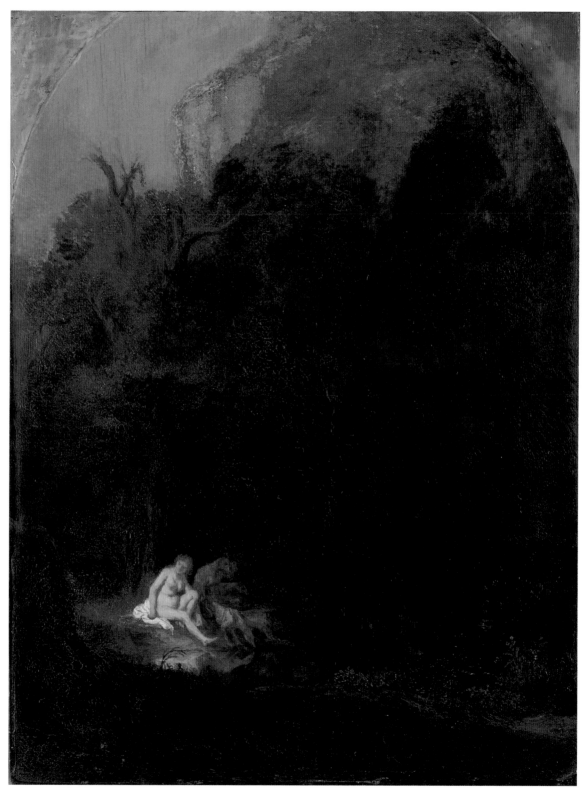

Fig. 225 Follower of Rembrandt, *Diana bathing*, late 1630s. London, National Gallery, NG 2538

central portion of sky, but although the same pigment is involved the texture and layer structure implies that these areas to the left and right are not original.

More finely ground smalt occurs in some of the darker, crustier foliage greens (Fig. 226) of the landscape setting, mixed with pigments such as finely ground mineral azurite, carbon black, earth colours and yellow lake; the smalt may have been included as a siccative (drying agent) for the oil paint. The more strongly green and yellow-green touches involve greenish-coloured azurite with greater or lesser quantities of yellow ochre and yellow lake. The darkest, thickest paint of foliage and landscape, at one time interpreted as bituminous in character, actually incorporates black pigment, red (cochineal) and yellow (possibly buckthorn) lakes, smalt and chalk, in combinations comparable to Rembrandt's own practice in other contexts.

It seems entirely plausible that the painter of this work was familiar with the work of Rembrandt and his followers. The style of the picture – in so far as its compromised condition allows a fair assessment – is reminiscent of Rembrandt's works of the late 1630s, such as his *Landscape with the Good Samaritan* of 1638 (Czartoryski Collection, Krakow).[10] Bearing the reservations about the condition in mind, however, the picture is not sufficiently accomplished to have been painted either by Rembrandt or by Flinck.

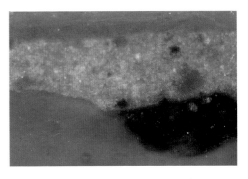

Fig. 226 Paint cross-section from impasto of dark green foliage, lower right in Cat. 23, showing the use of azurite, yellow ochre and other pigments, over dark underpaint containing azurite. Magnification 315X

REFERENCES
HdG, no. 198; Bredius, no. 473; MacLaren 1960, pp. 351–2; Bauch 1960, p. 49; Sumowski 1983–90, vol. 5, no. 2073; MacLaren and Brown 1991, vol. 1, pp. 372–3.

NOTES
1 MacLaren and Brown 1991, vol. 1, p. 373.
2 Examination in the Conservation Studio of the National Gallery on 15 November 2004.
3 *Corpus*, vol. 2, 1986, no. A92; Berlin, Amsterdam and London 1991–2, vol. 1, no. 16, pp. 167–70.
4 MacLaren 1960, p. 351.
5 Ibid.
6 Sumowski did not include the panel in his catalogue of Eeckhout's works (see Sumowski 1983–90, vol. 2).
7 Bauch 1960, p. 49.
8 Sumowski 1983–90, vol. 5, no. 2073, p. 3097.
9 This opinion was expressed by Volker Manuth in a letter to the authors in August 2005.
10 *Corpus*, vol. 3, 1989, no. A125.

FOLLOWER OF REMBRANDT

24 A Young Man and Girl playing Cards, 1645–50

Canvas, 123.5 × 104 cm
Bought 1888
NG 1247

Fig. 227 Nicolaes Maes, *Christ blessing the Children*, 1652–3.
Oil on canvas, 218 × 154 cm.
London, National Gallery, NG 757

In seventeenth-century Dutch painting there are numerous depictions of people – groups of men and women as well as soldiers – playing cards. Philips Angel in his treatise on art of 1642 had recommended the inclusion of 'people seated and throwing dice and playing cards' because such details are pleasing to the viewer and based on reality.[1] Yet more generally, like any other game of chance, card games were highly criticised at the time for being morally corrupting. Since the fifteenth century card playing had been associated with laziness, greed, conflict, betrayal and lack of chastity.[2] The military even issued ordinances against games of chance, yet involvement in morally questionable activities was not confined to soldiers, and there are innumerable depictions of men and women involved in card and board games (Fig. 228), often combined with brothel scenes, which depict men in the process of squandering their fortunes,[3] but also in more private contexts where the men attempt to seduce their female companion. Contemporary emblems also warned against the pitfalls of these situations.[4] It must, however, remain open to discussion how erotically charged the scene in this painting really is, given that the man seems more interested in us rather than the woman, while she, in turn, intently scrutinises her cards.

The painting came into the National Gallery's collection as a work by Nicolaes Maes and was catalogued as such until 1960.[5] Anton von Wurzbach and Hofstede de Groot registered doubts about the authorship,[6] but it was MacLaren who, comparing it with another accepted early work by Maes in the National Gallery, *Christ blessing the Children* (Fig. 227), wholly rejected the attribution.[7]

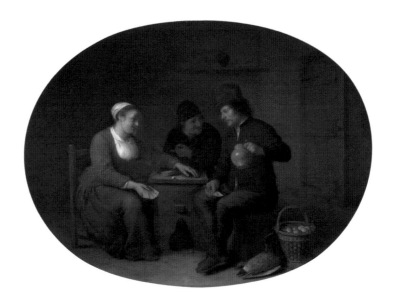

Fig. 228 Hendrick Sorgh, *A Woman playing Cards with Two Peasants*, 1644.
Oil on oak, oval, 26.3 × 36.1 cm.
National Gallery, London, NG 1055

205

The canvas support consists of two parts – a more or less square piece with a substantial addition below transforming it into a vertical format. The horizontal join, running across the tablecloth and the woman's skirt, is clearly evident on the picture surface and the stitching is apparent in the X-ray (Fig. 229). X-rays also clarify other details of the support. The main part of the canvas shows marked cusping along its lower edge – the edge now joined to the additional piece – and must, therefore, have been stretched independently before the addition was made. Although the canvas weave is similar on the two parts, the lower piece appears considerably denser in the X-ray image – implying a different ground type, which is, indeed, confirmed (see below). Also, there is substantial cracking of the paint above the join, suggesting that some damage occurred to the lower edge of the main part before it was extended.

The reason for the addition of canvas to the lower edge cannot be known. It is possible that, in repairing damage to the bottom of the original part, the opportunity was taken to enlarge it. It is certainly likely that the original format was conceived as a squarer composition and then extended to make a more satisfying

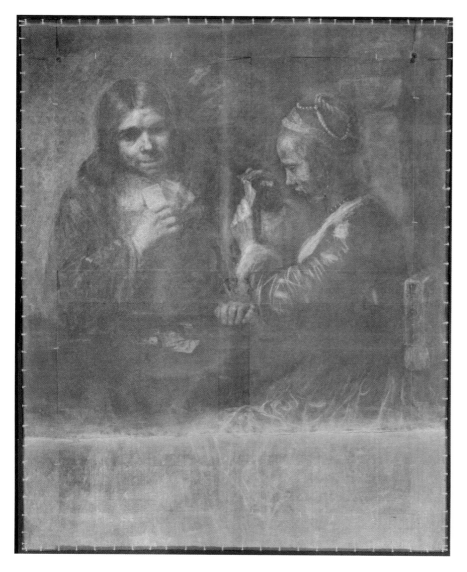

Fig. 229 X-ray mosaic of Cat. 24.

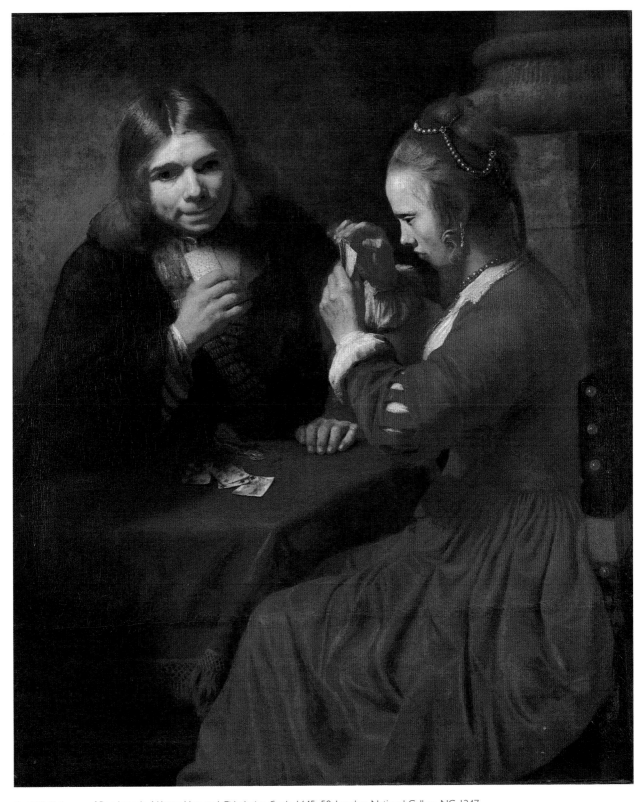

Fig. 230 Follower of Rembrandt, *A Young Man and Girl playing Cards*, 1645–50. London, National Gallery, NG 1247

design, perhaps to fit a particular frame. Whatever the explanation, it is clear from the materials and the paint layer structures on either side of the join that the addition of the lower strip must have followed soon after the creation of the upper, main part of the composition, since the constitution of the paint, and its manner of use, is typical of seventeenth-century practice and close to that employed in Rembrandt's studio. Thread counts of the canvas weave on the main section and added strip show these are of similar, but not identical density; the upper canvas is somewhat finer.

The upper section of canvas, bearing the two figures, has a single brown ground of the so-called 'quartz' type (Fig. 231), found also in autograph paintings by Rembrandt, see for example Cats 13, 20 and 21. The most recent research, by Karin Groen, on the grounds of Rembrandt's paintings indicates that this method of canvas preparation is probably restricted to works by Rembrandt himself, and those closely involved in his workshop production.[8] The lower section of canvas, however, bears a different type of ground, also a single layer of dark brown paint, but composed of a mixture of several kinds of dark-coloured earth pigments, with some yellow ochre and black (Fig. 232). There is also a little added lead white, and occasional particles of smalt can be observed under the microscope.

In enlarging the composition, the painter seems to have extended some of the new ground mixture over the earlier layers of the young woman's bright red dress, painted initially in vermilion mixed with red lake over the brown 'quartz ground' in the upper part of the picture, and then reworked the dress in a similar red pigment mixture over the new dark underlayer. The existence of the double layer structure for the dress also hints at early damage to the picture and subsequent contemporary repair. Some final areas of relative shadow on the dress were then added by glazing with cochineal lake with the possible addition of some madder, a mixture seen in other works from Rembrandt's studio, and perhaps a yellow lake, over the opaque scarlet vermilion-containing layer (Fig. 233). The paint medium used for the glaze contains a little pine resin varnish to give added translucency or gloss.[9] In this way, when the composition was extended by the addition of the lower canvas strip, the new red paint of the dress (Fig. 234) was brought across and over the join and used extensively over the surface of the earlier passage of this section. The brushstrokes representing these upper paint layers are evident in the X-ray of the painting.

Apart from the striking scarlet of the woman's costume, the overall key of the remainder of the painting is relatively low. However, some other strongly coloured materials are used to produce muted colour effects in the composition. For example, the man's cloak is a dark, muddy olive-toned paint comprising blue mineral azurite combined with black pigment, while a small section of the seat of the chair on which the young woman is sitting is represented with a thick layer of smalt pigment, the colour of which is now difficult to make out, although the thick crusty texture of the paint, also the result of the use of smalt, still catches the light. Many parts of the painting consist of upper layers of paint worked over darker,

Fig. 231 Paint cross-section from dark grey-brown of background, left-hand side of Cat. 24. Several layers can be seen, the lowermost of which contains azurite. The brown quartz ground is visible beneath. Magnification 190X

Fig. 232 Paint cross-section from warm brown of chair leg, lower right corner of Cat. 24. The several layers of mixed paint contain earth pigments. This part of the painting is on the lower added strip, and here the ground layer in the sample is a heterogeneous mixture of earth pigments and other materials. Magnification 140X

Fig. 233 Paint cross-section from reworked area of the girl's scarlet dress in Cat. 24, showing vermilion in the upper layer. An earlier red paint layer representing the dress is present beneath, applied directly onto the brown quartz ground.
Magnification 145X

Fig. 234 Paint cross-section from single red layer, containing vermilion used for the red dress on the lower strip of canvas in Cat. 24. The heterogeneous brown ground is present beneath.
Magnification 130X

almost black, underlayers, as in the background to the left (see Fig. 231) and beneath the stone column at the right. However, the dark tones glimpsed through the flesh paint of the woman's hand and face are not intentional, but are the result of the dark brown 'quartz' ground showing through, since the flesh paint lies directly on top of this and the effect is the result of wearing and damage in the upper layer. The presence of a large area of scarlet containing vermilion concurs with the authors' view that while this was a pigment readily available to Rembrandt's pupils, he himself chose to make little use of it.

Some alterations to the design are visible in the X-ray image. The girl's hair, for example, was originally arranged somewhat differently and two fillets or ribbons below the pearls were subsequently painted out. The white undersleeve at her right wrist is painted over the red sleeve and her right hand has been slightly shifted.

Attributions to Barent Fabritius (1624–73) and Cornelis de Bisschop (1630–74) have been suggested.[10] Any attribution to Fabritius can be ruled out on stylistic grounds. De Bisschop, a painter from Dordrecht, trained with Ferdinand Bol in Amsterdam until 1653, when he returned to his native city. Several of his works, influenced by Bol and Maes, have a certain resemblance in composition and subject matter to this painting, which prompted Sumowski to accept an attribution to this artist.[11] The presence of the quartz ground, however, places the painting firmly in Rembrandt's workshop, since this type of canvas preparation seems not to have been employed elsewhere, which means that de Bisschop can hardly have been the painter. Futhermore, the handling of the paint appears to be too broad for de Bisschop. Therefore an attribution to an anonymous pupil in Rembrandt's studio around 1645–50 seems more likely.

REFERENCES
Waagen 1857, p. 344; HdG, Maes, no. 109; Brière-Misme 1950–3, vol. 68, pp. 185–6; MacLaren 1960, pp. 349–51; Sumowski 1983–90, vol. 3, p. 1962 and note 82; MacLaren and Brown 1991, vol. 1, pp. 371–2.

NOTES
1 Angel 1642.
2 Amsterdam 1976, p. 151.
3 See, for example, the works of the Utrecht Caravaggists discussed in Franits 2004, pp. 68–71.
4 Emblems (symbolic images carrying moral messages) were very popular at this time, and were often collected into books and used as source material by artists; see Amsterdam 1976, p. 152.
5 For an account of the history of early attributions, including Waagen (1857, p. 344), who first attributed the work to Maes, see Sumowski 1983–90, vol. 3, p. 1966, note 82.
6 Von Wurzbach 1906–11, vol. 2, 1910, p. 90; HdG, Maes, no. 109.
7 MacLaren 1960, p. 349, with a more detailed account of the different opinions and further literature.
8 Groen 2005b.
9 White and Kirby 1994, p. 73 and note 60, p. 77.
10 For a detailed account see MacLaren and Brown 1991, vol. 1, pp. 371–2.
11 Sumowski 1983–90, vol. 3, pp. 1962, 1966, 1993. For further works by de Bisschop see Brière-Misme 1950–3.

25 An Old Man in an Armchair, 1650s

Canvas, 111 × 88 cm
Falsely signed and dated top right: Rembrandt.f. / 1652
Bought from the Duke of Devonshire, 1957
NG 6274

In his catalogue of the Dutch paintings at the National Gallery in 1960 Neil MacLaren cast doubt on the attribution of a number of paintings that had come into the collection as works by Rembrandt. Regrettably, the last 'Rembrandt' he acquired before the publication of his catalogue, *An Old Man in an Armchair*, has subsequently suffered a similar fate. For MacLaren the picture documented how 'Rembrandt has here avowed more explicitly than in any other picture his acquaintance with Venetian painting; this is perhaps a reminiscence of a Tintoretto portrait'[1] – an assessment that had also been put forward by Kenneth Clark, though neither gave any specific examples of paintings by the Venetian that Rembrandt might have known.[2] In the National Gallery dossier on the painting comparisons have been drawn with the figure of Saint Jerome in Tintoretto's *Madonna and Child with Saint Jerome, Saint Joseph and the Procurator Girolamo Marcello* (before 1540; private collection)[3] and his *Portrait of an Old Senator* of 1575/80 in Dublin (National Gallery of Ireland).[4] Shortly thereafter Gerson cast doubt on the attribution, arguing that the overall structure and, more particularly, the loose handling of the beard, fur coat and proper left hand were too weak for Rembrandt.[5] He also noted a marked difference in quality between the two hands. Comparing this painting with several of Rembrandt's highly accomplished portraits of the 1650s, such as the *Portrait of Nicolaes Bruyningh* of 1652 in Kassel and the *Portrait of Jan Six* of 1654 (Six Collection, Amsterdam), Gerson argued that such discrepancies were unthinkable in the artist's work of the 1650s. Although others continued to defend the picture,[6] the general consensus now seems to be that the picture cannot have been painted by Rembrandt.[7]

The seated three-quarter-length portrait had of course a tradition in European painting since the Renaissance. Examples in the collection of the National Gallery include Raphael's famous *Pope Julius II* of 1511–12 (NG 27); Rubens's *Portrait of Ludovicus Nonnius* of about 1627 (NG 6393); and the *Portrait of Suitbertus Purmerent* by Willem van der Vliet of 1631 (NG 1168). Rembrandt used the format for his works, most notably in his grandiose *Self Portrait* of 1658 in the Frick Collection, New York,[8] as well as in his *Apostle Paul* of about 1657 (National Gallery of Art, Washington) in which the saint assumes a comparable contemplative pose.[9]

The canvas used for this painting is of medium weight and shows cusping around the edges, indicating that its dimensions have remained unaltered. The

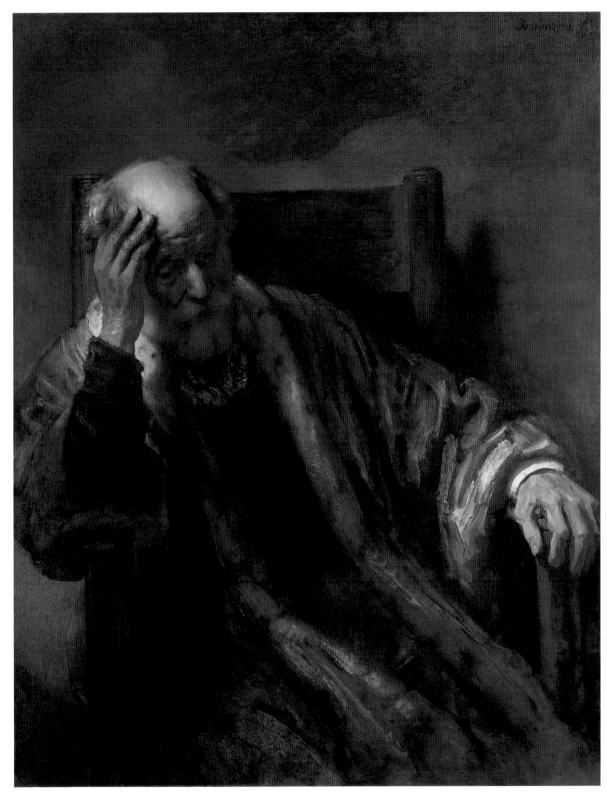

Fig. 235 Follower of Rembrandt, *An Old Man in an Armchair*, 1650s. London, National Gallery, NG 6274

X-ray (Fig. 238) of the figure and chair follows the visible paint surface very closely. This is a remarkably direct painting with no appreciable changes of composition. The canvas was prepared with a double ground consisting of a lower layer of silicaceous orange-coloured earth pigment and a second, irregular layer of a dull brownish-olive colour containing coarse lead white, wood charcoal and some yellow earth (Fig. 236). The constitution of this ground resembles that used for the large portrait pair of *Jacob Trip* and *Margaretha de Geer* (Cats 17 and 18). As in the case of those pictures, and for similar reasons, it is probable that the ground layers for the *Old Man in an Armchair* were applied in the studio and not by a professional primer.

Fig. 236 Paint cross-section from a single layer of mushroom-coloured paint in Cat. 25, containing a variety of pigments, including red lake. The double ground is visible beneath.
Magnification 140X

The greyish-brown background involves an heterogeneous mixture of pigments, for example combinations of black, white, red and brown earth pigments, vermilion, red lake and a colourless glass. The grey streaks on the chair upright consist of a mid-toned grey pulled over a darker brown underpaint, resulting in the cool tonality produced by the so-called 'turbid medium' effect. Elsewhere in the picture, however, particularly in the figure of the sitter and his costume, the paint layers are applied using much purer pigment. For example the bright red on the cuff consists of pure vermilion, and vermilion is mixed with white in the pure pink areas. The orange-yellow streaks on the cloak are just natural earth pigment, and the final deep plum-coloured glazes consist solely of red lake, containing principally cochineal dyestuff, but with traces of madder, perhaps suggesting the use of two lakes mixed together. The greenish grey at the shoulder consists only of ochre and some azurite. Similarly, the mid-tones of the sitter's left hand are painted as a glaze of pure red lake over a cream-coloured underpaint (Fig. 237). Although many of the effects produced are quite close to those seen in Rembrandt's autograph works, these techniques, and particularly the use of comparatively pure colour, are not generally seen in the paintings more securely given to Rembrandt's own hand.

The 'Venetian' colouring of the painting must be singled out as one of the primary reasons for excluding an attribution to Rembrandt himself. Equally telling are the evident weaknesses of form and inconsistencies of handling. As Gerson noted, the sitter's curiously ill-proportioned right arm and hand, bent forward and upwards to touch the side of his forehead, give no sense of recession into the picture space. Moreover, the style of the left arm and hand, draped towards the right is completely different: the paint of the upper hand is fussily detailed, while the lower hand is clumsy and fluid – and, it must be said, neither resembles the handling of the mature Rembrandt. In addition the face lacks the forceful structure normally found even in shadowed passages of Rembrandt's figure studies. Equally, it had also been suggested that the work is by the same hand as Nicolaes Maes's *Apostle Thomas* in Kassel, yet the considerably more accomplished handling of the anatomy of the figure and the space makes this highly unlikely.[10] Therefore, for the time being the attribution to an anonymous pupil or follower of Rembrandt must remain.

Fig. 237 Paint cross-section from sitter's proper left hand in Cat. 25, showing the use of a red lake glaze over a cream underpaint. The double ground is visible beneath.
Magnification 190X

REFERENCES

HdG, no. 292; MacLaren 1960, pp. 337–8; Bauch 1966, no. 206; Clark 1966, p. 130; Bredius 1969, no. 267; Schwartz 1984, no. 339, p. 305 (Rembrandt); MacLaren and Brown 1991, vol. 1, pp. 376–7; Tümpel 1993, no. A47.

NOTES

1 MacLaren 1960, p. 337.
2 Clark 1966, p. 130: 'we cannot point to the individual Titian or Tintoretto on which they are based.'
3 Palucchini and Rossi 1982, vol. 1, no. 6, p. 131.
4 Rossi [1974], vol. 1, p. 104 and fig. 182.
5 Gerson in Bredius 1969, no. 267.

6 Martin 1969, p. 266; Sumowski 1973, p. 107; Schwartz 1984, p. 305.
7 In a letter to Christopher Brown Sumowski subsequently changed his mind and now considers the picture a school piece (MacLaren and Brown 1991, vol. 1, p. 376). See also Tümpel 1993, no. A47 (as Rembrandt workshop).
8 *Corpus*, vol. 4, 2005, no. 14; see also London and The Hague 1999–2000, no. 71, p. 198.
9 Washington and Los Angeles 2005, no. 2; see also Wheelock 1995, pp. 241–7.
10 Nicolaes Maes, *The Apostle Thomas* ('*The Architect*'), canvas, Kassel, Gemäldegalerie Alte Meister, no. GK 246; see Schnackenburg 1996, vol. 1 (text), p. 176. See also MacLaren and Brown 1991, vol. 1, p. 376.

Fig. 238 X-ray mosaic of Cat. 25.

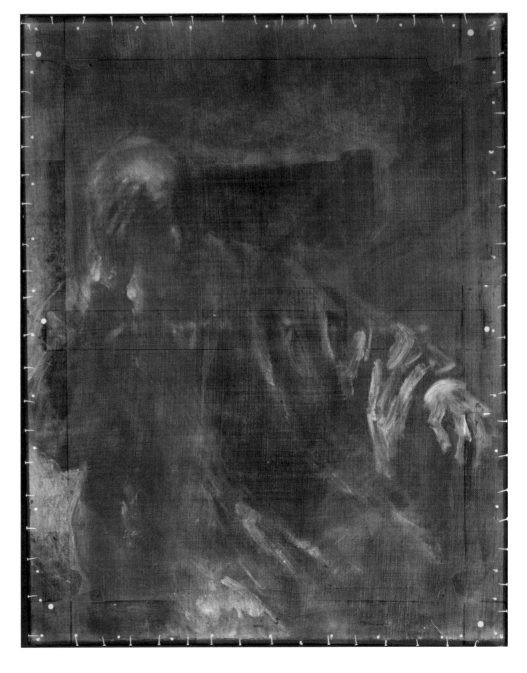

26 A Seated Man with a Stick, 1650–60

Canvas 137.5 × 104.8 cm
Signed probably falsely bottom left: R[…]mbrandt / […]6[…][1]
Sir George Beaumont Gift, 1823/8
NG 51

When the picture was given by George Beaumont to the British Museum for the future National Gallery it carried an attribution to Rembrandt, and in the catalogue of 1832 it is referred to as 'A Jew Merchant',[2] yet there is nothing in the painting to support this identification. The man's costume is imaginary, although some of its details, such as the plumed beret, derive loosely from sixteenth-century dress. The noticeable sleeve with the numerous small slashes is the painter's invention. Sleeves with such slashes occurred in the Netherlands around 1600, but they were invariably narrow instead of the loosely cut version shown in this picture.[3]

The relatively fine canvas of the support shows some cusping around the edges, indicating that it more or less retains its original dimensions. However, the X-ray reveals that the composition was not the original one (see Fig. 244). Clearly visible below the seated figure is an inverted depiction of Christ on the cross. The upright of the cross runs down the centre (where it becomes slightly confused with the image of the stick in the upper composition), and the horizontal cross-bar appears to run along the bottom edge of the canvas. Around the base of the cross there are faint indications of other figures that might be expected in a crucifixion scene, including a kneeling woman whose head obscures Christ's feet. The lower painting appears to be vigorously executed, but of crude quality. Its authorship is difficult to judge, but there is no reason to suppose that it is significantly earlier than the painting on top (see below).[4] We seem to be dealing here with the straightforward workshop re-use of a canvas on which a rough composition had been sketched out and abandoned.

The painting has a mid-yellow-brown ground, possibly applied in two layers, composed of an heterogeneous mixture of natural earth pigments, some calcium carbonate, lead white and occasional particles of smalt (see Fig. 240). Analysis has shown that among the earth pigments in the ground layer is a dark brown manganese-containing umber.

The paint layer structure is complex, perhaps explained in part by the painter's re-use of the canvas. From paint cross-sections (see Fig. 241), it is clear that many parts of the composition involve lower layers of dark-coloured, mixed paint: some of these may relate to the earlier use of the canvas, since it seems likely from the X-ray that in the underlying composition of the crucifixion, much of the surround-ings of the figure of Christ seem to be represented in dark-coloured paint relatively

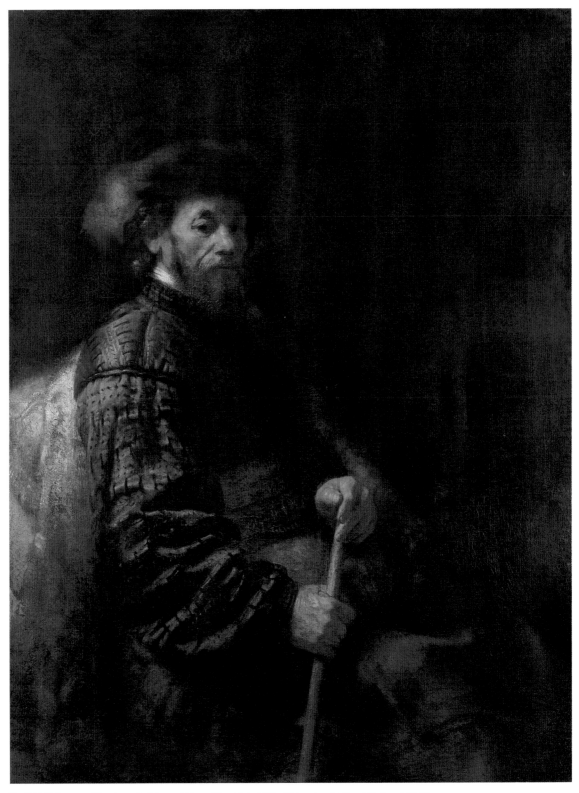

Fig. 239 Follower of Rembrandt, *A Seated Man with a Stick*, 1650–60. London, National Gallery, NG 51

free of X-ray opaque pigments such as lead white. The hidden body of Christ, in a cross-section taken from the painted-out arm where it lies beneath the rug on the knees of the surface figure, shows the flesh paint to be a deathly grey (Fig. 242). There is no evidence of discontinuities between the paint layers in the layer structures examined, and it is perfectly possible, therefore, that the painter of the abandoned Crucifixion was also responsible for the seated figure, now the subject of the painting.

The figure of the seated man is painted fairly directly, but some alterations are visible in the X-ray image. It appears that the man's face was initially turned more towards the right side of the picture, with his gaze in that direction. He was originally sitting rather more upright: the left profile of his sleeve was almost vertical, but now it slopes up to the left, giving the impression that the figure is leaning back in his chair. The shape of his hat was changed more than once: originally it was taller, then it was wider and flatter, tilted forward, and finally it became more compact and tilted slightly back. A light band running from below the man's beard down the front of his chest suggests that there was originally an opening in his jacket.

In common with many paintings by Rembrandt and his circle, the overall palette is relatively subdued and the paints are composed of highly mixed pigment. Often, also, there are highlights of stronger, purer colour on the surface, as in the orange-red and yellow touches on the sleeve (Fig. 243) using, respectively, virtually unmixed vermilion and natural earth pigment. Elsewhere, the more sombre tones of costume and background make use of a range of earth pigments, with white, bone black, Cassel earth and red lake pigment sometimes also mixed with smalt or azurite. Smalt occurs in the greyish-green paint of the rug over the sitter's knees, for example, while natural azurite is a component of the very dark background paint surrounding the figure in the upper-right quadrant.

The attribution of this painting was accepted in all publications on the artist in the early twentieth century until 1960, when MacLaren began to doubt the authorship on the evidence of the 'meaningless brushstrokes on the nose, the drawing of the right shoulder and the rather niggling treatment of the right sleeve' – although he still catalogued it as 'ascribed to Rembrandt'.[5] Also uncharacteristic of the artist are the handling of the beard with its lack of three-dimensionality, the weak construction of the eyes and the carelessly applied brushstrokes in the face and hands which appear to have no function (Rembrandt's flesh paints are always coherently structured, no matter how roughly they are painted). Additionally, while the gathered cloak at the left edge has the colourful touches of impasto often found in his draperies, it lacks the brilliantly descriptive texture that is the hallmark of Rembrandt's style. Thus, while the appearance of the surface paint superficially resembles his handling, it is generally agreed that these weaknesses of form and technique rule out Rembrandt's authorship. Sumowski attributed the picture to Samuel van Hoogstraten,[6] but the relatively rough brushwork of the face seems

Fig. 240 Paint cross-section from highlight on sitter's sleeve in Cat. 26, showing dark underlayers for the structure of the large sleeve beneath. The yellow-brown ground contains a large particle of smalt. Magnification 120X

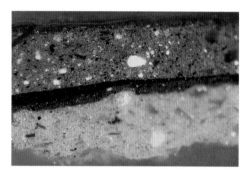

Fig. 241 Paint cross-section from blackish-brown paint of background, top in Cat. 26, over dark layers. The mixed mid yellow-brown ground is visible beneath. Magnification 135X

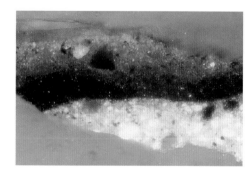

Fig. 242 Paint cross-section from dark greyish green of rug across the sitter's knees in Cat. 26, where the upper paint layers conceal the suppressed figure of the crucified Christ (see Fig. 244). The lowest greyish layer in the section represents Christ's flesh paint (the ground is missing). Magnification 265X

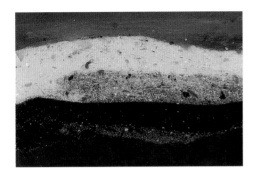

Fig. 243 Paint cross-section from orange and yellow impasto touch on the sitter's waistband in Cat. 26, showing the use of strongly coloured earth pigments. Magnification 145X

to be markedly different from that artist's usual approach. Likewise, an earlier suggested attribution to Willem Drost has recently been refuted on stylistic grounds.[7] It is, however, plausible that the picture was painted in Rembrandt's lifetime around the middle of the seventeenth century rather than being a late seventeenth- or early eighteenth-century imitation as Brown suggested.[8]

REFERENCES

HdG, no. 391; Bredius, no. 257; Sumowski 1983–90, vol. 2, no. 854 (as Hoogstraten); MacLaren and Brown 1991, vol. 1, pp. 3701; Bikker 2005, no. R25, pp. 156–7.

NOTES

1 The signature and traces of the date are not visible to the authors. MacLaren noted that the signature, which had come to light after the cleaning of the picture in 1936, was 'almost effaced' (1960, p. 341).
2 Young Ottley 1832, p. 36.
3 The authors are grateful to Marieke de Winkel, Nijmegen, who communicated the information on the dress in a letter.
4 Here one may perceive faint similarities in the handling of the paint in the figure of Christ, particularly the arms, with the *Descent from the Cross* by an anonymous painter from Rembrandt's workshop in the collection of the National Gallery of Art, Washington (Rembrandt Workshop, *The Descent from the Cross*, 1650/2, canvas, 142 x 110 cm, inv. no. 1949.9.61; see Wheelock 1995, pp. 300–9). Yet the X-ray image of *A Seated Man with a Stick* is not sufficiently clear for the authors to arrive at any more reliable conclusions.
5 MacLaren 1960, p. 342.
6 Sumowski 1983–90, vol. 2, no. 854. Brown did not accept this attribution in 1991 (MacLaren and Brown 1991, vol. 1, p. 370 and note 2).
7 Bikker 2005, p. 157.
8 MacLaren and Brown 1991, vol. 1, p. 370.

Fig. 244 X-ray mosaic of Cat. 26

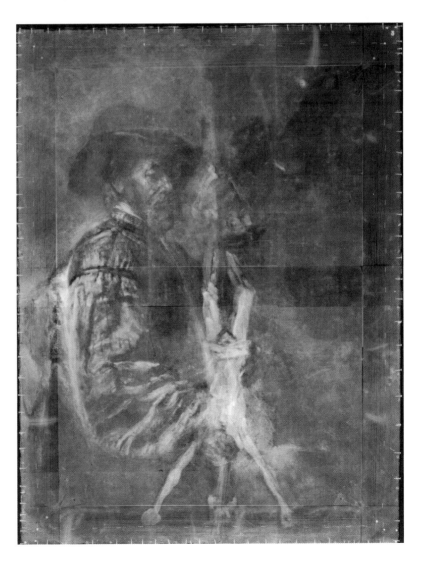

27 Study of an Elderly Man in a Cap, 1650s–60s

Canvas, 67 × 53 cm
Falsely signed and dated centre right: Rembrandt.f. / 16[…]
Salting Bequest, 1910
NG 2539

Wilhelm von Bode was the first to publish this picture with an attribution to Rembrandt, praising it for its beauty and carefully modulated fleshtones and dating it to 1648.[1] The attribution was subsequently accepted by Hofstede de Groot and Valentiner.[2] The National Gallery's catalogue of 1929, however, expressed doubts about the authorship, and in 1960 MacLaren confirmed this view, following the then recent cleaning of the picture, calling it 'an imitation of Rembrandt, possibly a rather late one'.[3] This assessment has more recently been called into question based on the technical examination of the picture.

While there can be no doubt that the picture's handling differs considerably from Rembrandt's style, the technical analysis indicates that there is no reason to believe that the picture is an eighteenth- or nineteenth-century pastiche. Indeed, in his entry on the painting in the British Museum's exhibition *Fake? The Art of Deception* of 1990 Ernst van de Wetering already acknowledged this.[4] The author did not, of course, mean to argue for attributing the work to Rembrandt, but the technical results indicate a strong connection with seventeenth-century Dutch painting technique and bear some resemblance to the approach of Rembrandt and his studio. Yet several aspects of this approach seem poorly understood. For example, the shadow structure around the sitter's right eye is a weak attempt to exploit Rembrandt's method, by using featureless brown paint instead of exposed ground colour.

It has been established by analysis that the relatively coarse canvas has been primed with a single brown ground of the 'quartz' type, and this constitutes the strongest piece of evidence that the picture was produced in the seventeenth century, not later, and that it very likely has a close connection to Rembrandt's studio. This ground does not absorb X-rays strongly, so the radiograph of the portrait (see Fig. 246) shows clear contrast between the background, the sitter's costume and the strongly absorbent paint of the head of the portrait (containing lead white), particularly the temple, upper cheek and nose, which are strongly modelled and thickly applied in the Rembrandt manner. (The white elongated f-shaped feature in the X-ray to the right of the sitter's head is an old tear in the canvas filled with material that absorbs X-rays.)

The sitter's dark-coloured coat is painted in a mixture of bone black, a variety of earth pigments, particularly red ochre, and a little red lake and lead white. The paint

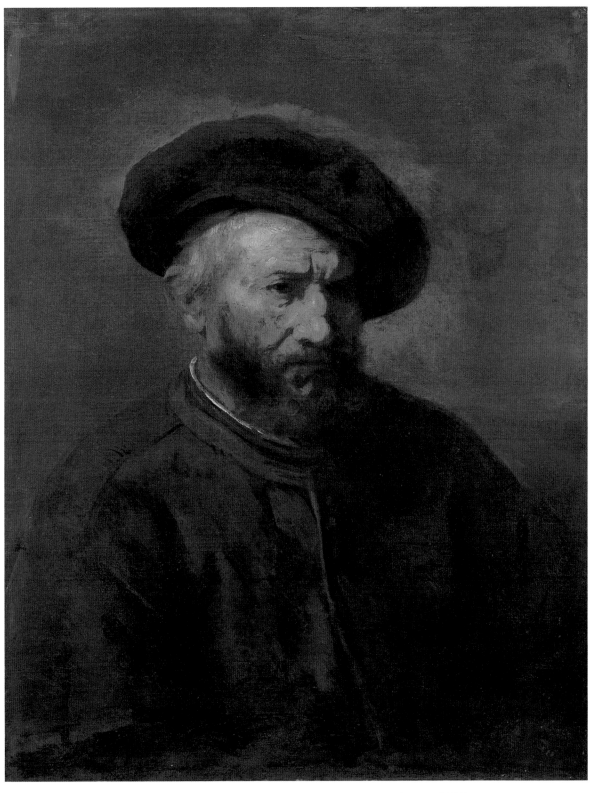

Fig. 245 Follower of Rembrandt, *Study of an Elderly Man in a Cap*, 1650s–60s. London, National Gallery, NG 2539

layers also contain Cassel earth. The light greyish-green background tone at the right consists of lead white with some red lake pigment, bone black and Cassel earth, and a strongly coloured translucent yellow, possibly a lake. The lead white content of the paint layers shows large aggregate particles typical of many Dutch seventeenth-century pictures. The bright red highlight on the collar is made up of vermilion combined with red lake pigment while the warm tone of the sitter's flesh is provided in part by inclusion of some red lake pigment in the lead white of the paint layer: features not found in autograph works by Rembrandt.

In summary, therefore, as van de Wetering argued in 1990, this painting should be considered a seventeenth-century work by an anonymous artist who either worked in Rembrandt's studio or was closely acquainted with Rembrandt's techniques.

REFERENCES

Bode 1906, p. 10; HdG, nos 394, 742; Valentiner 1921, N62 and p. 60; MacLaren 1960, p. 352 (as Imitator of Rembrandt); London 1990, no. 136, pp. 129–32; MacLaren and Brown 1991, vol. 1, pp. 377–8 (as Imitator of Rembrandt).

NOTES

1 Bode 1906, p. 10: 'ungewöhnlich sorgfältig in der Durchbildung und durch die reichen Farbtöne im Fleisch ausgezeichnet […] von 1648 […]'. It is not clear what the basis for the date is.
2 HdG, nos 394, 742; Valentiner 1921, N62 and p. 60.
3 MacLaren 1960, p. 352.
4 London 1990, no. 136, p. 132: 'In fact, analysis of the painting material has given no grounds whatsoever to argue against an attribution to Rembrandt.'

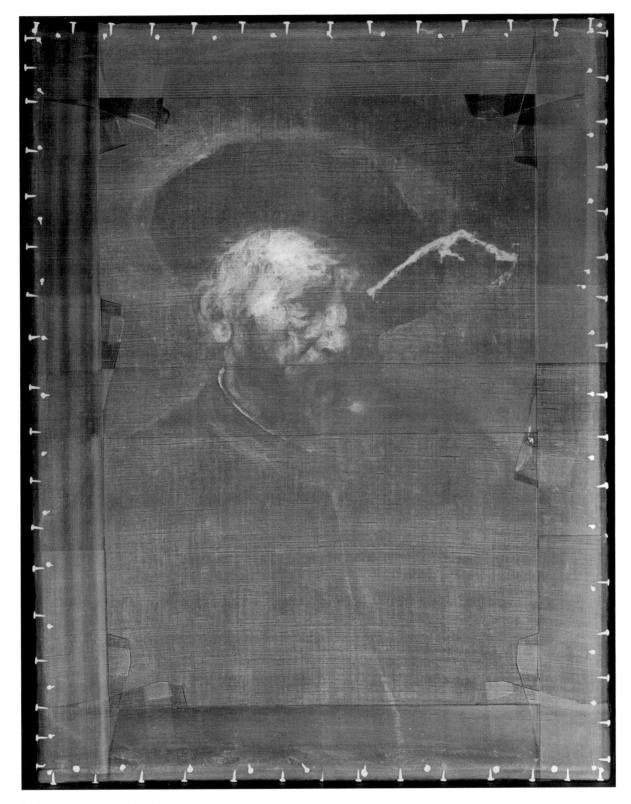

Fig. 246 X-ray mosaic of Cat. 27

Notes to essays

Introduction

1 On the term 'technical art history' see Bomford 1998.
2 For full citations of this and the following titles see the bibliography in the back of the book.
3 The Hague 1998–9.
4 Amsterdam 2003.
5 Wadum 2002.
6 See, for example, the catalogue of the Dutch paintings of the National Gallery of Art, Washington (Wheelock 1995).
7 London 1988, p. 11.

Studio

1 Miedema 1987a; Miedema 1989; de Jager 1990; Hoogewerff 1947.
2 Israel 1995, pp. 307–12, 344–51, 395–8, 547–52.
3 Rombouts and Van Lerius 1864–76, vol. 1, p. 31; Miedema 1987a, p. 10.
4 Angel 1642; for an English translation see Hoyle and Miedema 1996.
5 Van de Wetering 1997, pp. 60–72.
6 Strauss and van der Meulen 1979, 1656/12, pp. 348–57.
7 The first edition of Dürer's work was published in 1528, following the publication of his book on perspective and geometry in 1525: see Dürer 1528. The book was subsequently published in Latin, followed by a number of translations and later editions.
8 De Passe 1643. This and other drawing books are discussed by J. Bolten in *Dutch and Flemish Drawing Books: method and practice 1600–1750*, Landau 1985.
9 Van Eikema Hommes 2005, pp. 23–4.
10 Miedema 1987a, pp. 17–21; see also Emmens 1979.
11 Amsterdam, San Francisco and Hartford 2002, pp. 133–5.
12 De Klerk 1982.
13 Bredius 1915–22, vol. 2, pp. 407–8; see also, for example, vol. 1, p. 140, inventory of Jan Bassé the Elder's property, 9–30 March 1637.
14 De Jager 1990; van de Wetering 1986b, p. 54.
15 Von Sandrart 1675–9, vol. 1, pp. 326–7; von Sandrart 1925, pp. 202–3; van de Wetering 1986b, pp. 55–6; Bruyn 1991–2, p. 69. See also Liedtke 2004, pp. 51–2; Horn 2000, p. 475.
16 Miedema 1989; de Jager 1990; van de Wetering 1986b, pp. 52–6; Bruyn 1991–2, pp. 68–9.
17 Dudok van Heel 1991–2, pp. 51–3.
18 Ibid., p. 54.
19 Von Sandrart 1675–9, vol. 1, p. 326; von Sandrart 1925, p. 203.
20 Van de Wetering 1986b; Bruyn 1991–2, p. 69.
21 Liedtke 2004; Bruyn 1991–2; van der Wetering 1986b; Wheelock 1995, pp. 205–10.
22 Balis 1986, pp. 36–46; Tokyo 1993.
23 Bruyn 1989; Bruyn 1991–2; van de Wetering 1986b, pp. 60–90; compare Liedtke 2004, pp. 53–8.
24 Van de Wetering 1986b, pp. 48–51.
25 Van de Wetering 1997, pp. 138–43.
26 Vey 1960; Talley 1981, pp. 150–5; Kirby 1999, p. 13.
27 Van de Graaf 1958; this edition has been used for citations throughout this catalogue, but see also Berger 1901; Kirby 1999, pp. 11–15.
28 Hoogstraten 1969: on Rembrandt's colour, pp. 291, 306; his flesh tints, pp. 227–8; his chiaroscuro and treatment of light, pp. 176, 273, 305–6.
29 Compare von Sandrart 1675–9, vol. 1, pp. 66–7, 72–3, 84–8.
30 Von Sandrart 1675–9, vol. 1, pp. 80–1.
31 British Library, London, MS Harley 6376, ff. 86–7; see also ff. 6–7. On the manuscript see Norgate 1997, pp. 25, 221.
32 Dudok van Heel 1991–2, pp. 54–61; S.A.C. Dudok van Heel, 'Rembrandt: his life, his wife, the nursemaid and the servant', in Edinburgh and London 2001, pp. 18–27, esp. pp. 21–4.
33 Houbraken 1943–4, vol. 1, p. 202, Horn 2000, pp. 461–2; Bruyn 1991–2, p. 71.
34 Kirby 1999, pp. 17–18.
35 Klein 1998.
36 Van de Wetering 1997, pp. 14–17; Bruyn 1979; see also Miedema 1981.
37 Bredius 1915–22, vol. 5, pp. 1641–2; see also vol. 1, pp. 4–8, the inventory of Jan Molenaer's property, 10 August 1668, and other examples.
38 Rotterdam 1994–5, p. 49 and notes 84–5, p. 53.
39 Van de Wetering 1986a, pp. 21–30; van de Wetering 1997, pp. 100–8.
40 Van de Wetering 1986a, pp. 25, 30; van de Wetering 1997, pp. 109, 118 and notes 62–4, p. 302, Kirby 1999, pp. 19–20, 26.
41 Rotterdam 1994–5, p. 49 and notes 84–5, p. 53; van de Wetering 1986a, pp. 25, 30; van de Wetering 1997, pp. 109, 118 and notes 62–4, p. 302.
42 Van de Wetering 1986a, pp. 25, 30; van de Wetering 1997, pp. 109, 118 and notes 62–4, p. 302.
43 Van de Wetering 1986a, pp. 32–3; van de Wetering 1997, p. 116.
44 Blankert 1973.
45 Lairesse 1707, vol. 1, pp. 12–14; van de Wetering 1982, pp. 25–30; van de Wetering 1997, pp 32–44.
46 Bredius 1915–22, vol. 2, p. 408.
47 Van de Wetering 1993; van de Wetering 1995; van de Wetering 1997, p. 147.
48 Martin 1901.
49 Rotterdam 1994–5; Levy-van Halm 1998; compare Kirby 1999, pp. 33–5.
50 Bredius 1915–22, inventory of the property of Vincent Laurenz van de Vinne, 28 July 1702, p. 1261: 'een verruw molen'; Peres 1988, p. 281.
51 Thanks are due to Jill Dunkerton for useful discussions on this point.
52 Bredius 1915–22, vol. 1, pp. 112–19, vol. 7, pp. 77–86.

Ground

1 Groen 2005a; Groen 2005b.
2 Van de Graaf 1958; Miedema and Meijer 1979; van Hout 1998; Dunkerton and Spring 1998.
3 Groen 2005b.

Paint

1 Smith 1993, p. 22.
2 Lairesse 1707; see also Dolders 1985. On Lairesse's use of language see de Vries 2004.
3 Miedema 1987b.
4 Von Sandrart 1675–9, vol. 1, p. 72.
5 See also van de Wetering 1982, pp. 25–30; van de Wetering 1997, pp. 32–44.
6 Hoogstraten 1969, p. 233.
7 Strauss and van der Meulen 1979, 1639/4, p. 167.
8 Houbraken 1943–4, vol. 1, p. 212 (p. 269 in original 1718–21 edn).

Palette

1 Bredius 1915–22, vol. 1, pp. 112–19; vol. 7, pp. 77–86; Rotterdam 1994–5; Levy-van Halm 1998. The situation in the Southern Netherlands was similar: see Kirby 1999, pp. 33–5.
2 Von Sandrart 1675–9, vol. 1, p. 87; Rotterdam 1994–5; Kirby 1999, pp. 30–1.
3 Hoogstraten 1969, p. 291.
4 Gettens, Kühn and Chase 1993, p. 68.
5 Harley 1982, pp. 166–72.
6 Van de Graaf 1958, p. 34. These lumps of pigment, which are hard and extremely difficult to grind to a fine powder, should be distinguished from the translucent white inclusions of lead soaps, formed in paint films containing, for example, lead-tin yellow and red lead, which look rather similar but tend to have a striated appearance due to their method of formation.
7 Goedings and Groen 1994a.
8 Van de Graaf 1961.
9 Kühn 1993.
10 Lomazzo 1584, p. 191.
11 An example of a process for lead-tin yellow is given in Vandamme 1974, recipe 8, p. 116.
12 Hoogstraten 1969, p. 220; von Sandrart 1675–9, vol. 1, p. 87. In his manuscript 'Pictoria, sculptoria, tinctoria et quae subalternarum artium spectantia …', compiled in London between 1620 and 1646, (British Museum, MS Sloane 2052) Theodore Turquet de Mayerne mentions three or four varieties, 'more or less pale or brown [presumably more golden]' : van de Graaf 1958, p. 144. Cornelis Biens, in *De Teecken-Const* (Amsterdam 1636) mentions two, 'yellow and pale': de Klerk 1982, p. 56.
13 Higgitt, Spring and Saunders 2003.
14 Van Schendel 1972, describing the large-scale preparations of vermilion given in the notebook of the Amsterdam manufacturer Willem Pekstok, dating from the second half of the seventeenth century (Municipal Archives, Amsterdam, No. N-09–23).
15 Spring and Grout 2002, p. 57.
16 Harley 1982, p. 127.
17 Hoogstraten 1969, p. 220; von Sandrart 1675–9, vol. 1, p. 87; Harley 1982, pp. 89–91, 119–20, 148–9; Scarzella and Natale 1989.
18 De Klerk 1982, p. 56; Harley 1982, pp. 149–50.
19 Kirby 1999, p. 38; Roy 1999a; Roy 1999b, pp. 94–5.
20 Commenting on red lake as it was traditionally used, Biens wrote, 'Vermilion is very beautiful glazed with lake and is especially useful for clothing': De Klerk 1982, p. 56; see also Kirby 1999, pp. 38–9.
21 Kirby and White 1996, pp. 63–9.
22 Hermens and Wallert 1998, pp. 271–80, citing the recipe given in the so-called Pekstok papers (see note 14 above).

23 Battus 1650, p. 265, copied from one in the sixteenth-century collection attributed to Alessio Piemontese. See also Hofenk de Graaff 2004.
24 Kirby 1977; Kirby 1999, p. 37.
25 Van de Graaf 1958, pp. 48–9; Plesters 1987, p. 79.
26 Goedings and Groen 1994b.
27 Kirby 2003.
28 Groen 1998, pp. 172–5; Washington 2001, pp. 65–6.
29 Hermens and Wallert 1998, pp. 281–7, citing methods given in the Pekstok papers (see note 14 above).
30 Pomet 1694, book 1, p. 25.
31 Hermens and Wallert 1998, p. 281.
32 Ainsworth 1982, p. 103.
33 Andriessen 1581, chapter 4: Hungary is given as the source of the pigment, perhaps indicating the mountainous regions of present-day southern Germany and Bohemia (the Czech Republic) or Slovakia.
34 Kirby 1999, pp. 30–1.
35 Kühn 1968, p. 168; Groen 1998, pp. 171–2; Costaras 1998, p. 157.
36 Washington 2001, pp. 66–7. This pigment is a possible candidate for the Haarlem ashes mentioned by Hoogstraten: Hoogstraten 1969, p. 221.
37 Noble and van Loon 2005, pp. 86–7.
38 Mühlethaler and Thissen 1993.
39 Hoogstraten 1969, p. 221; Kirby 1999, pp. 36–7.
40 Boon 2001; Spring, Higgitt and Saunders 2005.
41 See also Noble and van Loon 2005, pp. 82–6.
42 Ainsworth 1982, pp. 102–3.

Medium

1 An account of the range, production and properties of oil media in the context of Dutch painting and of Rembrandt and his immediate circle, as represented in the National Gallery Collection in particular, was published some years ago; see White and Kirby 1994. See also White and Pilc 1993, p. 89; White, Pilc and Kirby 1998, pp. 77–9, 88–9; White 1999; Groen 1997; van de Wetering 1997; The Hague 1998–9, pp. 65–6; van der Weerd 2002 [on Rembrandt's *Portrait of a Standing Man*, 1839 (Gemäldegalerie, Kassel)].
2 It has also been suggested that the analytical procedures used by the Gallery in earlier studies failed to detect essential resinous additions to the basic oil medium, among other organic components: Van de Wetering 1997, pp. 229–43; The Hague 1998–9, pp. 65–6. In addition to lipid components, various protein and gum additives have been reported in certain of Rembrandt's paintings by other researchers: see The Hague 1998–9, pp. 39–64. The recent results obtained from paintings by Rembrandt's associates (see White and Kirby 1994) were achieved using the same analytical procedures as before. No difficulty was experienced in identifying the resinous content of the paint in these cases, so it seems implausible that the same procedures would be successful for paintings emanating from Rembrandt's circle, but fail for those of Rembrandt himself.
3 Mills and White 1982.
4 See, for example, The Hague 1998–9.
5 See Pilc and White 1995.
6 White and Kirby 1994, p. 68.
7 Boon 2001; Spring, Higgitt and Saunders 2005.
8 White and Kirby 1994, pp. 66, 71.
9 White and Kirby 1994, pp. 69–70.
10 White, Pilc and Kirby 1998, pp. 77–9, 88–9; White and Pilc 1995, pp. 88–9.

TABLE 1

The structure of the ground in paintings by Rembrandt and followers

Title	Date	Support	Ground Type	Lower Layer[1]	Elemental Composition[2]	Upper Layer[1]	Elemental Composition[2]	Comments
Judas returning the 30 Pieces of Silver L952	1629	Oak panel	Single	Chalk	Ca	*Primuersel:* lead white, yellow-brown earth	Pb, Fe (Ca, Si)	
Anna and the Blind Tobit NG 4189	About 1630	Oak panel	Single	Chalk	Ca	*Primuersel:* lead white, Cassel earth	Pb (Fe, Ca)	Exceptionally thin *primuersel.*
Portrait of Aechje Claesdr NG 775	1634	Oak panel	Single	Chalk	Ca (Al, Si)	*Primuersel:* lead white, umber	Pb, Fe (Mn)	
Ecce Homo NG 1400	1634	Paper	Single	Lead white	Pb	–	–	
Portrait of Philips Lucasz. NG 850	1635	Oak panel	Single	Chalk	Ca (Si)	*Primuersel:* lead white, chalk, umber	Pb, Ca, Fe, Mn (Si, Al)	
Saskia van Uylenburgh as Flora NG 4930	1635	Canvas	Double	Orange-red earth	Fe, Si, Al (Pb, Ti)	Light grey: lead white, charcoal (ochre)	Pb (Ca, Fe, Si)	Painting transferred, and lower ground layer thinned.
The Lamentation over the Dead Christ NG 43	About 1635	Paper	No ground	–	–	–	–	Paper mounted on canvas sections bearing conventional double grounds (see Catalogue).
Belshazzar's Feast NG 6350	1636–8	Canvas	Double	Orange-red earth	Fe, Si, Al (Pb, Ca)	Light fawnish grey: lead white, umber, carbon black	Pb, Ca, Fe, Mn, Al (Si)	
Self Portrait at the Age of 34 NG 672	1640	Canvas	Double	Red earth	Fe, Si, Al (Pb, Ca, Ti, Mn)	Fawnish grey: lead ochre white, brown earth (charcoal)	Pb, Fe (Si)	Painting transferred; layer of dark-coloured adhesive detectable beneath original ground.
The Woman taken in Adultery NG 45	1644	Oak panel	Single	Chalk	Ca	*Primuersel:* lead white, yellow-brown earth	Pb, Fe, Ca (Si, Al, Mn)	Ground scraped down in places.
The Adoration of the Shepherds NG 47	1646	Canvas	Single	Quartz, brown ochre	Si, Fe, Al	–	–	
A Woman bathing in a Stream NG 54	1654	Oak panel	Single	Chalk	–	*Primuersel:* lead white, yellow-brown earth, umber	Pb, Fe, Ca, Mn, Al (Si)	
Portrait of Hendrickje Stoffels NG 6432	Probably 1654–6	Canvas	Single	Quartz, brown ochre (lead white)	Si, Fe, Al (Pb)	–	–	
A Franciscan Friar NG 166	About 1655/6	Canvas	Double	Orange-red earth	–	Off white: lead white (colourless smalt/glass)	Pb, Si	Painting transferred and marouflaged. Lower layer of original ground mainly removed.
A Bearded Man in a Cap NG 190	About 1657	Canvas	Double	Orange-red earth	–	Brownish yellow: lead white, brown ochre, umber	Pb, Fe, Al, Si (Mn)	

224

Title	Date	Support	Ground Type	Lower Layer[1]	Elemental Composition[2]	Upper Layer[1]	Elemental Composition[2]	Comments
An Elderly Man as Saint Paul NG 243	Probably 1659	Canvas	Double	Lead white, umber, black	Pb, Fe Mn, Al, Si (Ca)	Greyish brown: lead white, charcoal (umber)	Pb (Fe, Mn, Al, Si)	
Portrait of Jacob Trip NG 1674	About 1661	Canvas	Double	Orange-red earth	Fe, Si (Ca, Al, Mn, Pb)	Greyish-olive: lead white, chalk, yellow ochre, umber, charcoal	Pb, Ca, Fe, Si, Mn, Al	Some red lake pigment present in lower ground layer (see Catalogue).
Portrait of Margaretha de Geer NG 1675	About 1661	Canvas	Double	Orange-red earth	Fe, Si (Ca, Al, Mn)	Greyish-olive: lead white, chalk, yellow ochre, umber, charcoal	Pb, Ca, Fe, Si, Al (Mn)	
Portrait of Margaretha de Geer (bust length) NG 5282	1661	Canvas	Double	Chalk	Ca (Al)	Light yellowish brown: lead white, chalk, yellow and red earth, charcoal	Pb, Ca, Fe (Si, Al)	Unusual ground structure (see Catalogue).
Portrait of Frederik Rihel on Horseback NG 6300	Probably 1663	Canvas	Single	Quartz, brown ochre	Si, Fe (Al, Ca)	–	–	
Self Portrait at the Age of 63 NG 221	1669	Canvas	Single	Quartz, brown ochre	Si, Fe (Al, Ca, Ti)	–	–	
A Seated Man in a Lofty Room NG 3214	Early 1630s	Oak panel	Single	Chalk	Ca	*Primuersel:* thin warm brown layer	Not analysed	
Diana bathing NG 2538	Late 1630s	Oak panel	Single	Chalk	Ca	*Primuersel:* lead white, Cassel earth	Pb (Fe, Ca)	
A Young Man and Girl playing Cards NG 1247	1645–50	Canvas	Single	Quartz, brown ochre, alumina (lead white)	Si, Fe, Al (Pb, K, Ti)	–	–	Ground present on upper, main part of composition (see Catalogue).
			Single	Several different earth pigments: yellow, red, brown (lead white, smalt)	Fe, Si, Al, Pb (K, Co)	–	–	On lower strip of canvas only.
An Old Man in an Armchair NG 6274	1650s	Canvas	Double	Orange-red earth	Fe, Si, Al (K, Ca, Mn)	Brownish olive: lead white, charcoal, yellow ochre	Pb, Fe, Si (Al, Ca)	
A Seated Man with a Stick NG 51	1650–60	Canvas	Single (?)	Yellow and brown ochres, lead white, calcium carbonate (smalt)	Fe, Si, Pb, Ca (Al, K, Co, Ti)	–		May be present as two applications of similar constitution.
Study of an Elderly Man in a Cap NG 2539	1650s–1660s	Canvas	Single	Quartz, brown ochre, alumina	Si, Fe, Al (K, Ca)	–	–	

Notes to the table:
1 Minor constituents are noted in brackets.
2 Analysis by energy dispersive X-ray microanalysis (EDX) or laser microspectral analysis (LMA).
 Minor components noted in brackets. Certain analyses confirmed by X-ray diffraction analysis (XRD).

TABLE 2

A survey of the paint medium in paintings by Rembrandt and his followers

Note: The media of *Ecce Homo* (NG 1400) and *A Woman bathing in a Stream* (NG 54) were not examined.

Picture	Date	Source/location of sample taken	Medium
Judas returning the 30 Pieces of Silver L952	1629	1. Ground, upper layer 2. Ground, lower layer 3. Black of floor 4. Grey-green background	Linseed oil Linseed oil (?)[1] Linseed oil Walnut oil
Anna and the Blind Tobit NG 4189	About 1630	1. Dark brown paint of Anna's chair 2. Brownish purple of Tobit's robe 3. Green leaf on branch outside window 4. White paint of sky through window	Linseed oil Linseed oil Linseed oil Probably linseed oil
Portrait of Aechje Claesdr NG 775	1634	1. Light fawn background to left of sitter 2. Black paint of dress	Linseed oil[2] Linseed oil[2]
Portrait of Philips Lucasz. NG 850	1635	1. Grey of sitter's costume, LH edge 2. White impasto of collar 3. Yellow-orange impasto of chain	Linseed oil Probably linseed oil Linseed oil[2]
Saskia van Uylenburgh as Flora NG 4930	1635	1. Grey-white of bottom of dress 2. Dark black/brown of foliage, top	Walnut oil Linseed oil
The Lamentation over the Dead Christ NG 43	About 1635	1. Warm white impasto, RH edge 2. White cloud, by cross, upper LH edge 3. Mustard colour, by white shroud 4. Dark brown/black background, RH edge	Alkyd[3] Poppyseed oil Linseed oil Linseed oil
Belshazzar's Feast NG 6350	1636–8	1. White impasto of robe 2. Yellow impasto of robe trimmings 3. LH woman's headdress, shadow 4. Red dress of RH woman	Linseed oil[4] Linseed oil Linseed oil Linseed oil
Self Portrait at the Age of 34 NG 672	1640	1. Light brown parapet, RH side	Walnut oil
The Woman taken in Adultery NG 45	1644	1. Dark impasto, top of centre column 2. Pale orange-brown of RH column 3. Ground 4. Red background, top RH edge	Linseed oil Linseed oil Linseed oil Linseed oil
The Adoration of the Shepherds NG 47	1646	1. Black background 2. Ground 3. Mustard highlight of roof beam, LH edge	Linseed oil Linseed oil Linseed oil
Portrait of Hendrickje Stoffels NG 6432	Probably 1654–6	1. White highlight of robe 2. Red background	Walnut oil Walnut oil
A Franciscan Friar NG 166	About 1655/6	1. Brown habit 2. Pale buff paint, top edge 3. Grey-blue background	Linseed oil Walnut oil Linseed oil
A Bearded Man in a Cap NG 190	About 1657	1. Black coat 2. Ground	Walnut oil Walnut oil
An Elderly Man as Saint Paul NG 243	Probably 1659	1. Black sleeve of robe 2. Reddish brown, upper RH corner	Linseed oil Linseed oil
Portrait of Jacob Trip NG 1674	About 1661	1. White scarf, right shoulder 2. Reddish brown, side of chair 3. Black, bottom of cane	Walnut oil Linseed oil Linseed oil
Portrait of Margaretha de Geer NG 1675	About 1661	1. White ruff 2. Brown background 3. Ground	Linseed oil[2] Oil+egg(?)[5] Linseed oil
Portrait of Margaretha de Geer (bust length) NG 5282	1661	1. White impasto 2. Black background	Linseed oil Linseed oil+resin[6]

Picture	Date	Source/location of sample taken	Medium
Portrait of Frederik Rihel on Horseback NG 6300	Probably 1663	1. White impasto, jacket trimmings 2. Red impasto, cuff trimmings	Linseed oil[7] Linseed oil
Self Portrait at the Age of 63 NG 221	1669	1. Dark brown, right sleeve 2. Olive-brown background at top edge 3. Ground	Linseed oil Linseed oil Linseed oil

FOLLOWERS OF REMBRANDT

Picture	Date	Source/location of sample taken	Medium
A Seated Man in a Lofty Room NG 3214	Early 1630s	1. Rich, white impasto of illuminated wall 2. Rich, thick black paint from tablecloth	Walnut oil[2,8] Linseed oil[2,8]
Diana bathing NG 2538	Late 1630s	1. Green impasto of leaf 2. Dark red brown of foreground	Linseed oil[2] Linseed oil[2]
A Young Man and Girl playing Cards NG 1247	1645–50	1. Red of dress 2. White, dry impasto of scarf 3. Mustard highlight, chair's fitment	Linseed oil[8] Linseed oil[9] Linseed oil
An Old Man in an Armchair NG 6274	1650s	1. Brownish-red lower ground 2. White impasto of cuff 3. Brownish black paint	Linseed oil Walnut oil Linseed oil
A Seated Man with a Stick NG 51	1650–60	1. Pinkish brown fur on robe 2. Pale buff impasto stroke, mid LH edge 3. Black background, LH edge	Linseed oil[10] Linseed oil[10] Linseed oil[2,8]
Study of an Elderly Man in a Cap NG 2939	1650s–60s	1. Greenish-brown background 2. Buff paint of highlight on sitter's right shoulder	Linseed oil Walnut oil

NOTES

1　Examined by gas-chromatography alone. The palmitate/stearate ratio was just at the borderline for the classification of oil-type, but probably indicates the use of linseed oil.

2　Heat-bodying (or prepolymerisation) of oil is indicated by the ratio between two of the dicarboxylic acids present, the C9 (nonanedioic) acid and C8 (octanedioic) acids. In the case of a heat-bodied oil the C9/C8 dicarboxylic ester ratio is around 3, as detected in this sample; in a non-heat-bodied oil it is typically around 7 (Mills and White 1982, Mills and White 1983).

3　The oil-modified alkyd detected in sample 1 is a modern synthetic medium; its use here occurs in paint from the added section on the right of the painting and must be due to the presence of retouching. Its presence was established by the identification of dimethyl phthalates. Sample 2 was taken from the region between the added strip at the top (stage 3) and that on the left (stage 2) on the upper left hand edge; the use of poppyseed oil perhaps suggests a paint applied at a later period.

4　The C9/C8 dicarboxylic ester ratio of 2.73 in the white impasto (sample 1) suggests the use of heat-bodied linseed oil (compare note 2), whereas the yellow impasto gave no indication of such prepolymerisation. This may account for the fact that the white impasto yielded in a plastic manner during sampling, whereas the yellow impasto was hard and brittle and clearly bodied by a high proportion of pigment.

5　The chromatogram of paint from the brown background (sample 2) gave an intermediate azelaic to palmitic ester ratio. This would normally be interpreted as suggesting the presence of a mixture of drying oil and egg tempera. One explanation for this could be that some retouching carried out in egg tempera was accidentally present in the sample. However, it is now known that the presence of smalt which has discoloured and reacted with the medium – as appears to be the case here – can lead to the apparent depletion of azelaic ester levels, giving a pattern reminiscent of the presence of egg tempera with the oil. It is likely that this has happened here and the medium is simply drying oil.

6　Sample 2 from the black background was taken from an area which contained no visible retouching. Linseed oil was identified together with a diterpenoid resin component using GC–MS. The main resin component detected had a molecular ion at $m/z = 312$, with base peak at $m/z = 237$, suggesting the presence of dehydrodehydroabietic acid ester. What is unusual is the absence of the component typical of aged pine resin, dehydroabietic acid ester. However a conifer resin is probably present.

7　The sample of rich, white impasto (sample 1) yielded in a similar manner to the white impasto from *Belshazzar's Feast* during sampling (see note 4) and here too the C9/C8 ratio (2.69) is indicative of the presence of heat-bodied oil. The red impasto (sample 2) was more brittle and the corresponding dicarboxylic acid ratio gave no indication of the use of a heat-bodied form of linseed oil.

8　Pine resin within medium.

9　Impasto produced by bodying with pigment.

10　Partially heat-bodied oil.

Dutch seventeenth-century painting materials and methods: an annotated bibliography

Bibliographical sources for Dutch seventeenth-century painting materials and methods

This section consists of primary sources relating to contemporary technical literature in Dutch on materials used in painting; Dutch seventeenth-century painting practice, particularly that of Rembrandt; and recent literature on the technical examination of Rembrandt's paintings.

Technical literature on painting materials in the Netherlands in the seventeenth century

For the investigation of the materials and methods used by Rembrandt, or by any other painter, a study of the technical literature written for craftsmen is of great value.[1] The development of any technology depends in part on the spread of information: science and industry were able to evolve in parallel with the growth of the printing and publishing industry in the sixteenth and seventeenth centuries. During this period there were considerable developments in science and technology generally in the Netherlands, notably in the field of dyeing. It was during the seventeenth century that an increased understanding of the scientific principles underlying natural phenomena and technical processes – for example, the use of the microscope in the discovery of certain protozoa and bacteria (by Anton van Leeuwenhoek), or the effect of tin salts on the colour of cochineal dyestuff (by Cornelius Drebbel) – began to be reflected in the publication of increasingly specialised technical literature, such as the *Proceedings* of the Royal Society in London, founded in 1660.

In general, technical literature concerned specifically with pigments appeared towards the later years of the seventeenth century, as, for example, *Der curiose Mahler*, published in Dresden in 1695. However, before this it was not unusual for a work on a relatively restricted, but related, field, such as glass-making, to contain instructions for preparing certain pigments: Antonio Neri's *L'arte vetraria* (Florence 1612; Latin translation Amsterdam 1686) contains detailed recipes for making lake pigments from cochineal and other dyestuffs. The revised translations into English (by Christopher Merret, London 1662) and German (by Johannes Kunckel, Amsterdam and Danzig [Gdansk] 1679, Frankfurt and Leipzig 1689) were probably also known in the Netherlands.[2]

Technical material intended for practical workshop use did not necessarily find its way into print – or, in earlier times, hand-written form – at all: the tradition of protecting trade secrets or, perhaps, guild regulations may have been partly responsible for this. However there are rare survivals of manuscript material, recipes noted down by the craftsman for his own use or

compiled for the benefit of his successors or employees. Seventeenth-century Holland was known for the excellent quality and colour of the vermilion manufactured there and one of the most detailed descriptions of the manufacturing process is to be found in a collection of workshop recipes, originally written by the Amsterdam manufacturer Willem Pekstok (1630/31–1691) and copied by his younger son Pieter. This copy is known today as the Pekstok papers (Municipal Archives, Amsterdam, No. N 09 23).[3] The collection includes recipes for other materials manufactured by Willem Pekstok, such as distilled verdigris, yellow lakes, brazilwood lake, processed indigo and litmus colouring matters, as well as instructions on the distillation of turpentine and the manufacture of sealing waxes.

Chemistry was not yet the systematic science that it is today, but a study of the chemical literature of the period can still be informative. Christopher Morley, a student at the University of Leiden in the latter part of the century, published his *Collectanea chymica leydensia*, notes taken from lectures given by the chemists Karl Maets, Christiaan Margrave and Jacob Le Mort in 1684 (a chemistry laboratory had been opened in the university in 1665).[4] These include brief instructions for the preparation of lead white by the method known today as the Dutch or stack process (here ascribed to Le Mort), vermilion, various varnishes (not necessarily for pictures) and the purification of linseed oil. The method for linseed oil purification (by washing with water and using bread to absorb the water) is also ascribed to Le Mort, but very similar methods were recorded some 40 or 50 years earlier by Sir Theodore Turquet de Mayerne, a doctor at the courts of the English kings James I and Charles I, who had a considerable and intelligent interest in the materials and methods used by the painters he met there.[5]

The materials used in medicine were quite extraordinarily varied, ranging from minerals to resins, coral and pearls to roots and bark; medical and botanical literature is thus surprisingly informative on the raw materials used in the preparation of pigments, binding media and varnishes. The remedies and *materia medica* which doctors were supposed to prescribe and apothecaries to dispense were gradually becoming standardised and collected into the pharmacopoeiae published in various cities, although the prescriptions themselves were largely based on earlier sources. The chief editor of the first Amsterdam pharmacopoeia (1636)[6] was that same Nicolaes Tulp painted by Rembrandt in *The Anatomy Lesson of Dr Nicolaes Tulp* (Mauritshuis, The Hague) in 1632. One of the most influential herbals of the period was Rembert Dodoens's *Cruijdeboeck* (Antwerp 1554), which appeared in many editions and translations in the sixteenth and seventeenth centuries – three in Flemish appeared in 1608, 1616 and 1644.[7]

In parallel with this specialised literature, traditional technical literature, such as the books of 'secrets', also remained relevant – to the general reader at least. This more popular literature received its first printed form in the sixteenth century, but descended from considerably older manuscript collections and folk remedies. The 'secrets' book consisted of a wide-ranging collection of recipes, particularly suitable for use by the craftsman or in the home. Not surprisingly, many recipes were medicinal. Instructions were also included for a wide range of other preparations: alchemical, metallurgical, cosmetic, culinary, cleaning, dyeing and pigment-making. Many such varied collections were in circulation well into the seventeenth century, some more

thorough and detailed, others rather trite.[8] *De' secreti del Reverendo Donno Alessio Piemontese*, of 1555/6 was one of the most famous: a best-seller, it ran into many editions and was translated into many European languages. There were at least six Dutch editions and the book was reprinted well into the seventeenth century. Alessio's work, in the earliest Italian editions, consisted of six books: these form the first part of the later, two- or three-part, editions. The second part varies: in the Dutch (and English) editions, derived from Christophle Landré's French edition (1559), it consists of the 1549 version of Symon Andriessen's tract, discussed below.[9] Most of the pigment recipes appear in book 5 of Alessio's original work: they include recipes for ultramarine, red lake pigments, various artificial blue pigments and vermilion. Instructions are given also for grinding pigments to their best advantage, particularly blues, which are inclined to lose their colour if too finely ground.

Carel Batin's *Secreetboek* (first published Dordrecht 1601) contains perhaps the cream of the many individual collections, as is described in the foreword to the book, and the original source for many of the recipes is given.[10] Apart from one or two recipes from Alessio – for vermilion and for a red lake pigment prepared from dyed clippings of cloth – the main section on pigments is unattributed. It is, in fact, a translation of the first part of Valentin Boltz's *Illuminirbuch* (Basel 1549),[11] itself a much reprinted, thorough and influential work. (It forms the basis of a later Dutch work, *Den geheimen Illuminir-Kunst … * by J.B. Pictorius (Leiden 1747), which is partly concerned with watercolour painting.) Boltz's book is an artist's manual: the colours to use for painting various items are suggested and instructions are given for preparing, washing and grinding a wide range of pigments. The recipes are for those pigments easily prepared, such as lakes. The version appearing in Batin's book is updated only in minor details. The later editions of Batin's work have an appendix which includes Andriessen's tract on painting described below.

There was a market in northern Europe, notably sixteenth-century Germany, for small practical handbooks, for home use or for the craftsman, which drew on a similar type of source material to that of the 'secrets' books and had similarly been in circulation in manuscript form. The contents, too, were similar, although the range was rather more restricted. New collections of old recipes were compiled at intervals, or old collections were reprinted. The 'Kunstbüchlein' group of books is an example of these.[12] Symon Andriessen's tract is partly related to this group: part of the 1549 edition of *Een schoon Tractaet* is a translation of the *Künstbüchlin* (Augsburg 1537), itself descended from an earlier work. Other editions of Andriessen's work – the 1552 and 1581 editions – contain a more detailed tract.[13] This, like Boltz's work, is an artist's handbook: it resembles Boltz's work also in that it is aimed more at the illuminator of manuscripts than at the easel painter, although many of the pigments used are common to both. It is much shorter and less sophisticated, containing a far narrower range of pigments. These are, however, of a similarly good quality; many are lakes and others, for which no recipes are given, such as vermilion, massicot and even expensive blues such as azurite, are at least mentioned by name. This work was reprinted in the seventeenth century.

Other small works, usually anonymous, with a history as long as that of the 'Kunstbüchlein'

group, were in circulation in the Netherlands in the sixteenth century. *Dat playsant Hofken van Recepten* (Antwerp 1548) was translated from a French edition and was reprinted as late as 1657.[14] The recipes are traditional, including instructions for preparing a blue pigment from verdigris and for making vermilion. An interesting sixteenth-century collection in manuscript form, the 'Traktaat om kleuren te bereiden' (Antwerp, Plantin-Moretus Museum, No. 64), is not merely a copy of earlier or well-known recipes: it contains recipes not found elsewhere and is notable both for the diagrams of some of the ovens and apparatus used and for its rare description of a method for making the yellow pigment lead-tin yellow 'type 1', referred to under the name 'massicot'.[15]

Traditional sources such as these persisted unchanged over a long period of time. Whether or not they are reliable indicators of seventeenth-century practice is debatable. The method of preparing pigments such as lead white or the manufactured variety of vermilion remained relatively constant: in such cases the recipes are likely to have remained valid and useful. Information on technological progress appeared in print fairly slowly and the absence of a recipe for a given pigment does not necessarily indicate that it was not prepared or used. Some pigments had their origin in a different technology: the blue glass pigment smalt, for example, in the glass-making industry; the different forms of lead-tin yellow in the ceramic and glass industries. The curious lack of contemporary recipes for lead-tin yellow – the presence of which has been confirmed in many paintings of the period, including those of Rembrandt – stems from this. Equally, the listing of a particular pigment, or the presence of a recipe for it, must also be treated with a certain amount of caution. This is particularly true of Alessio's recipes which, as well as having a long history, are also north Italian in origin. They are unlikely to reflect accurately seventeenth-century Dutch practice where, for example, the blue pigments ultramarine and azurite became increasingly difficult to obtain and extremely expensive (and Batin, in his selection of recipes from Alessio, did not include any for ultramarine). The same caution is necessary when reading certain artists' manuals. Goeree's 1670 revision of ter Brugge's work on watercolour, the *Verlichtery Kunst-Boeck*, first published in 1616, includes a surprisingly long list of suitable pigments, much longer than in the original. However, although one may wonder if some were still widely used or, indeed, available by 1670, watercolour is very much more economical in its use of pigments than is oil painting on panel or canvas, and the use of an expensive, rare pigment would have been possible.

Jo Kirby

(Full references for sources given in short form on pp. 233–5 are given in the alphabetical bibliography.)

Notes

1 Ferguson 1885–90; Ferguson 1906; Ferguson 1888–1916; Partington 1961–5, vol. 2, pp. 32–114.

2 C. Merrett, *The Art of Glass: wherein are shown the Wayes to make and colour Glass, Pastes, Enamels, Lakes and other Curiosities*; trans. from the Italian of A. Neri, London 1662; J. Kunckel, *Ars vitraria experimentalis, oder volkommene Glasmacher-Kunst*, Amsterdam and Danzig, 1679; another edn Frankfurt and Leipzig 1689.

3 W. Pekstok, 'Aantekeningen van Willem Pekstok (1630/31–1691), verfkoper, over het vervaardigen van verven, etc', the 'Pekstok papers', Amsterdam, Municipal Archives, No. N 09 23. For vermilion see van Schendel 1972; for the lake pigments see Hermens and Wallert 1998.

4 C.L. Morley, *Collectanea chymica leydensia, id est maetsiana, margraviana, le mortiana scilicet trium in Academia Lugduno-Batava facultatis chimicae . . . professorum*, Leyden 1684; later edns 1693, 1702; German edn 1696; see also Partington 1961–5, vol. 2, pp. 736–8.

5 Van de Graaf 1958, pp. 179–82.

6 *Amsterdam Pharmacopoeia, 1636*, facsimile of the first Amsterdam pharmacopoeia, with an introduction by D.A. Wittop Koning, Nieuwkoop 1961.

7 R. Dodoens, *Cruijdeboeck: In den welcken die gheheele historie dat es Tgheslacht, tfatsoen, naem, natuere, cracht, ende werckinghe, van den Cruyden . . .*, Antwerp 1554. 1st French edn trans. Charles de l'Escluse (better known as Clusius) Antwerp 1557, 2nd Flemish edn Antwerp 1563, 1st English edn London 1578, 1st Latin edn Antwerp 1583: the 3rd, enlarged, Flemish edn, entitled *Cruydt-Boeck* (Leiden 1608) was trans. from this. Later Flemish edns (Leiden 1618 and Antwerp 1644) derive from the 1608 edn; see A. Arber, *Herbals, their Origin and Evolution; a Chapter in the History of Botany 1470–1670*, 3rd edn, annotated by W.T. Stearn, Cambridge 1987 (repr. 1999).

8 Eamon 1994; Partington 1961–5, vol. 2, pp. 27–31; Vandamme 1974, pp. 101–13.

9 Alessio Piemontese [Girolamo Ruscelli?], *De' secreti del Reverendo Donno Alessio Piemontese . . .*, Venice 1555/6; 2nd edn. 1557. First Dutch edn, *De Secreten van den Eerweerdighen Heere Alexis Piemontois*, Antwerp 1561, trans. from the French edn of Christophle Landré (Paris 1559).

Seventeenth-century edns include those printed in Delft, 1602, and Amsterdam, 1631. Dutch edns of the second part of 'Alessio's' work, derived from the same French source appeared in the same years, with a later printing also in 1670; see Partington 1961–5, vol. 2, pp. 28–9; Vandamme 1974, pp. 111–12; Eamon 1994, pp. 139–51.

10 C. Batin, *Secreetboek, waerin vele diversche secrete ende heerlicke consten, in veelderleye materien uut seker latijnsche, fransoysche, hoochduytsche ende nederlantsche authoren te samen by een gebracht zyn . . .* Dordrecht 1601, 1609; Amsterdam 1650, 1656. (Author's surname appears in the form 'Battus' in the later edns.) The wording of the title is slightly different in the later edns, which also have an appendix (dated 1651 and 1656 respectively) including an unattributed section on painting and pigments; this is a reprint of the second tract of the 1552 and 1581 edns of Andriessen.

11 V. Boltz von Rufach, *Illuminierbuch: wie man allerlei Farben bereiten, mischen und auftragen soll* (Basel 1549), ed. C.J. Benzinger, Munich 1913 (repr. Schaan 1982).

12 Darmstaedter 1926; Partington 1961–5, vol. 2, pp. 68–9.

13 S. Andriessen, *Een schoon Tractaet van sommighe Werckingen der Alchemistische dinghen, om gout, silver te maken . . . noch een schoon tractaet boecxken, inholdende van alderley verwen te maecken . . .*, Amsterdam 1581. (Author's surname also appears in the form 'Andree'.) Edns of this work differ in content: first edn 1549, largely a trans. into Dutch of the *Künstbüchlin, gerecht-ten grundtlichen Gebrauchs/aller kunstbaren Werckleut*, Augsburg 1537. The 1552 edn, *Vier rondigh Tractaet Boeck*, contains four tracts, the second of which contains detailed recipes for colours and their use: this is not found in the *Künstbüchlin*. The 1581 edn contains only the last tract of the 1549 edn and the second tract of the 1552 edn. The 1600 edn is a reprint, uniting the 1549 and 1581 edns, itself reprinted in 1687. Andriessen's work also appears within other books.

14 *Dat playsant Hofken van Recepten, in het welcke gheplant syn diverse boomkens van naturael philosophie, inhoudende seer schoene remedien tot alle gebreken des lichaems . . .*, Antwerp 1548; later edns Antwerp 1551, 1553, 1657. This is trans. from a French version, itself derived from an Italian source; see Vandamme 1974, pp. 109–10.

15 Vandamme 1974.

Primary sources for Rembrandt's methods, techniques and studio practice

Where a primary source – Samuel van Hoogstraten's book, for example – has been cited in the main body of this book, it is given in short form below – Hoogstraten 1969; the full entry is given in the alphabetical bibliography following this section.

F. Baldinucci
Cominciamento e progresso dell'arte d'intagliare in rame …, Florence 1686, pp. 78–80.

A. Félibien
Entretiens sur les Vies et sur les Ouvrages des plus excellens Peintres anciens et modernes, 5 vols, Paris 1666–88; vol. 4, 1684, pp. 150–7.

Hoogstraten 1969
See, for example, pp. 13, 176, 191, 227–8, 273, 291, 305–6. On Hoogstraten see Brusati 1995.

Houbraken 1943–4
Vol. 1, pp. 200–15 (pp. 254–73 in the 1718–21 edn); see also comments on the painting methods of Aert de Gelder, pp. 161–4 (pp. 206–9 in the 1718–21 edn). On Houbraken see Horn 2000.

C. Huygens
[*Autobiographie*] *De Jeugd van Constantijn Huygens, door hemzelf beschreven,* trans. A.H. Kan, Rotterdam 1946 (repr. 1971), pp. 78–81. Written in Latin probably between May 1629 and May 1631; see J.A. Worp, 'Fragment eener Autobiographie van Constantijn Huygens', *Bijdragen en Mededeelingen van het Historisch Genootschap,* XVIII, 1897, pp. 1–121.

Lairesse 1707
Vol. 1, book 1, pp. 41–2; book 5, pp. 320, 323–5; vol. 2, book 7, p. 18. English trans. by J.F. Fritsch, London 1738. See also Dolders 1985; de Vries 2004.

F. Lecomte
Cabinet des Singularitez d'Architecture, Peinture, Sculpture et Graveure, 3 vols, Paris 1699–1700; vol. 1, pp. 51–2; vol. 3, pp. 125–7.

R. de Piles
Abregé de la Vie des Peintres, Paris 1699, pp. 433–8.

R. de Piles
Cours de Peinture par principes …, Paris 1708; 'Balance de Peintres', wherein he awards marks for composition, drawing, colour and expression to noteworthy painters of the day, pp. 489 ff.

Von Sandrart 1675–9
Vol. 1, pp. 326–7; von Sandrart 1925, pp. 202–3. See also the biographies of other Dutch artists: Gerrit Dou (vol. 1, pp. 320–1, von Sandrart 1925, pp. 195–6) and Gerrit van Honthorst (vol. 1, pp. 303–4; von Sandrart 1925, pp. 172–4), with whom von Sandrart studied.

Dutch seventeenth-century literature on painting, theory and practice

W. Beurs
De groote Waerelt in t'kleen geschildert . . . , Amsterdam 1692; German edn Amsterdam 1693.

C. de Bie
Het gulden Cabinet van de edele vry Schilder-Const, Antwerp 1661, pp. 208–11; on Rembrandt's work see p. 290.

C.P. Biens
De Teecken-Const: ofte een korte ende klaere aen-leydinghe tot die lofelijcke const van teeckenen tot dienst ende behulp van de eerstbeghinnende jeucht ende liefhebbers, in elf capittelen vervat, Amsterdam 1636; reprinted in de Klerk 1982.

G. ter Brugge
Verlichtery Kunst-Boeck in de welcke de rechte fondamenten en het volcomen gebruyck der illuminatie, Amsterdam 1616; later edn Leiden 1634. (The author's surname also appears in the form 'Terbrugghen'.) See also rev. edn by W. Goeree under the title *Verligterie-Kunde* (cited below).

W. Goeree
Inleyding tot de Praktyk der algemeene Schilderkonst, Amsterdam 1670, repr. 1697, 1704. Published in German as part of collected edn with *Inleydinge tot de algemeene Teyken-Konst,* about 1668, on drawing, and *Verligterie-Kunde,* 1670 (Hamburg 1678). Other books forming part of Goeree's planned encyclopedia of art are *Natuurlyk en schilderkonstig Ontwerp der Menschkunde,* Amsterdam 1682 and *d'Algemeene Bouwkunde,* Amsterdam 1681.

W. Goeree
Verligterie-Kunde of regt gebruik der water-verwen, Amsterdam 1670; on watercolour painting, an expanded revision of ter Brugge's work (cited above).

Hoogstraten 1969
Pages 26, 29–32 (drawing materials and techniques); p. 218 (the benefit of copying paintings); pp. 220–3 (pigments and varnishes); p. 241 (on paintings with smooth surfaces); pp. 306, 321 (the effect of the colour of the ground on the overall harmony of light and shade); pp. 333–40 (historical discussion of painting methods).

Lairesse 1707
Chaps 1–6.

K. van Mander
Het Schilder-Boeck: waer in voor eerst de leerlustighe iueght den grondt der edel vry schilder-const, Haarlem 1604; 2nd edn Amsterdam 1618: see the introductory essay, 'Den grondt der edel vry schilder-const', also published as *Den grondt der edel vry schilderconst*, ed. H. Miedema, 2 vols, Utrecht 1973. See chap. 12 (ff. 46v.–50 in 1604 edn).

Von Sandrart 1675–9
Vol. 1, pp. 66, 72–3 (methods of oil painting); pp. 80–1 (size and lighting of an artist's studio); pp. 80–1, 86 (pigments).

Sources unpublished in the seventeenth century include:

Dr Thomas Marshall
Commonplace book, Oxford, Bodleian Library, MS Marshall 80, observations on painting technique attributed to Anthony van Dyck, headed 'Observat d. Ant . . . Dykii': Vey 1960 (original Dutch with German trans.); Talley 1981 (English trans.).

T.T. de Mayerne
'Pictoria, sculptoria, tinctoria et quae subal-ternarum artium spectantia', 1620–46, London, British Library, MS Sloane 2052: the best edns are still Berger 1901, repr. Walluf bei Wiesbaden 1973 (original French text with German transl.); van de Graaf 1958 (French text with Dutch notes). See also Talley 1981, pp. 72–149.

See also Bredius 1915–22: inventories made at the death of an artist, or at those of his or her wife or husband, respectively, may mention frames, panels and canvases and artists' equipment. Informative inventories include those of the flower painter Jacob Marrell following the death of his wife, 26 October 1649 (vol. 1, pp. 112–19); Cornelis Cornelisz. van Harlem, 1 March 1639 (vol. 7, pp. 77–86); Lodewijck, son, and Anna du Pierre, widow, of Bartholomeus van der Helst, 8 January 1671 (vol. 2, pp. 398–421); Tryntge Pieters, widow of Crijn Hendricksz. Volmarijn, 12 March 1648 (vol. 5, pp. 1634–47).

Reports on the scientific and technical examination of Rembrandt's paintings

J. Bauch, D. Eckstein and M. Meier-Siem
'Dating the wood of panels by a dendrochrono-logical analysis of the tree-rings', *Nederlands Kunsthistorisch Jaarboek*, 23, 1972, pp. 485–96.

C. Brown and A. Roy
'Rembrandt's "Alexander the Great"', *Burlington Magazine*, CXXXIV, 1992, pp. 286–97.

P. Coremans
'L'*Autoportrait de Rembrandt à la Staatsgalerie de Stuttgart: examen scientifique*', *Jahrbuch der Staatlichen Kunstsammlungen in Baden-Württemberg*, 2, 1965, pp. 175–88. (See also supplement to article on the painting by C. Muller-Hofstede, *Pantheon*, 2, 1963, pp. 94–100.)

P. Coremans and J. Thissen
'Het wetenschappelijk onderzoek van het *Zelfportret van Stuttgart*: Bijdrage tot de Rembrandtvorsing', *Bulletin de l'Institut Royal du Patrimoine Artistique*, VII, 1964, pp. 187–95.

W. Froentjes
'Schilderde Rembrandt op goud', *Oud Holland*, 84, 1969, pp. 233–7.

L. Gavrilenko and N. Gerassimova
'Paint-layer cross-sections and colorimetric studies of Rembrandt's "Danae", damaged by sulphuric acid', in M. Marabelli and P. Santopadre (eds), *3a Conferenza internazionale sulle prove non distruttive, metodi microanalitici e indagini ambientali per lo studio e la conservazione delle opere d'arte, Viterbo 4–9 ottobre 1992*, Viterbo 1992, pp. 701–16.

K. Groen
'Schildertechnische aspecten van Rembrandts vroegste schilderijen', *Oud Holland*, 91, 1971, pp. 66–74.

K. Groen
'The examination of the *Portrait of Rembrandt in a Flat Cap*', *Bulletin of the Hamilton Kerr Institute*, 1, 1988, pp. 66–8.

P.F.J.M. Hermesdorf, E. van de Wetering and J. Giltaij
'Enkele nieuwe gegevens over Rembrandts *De Eendracht van het Land* (*The Concord of the State*)', *Oud Holland*, 100, 1986, pp. 35–49.

M. Hours
'Rembrandt: observations et présentation de radiographies exécutées d'après les portraits et compositions du Musée du Louvre', *Bulletin du Laboratoire du Musée du Louvre*, 6, 1961, pp. 3–43.

M.E. Houtzager et al.
Röntgenonderzoek van de oude schilderijen in het Centraal Museum te Utrecht, Utrecht 1967.

B.B. Johnson
'Examination and treatment of Rembrandt's *Raising of Lazarus*', *Los Angeles County Museum of Art Bulletin*, 20, 1974, pp. 18–35.

J. Kelch et al.
Bilder im Blickpunkt: Der Mann mit dem Goldhelm: *eine Dokumentation der Gemäldegalerie in Zusammenarbeit mit dem Rathgen-Forschungslabor SMPK und dem Hahn-Meitner-Institut Berlin*, Berlin 1986.

H. Kühn
'Untersuchungen zu den Malgründen Rembrandts', *Jaarbuch der Staatlichen Kunstsammlung in Baden-Württemberg*, 2, 1965, pp. 189–210.

H. Kühn
'Untersuchungen zu den Pigmenten und den Malgründen Rembrandts, durchgeführt an den Gemälden der Staatlichen Kunstsammlungen Kassel', *Maltechnik/Restauro*, 82, 1976, pp. 25–32.

H. Kühn
'Untersuchungen zu den Pigmenten und den Malgründen Rembrandts, durchgeführt an den Gemälden der Staatlichen Kunstsammlungen Dresden', *Maltechnik/Restauro*, 83, 1977, pp. 223–33.

C. Laurenze-Landsberg
'Neutron activation autoradiography of paintings by Rembrandt at the Berlin Picture Gallery', in J.H. Townsend, K. Eremin and A. Adriaens (eds), *Conservation Science 2002: Papers from the Conference held in Edinburgh, Scotland, 22–24 May 2002*, London 2003, pp. 254–8.

P. Noble, J.J. Boon and J. Wadum
'Dissolution, aggregation and protrusion: lead soap formation in 17th century grounds and paint layers', *Art Matters – Netherlands Technical Studies in Art*, 1, 2002, pp. 46–61.

P. Noble, J. Wadum, K. Groen, R. Heeren and K.J. van den Berg
'Aspects of 17th-century binding medium: inclusions in Rembrandt's Anatomy Lesson of Dr Nicolaes Tulp', in *Art et Chimie, la couleur: actes du congrès*, Paris 2000, pp. 126–9.

G. Pieh
'Die Restaurierung des *Mann mit dem Goldhelm*', *Maltechnik/Restauro*, 93, 1987, pp. 9–34. (See also J. Kelch et al., cited above.)

Rembrandt Research Project
Symposium on Technical Aspects of Rembrandt Paintings, organised by the Rembrandt Research Project and the Central Research Laboratory for Objects of Art and Science, 22–4 September 1969 (abstracts), Amsterdam 1970.

H.F. von Sonnenburg
'Technical aspects: scientific examination' (round-table discussion), in *Rembrandt after Three Hundred Years: a symposium – Rembrandt and his followers*, 22–4 October 1969, Art Institute of Chicago, Chicago 1973, pp. 83–101.

H.F. von Sonnenburg
'Maltechnische Gesichtspunkte zur Rembrandtforschung', *Maltechnik/Restauro*, 82, 1976, pp. 9–24.

H.F. von Sonnenburg
'Rembrandts *Segen Jacobs* (*Jacob blessing the Children of Joseph*)', *Maltechnik/Restauro*, 74, 1978, pp. 217–43.

A.B. de Vries et al.
Rembrandt in the Mauritshuis: an interdisciplinary study, Alphen aan de Rijn 1978.

E. van de Wetering
'De jonge Rembrandt aan het werk', *Oud Holland*, 91, 1977, pp. 27–65.

E. van de Wetering
'Het raadsel van het bindmiddel bij Rembrandt', in W.G.T. Roelofs and J.A. Mosk (eds) *Schilderkunst materialen en technieken*. CL themadag (Centraal Laboratorium voor Onderzoek van Voorwerpen van Kunst en Wetenschap) Amsterdam 1989, pp. 65–74.

E. van de Wetering and P. Broekhoff
'New directions in the Rembrandt Research Project, part I: the 1642 self-portrait in the Royal Collection' *Burlington Magazine*, CXXX, 1996, pp. 174–80.

E. van de Wetering, K. Groen and J.A. Mosk
'Summary report on the results of the technical examination of Rembrandt's *Nightwatch*', *Bulletin van het Rijksmuseum*, 24, 1976, pp. 68–98.

See also van de Wetering 1982; van de Wetering 1986a; both included (updated) in van de Wetering 1997.

Bibliography

Ainsworth 1982
M.W. Ainsworth et al., *Art and Autoradiography: Insights into the genesis of paintings by Rembrandt, van Dyck and Vermeer*, The Metropolitan Museum of Art, New York 1982.

Amsterdam 1976
E. de Jongh, *Tot Lering en Vermaak, Betekenissen van Hollandse genervoorstellingen uit de zeventiende eeuw*, exh. cat., Amsterdam, Rijksmuseum, 1976. Amsterdam 1976.

Amsterdam 1991
A. Tümpel and P. Schatborn, *Pieter Lastman, leermeester van Rembrandt/ Pieter Lastman, the man who taught Rembrandt*, exh. cat., Amsterdam, Museum Het Rembrandthuis, 1991. Zwolle 1991.

Amsterdam 1996
C. Schuckman et al., *Rembrandt and van Vliet: A Collaboration on Copper*, exh. cat., Amsterdam, Museum het Rembrandthuis, 1996. Amsterdam 1996.

Amsterdam 2000
J. Kiers and F. Tissink, *The Glory of the Golden Age: Dutch Art of the 17th Century: Painting, Sculpture and Decorative Art*, exh. cat., Amsterdam, Rijksmuseum, 2000. Amsterdam and Zwolle 2000.

Amsterdam 2003
E. van de Wetering, *Rembrandt's Hidden Self-portraits/ Rembrandts verborgen zelfportretten*, exh. cat., Amsterdam, Museum Het Rembrandthuis, 2003. (*Kroniek van het Rembrandthuis*, vol. 2002/1–2, special edition to accompany the exhibition of the same title.)

Amsterdam 2006
D. Bull et al., *Rembrandt-Caravaggio*, exh. cat., Amsterdam, Rijksmuseum. Amsterdam and Zwolle 2006.

Amsterdam and Berlin 2006–7
E. van de Wetering et al., *Rembrandt: Quest of a Genius*, exh. cat., Amsterdam, Rembrandthuis; and Berlin, Staatliche Museen zu Berlin, Gemäldegalerie. Amsterdam and Zwolle 2006.

Amsterdam and Jerusalem 1991
C. Tümpel et al., *Het Oude Testament in de Schilderkunst van de Gouden Eeuw*, exh. cat., Amsterdam, Joods Historisch Museum; and Jerusalem, Israel Museum, 1991. Zwolle 1991.

Amsterdam, San Francisco and Hartford 2002
G. Janson and P.C. Sutton, *Michael Sweerts (1618–1664)*, with contributions by J. Bikker, L. Federle Orr, G. Luijten, W. de Ridder, A. Wallert and E.M. Zafran, ed. D. Bull, exh. cat., Amsterdam, Rijksmuseum; San Francisco, Fine Arts Museums; and Hartford, Wadsworth Atheneum Museum of Art. Zwolle 2002.

Andriessen 1581
S. Andriessen, *Een schoon Tractaet van sommighe Werckingen der Alchemistische dinghen, om gout, silver te maken . . . noch een schoon tractaet boecxken, inholdende van alderley verwen te maecken . . .*, Amsterdam 1581.

Angel 1642
P. Angel, *Lof der Schilder-Konst*, Leiden 1642.

Baer 1990
R. Baer, *The Paintings of Gerrit Dou (1613–1675)*, PhD thesis, New York University, New York 1990.

Balis 1986
A. Balis, *Corpus Rubenianum Ludwig Burchard, XVIII, part II: Rubens Hunting Scenes*, London 1986

Bartsch
A. Bartsch, *Le peintre-graveur*, 21 vols, Vienna 1802–21.

Battus 1650
C. Battus [C. Batin], *Secreet-Boeck van vele diversche en heerlicke consten, in veelderleye materien . . . wt latijnsche, francoische, hooghduytsche ende nederduytsche autheuren vergadert*, Amsterdam 1650.

Bauch 1960
K. Bauch, *Der frühe Rembrandt und seine Zeit: Studien zur geschichtlichen Bedeutung seines Frühstils*, Berlin 1960.

Bauch 1966
K. Bauch, *Rembrandt Gemälde*, Berlin 1966.

Benesch
O. Benesch, *The Drawings of Rembrandt*, 2nd edn, 6 vols, London 1973.

Bergen 1992
Rembrandt: Ridderen med falken, exh. cat., Bergen Billedgalleri, 1992. Bergen 1992.

Berger 1901
E. Berger, *Quellen für Maltechnik während der Renaissance und deren Folgezeit (XVI–XVIII. Jahrhundert)*, Munich 1901 (repr. Walluf bei Wiesbaden 1973; Beiträge zur Entwicklungsgeschichte der Maltechnik, IV), pp. 92–408.

Berger 2000
H. Berger, Jr, *Fictions of the Pose: Rembrandt against the Italian Renaissance*, Stanford 2000.

Berlin, Amsterdam and London 1991–2
C. Brown, J. Kelch and P. van Thiel, *Rembrandt: The Master and his Workshop*, exh. cat., 2 vols, Berlin, Staatliche Museen Preussischer Kulturbesitz, Gemäldegalerie; Amsterdam, Rijksmuseum; and London, The National Gallery. London 1991–2.

Białostocki 1969
J. Białostocki, *Catalogue of Paintings, Foreign Schools*, National Museum in Warsaw, 2 vols, Warsaw 1969.

Bikker 2005
Jonathan Bikker, *Willem Drost (1633–1659), A Rembrandt Pupil in Amsterdam and Venice*, New Haven and London 2005.

Blankert 1973
A. Blankert, 'Rembrandt, Zeuxis and Ideal Beauty', in J. Bruyn, J.A. Emmens, E. de Jongh and D.P. Snoep (eds), *Album Amicorum J. G. van Gelder*, The Hague 1973, pp. 32–9.

von Bode 1906
W. von Bode, 'Neuentdeckte Rembrandtbilder', *Zeitschrift für bildende Kunst*, 17, 1906, pp. 8–14.

Bomford 1998
D. Bomford, 'Introduction', in E. Hermens, A. Ouwerkerk and N. Costaras (eds), *Looking through Paintings: The Study of Painting Techniques and Materials in Support of Art Historical Research* (*Leids Kunsthistorisch Jaarboek*, XI), Baarn and London 1998, pp. 9–12.

Boon 2001
J.J. Boon, K. Keune, J. van der Weerd, M. Geldof and J.R.J. van Asperen de Boer, 'Imaging Microspectroscopic, Secondary Ion Mass Spectrometric and Electron Microscopic Studies on Discoloured and Partially Discoloured Smalt in Cross-sections of 16th Century Paintings', *Chimia*, 55, 2001, pp. 952–60.

Boston 2000
A. Chong (ed.), *Rembrandt Creates Rembrandt: Art and Ambition in Leiden*, exh. cat., Boston, Isabella Stewart Gardner Museum, 2000. Boston 2000.

Boston and Chicago 2003–4
C.S. Ackley, R. Baer, T.E. Rassieur and W.W. Robinson, *Rembrandt's Journey: Painter, Draughtsman, Etcher*, exh. cat., Boston, Museum of Fine Arts; and Chicago, Art Institute, 2003–4. Boston 2003.

Bredius 1910
A. Bredius, 'Rembrandtiana', *Oud Holland*, 28, 1910, pp. 193–204.

Bredius 1915–22
A. Bredius, *Künstler-Inventare: Urkunden zur Geschichte der holländischen Kunst des XVIten, XVIIten and XVIIIten Jahrhunderts*, 8 vols, The Hague 1915–22.

Bredius 1969
A. Bredius, *Rembrandt*, 3rd edn rev. H. Gerson, London 1969.

Brière-Misme 1950–3
C. Brière-Misme, 'Un petit maître hollandais: Cornelis Bisschop (1630–1674)', *Oud Holland*, 55, 1950, pp. 104–16; 57, 1952, pp. 181–2; 58, 1953, pp. 184–6.

Broos and van Suchtelen 2004
B. Broos and A. van Suchtelen, *Portraits in the Mauritshuis 1430–1790*, The Hague and Zwolle 2004.

Brown 1983
C. Brown, 'Rembrandt's *Saskia as Flora* X-rayed', in A.-M. Logan (ed.), *Essays in Northern European Art Presented to Egbert Haverkamp-Begemann*, Doornspijk 1983, pp. 49–51.

Brown and Plesters 1977
C. Brown and J. Plesters, 'Rembrandt's Portrait of Hendrickje Stoffels', *Apollo*, 106, 1977, pp. 286–91.

Brusati 1995
C. Brusati, *Artifice and Illusion: The Art and Writing of Samuel van Hoogstraten*, Chicago 1995.

Bruyn 1979
J. Bruyn, 'Een onderzoek naar 17de-eeuwse schilderijformaten voornamelijk in Noord-Nederland', *Oud Holland*, 93, 1979, pp. 96–115.

Bruyn 1989
J. Bruyn, 'Studio practice and studio production', in *Corpus*, vol. 3, 1989, pp. 12–50.

Bruyn 1991–2
J. Bruyn, 'Rembrandt's workshop: its function and production', in Berlin, Amsterdam and London 1991–2, pp. 68–89.

Chapman 1990
H. Perry Chapman, *Rembrandt's Self-Portraits: A Study in Seventeenth-Century Identity*, Princeton 1990.

Charrington 1923
J. Charrington, *A Catalogue of the Mezzotints after, or said to be after, Rembrandt*, Cambridge 1923.

Clark 1966
K. Clark, *Rembrandt and the Italian Renaissance*, London 1966.

Clarke and Boon 2003
M. Clarke and J. Boon (eds), *MolArt: A multidisciplinary NWO PRIORITEIT Project on Molecular Aspect of Ageing in Painted Works of Art. Final Report and Highlights, 1995–2002*, FOM Institute AMOLF, Amsterdam 2003.

Collins Baker 1939
C.H. Collins Baker, 'Rembrandt's thirty pieces of silver', *Burlington Magazine*, LXXV, 1939, pp. 179–80.

Coolhaas 1973
W.P. Coolhaas, *Het Huis 'De Dubbele Arend'*, Amsterdam 1973.

Copenhagen 2006
L. Bøgh Rønberg, E. de la Fuente Pedersen et al., *Rembrandt? The Master and his Workshop*, exh. cat., Copenhagen, Statens Museum for Kunst, 2006. Copenhagen 2006.

Corpus
J. Bruyn, B. Haak, S.H. Levie, P.J.J. van Thiel and E. van de Wetering, *A Corpus of Rembrandt Paintings*, with the collaboration of L. Peese Binkhorst-Hoffscholte and (vols 2 and 3) J. Vis, trans. D.

Cook-Radmore, Stichting Foundation Rembrandt Research Project, Dordrecht, Boston and London, vol. 1 (1625–1631), 1982; vol. 2 (1631–1634), 1986; vol. 3 (1635–1642), 1989; vol. 4, *The Self Portraits*, by E. van de Wetering, with contributions by K. Groen, P. Klein, J. van der Veen and M. de Winkel, with the collaboration of P. Broekhoff, M. Franken and L. Peese Binkhorst, trans. J. Kilian, K. Kist and M. Pearson, Dordrecht 2005.

Costaras 1998
N. Costaras, 'A Study of the Materials and Techniques of Johannes Vermeer', in I. Gaskell and M. Jonker (eds), *Vermeer Studies*, New Haven and London 1998, pp. 145–67 (Proceedings of the Symposia 'New Vermeer Studies', held 1 December 1995, Washington, and 30–31 May, The Hague; National Gallery of Art, Washington, *Studies in the History of Art*, 55, Center for Advanced Study in the Visual Arts, Symposium Papers XXXIII).

Dahlgren 1923
E.W. Dahlgren, *Louis de Geer, 1587–1652: Hans lifn och verk*, 2 vols, Uppsala 1923.

Darmstaedter 1926
E. Darmstaedter, *Berg-, Probir- und Kunstbüchlein*, Munich 1926.

Dickey 1994
S.S. Dickey, *Prints, Portraits and Patronage in Rembrandt's Work around 1640*, PhD thesis, New York University, New York 1994.

Dickey 1995
S.S. Dickey, '"Met een wenende ziel . . . doch droge ogen": Women Holding Handkerchiefs in Seventeenth-Century Dutch Portraits', *Nederlands Kunsthistorisch Jaarboek* (*Image and Self-Image in Netherlandish Art, 1550–1750*), 46, 1995, pp. 333–67.

Dickey 2002
S.S. Dickey, 'Rembrandt and Saskia', in A. Chong and M. Zell (eds), *Rethinking Rembrandt* (Fenway Court, no. 30), Zwolle 2002.

Dickey 2004
S.S. Dickey, *Rembrandt: Portraits in Print* (OCULI, Studies in the Art of the Low Countries, 9), Amsterdam and Philadelphia 2004.

Dolders 1985
A. Dolders, 'Some remarks on Lairesse's *Groot Schilderboek*', *Simiolus*, 15, 1985, pp. 197–220.

Dordrecht 1992–3
Peter Marijnissen et al. (eds), *De zichtbaere werelt, schilderkunst mit de gouden eeuw in Hollands oudste stad*, exh. cat., Dordrechts Museum. Dordrecht and Zwolle 1992–3.

Dudok van Heel 1979
S.A.C. Dudok van Heel, 'Het maecenaat Trip: Opdrachten aan Ferdinand Bol en Rembrandt von Rijn', *Kroniek van het Rembrandthuis*, 31/1, 1979, pp. 14–26.

Dudok van Heel 1991–2
S.A.C. Dudok van Heel, 'Rembrandt van Rijn (1606–1669): A Changing Portrait of the Artist', in Berlin, Amsterdam and London 1991–2, pp. 50–67.

Dudok van Heel 1992
S.A.C. Dudok van Heel, 'Enkele Observaties by het Portret van een 83-jarige Dame uit 1634 door Rembrandt', *Jaarboek Amstelodamum*, 79, 1992, pp. 6–15.

Dudok van Heel 1993
S.A.C. Dudok van Heel, 'Rembrandt en Menasseh ben Israël', *Kroniek van het Rembrandthuis*, 93/1, 1993, pp. 22–9.

Dudok van Heel 1994
S.A.C. Dudok van Heel, 'De remonstrantse wereld van Rembrandts opdrachtgever Abraham Anthoniszn Recht', *Bulletin van het Rijksmuseum*, 42, 1994, pp. 334–46.

Dudok van Heel 2006
S.A.C. Dudok van Heel, *De jonge Rembrandt onder zijn tijdgenoten. Godsdienst en schilderkunst in Leiden en Amsterdam*, PhD thesis, University of Nijmegen 2006.

Dunkerton and Spring 1998
J. Dunkerton and M. Spring, 'The Development of Painting on Coloured Surfaces in Sixteenth-Century Italy,' in A. Roy and P. Smith (eds), *Painting Techniques: History, Materials and Studio Practice: Contributions to the International Institute for Conservation Dublin Congress, 7–11 September 1998*, London 1998, pp. 120–30.

Dürer 1528
A. Dürer, *Hierin sind begriffen vier bücher von menschlicher Proportion*, Nuremburg 1528.

Eamon 1994
W. Eamon, *Science and the Secrets of Nature*, Princeton 1994.

Edinburgh and London 2001
J. Lloyd Williams et al., *Rembrandt's Women*, exh. cat., Edinburgh, National Gallery of Scotland; and London, Royal Academy of Arts, 2001. London and Edinburgh 2001.

van Eeghen 1956a
I.H. van Eeghen, 'De Portretten van Philips Lucas en Petronella Buys', *Maandblad Amstelodamum*, 43, 1956, p. 116.

van Eeghen 1956b
I.H. van Eeghen, 'De Kinderen van Rembrandt en Saskia', *Maandblad Amstelodamum*, 43, 1956, pp. 144–6.

van Eeghen 1958
I.H. van Eeghen, 'Frederick Rihel, een 17de Eeuwse Zakenman en Paardenliefhebber', *Maandblad Amstelodamum*, 45, 1958, pp. 73–81.

van Eikema Hommes 2005
M. van Eikema Hommes, 'Pieter de Grebber and the Oranjezaal in Huis ten Bosch; Part I: the Regulen', *Art Matters – Netherlands Technical Studies in Art*, 3, 2005, pp. 20–36.

Emmens 1979
J.A. Emmens, *Rembrandt en de regels van de kunst*, Amsterdam 1979.

Ferguson 1885–90
J. Ferguson, 'Bibliographical notes on histories of inventions and books of secrets' [6 papers read between 1882 and 1888], *Transactions of the Archaeological Society of Glasgow*, 1885–90 (repr. Glasgow 1895).

Ferguson 1888–1916
J. Ferguson, *Some early treatises on technological chemistry*, Glasgow 1888–1916, 6 vols.

Ferguson 1906
J. Ferguson, *Bibliotheca chemica: a catalogue of the alchemical, chemical and pharmaceutical books in the collection of the late James Young of Kelly and Durris, Esq*, 2 vols, Glasgow 1906.

Folch y Costa 1804
J. Folch y Costa, 'Nobles Artes. Sigue el juicio de los quadros que hay en el Carmen Descalzo de esta Corte', *Variedades de Ciencias, literatura y artes. Obra periódica*, 4/22, 1804, pp. 235–43.

Franits 2004
W. Franits, *Dutch Seventeenth-Century Genre Painting, its Stylistic and Thematic Evolution*, New Haven and London 2004.

van Gelder 1953
J.G. van Gelder, 'Rembrandts vroegste ontwikkeling', *Mededelingen der Koninklijke Nederlandse Akademie van Wetenschappen*, 16/5, 1953, pp. 1–28 (273–300).

van Gelder 1973
J.G. van Gelder, 'Frühe Rembrandt-Sammlungen', in O. von Simson and J. Kelch (eds), *Neue Beiträge zur Rembrandt-Forschung*, Berlin 1973, pp. 189–206.

Gerson 1961
H. Gerson, *Seven Letters by Rembrandt*, The Hague 1961.

Gettens, Kühn and Chase 1993
R.J. Gettens, H. Kühn and W.T. Chase, 'Lead white', *Artists' Pigments: A Handbook of their History and Characteristics*, vol. 2, ed. A. Roy, Washington and Oxford 1993, pp. 67–81.

Giltaij 1992
J. Giltaij, 'De Grafsteen van Haesje', *Kroniek van het Rembrandthuis*, 92/1, 1992, pp. 10–12.

Goedings and Groen 1994a
T. Goedings and K. Groen, 'Dutch pigment terminology I: a seventeenth-century explanation of the word "schulpwit"', *Hamilton Kerr Institute Bulletin*, 2, 1994, pp. 85–7.

Goedings and Groen 1994b
T. Goedings and K. Groen, 'Dutch pigment terminology II: "schiet" yellow or "schijt" yellow?', *Hamilton Kerr Institute Bulletin*, 2, 1994, pp. 88–9.

Golahny 1987
A. Golahny, 'The *Adulteress* by Rembrandt and by Van den Eeckhout: Variations on an Italian Magdalene', in W.H. Fletcher (ed.), *Papers from the Second Interdisciplinary Conference on Netherlandic Studies held at Georgetown University 7–9 June 1984*, Lanham, New York and London 1987.

Golahny 1999–2000
A. Golahny, 'Rembrandt's practical approach to Italian art', *Low Countries*, 7, 1999–2000, pp. 123–31.

van de Graaf 1958
J.A. van de Graaf, *Het de Mayerne Manuscript als bron voor de schildertechniek van de Barok*, PhD thesis, Rijksuniversiteit te Utrecht, Utrecht 1958.

van de Graaf 1961
J.A. van de Graaf, 'Betekens en toepassing van "lootwit" en "schelpwit" in de XVIIe-eeuwse nederlandse schilder-kunst', *Bulletin de l'Institut Royal du Patrimoine Artistique*, IV, 1961, pp. 198–201.

Groen 1997
K. Groen, 'Investigation of the Use of the Binding Medium by Rembrandt', *Zeitschrift für Kunsttechnologie und Konservierung*, 11, 1997, pp. 207–27.

Groen 2005a
K. Groen, 'Grounds in Rembrandt's workshop and in paintings by his contemporaries', *Corpus*, Vol. 4, 2005, pp. 318–34.

Groen 2005b
K. Groen, 'Earth Matters: the origin of the material used for the preparation of the Night Watch and many other canvases in Rembrandt's workshop after 1640', *Art Matters – Netherlands Technical Studies in Art*, 3, 2005, pp. 138–54.

Groen et al. 1998
K.M. Groen, I.D. van der Werf, K.J. van den Berg and J.J. Boon, 'Scientific Examination of Vermeer's *Girl with a Pearl Earring*', in I. Gaskell and M. Jonker (eds), *Vermeer Studies*, New Haven and London 1998, pp. 168–83 (Proceedings of the Symposia 'New Vermeer Studies', held 1 December 1995, Washington, and 30–31 May, The Hague; National Gallery of Art, Washington, *Studies in the History of Art*, 55, Center for Advanced Study in the Visual Arts, Symposium Papers XXXIII).

Guratzsch 1975
H. Guratzsch, 'Die Untersicht als ein Gestaltungsmittel in Rembrandts Frühwerk', *Oud Holland*, 89, 1975, pp. 250–1.

Haak 1969
B. Haak, *Rembrandt: his Life, his Work, his Times*, London 1969.

Haak 1973
B. Haak, 'Nieuwlicht op Judas en de zilverlingen van Rembrandt', in J. Bruyn, J.A. Emmens, E. de Jongh and D.P. Snoep (eds), *Album Amicorum J.G. van Gelder*, The Hague 1973, pp. 155–8.

The Hague 1998–9
N. Middelkoop, P. Noble, J. Wadum and B. Broos, *Rembrandt under the Scalpel: The Anatomy Lesson of Dr Nicolaes Tulp Dissected*, exh. cat., The Hague, Mauritshuis, 1998–9. Amsterdam 1998.

Harley 1982
R.D. Harley, *Artists' Pigments c. 1600–1835: A Study in English Documentary Sources*, 2nd edn, London 1982.

Harris 1969
A. Harris, 'Rembrandt's Study for *The Lamentation for* [sic] *Christ*', *Master Drawings*, 7, 1969, pp. 158–64.

Hausherr 1963
R. Hausherr, 'Zur Menetekel-Inschrift auf Rembrandts Belsazarbild', *Oud Holland*, 78, 1963, pp. 142–9.

Heesakkers 1987
C.L. Heesakkers, *Constantijn Huygens, 'Mijn Jeugd'*, Amsterdam 1987.

Held 1964
J.S. Held, *Rembrandt and the Book of Tobit*, Northampton, Mass., 1964.

Held 1991
J.S. Held, *Rembrandt Studies*, rev. enl. edn, Princeton 1991.

Hermens and Wallert 1998
E. Hermens and A. Wallert, 'The Pekstok Papers, Lake Pigments, Prisons and Paint-mills', in E. Hermens, A. Ouwerkerk and N. Costaras (eds), *Looking through Paintings: The Study of Painting Techniques and Materials in Support of Art Historical Research* (*Leids Kunsthistorisch Jaarboek*, XI), Baarn and London 1998, pp. 269–94.

Higgitt, Spring and Saunders 2003
C. Higgitt, M. Spring and D. Saunders, 'Pigment-medium Interactions in Oil Paint Films containing Red Lead or Lead-tin Yellow', *National Gallery Technical Bulletin*, 24, 2003, pp. 75–95.

Hind 1915–31
A.M. Hind, *Catalogue of Drawings by Dutch and Flemish Artists preserved in the British Museum*, 4 vols, London 1915–31.

Hofenk de Graaff 2004
J.H. Hofenk de Graaff, 'Recycling in the 17th-century textile industry', in J.H. Hofenk de Graaff, *The Colourful Past: Origins, Chemistry and Identification of Natural Dyestuffs*, with contributions from W.G.T. Roelofs and M.R. van Bommel, London 2004, pp. 344–52; first published in *Dyes in History and Archaeology*, 14, 1996, pp. 60–69.

HdG
C. Hofstede de Groot, *Beschreibendes und kritisches Verzeichnis der Werke der hervorragendsten holländischen Maler des XVII. Jahrhunderts*, 10 vols, Esslingen, Stuttgart, Paris 1907–28; esp. vol. 6, 1915.

Hofstede de Groot 1913
C. Hofstede de Groot, 'Rembrandts Portretten van Philips Lucasse en Petronella Buys', *Oud Holland*, 31, 1913, pp. 236–40.

Hofstede de Groot 1928
C. Hofstede de Groot, 'De portretten van het echtpaar Jacob Trip en Margaretha de Geer door de Cuyp's, N. Maes en Rembrandt', *Oud Holland*, 45, 1928, pp. 255–64.

Holl.
F.W.H. Hollstein, *Dutch and Flemish Etchings, Engravings and Woodcuts, ca. 1450–1700*, vols 1–58, Amsterdam and Rotterdam 1949–2001.

Holmes 1926
C. Holmes, '*Tobit and his wife*, by Rembrandt and Gerard Dou', *Burlington Magazine*, XLIX, 1926, pp. 55–61.

Hoogewerff 1947
G.J. Hoogewerff, *De geschiedenis van de St Lucasgilden in Nederland*, Amsterdam 1947.

Hoogstraten 1969
S. van Hoogstraten, *Inleyding tot de hooge Schoole der Schilderkonst* (Rotterdam 1678), facsimile reprint, Doornspijk 1969.

Horn 2000
H.J. Horn, *The Golden Age Revisited: Arnold Houbraken's Great Theatre of Netherlandish Painters and Painteresses*, 2 vols, Doornspijk 2000.

Houbraken 1943–4
A. Houbraken, *De groote Schouburgh der nederlantsche Konstschilders en schilderessen*, 3 vols (Amsterdam 1718–21), repr. Maastricht 1943–4.

van Hout 1998
N. van Hout, 'Meaning and Development of the Ground Layer in Seventeenth Century Painting', in E. Hermens, A. Ouwerkerk and N. Costaras (eds.) *Looking through Paintings: The Study of Painting Techniques and Materials in Support of Art Historical Research* (*Leids Kunsthistorisch Jaarboek*, XI), Baarn and London 1998, pp. 199–225.

Hoyle and Miedema 1996
M. Hoyle and H. Miedema, 'Philips Angel, Praise of Painting', *Simiolus*, 24, 1996, pp. 227–58.

Israel 1995
J.I. Israel, *The Dutch Republic: Its Rise, Greatness and Fall, 1477–1806*, Oxford 1995 (repr. 1998).

de Jager 1990
R. de Jager, 'Meester, leerjongen, leertijd: een analyse van zeventiende-eeuwse Nord-Nederlandse leerlingcontracten van kunstschilders, goud- en zilversmeden', *Oud Holland*, 104, 1990, pp. 69–111.

de Jongh 1969
E. de Jongh, 'The Spur of Wit: Rembrandt's Response to an Italian Challenge', *Delta: A review of arts, life and thought on the Netherlands*, 12/2, Summer 1969, pp. 49–67.

Kassel and Amsterdam 2001
E. van de Wetering and B. Schnackenburg, *The Mystery of the Young Rembrandt*, exh. cat., Kassel, Staatliche Museen Kassel, Gemäldegalerie Alte Meister; and Amsterdam, Museum het Rembrandthuis, 2001. Wolfratshausen 2001.

Kettering 1983
A. Kettering, *The Dutch Arcadia: Pastoral Art and its Audience in the Golden Age*, Montclair, N.J., 1983.

Keyes 2004
G.S. Keyes, S. Donahue Kuretsky, A. Rüger and A.K. Wheelock, Jr, *Masters of Dutch Painting: The Detroit Institute of Arts*, Detroit 2004.

Kingston 1996–7
V. Manuth et al., *Wisdom, Knowledge and Magic: The Image of the Scholar in Seventeenth-Century Dutch Art*, exh. cat., Kingston (Ontario), Agnes Etherington Art Centre, Queen's University, 1996–7. Kingston (Ontario) 1996.

Kirby 1977
J. Kirby, 'A Spectrometric Method for the Identification of Lake Pigment Dyestuffs', *National Gallery Technical Bulletin*, 1, 1977, pp. 35–45.

Kirby 1999
J. Kirby, 'The Painter's Trade in the Seventeenth Century: Theory and Practice', *National Gallery Technical Bulletin*, 20, 1999, pp. 5–49.

Kirby 2003
J. Kirby, 'Sir Nathaniel Bacon's "Pinke"', *Dyes in History and Archaeology*, 19, 2003, pp. 37–50.

Kirby and White 1996
J. Kirby and R. White, 'The Identification of Red Lake Pigment Dyestuffs and a Discussion of Their Use', *National Gallery Technical Bulletin*, 17, 1996, pp. 56–80.

Klein 1965
P.W. Klein, *De Trippen in de 17de eeuw: een studie over het ondernemersgedrag op de Hollandse stapelmarkt*, Assen 1965.

Klein 1998
P. Klein, 'Some Aspects of the Utilization of different Wood Species in certain European Workshops', in A. Roy and P. Smith (eds), *Painting Techniques: History, Materials and Studio Practice:*

Contributions to the International Institute for Conservation Dublin Congress, 7–11 September 1998, London 1998, pp. 112–14.

de Klerk 1982
E.A. de Klerk, '*De Teecken-Const*, een 17de-eeuws nederlands traktaatje', *Oud Holland*, 96, 1982, pp. 16–60.

de Klerk 1989
E.A. de Klerk, '"Academy-beelden" and "Teeken-schoolen" in Dutch seventeenth-century treatises on art', in A.W.A. Boschloo, E.J. Hendrickse, L.C. Smit and G.J. van der Sman (eds) *Academies of Art between Renaissance and Romanticism (Leids Kunsthistorisch Jaarboek, V–VI)*, The Hague 1989, pp. 283–8.

Kühn 1968
H. Kühn, 'A study of the pigments and grounds used by Jan Vermeer', *Report and Studies in the History of Art*, National Gallery of Art, Washington 1968, pp. 155–75.

Kühn 1993
H. Kühn, 'Lead-Tin Yellow', *Artists' Pigments: A Handbook of their History and Characteristics*, vol. 2, ed. A. Roy, Washington and Oxford 1993, pp. 83–112.

Kyoto and Frankfurt 2002–3
J. Giltaij, *Rembrandt, Rembrandt*, exh. cat. (German edn), Kyoto National Museum; and Frankfurt am Main, Städelsches Kunstinstitut und Städtische Galerie, 2002–3. Wolfratshausen 2003.

Lairesse 1707
G. de Lairesse, *Het groot Schilderboek*, 2 vols, Amsterdam 1707.

Landsberger 1946
F. Landsberger, *Rembrandt, the Jews and the Bible*, Philadelphia 1946.

Leiden 1991–2
M.L. Wurfbain (ed.), *Rembrandt en Lievens, 'een jon en edel schildersduo'/ Rembrandt and Lievens, 'a pair of young and noble painters'*, exh. cat., Leiden, Stedelijk Museum De Lakenhal, 1991–2. Leiden 1991.

Leiden 2005–6
C. Vogelaar, G. Korevaar, *Rembrandt's Mother: Myth and Reality*, exh. cat., Leiden, Stedelik Museum De Lakenhal, Zwolle 2005.

Leja 1996
J. Leja, 'Rembrandt's *Woman bathing in a Stream*', *Simiolus*, 24/4, 1996, pp. 320–7.

Levy-van Halm 1998
K. Levy-van Halm, 'Where did Vermeer buy his Painting Materials? Theory and Practice', in I. Gaskell and M. Jonker (eds), *Vermeer Studies*, New Haven and London 1998, pp. 137–43 (Proceedings of the Symposia 'New Vermeer Studies', held 1 December 1995, Washington, and 30–31 May, The Hague; National Gallery of Art, Washington, *Studies in the History of Art*, 55, Center for Advanced Study in the Visual Arts, Symposium Papers XXXIII).

Liedtke 1991
W. Liedtke, 'Letter from Berlin', *Apollo*, 132, 1991, pp. 356–8.

Liedtke 1992
W. Liedtke, 'Rembrandt and the Rembrandt Style', *Apollo*, 135, 1992, pp. 140–5.

Liedtke 2004
W. Liedtke, 'Rembrandt's "Workshop" revisited', *Oud Holland*, 117, 2004, pp. 48–73.

Littman 1993
R. Littman, 'An error in the Menetekel inscription in Rembrandt's "Belshazzar's Feast"', *Oud Holland*, 107, 1993, pp. 296–7.

Lomazzo 1584
G.P. Lomazzo, *Trattato dell'arte de la pittura*, Milan 1584.

London 1980
C. Brown, *Second Sight: Titian and Rembrandt*, exh. cat., London, The National Gallery, 1980. London 1980.

London 1988
D. Bomford, A. Roy and C. Brown, with contributions from J. Kirby and R. White, *Art in the Making: Rembrandt*, exh. cat., London, The National Gallery, 1988. London 1988.

London 1990
M. Jones, *Fake? The Art of Deception*, exh. cat., London, British Museum, 1990. London 1990.

London 2001
E. Hinterding, G. Luijten and M. Royalton-Kisch, *Rembrandt the Printmaker*, exh. cat., London, British Museum, 2001. London 2001.

London 2002
G. Bartrum et al., *Albrecht Dürer and his Legacy*, exh. cat., London, British Museum, 2002. London and Princeton 2002.

London 2003
D. Jaffé (ed.), *Titian*, exh. cat., London, The National Gallery, 2003. London 2003.

London 2003–4
R. Verdi et al., *Saved! 100 Years of the National Art Collections Fund*, exh. cat., London, Hayward Gallery, 2003–4. London 2003.

London and The Hague 1999–2000
C. White and Q. Buvelot (eds), *Rembrandt by Himself*, exh. cat., London, The National Gallery; and The Hague, Royal Cabinet of Paintings Mauritshuis, 1999–2000. London 1999.

London and Sydney 2005–6
A. Bond and J. Woodall, *Self Portrait: Renaissance to the Contemporary*, exh. cat., London, National Portrait Gallery; and Sydney, Art Gallery of New South Wales, 2005. London 2005.

Luttervelt 1957
R. van Luttervelt, 'De Grote Ruiter van Rembrandt', *Nederlands Kunsthistorisch Jaarboek*, 8, 1957, pp. 185–219.

Luttervelt 1958
R. van Luttervelt, 'Frederick Rihel of Jacob de Graeff?', *Maandblad Amstelodamum*, 45, 1958, pp. 147–50.

MacGregor 1995
N. MacGregor, *"To the happier carpenter": Rembrandt's War-Heroine Margaretha de Geer, the London Public and the Right to Pictures*, the 8th Horst Gerson Lecture held in the aula of the University of Groningen, 9 November 1995, Groningen 1995.

MacLaren 1960
N. MacLaren, *National Gallery Catalogues: The Dutch School*, London 1960.

MacLaren and Brown 1991
N. MacLaren, *National Gallery Catalogues: The Dutch School 1600–1900*, rev. en. edn by C. Brown, 2 vols, London 1991.

Manuth 1998
V. Manuth, 'Zum Nachleben der Werke Hans Holbeins d.J. in der holländischen Malerei und Graphik des 17. Jahrhunderts', in M. Senn (ed.), *Hans Holbein der Jüngere. Akten des Internationalen Symposiums, Kunstmuseum Basel, 26.–28. Juni 1997, Zeitschrift für Schweizerische Archäologie und Kunstgeschichte* (published by the Schweizerisches Landesmuseum, Zurich), 55 (special edn), 2–4, 1998, pp. 323–55.

Manuth and Rüger 2004
V. Manuth and A. Rüger (eds), *Collected Opinions: Essays on Netherlandish Art in Honour of Alfred Bader*, London 2004.

Manuth and de Winkel [2003]
V. Manuth and M. de Winkel, *Rembrandt's* Minerva in her Study *of 1635: The Splendor and Wisdom of a Goddess*, New York [2003].

Martin 1901
W. Martin, '"Een kunsthandel" in een klappermanswachthuis', *Oud Holland*, 19, 1901, pp. 86–8.

Martin 1913
W. Martin, *Gerard Dou* (Klassiker der Kunst, vol. 24), Stuttgart 1913.

Martin 1967
G. Martin, 'A Rembrandt Self Portrait from his last year', *Burlington Magazine*, CIX, 1967, p. 355.

Martin 1969
G. Martin, 'The Death of a Myth' (Review of Bredius 1969), *Apollo*, XC, 1969, pp. 266–7.

Meischke and Reeser 1983
R. Meischke and H.E. Reeser (eds), *Het Trippenhuis te Amsterdam*, Amsterdam 1983.

Melbourne and Canberra 1997–8
A. Blankert (ed.), *Rembrandt: A Genius and his Impact*, exh. cat., Melbourne, National Gallery of Victoria; and Canberra, National Gallery of Australia, 1997–8. Zwolle 1997.

Miedema 1981
H. Miedema, 'Verder onderzoek naar zeventiende-eeuwse schilderijformaten in Noord-Nederland', *Oud Holland*, 95, 1981, pp. 31–49.

Miedema 1987a
H. Miedema, 'Kunstschilders, gilde en academie: Over het probleem van de emancipatie van de Kunstschilders in de noordelijke Nederlanden van de 16de en 17de eeuw', *Oud Holland*, 101, 1987, pp. 1–34.

Miedema 1987b
H. Miedema, 'Over kwaliteitsvoorschriften in het St. Lucasgilde; over "doodverf"', *Oud Holland*, 101, 1987, pp. 141–7.

Miedema 1989
H. Miedema, 'Over vakonderwijs aan kunstschilders in de Nederlanden tot de zeventiende eeuw', in A.W.A. Boschloo, E.J. Hendrickse, L.C. Smit and G.J. van der Sman, *Academies of Art between Renaissance and Romanticism* (*Leids Kunsthistorisch Jaarboek*, V–VI), The Hague 1989, pp. 268–82.

Miedema and Meijer 1979
H. Miedema and B. Meijer, 'The introduction of coloured ground in painting and its influence on stylistic development, with particular respect to sixteenth-century Netherlandish art', *Storia dell' Arte*, 35, 1979, pp. 79–98.

Mills and White 1982
J. Mills and R. White, 'Organic Mass-Spectrometry of Art Materials: Work in Progress, *National Gallery Technical Bulletin*, 6, 1982, pp. 3–18.

Mills and White 1983
J. Mills and R. White, 'Analyses of Paint Media', *National Gallery Technical Bulletin*, 7, 1983, pp. 65–7.

Mühlethaler and Thissen 1993
B. Mühlethaler and J. Thissen, 'Smalt', *Artists' Pigments: A Handbook of their History and Characteristics*, vol. 2, ed. A. Roy, Washington and Oxford 1993, pp. 113–30.

Munich 1998–9
H. Gassner et al., *Die Nacht*, exh. cat., Munich, Haus der Kunst, 1998–9. Munich 1998.

Nadler 2003
S. Nadler, *Rembrandt's Jews*, Chicago and London 2003.

Naumann 1981
O. Naumann, *Frans van Mieris (1635–1681) the Elder*, 2 vols, Doornspijk 1981.

Németh and van Leeuwen 1992
I. Németh and R. van Leeuwen, 'Onthullingen over onze Jacob Trip', *Mauritshuis Nieuwsbrief*, 5/3–4, 1992, pp. 8–9.

New York 1995
H. von Sonnenburg, W. Liedtke, C. Logan, N. M. Orenstein and S.S. Dickey, *Rembrandt/Not Rembrandt in the Metropolitan Museum of Art: Aspects of Connoisseurship*, 2 vols, New York, The Metropolitan Museum of Art, 1995. New York 1995.

New York 2000
Rembrandt and the Venetian Influence, exh. cat., New York, Salander-O'Reilly Galleries, 2000. New York 2000.

Noble, Boon and Wadum 2002
P. Noble, J.J. Boon and J. Wadum, 'Dissolution, aggregation and protrusion: lead soap formation in 17th-century grounds and paint layers', *Art Matters – Netherlands Technical Studies in Art*, 1, 2002, pp. 46–61.

Noble and van Loon 2005
P. Noble and A. van Loon, 'New Insights into Rembrandt's Susanna', *Art Matters – Netherlands Technical Studies in Art*, 2, 2005, pp. 76–96.

Norgate 1997
E. Norgate, *Miniatura or the Art of Limning*, ed. J.M. Muller and J. Murrell, New Haven and London 1997.

Palucchini and Rossi 1982
R. Palucchini and P. Rossi, *Tintoretto: Le opere sacre e profane*, 2 vols, Milan 1982.

Partington 1961–5
J.R. Partington, *A History of Chemistry*, 4 vols, London and New York, 1961–5.

de Passe 1643
C. de Passe, *Van t'light der Teken en Schilder Konst*, Amsterdam 1643.

Peres 1988
C. Peres, 'Materialkundliche, wirtschaftliche und soziale Aspekte zur Gemäldeherstellung in den Niederlanden im 17. Jahrhundert', *Zeitschrift für Kunsttechnologie und Konservierung*, 2, 1988, pp. 263–96.

Pilc and White 1995
J. Pilc and R. White, 'The Application of FTIR-Microscopy to the Analysis of Paint Binders in Easel Paintings', *National Gallery Technical Bulletin*, 16, 1995, pp. 73–84.

Pigler 1974
A. Pigler, *Barockthemen: eine Auswahl von Verzeichnissen zur Ikonographie des 17. und 18. Jahrhunderts*, 2nd. rev. en. edn, 3 vols, Budapest 1974.

Plesters 1983
J. Plesters, '"Samson and Delilah": Rubens and the Art and Craft of Painting on Panel', *National Gallery Technical Bulletin*, 7, 1983, pp. 30–49.

Plesters 1987
J. Plesters, 'The materials and technique of the "Peepshow" in relation to Hoogstraten's book', in C. Brown, D. Bomford, J. Plesters and J. Mills, 'Samuel van Hoogstraten: Perspective and Painting', *National Gallery Technical Bulletin*, 11, 1987, pp. 60–85; see pp. 77–84.

Pomet 1694
P. Pomet, *Histoire générale des drogues, traitant des plantes, des animaux, et des mineraux*, Paris 1694.

Ponz 1772–94
A. Ponz, *Viage in España*, 12 vols, Madrid 1772–94.

Raupp 1984
H.-J. Raupp, *Untersuchungen zu Künstlerbildnis und Künstlerdarstellungen in den Niederlanden im 17. Jahrhundert*, Hildesheim, Zurich and New York 1984.

Rombouts and Van Lerius 1864–76
P. Rombouts and T. Van Lerius, *De Liggeren en andere Historische Archiven der Antwerpse Sint-Lucasgilde*, 2 vols, Antwerp 1864, The Hague 1876.

Rome 2002–3
G. Luijten et al., *Rembrandt: dipinti, incisioni e reflessi*, exh. cat., Rome, Scuderie del Quirinale, 2002–3. Rome and Milan 2002.

Rose 1983
I. Rose, *Manuel Godoy patron de las artes y coleccionista*, 2 vols, Madrid 1983.

Rose-de Viejo 2002
I. Rose-de Viejo, 'On the Madrid provenance of "Anna and the blind Tobit"', *Burlington Magazine*, CXLIV, 2002, pp. 618–21.

Rossi [1974]
P. Rossi, *Jacopo Tintoretto: I Ritratti*, vol. 1, Milan [1974].

Rotterdam 1988
J. Giltaij et al., *Een gloeiend palet: Schilderijen van Rembrandt en zijn school*, exh. cat., Rotterdam, Museum Boijmans Van Beuningen, 1988. Rotterdam 1988.

Rotterdam 1994–5
X. Henny, 'Hoe kwamen de Rotterdamse schilders aan hun verf?', in N. Schadee (ed.), *Rotterdamse meesters uit de Gouden Eeuw*, exh. cat., Rotterdam, Historisch Museum 1994–5. Zwolle 1994, pp. 42–53.

Roy 1999a
A. Roy, 'The National Gallery Van Dycks: Technique and Development', *National Gallery Technical Bulletin*, 20, 1999, pp. 50–83.

Roy 1999b
A. Roy, 'Rubens's "Peace and War"', *National Gallery Technical Bulletin*, 20, 1999, pp. 89–95.

Royalton-Kisch 1984
M. Royalton-Kisch, 'Over Rembrandt en van Vliet', *Kroniek van het Renbrandthuis*, 84/1–2, 1984, pp. 3–23.

Royalton-Kisch 1989
M. Royalton-Kisch, 'Rembrandt's Sketches for Paintings', *Old Master Drawings*, 27, 1989, pp. 128–45.

Royalton-Kisch 1994
M. Royalton-Kisch, 'Some further thoughts on Rembrandt's Christ before Pilate', *Kroniek van het Rembrandthuis*, 94/2, 1994, pp. 3–13.

Royalton-Kisch 1995
M. Royalton-Kisch, 'Rembrandt's Clock', in C.P. Schneider, W.W. Robinson and A.I. Davies (eds), *Shop Talk: Studies in Honour of Seymour Slive*, Cambridge, Mass., 1995, pp. 216–18.

Rüger 2002
A. Rüger, Review of Kassel and Amsterdam 2001, *Burlington Magazine*, CXLIV, 2002, pp. 179–81.

Rüger 2003
A. Rüger, 'Portrait of a Lady', *Art Quarterly*, summer 2003, pp. 30–3.

Russell Corbett 2004
J.P. Russell Corbett, *Painted Science: Convention and Change in Seventeenth-Century Netherlandish Painting of Alchemists, Physicians and Astronomers*, PhD thesis, Queen's University, Kingston, Ontario 2004.

von Sandrart 1675–9
J. von Sandrart, *L'academia todesca della architectura, scultura e pittura, oder, Teutsche Academie der edlen Bau-, Bild- und Mahlerey-Künste . . .* , 2 vols, Nuremberg, vol. 1, 1675; vol. 2, 1679.

von Sandrart 1925
J. von Sandrart, *L'academia todesca della architectura, scultura e pittura, oder, Teutsche Academie der edlen Bau-, Bild- und Mahlerey-Künste*, selections, ed. A.R. Pelzer, Munich 1925.

Scarzella and Natale 1989
P. Scarzella and P. Natale, *Terre coloranti naturali e tinte murali a base di terre; monografie e catalogo delle collezioni di terre coloranti e di campioni di coloriture a base di terre allestite al Politecnico di Torino*, Turin 1989.

Schama 1999
S. Schama, *Rembrandt's Eyes*, New York, London 1999.

Schatborn 1985
P. Schatborn, *Tekeningen van Rembrandt, zijn onbekende leerlingen en navolgers* (Catalogus van de Nederlandse tekeningen in het Rijksprentenkabinet, Rijksmuseum Amsterdam IV)/ *Drawings by Rembrandt, his anonymous pupils and followers* (Catalogue of the Dutch and Flemish Drawings in the Rijksprentenkabinet, Rijksmuseum Amsterdam IV), The Hague 1985.

van Schendel 1972
A.F.E. van Schendel, 'Manufacture of vermilion in 17th-century Amsterdam: the Pekstok papers', *Studies in Conservation*, 17, 1972, pp. 70–82.

Schiller 1972
G. Schiller, *Iconography of Christian Art* (English trans. by J. Seligman of 3rd German edn, Gütersloh 1968), 2 vols, London, vol. 1, 1971; vol 2, 1972.

Schnackenburg 1996
B. Schnackenburg, *Gemäldegalerie Alte Meister: Gesamtkatalog*, Staatliche Museen Kassel, 2 vols, Mainz 1996.

Schwartz 1984
G. Schwartz, *Rembrandt: zijn leven, zijne schilderijen*, Maarssen 1984.

Smith 1693
M. Smith, *The Art of Painting, according to the Theory and Practise of the best Italian, French and Germane* [sic] *Masters*, 2nd edn, London 1693.

Smith 1829–42
John Smith, *A Catalogue Raisonné of the works of the Most Eminent Dutch, Flemish and French Painters . . .* , with supplement, 9 vols, London 1829–42.

Spring and Grout 2002
M. Spring and R. Grout, 'The Blackening of Vermilion: An Analytical Study of the Process in Paintings', *National Gallery Technical Bulletin*, 23, 2002, pp. 50–61.

Spring, Higgitt and Saunders 2005
M. Spring, C. Higgitt and D. Saunders, 'Investigation of Pigment-Medium Interaction Processes in Oil Paint containing Degraded Smalt', *National Gallery Technical Bulletin*, 26, 2005, pp. 56–70.

van der Stan 2005
G. van der Stan, 'Het schilderij en de werkelijkheid', *Bulletin van het Rijksmuseum*, 53, 2005, pp. 69–73.

Stechow 1929
W. Stechow, 'Rembrandts Darstellungen der Kreuzabnahme', *Jahrbuch der Preussischen Kunstsammlungen*, 50, 1929, pp. 226–7.

Stem 1973
D.C. Stem, *Rembrandt after Three Hundred Years: A Symposium – Rembrandt and his Followers* (1969), Chicago 1973.

Strauss and van der Meulen 1979
W.L. Strauss and M. van der Meulen, *The Rembrandt Documents*, New York 1979.

Sumowski 1973
W. Sumowski, 'Kritische Bemerkungen zur neuesten Gemälde Kritik', in O. von Simson and J. Kelch (eds) *Neue Beiträge zur Rembrandt-Forschung*, Berlin 1973, pp. 91–110 (incl. discussion).

Sumowski 1979–92
W. Sumowski, *Drawings of the Rembrandt School*, 10 vols, New York 1979–92.

Sumowski 1983–90
W. Sumowski, *Gemälde der Rembrandt-Schüler*, 6 vols, Landau 1983–90.

Talley 1981
M.K. Talley, *Portrait Painting in England: Studies in the Technical Literature before 1700*, published privately by the Paul Mellon Centre, London 1981.

Tokyo 1993
A. Balis, '"Fatto da un mio discepolo": Rubens's Studio Practices Reviewed', in T. Nakamura (ed.), *Rubens and his Workshop: 'The Flight of Lot and his Family from Sodom'*, exh. cat., Tokyo, National Museum of Western Art, 1993. Tokyo 1993, pp. 97–127.

Tokyo 2003
A. Kofuku (ed.), *Rembrandt and the Rembrandt School: The Bible, Mythology and Ancient History*, exh. cat., Tokyo, Museum of Western Art, 2003. Tokyo 2003.

Tümpel 1986
C. Tümpel, *Rembrandt: Mythos und Methode*, Antwerp and Königstein im Taunus 1986.

Tümpel 1993
C. Tümpel, *Rembrandt: All Paintings in Colour*, Antwerp and New York 1993.

Valentiner 1921
W.R. Valentiner, *Rembrandt: Wiedergefundene Gemälde* (Klassiker der Kunst, vol. 27), Stuttgart, Berlin and Leipzig 1921.

Valentiner [1925]
W.R. Valentiner, *Rembrandt: Des Meisters Handzeichnungen*, vol. 1 (Klassiker der Kunst, vol. 31), Stuttgart, Berlin and Leipzig [1925].

Vandamme 1974
E. Vandamme, 'Een 16e-eeuws zuidnederlands receptenboek', *Jaarboek van het Koninklijk Museum voor Schone Kunsten Antwerpen*, 1974, pp. 101–37.

Vey 1960
H. Vey, 'Anton van Dijck: über Maltechnique', *Bulletin van der Koninklijke Musea voor Schone Kunsten*, 9, 1960, pp. 193–200.

Vienna 2004
K.A. Schröder and M. Bisanz-Prakken (eds), *Rembrandt*, exh. cat., Vienna, Albertina, 2004. Vienna 2004.

de Vries 2004
L. de Vries, 'Gerard de Lairesse: the critical vocabulary of an art theorist', *Oud Holland*, 117, 2004, pp. 79–98.

Waagen 1854
G.F. Waagen, *Treasures of Art in Great Britain*, 3 vols, London 1854.

Waagen 1857
G.F. Waagen, *Galleries and Cabinet of Art in Great Britain*, London 1857 (supplement to Waagen 1854).

van der Waal 1974
H. van der Waal, *Steps towards Rembrandt: Collected Articles, 1937–72*, Amsterdam 1974.

Wadum 2002
J. Wadum, 'Dou doesn't paint, oh no, he juggles with his brush: Gerrit Dou, a Rembrandtesque "Fijnschilder"', *Art Matters – Netherlands Technical Studies in Art*, 1, 2002, pp. 62–77.

Wadum and Noble 1999
J. Wadum and P. Noble, 'Is there an ethical problem after the twenty-third treatment of Rembrandt's *Anatomy Lesson of Dr Nicolaes Tulp*?' in J. Bridgland (ed.) *12th Triennial Meeting of ICOM Committee for Conservation, Lyon, 29 August – 3 September 1999: Preprints*, London 1999, pp. 206–10.

Washington 2001
M. Spring, 'Pigments and color change in the paintings of Aelbert Cuyp', in A.K.Wheelock, Jr (ed.) *Aelbert Cuyp*, exh. cat., Washington, National Gallery of Art, 2001. Washington 2001, pp. 64–73.

Washington and Los Angeles 2005
A.K. Wheelock, Jr, P.C Sutton, V. Manuth and A.T. Woollett, *Rembrandt's Late Religious Portraits*, exh. cat., Washington, National Gallery of Art; and Los Angeles, J. Paul Getty Museum, 2005. Washington 2005.

Washington, Detroit and Amsterdam 1980
A. Blankert et al., *Gods, Saints and Heroes: Dutch Painting in the Age of Rembrandt*, exh. cat., Washington, National Gallery of Art; The Detroit Institute of Arts; and Amsterdam, Rijksmuseum, 1980. Washington 1980.

van der Weerd 2002
J. van der Weerd, H. Brammer, J.J. Boon and R.M.A. Heeren, 'Fourier transform infrared microscopic imaging of an embedded paint cross-section', *Applied Spectroscopy*, 56, 2002, pp. 275–83.

Weisbach 1926
W. Weisbach, *Rembrandt*, Berlin 1926.

van de Wetering 1982
E. van de Wetering, 'Painting materials and working methods', in *Corpus*, vol. 1, 1982, pp. 11–33.

van de Wetering 1986a
E. van de Wetering, 'The canvas support', in *Corpus*, vol. 2, 1986, pp. 15–43.

van de Wetering 1986b
E. van de Wetering, 'Problems of apprenticeship and studio collaboration', in *Corpus*, vol. 2, 1986, pp. 45–90.

van de Wetering 1993
E. van de Wetering, 'De paletten van Rembrandt en Jozef Israëls, een onderzoek naar de relatie tussen stijl en schildertechniek', *Oud Holland*, 107, 1993, pp. 137–51.

van de Wetering 1995
E. van de Wetering, 'Reflections on the relation between technique and style: the use of the palette by the seventeenth-century painter', in A. Wallert, E. Hermens and M. Peek, *Historical Painting Techniques, Materials and Studio Practice: Preprints of a Symposium, University of Leiden, The Netherlands, 26–29 June, 1995*, Los Angeles 1995, pp. 196–203.

van de Wetering 1997
E. van de Wetering, *Rembrandt: The Painter at Work*, Amsterdam 1997.

Wheelock 1995
A.K. Wheelock, Jr, *Dutch Paintings of the Seventeenth Century: The Collections of the National Gallery of Art Systematic Catalogue*, Washington 1995.

White 1999
R. White, 'Van Dyck's Paint Medium', *National Gallery Technical Bulletin*, 20, 1999, pp. 84–8.

White and Kirby 1994
R. White and J. Kirby, 'Rembrandt and his Circle: Seventeenth-Century Dutch Paint Media Re-examined', *National Gallery Technical Bulletin*, 15, 1994, pp. 64–78.

White and Pilc 1993
R. White and J. Pilc, 'Analyses of Paint Media', *National Gallery Technical Bulletin*, 14, 1993, pp. 86–94.

White and Pilc 1995
R. White and J. Pilc, 'Analyses of Paint Media', *National Gallery Technical Bulletin*, 16, 1995, pp. 85–95.

White, Pilc and Kirby 1998
R. White, J. Pilc and J. Kirby, 'Analyses of Paint Media', *National Gallery Technical Bulletin*, 19, 1998, pp. 74–95.

de Winkel 1995
M. de Winkel, '"Eene der deftigsten dragten": The Iconography of the "Tabbaard" and the Sense of Tradition in Dutch Seventeenth-century Portraiture', *Nederlands Kunsthistorisch Jaarboek*, 46, 1995, pp. 145–67.

von Wurzbach 1906–11
A. von Wurzbach, *Niederländisches Künstler-Lexikon*, 3 vols, Vienna, Leipzig 1906–11.

Young Ottley 1832
W. Young Ottley, *Descriptive Catalogue of the Pictures in the National Gallery*, London 1832.

Glossary

alla prima Painted in one session, without alteration; cf. *pentimento*.

anthraquinone A class of organic chemical compound, occurring widely in plants and also insects. Many of these compounds are coloured and are constituents of historically important and widely used natural red dyes, including madder and cochineal, both found in lake pigments (q.v.). Anthraquinones were often also the active agents in pharmaceutical preparations and medicines prepared from plant sources.

azurite Natural basic copper carbonate, blue or blue-green in colour according to its purity; used as a pigment and, in small amounts, as a drying agent in oil paint.

bone black A black pigment made from carbonised bone, which gives a warmer black than does wood charcoal.

carbon black A black pigment made from wood or other vegetable matter or carbonised bone (see charcoal, bone black).

Cassel earth A dark brown earth pigment (q.v.) prepared from lignite (brown coal), and containing a good deal of organic matter as well as iron oxide; later known as Vandyke brown.

chalk A natural form of calcium carbonate. Mixed with oil, it becomes translucent, and can be used to stiffen glazes without rendering them opaque; it is also used as a cheap extender for lead white, whose opacity it reduces, and as one of the materials of grounds.

charcoal Carbon made by burning wood. Sticks of charcoal are used for sketching. Wood charcoal, powdered and used as a pigment, has a bluish-black colour.

coccolith The microscopic rounded skeletal remains of fossilized marine unicellular organisms (phytoplankton) composed of calcium carbonate. Natural chalk is composed of ancient sediments made up of countless millions of coccoliths.

cochineal A red dye extracted from the cochineal scale insect, used to make crimson lake (see lake).

Cologne earth Similar to Cassel earth (q.v.).

cool Of a colour: tending towards the blue end of the spectrum. Cool colours tend to seem farther away from the spectator than warm colours, a phenomenon used to create perspective effects.

craquelure The network of cracks that develops in the surface of a picture as the paint layers age.

cross-section By examining minute samples of paint in cross-section under the microscope, the layer structure of the painting, including the ground layers, can be determined for that sample point. Many pigments can be identified by their colour and optical properties in a cross-section, and analysis by LMA (q.v.) or EDX (q.v.) can be carried out on individual layers. Samples are mounted in a block of cold-setting resin, then ground and polished to reveal the edge of the sample for examination in reflected (incident) light under the optical microscope. The usual magnification range is 60–800×.

crystallite A small or imperfectly formed crystal.

cusping Wavy distortion of the weave at the edge of a canvas, caused by its being held taut with cords while the canvas was primed. Lack of cusping on an edge is sometimes a sign that a painting has been cut down in size.

darks Dark coloured paints; the dark areas of a picture.

dead colour Monochrome or dull colours used to build up the light and dark areas of a painting before further colour is applied on top.

dendrochronology A technique used to date wooden objects, including panel paintings, by examining annual growth rings in the wood. Trees grow faster in favourable summers, giving

wider rings than those formed in bad summers. A sequence of ring widths has been worked out reaching many centuries into the past, so that dates can usually be calculated for when a tree was alive. The year in which it was cut down can be known precisely only if the final ring, just under the bark, is present, but an estimation of the felling date can usually be made.

drier See siccative.

earth pigment One of a range of natural pigments mined in various parts of the world. They consist of a mixture of clay and various oxides of iron in different proportions, and other substances, and are yellow, red, brown or even black in colour. (Green earth also exists, coloured by another iron compound, ferrous silicate.) See Cassel earth, Cologne earth, ochre, sienna, umber.

ell A unit of measurement traditionally used for the width of fabric. A Flemish ell, as used in the Netherlands in the seventeenth century, is 69 cm (but an English ell is 114 cm).

energy-dispersive X-ray microanalysis: EDX A method of elemental analysis carried out in the scanning electron microscope (q.v.). Small areas of a sample which has been imaged in the SEM can be selected and analysed for their component elements. For example, a single paint layer in a cross-section, or a single pigment particle, may be selectively analysed. The electron beam which falls on the specimen in the SEM generates X-rays which are characteristic in their energies of the elements in the sample which produce them. The instrument measures the energies of these X-rays and assigns them on a visual display to the elements present. For the purposes of pigment identification, the results show whether the sample contains lead, copper, iron, cobalt and so on, but not what the actual component pigments are. These analytical data must then be interpreted in conjunction with the examination of paint samples by optical microscopy in order to specify the pigments involved. (See also LMA.)

etching A method of making prints. A copper plate is coated with an acid-proof wax or varnish, known as a resist, and then drawn on with a stylus to scratch through the resist. Acid is applied to eat away the exposed metal, forming small indentations. After this, the resist is removed. To make a print, the plate is inked and then wiped, leaving ink only in the indentations. When the plate is pressed on to paper, this ink prints a picture which is a reversed, mirror-image version of the original drawing.

flavonoid A large class of organic chemical compound, usually yellow in colour, occurring in all plants. Many are found in natural yellow dyes, from the homely onion to the important, internationally used dyeplant weld, also used for lake pigment making (q.v.). Flavonoids are also known today for their anti-oxidant properties and are found in many pharmaceutical products.

fugitive the description applied to certain artists' materials, particularly pigments, on account of their tendency to fade readily. Lake pigments (q.v.) for example are often fugitive materials.

gas chromatography with mass spectrometry: GC–MS An analytical technique that combines the separation using gas chromatography of extremely small amounts of complex mixtures of organic materials (such as are found in paint binders and varnishes) with the subsequent identification of those components in the mass spectrometer. The mass spectrometer is able to provide information on the chemical (molecular) structure of the materials fed to it from the gas chromatograph.

glaze A layer of translucent paint applied over other paint to modify its colour, or to give depth and richness of colour.

grisaille The process of painting in different shades of grey or near-monochrome; a painting so executed.

ground A preparatory underlayer, its colour sometimes giving a prevailing tone to the paint applied over it. Two different layers may be used (a double ground).

gypsum Natural hydrated calcium sulphate, which when heated becomes plaster of Paris; commonly used in grounds for Italian Renaissance panel paintings.

half-tones The transitional regions between light and dark areas of a painting.

impasto Thickly applied paint which stands out from the surface in relief.

infrared A form of radiation similar to visible light, but slightly too long in wavelength for the eye to see. However, it can be photographed. Two apparently similar colours may look quite different when photographed under infrared. Some materials opaque to ordinary light are transparent

to infrared, so that otherwise invisible underlayers of paint or drawing may be seen. *Pentimenti* and underdrawing containing black show particularly clearly in an infrared photograph; on light ground pictures the structure of the brushstrokes often appears accentuated because of the greater penetration of infrared radiation to the reflecting layers underneath.

lake A pigment made by precipitation on to a base from a dye solution – that is, causing solid particles to form, which are coloured by the dye. Lakes may be red, yellow, reddish brown or yellowish brown and are generally translucent pigments when mixed with the paint medium. Often used as glazes.

laser microspectral analysis: LMA A method for elemental analysis of minute samples, yielding similar information to EDX analysis (q.v.). An area of a sample is selected for analysis under a specialised microscope, and a laser pulse fired at this spot causing part of the specimen to be vaporised. The specimen vapour passes between a pair of electrodes across which an electrical spark is induced. This heats the vapour to a high temperature very rapidly, causing it to emit light whose wavelengths are characteristic of the composition of the sample. The emitted light is analysed by a spectrograph and recorded on a photographic plate as a spectrum of lines related to the elements present in the sample. In the same way as in EDX analysis, the pigment composition of a paint layer can be determined by referring its elemental composition to examination of the sample by optical microscopy. LMA may be used on paint cross-sections (q.v.) for a layer-by-layer analysis, or on minute unmounted flakes.

lay in To underpaint as a rough basis for some feature of a painting; such an area is known as a lay-in.

lead A chemical element and constituent of several pigments. See lead white, lead-tin yellow, massicot, minium, all of which are chemical compounds of lead.

lead white Basic lead carbonate, synthetically prepared for use as an opaque white pigment.

lead-tin yellow A yellow opaque pigment made by heating lead or a lead compound with stannic (tin) oxide, pale to dark yellow according to the temperature of preparation.

mahlstick or maulstick A painter's stick used to rest or steady the hand.

marouflage To stick a canvas to a rigid support such as a wall or board.

massicot (also massicott, masticot, mastikot, mastecot and other variant spellings) A yellow pigment. Today, the term describes pure synthetically prepared yellow lead monoxide. In Rembrandt's time it was used for lead-tin yellow (q.v.)

medium The binding agent for pigments in a painting; see also oil.

minium Red lead, a synthetically prepared lead oxide; occasionally used as an orange pigment or a drier.

neutron activation autoradiography A method of forming images of the different types of pigment used in a painting. The painting is bombarded with neutrons in a nuclear reactor, so that all the materials in it become temporarily faintly radioactive, emitting electrons and other radiation which will produce an image on special photographic film. Different substances lose their radioactivity at different rates. Film is laid on the painting and changed at regular intervals, so that a series of images is obtained. For example, a few hours after bombardment the most strongly radiating element is manganese, revealing an image of all the umber in the painting. Four days afterwards, the main emitter is phosphorus, giving an image of passages carried out in bone black.

ochre An earth pigment (q.v.) of a dull red, orange, yellow or brown colour.

oil The oils used in oil paint are drying oils – that is, oils which dry naturally in air – such as linseed, walnut and poppyseed oil. Pigments are ground in this oil medium to make paint.

pastose Of paint: mixed to a stiff texture, so that it can be used to create impasto (q.v.).

pentimento (plural *pentimenti*) Alteration made by the artist to an area already painted.

pigment identification/analysis Many pigment identifications in minute samples of paint may be accomplished by optical microscopy of mounted cross-sections (q.v.), thin cross-sections (q.v.) and pigment dispersions, by classical methods of optical mineralogy. Supplementary chemical identification is often required to confirm the results of optical examination, and in the present study included laser microspectral analysis (q.v.), energy-dispersive X-ray microanalysis (q.v.), X-ray diffraction

analysis (q.v.) and chemical microscopy (wet chemical tests carried out under the microscope). Certain pigment samples and cross-sections were investigated further by imaging in the scanning electron microscope (q.v.). All the pigment and media examples for Rembrandt's painting materials quoted in the Catalogue are the result of some positive method of identification or analysis, whether by optical microscopy in some form, or by instrumental means. In many cases confirmation of the identity of a material was obtained by several different techniques.

pink In the seventeenth and eighteenth centuries, a term used for yellow lakes (see lake).

primuersel A thin layer of oil paint applied to the ground before beginning to paint, particularly in the context of a white chalk ground bound in glue for a panel painting. This layer modifies the colour of the ground and also, in the case of a chalk ground, makes it less liable to absorb oil from the paint layers above.

quartz See silica.

radioabsorbent Of a material: obstructing the passage of X-rays (q.v.). Lead and lead-containing pigments are strongly radioabsorbent; also vermilion.

radiograph An image created on photographic film by X-rays (or occasionally by other forms of radiation). The process is known as radiography. See X-rays.

raking light A technique for revealing surface details of a painting by casting light across it at a low angle.

recession The illusion that a certain part of a painting is further away from the viewer than another part. See also cool and warm.

reline To reinforce the original canvas support with a secondary canvas support stuck to the back.

reserve To omit paint from an area of a composition so that some planned feature may be painted on it later; an area treated in this way.

scanning electron microscopy: SEM A technique capable of revealing the fine details of objects at far higher magnifications than is possible with the optical (light) microscope. The scanning electron microscope uses a beam of electrons to scan the sample under examination, and the electrons scattered by the surface are collected and used to generate a video image. The SEM will show surface

topography and three-dimensional structure at magnifications up to 100,000×, but the image can only be in monochrome. Equipment for microanalysis of very small areas of a specimen can be attached to the SEM (see EDX analysis).

scumble To apply a thin layer of semi-opaque paint over a colour to modify it – usually light over dark; a layer of paint used in this way.

siccative Having a drying effect; a material which has such an effect (also known as a drier).

sienna An earth pigment (q.v.) of a reddish-brown colour. Sienna may be used as it is – raw – or burnt, that is, heated in a furnace to make the colour warmer.

silica Silicon dioxide, naturally found as quartz or sand. Powdered, it is used in certain grounds.

smalt Potash glass coloured blue with cobalt oxide, but often rather pale in colour. It is powdered and used as a blue pigment, or as a drying agent in oil paints.

stack process The traditional method for the manufacture of lead white pigment, in which a 'stack' of strips or buckles of metallic lead are exposed to acetic acid vapour and carbon dioxide; hence the term 'stack-process' lead white.

strainer A fixed wooden frame on which a canvas is mounted to hold it taut.

stretcher Strictly, a wooden frame which may be expanded with wedges or keys, and on which a canvas is mounted to hold it taut; an eighteenth-century invention, not used by Rembrandt himself. The term is often, but wrongly, used for a fixed strainer (q.v.).

stretching frame A temporary frame to which a canvas is attached with cords to hold it taut while a ground is being applied or it is being painted.

support The canvas, wood panel or other material on which a painting is executed.

tabby The simplest plain weave of a fabric.

tacking edge The margins of a canvas where it has been turned around and tacked to the edges of a strainer or stretcher.

thin cross-section A method of preparing thin slivers of paint to reveal their layer structure in transmitted light under the optical microscope, up to a magnification of 1200×. The technique is particularly suitable for the examination of translucent paint and varnish layers which allow

light to pass through the specimen under the microscope. (See also cross-section.)

transfer To remove the original support (whether canvas or panel) from the back of the paint and ground, and replace it with a new support. The ground may also be partially or completely removed during the process, and a new ground applied to the back of the paint layers.

turbid medium effect The production of a cool, bluish tone by superimposing a lighter semi-translucent layer of colour over a darker, warmer underpaint. Cool half-tones in flesh paints can be achieved by brushing the light skin colour thinly to overlap the dark undermodelling for the shadows.

ultramarine A precious fine blue pigment extracted from lapis lazuli.

ultra-violet A form of radiation similar to visible light, but slightly too short in wavelength for the eye to see. Some substances, when illuminated with ultra-violet, fluoresce – give off visible light – allowing details not otherwise visible to become apparent.

umber An earth pigment (q.v.) containing black manganese dioxide, giving it a dark brown colour. Umber may be used as it is – raw – or burnt, that is, heated in a furnace to make the colour warmer.

undermodelling Preliminary painting of features to suggest their shape and shading, before colour and details are added.

verditer (blue) Synthetic azurite (q.v.).

vermilion Mercuric sulphide, usually synthetic but sometimes the ground natural mineral cinnabar; used as a pigment.

warm Of a colour: tending towards the red end of the spectrum. Warm colours tend to seem nearer to the spectator than cool colours, a phenomenon used to create perspective effects.

wet-into-wet Laying down one colour next to or on to another before the first is dry, so that some intermixing occurs.

X-ray diffraction analysis: XRD A technique for the identification of substances in crystalline form (many pigments are crystalline materials). A narrow beam of X-rays (q.v.) is projected through a very small specimen inside a specially designed form of camera. The regular arrangement of atoms in the crystal scatters the X-rays, producing a 'fingerprint' pattern, unique to that crystalline material, on a strip of film. Identification of this pattern allows unambiguous recognition of the material under study. XRD is particularly suitable for the identification of fairly pure samples of crystalline pigments, containing, for example, lead white, lead-tin yellow, vermilion, azurite, chalk, the earth pigments and others.

X-rays A form of radiation which passes through solid objects, but is obstructed to differing degrees by differing materials. The larger the atoms of which a substance is made, the more opaque it is to X-rays. Lead compounds are particularly opaque, those containing lighter metals less so. Thus in an X-ray image (known as a radiograph) of a painting, areas of paint containing lead pigments will appear almost white, areas containing iron pigments will appear in an intermediate grey, and areas containing lighter materials will appear dark.

In interpreting X-rays it should be remembered that all layers are superimposed: thus the image of a stretcher and features on the back of a painting may seem to overlie the image of the paint itself. Details of the weave of a linen canvas and the grain of a wood panel would normally not register significantly in a radiograph: they are, however, made visible in the X-ray image by a radioabsorbent ground which lies directly on them and which takes on the imprint of their surface structure. Thus a prominent thread in a canvas weave will appear dark in the radiograph because there is an absence of ground in this region. Even when a canvas is removed by transfer, the X-ray image of the weave often remains, imprinted in the ground layers. Except in the case of very small paintings, several X-ray plates have to be used. The plates are pieced together to form an X-ray mosaic.

Photographic Credits

Amsterdam
© Bibliotheek van de Universiteit van Amsterdam: Fig. 178
© Museum Het Rembrandthuis, Amsterdam: Fig. 33
© Rijksmuseum, Amsterdam: Figs 8, 21, 26, 35–6, 41, 43, 157

Berlin
© Staatliche Museen zu Berlin. Bildarchiv Preussischer Kulturbesitz: Photo Jörg P. Anders: Figs 66, 85, 146

Boston, MA
Photograph © 2006 Museum of Fine Arts, Boston, Massachusetts: Fig. 6

Brunswick
© Herzog Anton Ulrich-Museum Braunschweig, Kunstmuseum des Landes Niedersachsen
Photo Museumsfoto: Fig. 71

Budapest
© Szépmüvészéti Muzeum, Budapest. Photo Dénes Józsa: Figs 180, 187

Copenhagen
© Statens Museum for Kunst, Copenhagen. DOWIC Fotografi: SMK Foto: Fig. 199

Detroit, MI
Photograph © 1990 The Detroit Institute of Arts: Fig. 123

Dresden
© Gemäldegalerie Alte Meister, Staatliche Kunstsammlungen Dresden: Figs 3, 99
© Kupferstichkabinett, Staatliche Kunstsammlungen Dresden: Fig. 24

Frankfurt am Main
© Städelsches Kunstinstitut, Frankfurt am Main: Figs 7, 98

Göteborg
© Göteborgs Konstmuseum, Göteborg: Photo Ebbe Carlsson: Fig. 200

Haarlem
© Frans Hals Museum, Haarlem-de Hallen: Fig. 2

Helsinki
© Central Art Archives, Helsinki: Photo: Jouko Könönen: Fig. 158

London
© Permission British Library, London: Fig. 18 (450.l.2); Fig. 19 (455.g.14); Fig. 95 (1020.a.19 (1&2) f.160)
© Copyright The Trustees of the British Museum: Figs 49–50, 80, 149, 169
© English Heritage Photographic Library: Fig. 4
© The National Gallery, London: Figs 9–10, 13–15, 17, 20, 22, 28–9, 31–2, 34, 38–40, 44–8, 51–5, 57–64, 67–70, 73–9, 81–2, 84, 86–94, 96, 100–9, 111–12, 117–20, 122, 124–9, 131–6, 138–45, 148, 150–6, 159–62, 165–8, 170–7, 179, 181–6, 188–98, 201–9, 211–20, 222–46

Los Angeles, CA
Photograph © 2005 Museum Associates/LACMA: Fig. 42

Madrid
© Museo Nacional del Prado, Madrid: Fig. 114

Munich
© Bayerische Staatsgemäldesammlungen, Munich. Photo: Kunstdia-Archiv Artothek, D-Weilheim: Fig. 97
Photo Blauel/Gnamm: Fig. 130

New York
Photograph © 1991 The Metropolitan Museum of Art: Fig. 147

The Metropolitan Museum of Art, New York, Special contributions and funds given or bequeathed by friends of the Museum, 1961 (61.198). Photograph © 1995 The Metropolitan Museum of Art: Fig. 163

Oxford
© Copyright in this photograph reserved to the Ashmolean Museum, Oxford: Fig. 5

Paris
© RMN, Paris. Photo Michèle Bellot: Fig. 72. Photo Jean-Gilles Berizzi: Fig. 110

Private collections
© Agnew's, London, UK. Photo Bridgeman Art Library, London: Fig. 37
© Photo Courtesy of the owner. The National Gallery London: Figs 16, 23, 30
© By courtesy of Sotheby's Picture Library, London: Fig. 115
© Photo Courtesy of Wildenstein & Co., New York: Fig. 56

Rotterdam
© Museum Boijmans Van Beuningen, Rotterdam: Figs 11, 27

St Petersburg
© The State Hermitage Museum, St Petersburg: Figs 65, 164

The Hague
© Royal Cabinet of Paintings Mauritshuis, The Hague: Figs 121, 210, 221

Toledo, OH
© Toledo Museum of Art, Toledo, Ohio: Fig. 116

Vienna
© Albertina, Vienna: Fig. 113
© KHM, Vienna: Fig. 137

Washington, DC
Image 2006 © Board of Trustees, National Gallery of Art, Washington: Fig. 12

Weimar
© Stiftung Weimar Klassik und Kunstsammlungen: Fig. 1

Index of Works

Works in bold indicate a reference to a catalogue entry; page numbers in bold indicate a reference to an illustration.

Bol, Ferdinand, *The Lamentation (copy after Rembrandt)*, about 1635, Germany, private collection, **102**, 102
Self Portrait, 1647, Ohio, Toledo Museum of Art, 121, **122**
Brugghen, Hendrick ter, *Jacob reproaching Laban for giving him Leah in place of Rachel*, 1627, London, National Gallery, 29
Dou, Gerrit, *Anna and Tobit*, Paris, Musée du Louvre, 66
Man writing by his Easel, about 1631–2, private collection, **65**, 65
Old Woman reading a Lectionary, about 1631–2, Amsterdam, Rijksmuseum, **65**, 65
Dürer, Albrecht, *Self Portrait*, 1498, Madrid, Museo del Prado, **121**, 121
Flinck, Govert, *The Lamentation*, 1637, formerly with dealer Le Goupy, Paris, 104
Saskia as Shepherdess, 1636, Brunswick, Herzog Anton Ulrich-Museum, 90
Shepherd, Amsterdam, Rijkmuseum, 90
Gelder, Aert de, *The Artist Himself painting an Old Lady*, 1685, Frankfurt am Main, Städelsches Kunstinstitut, 19, **24**, 25–6
Hoogstraten, Samuel van, *Studio Scene: Rembrandt with his Pupils*, about 1642–8, Klassik Stiftung Weimar, **14**, 16
Keyser, Thomas de, *Portrait of Constantijn Huygens and his (?) Clerk*, 1627, London, National Gallery, **54**, 54
Leeuw, Willem van der, *Anna and the Blind Tobit*, Amsterdam, Rijksmuseum, 62, **64**, 64
Lievens, Jan, *Christ in Gethsemane*, about 1627–8, Dresden, Kupferstichkabinett, **56**, 56
Job in Distress, 1631, Ottawa, National Gallery of Canada, 66
Maes, Nicolaes, *Christ blessing the Children*, 1652–3, London, National Gallery, **205**, 205
Portrait of Jacob Trip, about 1660–1, Budapest, Szépmüvészéti Muzeum, **168**, 168
Portrait of Margaretha de Geer, about 1660–1, Budapest, Szépmüvészéti Muzeum, **172**, 172
Ostade, Adriaen van, *The Painter in his Studio*, 1663, Dresden, Gemäldegalerie Alte Meister, 16, **17**
The Painter's Studio, about 1640, Amsterdam, Rijksmuseum, **26**, 26

Raphael, *Portrait of Pope Julius II*, 1511–12, London, National Gallery, 210
Portrait of Baldassare Castiglione, 1514–15, Paris, Musée du Louvre, **118**, 118
REMBRANDT VAN RIJN
Abduction of Europa, 1632, Los Angeles, J. Paul Getty Museum, 84
Abraham's Sacrifice, 1636, Munich, Alte Pinakothek, **112**, 113
Abraham's Sacrifice, 1655, London, British Museum, **160**, 160
The Adoration of the Shepherds, 1646, London, National Gallery (Cat. 11), **28** (micrograph), 29, 32, 39, 45, 129, 132–7, **133**
The Adoration of the Shepherds, 1646, Munich, Alte Pinakothek, **132**, 132
The Anatomy Lesson of Dr Nicolaes Tulp, 1632, The Hague, Mauritshuis, 10, 229
The Angel taking Leave of Tobias, 1637, Paris, Musée du Louvre, 112
Anna and the Blind Tobit, about 1630, London, National Gallery (Cat. 2), 10, 62–9, **63**, 153
Anna and Tobit with the Kid, 1626, Amsterdam, Rijksmuseum, 66, **68**
The Apostle Paul, about 1657, Washington, National Gallery of Art, 157, 160, 198, 210
Aristotle contemplating a Bust of Homer, 1653, New York, Metropolitan Museum of Art, **157**, 157
Artemisia, 1634, Madrid, Museo del Prado, 89, 112
The Artist in his Studio, about 1628, Boston, Museum of Fine Arts, **22**, 22
The Artist's Studio with a Model, about 1654, Oxford, Ashmolean Museum, **21**, 21
A Bearded Man in a Cap, about 1657, London, National Gallery (Cat. 15), 24, 46, 157–9, **159**, 182
A Bearded Man in a Cap, 1661, St Petersburg, State Hermitage Museum, **157**, 157
Bellona, 1633, New York, Metropolitan Museum of Art, 89
Belshazzar's Feast, about 1636–8, London, National Gallery (Cat. 8), **front cover** (detail), **title page** (detail), 28, 31, 32, 37, 39, 41, 42, 45, 47, 50, 56, 85, 94, 96, 98, 110–17, **111**, 130

The Blind Tobit advancing to welcome his Sons, about 1651, Amsterdam, Museum Het Rembrandthuis, **62**, 62
The Blinding of Samson, 1636, Frankfurt am Main, Städelsches Kunstinstitut, **112**, 112
Christ on the Sea of Galilee, 1633, Boston, Isabella Stewart Gardner Museum, 84
Company of Frans Banning Cocq and Willem van Ruytenburch ('The Nightwatch'), Amsterdam, Rijksmuseum, 29
The Concord of the State, about 1640–5, Rotterdam, Museum Boijmans Van Beuningen, **31**, 31
The Crusader, 1659–61, Copenhagen, Statens Museum for Kunst, **183**, 183
Disputing Scholars, 1628, Melbourne, National Gallery of Victoria, 198
Ecce Homo, 1634, London, National Gallery (Cat. 4), **8–9** (detail), 31, 75–81, 77, 103, 104, 136, 138
Ecce Homo, 1636, London, British Museum, 75, **76**
An Elderly Man as Saint Paul, probably 1659, London, National Gallery (Cat. 16), 28, 44, 46, 47, 153, 160–5, **161**
Flora, around 1654, New York, Metropolitan Museum of Art, 90
A Franciscan Friar, about 1655/6, London, National Gallery (Cat. 14), 29, 46, 154–6, **155**
Joseph telling his Dreams, Amsterdam, Rijksmuseum, 103
Judas returning the 30 Pieces of Silver, 1629, private collection (Cat. 1), 28, 34, **34** (detail), 44, 54–61, **55**
Study for Judas returning the 30 Pieces of Silver, 1628–9, private collection, 57, **57**, 58
Study for Group of Figures in Judas returning the 30 Pieces of Silver, 1628–9, Amsterdam, Rijksmuseum, 57, **57**, 58
Judith and Holofernes, 1632–4, Paris, Musée du Louvre, 94, **95**
The Knight with the Falcon, about 1662–5, Göteborg, Göteborgs Konstmuseum, 157, **183**, 183
The Lamentation, about 1634–5, London, British Museum, **100**, 100, 108
The Lamentation over the Dead Christ, about 1635, London, National Gallery (Cat. 7), 24, 100–9, **101**

Landscape with the Good Samaritan, 1638, Krakow, Czartoryski Collection, 204

Man writing by Candlelight, Milwaukee, Bader Collection, 198

Portrait of Maria Trip, 1639, Amsterdam, Rijksmuseum, 168

Minerva, 1635, New York, Otto Naumann, 89, 112, 113

A Monk Reading, 1661, Helsinki, Sinebrychoffin Art Museum, **154**, 154

The Polish Rider, mid-1650s, New York, Frick Collection, 184

Portrait of Aletta Adriaensdr, 1639, Rotterdam, Museum Boijmans Van Beuningen, 168

Portrait of Aechje Claesdr, 1634, London, National Gallery (Cat. 3), 10, 28, 34, **34** (detail), 36 (detail), 44, 70–4, **71**, 84, 87, 88

Portrait of Castiglione (after Raphael), 1639, Vienna, Albertina, 118, **120**

Portrait of Dirck Jansz. Pesser, about 1634, Los Angeles County Museum of Art, 70, 70, 72

Portrait of Frederik Rihel on Horseback, probably 1663, London, National Gallery (Cat. 20), 29, 33, 41, 42, 47, 50, 149, 153, 184–9, **185**, 208

Portrait of Haesje van Cleyburgh, 1634, Amsterdam, Rijksmuseum, 70, 70

Portrait of Hendrickje Stoffels, 1660, New York, Metropolitan Museum of Art, 138, **146**, 146, 149

Portrait of Hendrickje Stoffels, about 1652, Paris, Musée du Louvre, 138, 146

Portrait of Hendrickje Stoffels, probably 1654–6, London, National Gallery (Cat. 13), 29, 41, 42, 44, 68, 132, 138, 146–53, **147**, 208

Portrait of Jacob Trip, about 1661, London, National Gallery (Cat. 17), 24, 27, 42, 44, 47, 164, 166–71, **167**, 172, 174, 178, 212

Portrait of Jan Six, 1654, Amsterdam, Six Collection, 34, 210

Portrait of Johannes Wtenbogaert 1633, Amsterdam, Rijksmuseum, 70

Portrait of Maerten Looten, 1632, Los Angeles County Museum of Art, 70

Portrait of Margaretha de Geer, about 1661, London, National Gallery (Cat. 18), 11, 27, 37, 44, 47, 51, 115, 164, 166, 169, 170, 171, 172–7, **173**, 178, 182, 212

Portrait of Margaretha de Geer (bust length), 1661, London, National Gallery (Cat. 19), 29, 37, 172, 178–83, **179**

Portrait of Petronella Buys, 1635, private collection, 82, 82

Portrait of Philips Lucasz., 1635, London, National Gallery (Cat. 5), 21, 23, 28, **29** (micrograph), 37, 39, 44, 45, 70, 74, 82–8, **83**, 115

Portrait of a Rabbi, 1657, San Francisco Museum of Fine Art, 157

Portrait of a Woman leaning at an Open Door, 1656–7, Berlin, Gemäldegalerie, 138, 146, **146**

Saint John the Baptist preaching, 1634–5, Berlin, Gemäldegalerie, **103**, 103, 104, 136

Saint Paul at his Desk, about 1629/30, Nuremberg, Germanisches Nationalmuseum, 160, 198

Saint Paul in Prison, 1627, Stuttgart, Staatsgalerie, 160

Saskia as Flora, 1634, St Petersburg, State Hermitage Museum, 89, **90**, 92

Saskia as Flora, 1641, Dresden, Gemäldegalerie Alte Meister, 90

Saskia in a Straw Hat, 8 June 1633, Berlin, Kupferstichkabinett, 89, **90**

Saskia van Uylenburgh as Flora, 1635, London, National Gallery (Cat. 6), 28, 33, 37, 39, 44, 45, **45** (detail), 46, 89–99, **91**, 114, 115, 116

Scholar in a Room with a Winding Stair, about 1633, Paris, Musée du Louvre, 198

Scholar in a Vaulted Room, 1631, Stockholm, Nationalmuseum, 198

A Seated Woman, about 1655/6, London, British Museum, 148, 148, 150

Self Portrait, 1658, New York, Frick Collection, 210

Self Portrait, 1665, London, Kenwood House, 19, 19

Self Portrait, 1669, The Hague, Mauritshuis, 190, 190

Self Portrait at the Age of 34, 1640, London, National Gallery (Cat. 9), 28, 30, 33, 92, 114, 118–25, **119**, 152, 180, 190

Self Portrait at the Age of 63, 1669, London, National Gallery (Cat. 21), 29, 34, 42–3, 44, 46, 132, 149, 186, 190–5, **191**, 208

Self Portrait as the Apostle Paul, 1661, Amsterdam, Rijksmuseum, 160

Self Portrait as Zeuxis, Cologne, Wallraf-Richartz-Museum, 25

Simeon praising Christ, 1631, The Hague, Mauritshuis, **126**, 126

Susanna and the Elders, late 1630s, The Hague, Mauritshuis, 46

Titus as a Franciscan, 1660, Amsterdam, Rijksmuseum, **154**, 154

Two Figures sitting, 1628–9, Rotterdam, Museum Boijmans Van Beuningen, **57**, 57, 59

Wedding Feast of Samson, 1638, Dresden, Gemäldegalerie Alte Meister, **112**, 112

A Woman bathing in a Stream, 1654, London, National Gallery (Cat. 12), 31, 33, **33** (detail), 34, 37, 41, 44, 45, 138–45, **139**, 146

The Woman taken in Adultery, 1644, London, National Gallery (Cat. 10), 24, 30, 32, 39, **41** (detail), 52–3 (detail), 61, 115, 126–31, **127**, 136. 163

A Young Woman sleeping, around 1654, London, British Museum, 140

Rembrandt van Rijn and Gerrit Dou, *Prince Rupert of the Palantine and his Teacher as 'Eli teaching Samuel'*, about 1631, Los Angeles, J. Paul Getty Museum, 64

Rembrandt, After, *Hendrickje Stoffels as Venus*, Paris, Musée du Louvre, 138

Rembrandt, Circle of, *Travellers resting (on the Flight into Egypt?)*, about 1629–30, The Hague, Mauritshuis, **200**, 201

REMBRANDT, FOLLOWER OF

Diana bathing, late 1630s, London, National Gallery (Cat. 23), 202–4, **203**

An Old Man in an Armchair, 1650s, London, National Gallery (Cat. 25), 28, 210–13, **211**

A Seated Man in a Lofty Room, early 1630s, London, National Gallery (Cat. 22), 33, **196**–7 (detail), 198–201, **199**

A Seated Man with a Stick, 1650–60, London, National Gallery (Cat. 26), 214–17, **215**

Study of an Elderly Man in a Cap, 1650s–60s, London, National Gallery (Cat. 27), 218–21, **219**

A Woman Weeping, 1654–5, Detroit Institute of Arts, 126, **128**

A Young Man and Girl playing Cards, 1645–50, London, National Gallery (Cat. 24), 29, 205–9, **207**

Rembrandt and his workshop (probably Govert Flinck), *Man in Oriental Costume*, about 1635, Washington, National Gallery of Art, **32**, 32

Rubens, Peter Paul, *Hélène Fourment in a Fur Wrap ('Het Pelsken')*, about 1635–40, Vienna, Kunsthistorisches Museum, **140**, 140, 149

Judith with the Head of Holofernes, Brunswick, Herzog Anton Ulrich-Museum, 94, **95**

Portrait of Ludovicus Nonnius, about 1627, London, National Gallery, 210

Santvoort, Dirck, *Shepherd*, 1632, Rotterdam, Museum Boijmans Van Beuningen, 90

Shepherdess, 1632, Rotterdam, Museum Boijmans Van Beuningen, 90

Sorgh, Hendrick, *A Woman playing Cards with Two Peasants*, 1644, London, National Gallery, **205**, 205

Sweerts, Michiel, *The Academy*, about 1655–60, Haarlem, Frans Hals Museum, **16**, 16

Tintoretto, *Madonna and Child with Saint Jerome, Saint Joseph and the Procurator Girolamo Marcello*, before 1540, private collection, 210

Portrait of an Old Senator, 1575/80, Dublin, National Gallery of Ireland, 210

Titian, *Flora*, Florence, Galleria degli Uffizi, 90

A Man with a Quilted Sleeve, about 1510, London, National Gallery, **118**, 118

Veronese, Paolo, *Rape of Europa*, Venice, Ducal Palace, 112

Vliet, Jan Joris van, *The Descent from the Cross*, 1633, London, British Museum, 75, **76**

Vliet, Willem van der, *Portrait of Suitbertus Purmerent*, 1631, London, National Gallery, 210